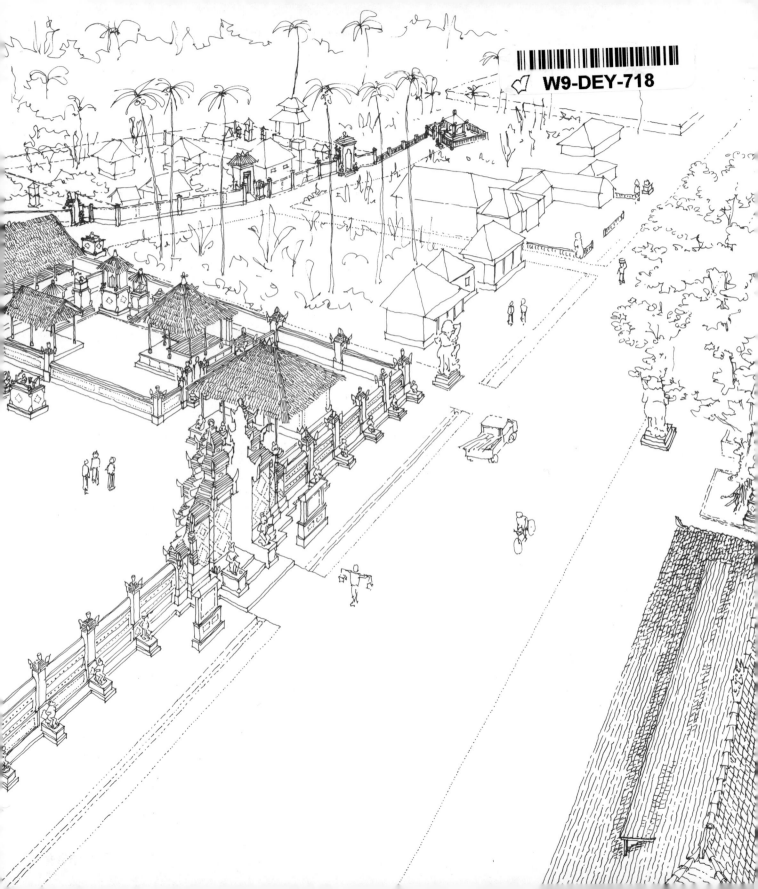

The Life of a Balinese Temple

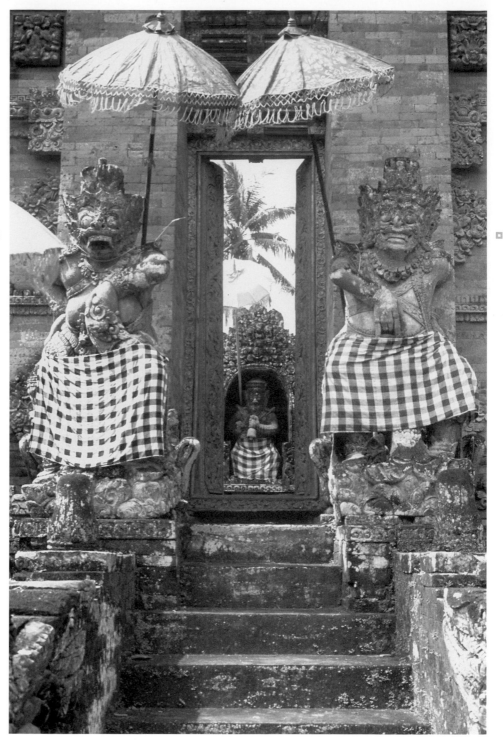

The Life of a Balinese Temple

Artistry, Imagination, and
History in a Peasant Village

Hildred Geertz

Illustrations by Sandra Vitzthum

 University of Hawai'i Press

Honolulu

09 08 07 06 05 04 6 5 4 3 2 1

Library of Congress Cataloging-in-Publication Data

Geertz, Hildred.

The life of a Balinese temple : artistry, imagination, and
history in a peasant village / Hildred Geertz ; illustrations
by Sandra Vitzthum.

 p. cm.

Includes bibliographical references and index.

ISBN 0-8248-2533-0 (hardcover : alk. paper)

1. Balinese (Indonesian people)—Indonesia—Batuan—
Rites and ceremonies. 2. Balinese (Indonesian people)—
Indonesia—Batuan—Religion. 3. Temples—Indonesia
—Batuan. 4. Art, Balinese—Indonesia—Batuan.
5. Architecture—Indonesia—Batuan. 6. Batuan
(Indonesia)—Social life and customs. 7. Batuan
(Indonesia)—Religious life and customs. I. Title.

DS632.B25G44 2004

306.6'94535'095986—dc22 2003025777

University of Hawai'i Press books are printed on acid-free
paper and meet the guidelines for permanence and durabil-
ity of the Council on Library Resources.

Designed by April Leidig-Higgins

Printed by Thomson-Shore, Inc.

For Andrea and Elena

Contents

Acknowledgments

Every time I returned to Bali, some of my understandings of Balinese conceptions (of life, of gods, of temples) proved wrong or distorted. Many of these new insights concerned details of word usage, customary practices, and novel acts, but occasionally they forced major reorientations in my thinking. As a result of these corrective experiences, I am painfully aware that much of this book is incomplete or partially accurate. There must be some still uncaught mis-attributions, mis-namings, mis-judgments, and mis-interpretations in it. Some of these failings may be due to the fragmentary and shallow qualities of my own experience in Bali, but many are due to the variations in knowledge, perspective, and memory found among the people of Bali. I do not yet know, really, what a "temple" is, what "deities" are, what "rituals" are supposed to accomplish, nor what "Balinese religion" is about. But I've felt that I must go ahead and publish the present state of my knowledge. I only hope that the Balinese who read this book will extend to it their usual tolerance of human mistakes, based on their usual skepticism about the nature of human knowledge. I hope that none of my errors offend them, and in such cases, I beg forgiveness. My research was carried out in Bali in 1956–1957 for nine months, in Europe in 1978–1979, and in Bali again for a total of twenty-eight months between 1981 and 1988, with about twenty-four of them in the village of Batuan. I made brief visits in 1995 and 2000.

My Indonesian institutional sponsors, over the years, were the Indonesian Institute of the Sciences (LIPI) and the University of Udayana in Bali. Funding was given by the following: the Social Science Research Council, the National Science Foundation (grants nos. BNS 81-12418, BNS 84-05549, and BNS 83-14361), the Institute for Intercultural Studies, the Wenner-Gren Foundation, the American Council of Learned Societies, and the Princeton University Committee on Research. I am deeply grateful to all of these institutions.

Research, like temple building, is a social enterprise, requiring help of all sorts, and I have had many collaborators, knowing and unknowing. First and foremost were the people of Batuan, who courteously allowed me to study them. The main contributors were Déwa Putu Beratha, Déwa Ketut Baru, Ida Bagus Madé Togog, Ida Bagus Putu Gedé, Ida Bagus Ketut Alit Budhiana, Pamangku Désa Nurada, Pamangku Alit Wayan Suda, Bendésa Wayan Regug, and I Wayan Ritug. Many others patiently and thoughtfully helped me, including Anak Agung Gedé Agung, Ida Bagus Putu Bun, Ni Ketut Cenik, Déwa Nyoman Cita, Ida Bagus Madé Diksa, I Wayan Djaboed, I Madé Djata, I Madé Jimat, I Ketut Kantor, Désak Madé Lebih, I Wayan Lugri, Dayu Niang

Modri, Déwa Putu Mudita, I Wayan Naka, Déwa Ayu Putu Padmi, Ida Bagus Rai Adhi, I Wayan Rajin, Déwa Putu Raka, I Wayan Ruta, I Nyoman Sadeg, Ida Bagus Madé Sanur, I Nyoman Saweg, Ni Wayan Sukri, I Ketut Songkrong, I Wayan Taweng, and I Madé Tubuh. There were, of course, many others with whom I had conversations that added to my understanding. There is no adequate way that I can express my gratitude to any of these people for all of their trust, tolerance, and goodwill over the years. I hope this book will be a partial return for their efforts.

Professor Dr. I Gusti Ngurah Bagus of the University of Udayana in Denpasar was a constant source of support, collegiality, and friendship. In addition, my two research assistants, I Wayan Suparto and I Nyoman Dhana, worked many hours for me, interviewing with me and transcribing our tapes. At a later stage, Degung Santikarma carried out extensive research at my request on Batuan's Taur Kasanga cycle of rituals and then later meticulously and critically read over this manuscript.

Sandy Vitzthum, who made most of the illustrations, has been an important collaborator, whose enthusiasm and insights throughout the years have buoyed me up. I cannot thank her enough. As a student in architecture at Princeton University she spent the summer of 1985 in Batuan, helping me and also working on her senior thesis, the designing of an imaginary American embassy building for Bali. In 1995 she spent another summer in Bali with me, this time photographing, mapping, and sketching Pura Désa Batuan, the results of which are evident in this volume. In 2002 she spent many hours in her studio finishing the drawings for publication. Over the years a number of other people have helped me with these illustrations. Most important was my son, Benjamin Geertz, who in 1983 photographed every carving in the temple, photos that I could use in interviewing. Other photographers, whose photos were helpful even though not reproduced here, were Fred B. Eiseman, Jr., and Deborah Hill, both of whom spent

many hours patiently following me about to try to catch an image I thought I saw. Thanks also are due to Lois Bateson for permission to print figures 4.8 and 6.4.

A study like this is also nourished through conversations with other scholars. Over these years those doing research with me in Bali at the same times stimulated and reassured me in numerous ways. I talked over my fieldwork with them, read their writings in manuscript and the books they suggested. I absorbed information and ideas from them in a continuous process of learning, and in my endnotes have tried to give them full credit. Some of their ideas I may have unconsciously made my own, and I hope they will understand how that can happen. Foremost among these colleagues was Margaret Wiener, who critically commented on this book in manuscript and on earlier papers as well. Others who taught me much were Linda Connor, Jean-Francois Guermonprez, Mark Hobart, Barbara Lovric, Ann McCauley, Michel Picard, Raechelle Rubinstein, Henk Schulte Nordholt, David Stuart-Fox, Adrian Vickers, and Carol Warren. In addition, the following scholars and their writings were helpful: James Boon, Frederik de Boer, Michelle Chin, Angela Hobart, Hedi Hinzler, Brigitta Hauser-Schaublin, J. Stephen Lansing, Albert Leeman, David Napier, Kiyoshi Nakamura, Yasayuki Nagafuchi, Abby Ruddick, Annette Rein, Martin Ramstedt, Kirsten Scheid-Idriss, and Mary Zurbuchen. Thanks also to Pamela Kelley at the University of Hawai'i Press and an anonymous reader. Kristina Melcher-Wija provided thoughtful help, warm friendship, and delightful amusement over the years while I stayed in Bali. There may be others, too, whom I should thank but have inadvertently omitted from this long list.

Every one of these many different kinds of people worked hard to make sure that I understood what was being told to me, but I am sure that, despite their efforts, errors and shortcomings remain, for which only I can be blamed.

Terms, Names, and Spelling

Many variations in pronunciation and spelling of Balinese terms can be found in Bali. I have followed the official dictionary, *Kamus Bali-Indonesia,* for all spelling. All italicized terms are Balinese unless otherwise indicated as Indonesian or Dutch. Proper nouns are not italicized. For instance, names of gods, names of altars, and names of people according to their occupation (e.g, the Pamangku—a particular priest of a certain temple) are not italicized. The term for a ritual (e.g., *odalan*) is italicized but the name of a ritual specific to a place is not (e.g., the Odalan of Batuan).

Balinese words are built around "roots" with affixes. I try to give both the word with its affix and its root, as in *mecaru* and *caru.* The nasalized prefixes *me-* or *nge-* or *n-* turn a "passive" word into "active" (e.g., *caru,* "an offering that is given to the demons," *macaru,* "to give an offering to the demons"). Adding the prefix *ke-* and the suffix *-an* can convert a concrete term into an abstraction (e.g., *sakti,* "spiritual power in the concrete," *kasaktian,* "abstract spiritual power").

Balinese words have no plurals (except for doubling when one wants to stress plurality). I usually give them in the singular, relying on context to show that they are plural.

An important meaning-bearing linguistic form in Balinese is the use of social register. An intricate vocabulary for indicating respect or familiarity is employed in nearly every sentence uttered. Such terms carry meanings not only concerning nuances of status of the persons to whom one is speaking, but also, importantly, the relative status of persons of whom one speaks.

Honorific titles of people and of gods are required in everyday speech and writing, such as "Ida Bagus" for Brahmana men and "Ida Betara" and "Ida Sanghyang" for gods. I follow Balinese usage here, giving the entire title out of respect for the personages referred to, despite the fact that it adds difficulty for some readers.

For rhetorical simplicity I use terms such as "gods," "deities," and "demons" to cover the various and changeable spiritual beings that the Balinese engage themselves with, even though many have mixed and fluid characteristics. Similarly, for convenience, sometimes I use the pronoun "he" for the gods, although, usually, there is no special reason for doing so since their gender is not marked linguistically. None of them is an "it," and most of them are thought of as male, at least some of the time.

In order to understand the meaning of artistic products, we have to forget them for a time, to turn aside from them and have recourse to the ordinary forces and conditions of experience that we do not usually regard as esthetic. We must arrive at the theory of art by means of a detour.
—John Dewey, *Art as Experience*[1]

Preface

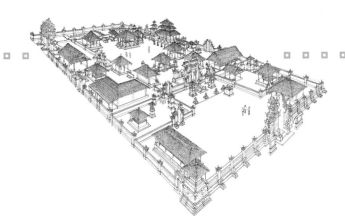

This book is an attempt to think about the anthropology of "art" through the tangled particulars of the stone carvings of a certain village temple on the island of Bali, a place known for its exuberance of art forms, energetic communal life, and religious complexity.

The members of the village temple of Batuan, working entirely without specialized help, have over the course of this century created a crowd of stone figures and paintings on and among its many altars. These, with decorated walls and gateways, mark out a garden-like setting for their rituals. The physical aspects of a Balinese temple appear to many Western visitors as ancient and unchanging. However, they have proved to have traceable recent histories of both innovation and conservation, histories that were intimately bound up with the histories of the group of people who support the temple.

The apparent permanence of stone carvings gives viewers a false sense of cultural continuity. The physical forms of carvings in almost any Balinese temple are residues of several quite different historical periods, eras in which even the basic theological principles within which a temple may have been conceived may have been quite different from those holding today.

The stone figures that stand and stare at the human goings-on in and around the temple were the initial targets of my research (as suggested by the phrase "an anthropology of art"). But my focus on these material "artworks" rapidly shifted away from them, to a study of the acts—social and cultural, personal and collective—that went into their making and that go into their continuing reception. It is not the artifacts themselves that should be the main center of a study of this sort but rather the labor of planning, conceptualizing, and making them; the uses to which they are and have been put; and of course the various socially authorized ways of "reading" the carvings—by their immediate audiences and by subsequent viewers, including those looking at this book.

In doing this, it is critically important to focus on what these objects and activities may have meant and mean for Balinese. One is in constant danger of projecting irrelevant meanings onto them until one knows what their makers, users, and viewers were and are doing with these carvings, what meanings they themselves found or find in them, and what sorts of values they placed or place on them, what Dewey called "the ordinary forces and conditions of experience." These are the central questions of this book, since they are logically prior to the efforts of any "outsider" to integrate perceptions of visible forms with meaningful interpretations of actions.

What a "temple" might be for Balinese frequenters is a subject of continuing research. By our definitions it is a site for "rituals," but what these are for and what sorts of "deities" they address is not immediately apparent. I've tried to set forth my present understandings of these matters, both as background for my readers and as the product of my studies in Batuan, even as I am aware of the complexity and contradictoriness of Balinese statements and the differences among scholars about these matters.

Nearly every Western scholar has written at least a few lines on "Balinese religion" (if that is the proper term), but only a few early ones have attempted a full account of it. Most popular accounts, which in their nature are sweeping overall pictures, give seriously misleading impressions of Balinese rituals and their meanings.

A history of culturally guided and socially monitored imaginings is very hard to construct, at least by usual anthropological and historical techniques. Rarely are such events caught in the act or even retrievable through interview, and one too often has to make do with speculative reconstruction based on circumstantial evidence.

Although field research is impossible without close examination of particulars, anthropologists do not often focus their writing on specific events or objects. However, when they do, anthropologists have usually looked at specific artifacts and events as windows toward more general understandings of the society and culture. Art historians in contrast focus on artworks in all their celebrated singularity. I try here to do both and, also, to keep myself aware of the various viewpoints of the other actors involved, to see each work as open to multiple interpretations, some opening out to more general insights, some narrowing down to their particularities.

There are those who hold that art is a universal language, based on fundamental human proclivities, understandable by those of sufficient sensitivity. However, while the common heritage of all human beings, biological in its universality, may enable some mutual understanding, it can never guarantee perfect insight into meanings. The assumption that certain Western attitudes or perceptual processes as described by philosophers of aesthetics are human universals is unnecessary and, at least at present, too vague to be useful. It is important not to found one's research on presuppositions about human universals, but still to leave open the possibility that some common groundings may be found. Therefore I treat "art" and related concepts such as "aesthetic," as James Clifford has phrased it, as categories "defined and redefined in specific historical contexts and relations of power," as culturally local terms

themselves, contested even as they are employed.[2] In just the same way I approach similar Balinese terms.

One alternative to a universalistic approach is that of extreme relativity, holding that the making of Balinese carvings occurs within an unfathomable and incomprehensible other world of thought and action, an assumption that is also untenable and unnecessary.

There is, however, a middle area between universalism and relativity, one of partial understandings and appreciations of one another's imaginative productions, a region occupied by me as anthropologist, by the Balinese who have tried to explicate their works to me, and, perhaps, also by the readers of this book.

. .

I have much to tell about the temple carvings, and it is all interconnected and cries out to be said and shown all at once. My inadequate solution to this intractable task has been to discuss the temple and its carvings successively from various points of view.

I divide the book into two parts, part 1 on the work that has gone into the making and viewing of the stone carvings of Batuan, and part 2 on the works themselves. In chapter 1, I introduce the temple, the villagers, and myself, and the kinds of work we have done. I discuss the project of ethnography, my methods, and the problematics of the Western concept of "art" as a guiding framework in research. I ask whether it is appropriate to call the objects and performances studied "art" when the insiders do not do so and when many outsiders also would not, and what the implications of that governing framework are. Appropriate or not, the use of the term "art" is impossible to avoid in writing within English discourses about these matters, but it repeatedly sets up difficult dilemmas in both field research and ethnographic writing, paradoxes that are further confronted in chapter 6.

In chapter 2 I outline the many different kinds of work—ideational as well as physical—that the villagers undertake in connection to the temple, and the social institutions that enable, constrain, and motivate such work. I present a description of the village of Batuan and its *pura désa* or "village temple," centered on the activities of building and rebuilding the temple and its parts. I address the question of how it could happen that the temple carvings have been modified over the years, given important Balinese religious constraints on innovation. How, that is, has it been possible, with the strong Balinese cultural stress on communal responsibility and participation, for some individual innovation and creativity to flourish? To answer this question, I look closely at the ways in which architectural and carving work are usually planned, organized, and carried out. The profound sociality of art (however defined) is strikingly illustrated in Bali. Neither of the two main popular romantic notions about art's relations to society is supported: the temple is not somehow the product of a group mind nor is the assembled work of uniquely talented individuals working alone.

Another kind of work is the subject of chapter 3, that of the worship of the gods. This is the culturally authorized primary intended goal of the temple and its carvings, as is recognized in the Balinese term *"karya"* which means not only "work" but "ritual," and covers not just prayer but also the labor of the craftsman and the dancer. In this chapter I give an analysis of the layout and carvings of the temple as they look from ritual perspectives. I show that the rituals themselves provide major (mainly unverbalized) interpretive frames within which Balinese may understand the carvings.

Here I also discuss some of the competing religious orientations available for interpretation of the rituals and hence the carvings, aspects of a continuing change in Balinese religious ideas that was going on throughout the twentieth century. The most prominent of these is the Hindu Dharma movement, a new interpretation of Balinese religious rituals that is self-consciously In-

dicising, universalizing, and individualizing, which presents a conception of Balinese deities as abstract harmonious forces and symbols. In contrast, other views of the rituals see the gods as beings who are local, sentient, willful, and personal. This latter religious orientation has been somewhat neglected by scholars of Balinese religion, especially the earlier ones. They have also ignored the pervasive concern in Bali with what they have dismissed as "sorcery" and "black magic." My study of the paintings made in the 1930s, which I wrote up first, led to recognition that concerns about witchcraft and sorcery were constantly pressing, not as "private" matters but as communal, "religious" issues. For many Balinese, the gods themselves can be malevolent and can cause disaster in much the same ways as human sorcerers, although most of the time they provide protection from and healing of the wounds and sufferings of human existence.

The interplay of differing visions of the cosmos and of human roles in relation to such a cosmos has immense implications for the multiplicity and ambiguity of meanings of the stone carvings, and also for their vitality, their "life." Temple carvings, for their Balinese makers, have not only vivid forms and many-layered meanings, but also significant practical effects, intended and unintended. How to recognize these forms, interpret these meanings, and infer these effects, in Balinese ways, are continuing questions for me.

A by-product of my study of the religious groundings of the temple carvings has been a recognition of the important contradictions between the ways many Balinese spoke with me about their religion and the ways they and others actually went about their worship during the 1980s. Reinforced by scholarly and political invocation of "harmony and order," their own discursive practices threw up a formidable screen against understanding anything about Bali before 1970. In attempting to articulate some ideas that were not directly stated to me, I don't claim to "know better than the

local people," but only to try to understand their commentaries in a responsible way and to integrate their words with their acts, to develop an account that is as comprehensive as possible.

Seeing the carvings as aids in the advancement of the ritual purposes of the people of Batuan tells us a great deal about the imaginational content of the carvings, but still leaves out much of what they may say about relationships among the human worshipers themselves, a concern explored in the historical chapters.

In part 2, "Works," I present, one by one, the "artworks" themselves, the carvings, set within the intricate sociocultural contexts of their making. This is the heart of the book. In it the history of the village of Batuan becomes the main framework for a discussion of each of the works of the temple. I look at the carvings each time from the perspectives of their makers, each generation in a different social situation. Who were, after the gods, the viewers that the makers had in their minds? What were the secondary interpretive frames through which they saw them? What sorts of clashes of interpretation or evaluation might have been there at different periods? I explore the roles played by the carvings in social maneuvering, both among village factions and between the village and more powerful external social entities, such as the noble and priestly groups and the Indonesian government.

Chapters 4 and 5 give the precolonial and colonial history of the making of the works of their times. It is during the latter period, from 1917 through 1940, that the main forms of Pura Désa Batuan and its carvings were set, a period in which religious conceptions and practices were not yet challenged by the Hindu Dharma movement that developed in the postcolonial years.

Chapter 6 is the most openly theoretical place in the book. Inserted between my accounts of "past" and "present" Bali, I examine some of the dilemmas of contemporary anthropology through the temple carvings created before 1940, especially the issues raised by

the concepts of "art," "aesthetics," "coherence," "representation," "sacredness," and "universality."

Chapters 7–9 take up that history again, and discuss the new carvings made during the tumultuous and complex social situations that arose with the expulsion of the Dutch colonial administration and the increasing globalization and commercialization of Balinese society. It is demonstrated yet again that any anthropology of art must also be historical.

Different readers may find different sections of this book important, but to me all are needed. Those interested in the puzzles of Balinese "religion" may focus on chapter 3; those primarily interested in the developing anthropology of "art," chapter 6; and those concerned with Bali's complex history, chapters 4, 5, 7, 8, and 9.

Because spatial relationships are central to matters of art and ritual, I have included a number of maps and diagrams so that the reader can visualize where statues and buildings are, and what stands near them.

Pura Désa Batuan is not a typical temple, nor is Batuan a typical village. I chose them for study for reasons that had nothing to do with representativeness. In any case, approaching an understanding of Balinese matters—temples or paintings or religious conceptions—through concepts of typicality and types would be a major mistake, since variability and heterogeneity are not only pervasive but valued in Bali. Nonetheless, because temples stand at the very heart of Balinese society, culture, and history, much can be learned through the story of the life of Pura Désa Batuan.[3] In paying attention both to the work of creating the temple—imaginational, social, cultural, physical—and to the works produced, the carvings, we can come to recognize that a temple is its supporters, its history is their biography, and its animation is their life.

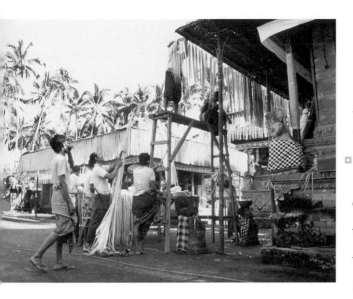

Part I. Work

■ ■

concerning the kinds of effort

that go into

the making and modifying of

Pura Désa Batuan

and its carvings

A Temple and an Anthropologist

The evening of the first full day I spent in Batuan, a large village in south Bali, I was taken to see a dance performance at the temple of the village (Pura Désa) by four girls from the household in which I had rented a room. The temple was on a slight rise on the northern edge of the village, on a dirt road with food-peddlers' stalls along it, strung with dim, bare-bulbed electric lights and kerosene lanterns. A large cement-floored, tile-roofed, open dance pavilion stood outside the gate of the temple.

When we arrived the show had already begun in the pavilion, which was large enough to hold the dancers and musicians and also the audience, standing and sitting around its edges, crowding in along its wall-less sides. There were old women and young matrons with babies, middle-aged men standing on the outside, children darting across the performing floor. The young people, including the teenagers I was with, sauntered around the outside, ogling and giggling and teasing one another, sometimes stopping to watch the performance. The masked kings and warriors and comic servants twirled and posed with grand style. The intricate music wound around us all, alternately clanging and tinkling.

There had been rituals all that day in Pura Désa Batuan, but no one had told me about them. I looked curiously across the road at the tall, split gate of the temple

looming there in the dark. I did not yet know that I was going to study it. There were a few people going in and out through the gate, some women carrying offerings on their heads, several white-dressed priests, the ever-present roaming dogs.

I could also see a row of stone statues in front of the temple, each about the size of a child. The statues were clothed in skirts of checked cloth that concealed much of the carving. No one was paying much attention to the statues, and in fact few were watching the dance itself.

I asked who the performers were, and the girls named some of our neighbors, then stopped for a while and followed the show, laughing at the ribald comic routines of the clowns and critically commenting on the technique of the dancers.

They turned away from the play again, pulled at by a trio of young men who teased them with a sharp insolence that seemed out of place. There was an underlying tension palpably present among these young people. The boys were commoners, but the girls of my family were gentry—distant relatives of a king who once reigned in Gianyar, now a bustling town some fifteen kilometers from Batuan.

I had only that morning, in June 1982, begun to learn about the nasty rupture in the community in the 1960s, when all the gentry families of Batuan had been forcibly evicted from membership in this temple. As nobles, my family were now outsiders to Pura Désa Batuan, never allowed to pray there. While the veneer of civility that is required of all Balinese remained always strong, underneath I could sense powerful angers at work between these commoner boys and noble girls. Several years later, when I finally put together all the details of the controversy, I was surprised to learn that the major divisive events had occurred at least twenty years previously, before the young people I was with were born. Pura Désa Batuan continued to be important in the consciousness of the evicted gentry of the

village. They had since built their own *pura désa,* but, at least in the late 1980s, many still set out offerings within their family temples to the deities of the old Pura Désa, who for them remain the guardians of the *gumi* or "realm" of Batuan. The girls had gone up to the temple not to worship but to enjoy the show of the *topéng* dance. Even though we were not actually going to enter the temple, we wore ceremonial dress as carefully attractive as if we were coming to meet the divine beings, for, since it was the time of the temple festival, those deities themselves were there among us, also enjoying the performance.

. .

I had chosen to study in Batuan not because of its temple but for its school of painting. In the 1930s, a group of young people there had created thousands of marvelous, arresting pictures, many of which had been collected by the anthropologists Margaret Mead and Gregory Bateson, who had also interviewed the artists while they lived in and studied the village. Mead showed me these paintings in 1973, and suggested I work on them. I had been looking for a research project in the anthropology of art, and decided to follow up on Bateson and Mead's research among the artists, to learn about the history and the meanings of the paintings. The 1930s paintings were forerunners of Bali's present-day flamboyant tourist art. The genre had been set in motion before Mead and Bateson arrived by Western artists who taught several peasant boys how to make these small, portable paintings on strong imported paper and who promoted their sale among foreign visitors. Commodified and bicultural from the start, the Batuan paintings, however, proved to be rich in culturally particular content.[1] Yet after three summers of field research, I decided to do some corrective background research on what I then thought of as "traditional aesthetic values."

I began to look for examples of traditional plastic

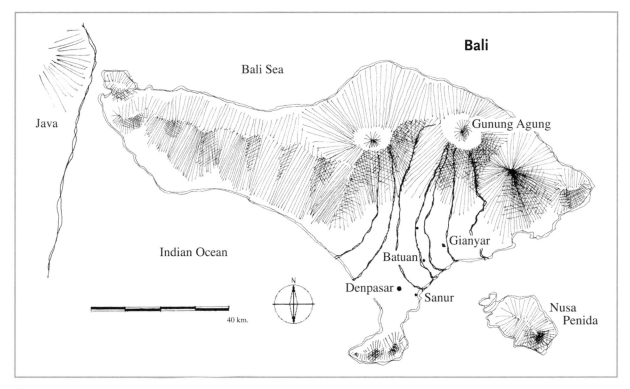

Figure 1.2.

arts and settled on the stone statues of Pura Désa Batuan, which appeared to be pure products of Balinese culture. (Ironically, I later found out that the temple and its carvings are also "bicultural" but in more subtle ways, and across less disparate cultural lines.)[2]

I had photographs of the temple carvings made, and I took sets of them around to my various consultants to elicit evaluative comments on each figure. This procedure was not very productive, since most Balinese have no conventional ways of speaking about "aesthetics" and express such judgments in ways too oblique for my then rather naive understanding. But what I did learn from these early interviews was that the carvings had a describable history, and I soon embarked on a major study of how each one of them came to be made.

Everyone in Batuan stressed the antiquity of their *pura désa,* and a sign by its front gate proclaims its

founding date as Saka year 944, which is 1022 C.E. However, I was surprised to discover that most of the temple had been made only recently, within the memory of living people. An earthquake in 1917 threw down most of the walls, gateways, and statues. Only some fragments of the earlier works remained, and these have been respectfully installed on new pedestals, but most are new carvings. To my astonishment, I found that the artists who made each one were remembered, and that they were all members of the village of Batuan itself.

I had had the notion, as most visitors do, that the stone carvings I saw were not only very old, but profoundly "traditional," that even though some might have been restored, their ritually specified forms had not been changed very much, because of what I thought of as Balinese religious conservatism. I knew that new carvings were continually being made, but I thought

that the artists always simply replicated the old. However, I later found out that not only were the new carvings not conscientious reproductions of earlier ones, but that as each new generation of carvers came to work, they produced new kinds of carvings that demonstrated changing tastes and sensibilities. I also discovered that, despite collective participation in Balinese temple construction and stone carving, master craftsmen are always recognized and given credit for their work. The names of the makers of parts of the temple are remembered. Since the names are never written down, they are lost when those who knew them die. The names and work of several of these master carvers who worked on the Pura Désa Batuan within the past sixty years are still known to many.

Some of the renovations were, in fact, major alterations. For instance, in the 1920s the villagers decided to move the main entrance of the temple from its west side to its south so that the gateway could be seen directly from the road and so that there would be greater space for celebratory dance-drama productions. This occurred during an era (the 1920s and 1930s) when, in response to various colonial social innovations, there was a general renaissance all over Bali in popular music and drama, a revitalization that accompanied a shift in patronage from royal houses to local village temples. Where formerly the main performance sites were in front of noble palaces, now they were in front of village temples. And a flood of new creations in the performance arts followed. Pura Désa Batuan's decision to change its architectural orientation was probably, in part, a response to the new excitement in the arts of that historical moment. The work, which seems to have gone in bursts—first in the early 1920s, then in the early 1930s, again in the late 1940s, and, after a long lapse, in the 1970s through the 1980s and continuing today—is marked by the tastes and sentiments of each era.

I started the research on the paintings by locating a family in Batuan willing to take me in as a paying boarder. I was extremely fortunate to find one whose head was a painter whose pictures were in the Bateson-Mead collection. His brother was a musician and dancer. Between them they were a constant source of information about the active cultural life of the village. Their wives and older daughters pulled me immediately into their ritual and social life, instructing me in the making of offerings and prayers and filling in for me the gossip of the village. Unfortunately for the research on Pura Désa Batuan, they were members of the gentry faction exiled from the temple in 1966, and they had not entered it since that time. But they were proud of their former temple and glad when I started studying it in detail. I stayed with this family whenever I visited Batuan, periodically from 1981 through 2000, a period of considerable work on the temple carvings. The longest visit of eighteen months was in 1984–1985, and in all I spent a total of twenty-seven months in Batuan.

The temple project proceeded in tandem with my study of the history of painting in Batuan. The two enriched one another, as did another study of the dance and drama performers of the village. In fact, the theater turned out to be foundational to both painting and temple carving.

To learn about the temple and its carvings I talked with priests and other religious specialists, with the village officers who run the temple from day to day, with dance-drama performers, and with various older people who were able to report what they remembered about the renovation of Pura Désa Batuan. I also asked what their parents had told them about the temple, thereby pushing my oral histories back to the 1920s and before. I spoke with some master carvers and their adult children and apprentices. I gradually pieced together not only the history, but also a sense of the meanings and purposes of some of the statues. Most of my consultants were commoners.

I worked, first, to discover who the maker or makers were of each structure and artifact, what their social

positions were, what aspects of their cultural heritage they knew of, what their intentions were in making those particular carved figures and in making them in the particular, stylized ways they did. I asked what each carving represented and what was the story connected with it. I worked out a detailed chronology for each architectural and sculptural part of the temple. Further, I attempted to become familiar with the resources that the temple makers had at hand: the sources of stone, their knowledge of other temples and their carvings in the vicinity, the images presented in other genres of imaginative works in Bali such as the dance and drama.

Through these interviews linked with what historical materials I could find, I reconstructed the political and economic circumstances that at different times have enabled or constrained the practical acts of temple building in Batuan.

I also studied the uses to which the temple is put, the roles its various parts play in the many different rituals that are performed within it. I did briefer research on about ten other temples and the histories of their carvings. I attended countless ceremonies, both within temples and in homes, followed by interviews with knowledgeable people concerning the purposes and meanings of various ritual steps and ritual objects.

The temple rituals, as I shall show, enact a complex narrative that provides a major indigenous interpretive frame for finding the deeper meanings of the carvings found within the temple. The conflict between the gentry and commoners, understood at first by me as simply an outcome of the revolutionary upheavals of the 1960s, turned out to have deeper, tragic, religious meanings, with consequences for the way they understood the meanings of the carvings.

. .

Some days, while I was walking alone in the temple in a contemplative and appreciative mood, looking at the carvings one by one, it seemed to me much like a museum, a place for the preservation and display of the ancient artworks, or, since so many of the carvings are new, like a contemporary art gallery. I could admire the style of a grotesque monster here or a curious bas-relief there. I could compare styles and content of different eras.

I found myself fantasizing about this book, imagining a lovely layout with graceful illustrations that brought out the "beauty" of the stone carvings. I realize now that I was reverting to notions out of my own culture and dreaming up an imaginary art exhibition assembled out of what was for the Balinese something quite different. Approaching each carving as an "artwork" is an acceptable interpretive stance in Western culture, as shown by art museums, which present each work virtually stripped of its original context, but it is severely limited by its neglect of meaningful aspects.

When, however, I walked in the temple not alone but with Balinese, it was constantly impressed on me that, in the eyes of its worshipers, the temple is the antithesis of a museum or art gallery. The carvings are not thought of as "expressive forms" or intended to bring about an "aesthetic experience." Each of the carvings preserved in the temple is alive, a potential or actual vehicle of the gods and their followers. Even the craftsmen revere most not the new and polished statues but the clumsier, ancient carvings that have weathered Bali's earthquakes, fungi, and torrential rains, because they consider them *tenget*. *"Tenget"* could be translated as "sacred" but a less misleading gloss might be "haunted or inhabited" since it means that there may be spiritual beings hovering in and around the carving, invisible beings who are sensitive to human words and acts. Daily offerings of rice, flowers, and betelnut are placed in front of many of the statues. But when an ancient carving finally loses its clarity, the villagers do not hesitate to replace it with a new one, setting the old one respectfully aside and performing ded-

icatory offerings to the spiritual beings who may move to its replacement.

Nor, despite my constant questions about time periods, did any of my consultants see the temple as a historical archive. Although a carving may be a remnant of the work of a long-deceased craftsman, this same craftsman's spirit is still alive and may be reincarnated in one of his descendants. Today there are Balinese historians and archeologists with Western training and interests, and other educated people who speak of "history" and "reminders of sacred traditions" and, often, of the "symbolism" of temple carvings. But when these same people are worshipers, they see the temple not as a collection of relics of past actions, but as a place where the many invisible deities, ancestral spirits, and demons can meet and interact with human beings. The carvings, whether old or new, are primarily instruments to further that interaction.

Western museums are intended to provide settings for disengaged contemplation, but a Balinese temple is primarily a place for significant action. In Western museums (and in books such as this) artifacts have been pulled out of their social and cultural contexts and may be provided with a new, wholly aesthetic or historical interpretive ambience. We researchers must ask ourselves what it entails when we treat a religious edifice as if its features were purely aesthetic or simply historical, when we place it in frames that are foreign—at least in part—to the intents of its makers and the concerns of its users.

From the outset of my research I was dubious about the use of the term "art" to label these stone carvings. It was not merely that they aren't "masterpieces" compared to those in other temples or those I've seen in museums—high quality is a crucial criterion for deserving the characterization of "art." I was afraid, as an anthropologist, that the discourses on "art" of my own world would lead me too far away from my goal of un-

derstanding the carvings on Balinese terms. I worried that seeing and discussing them as "art" would set up conceptual blinders, powerful interpretive frames that set up major distinctions of relevance and irrelevance and exclude those aspects that are predefined as not germane, blinders that could result in impoverished descriptions and analyses of these works by culturally distant Balinese. Would I miss the point of these carvings and create only caricatures of them?

I resolved to avoid looking at these objects as "art" and not to trust my own eye and empathy in interpreting and responding to them, to pay attention only to Balinese ways of seeing and interpreting them.

In the end, I never succeeded in evicting the word "art" and its associations from my thought and writings, but I could recognize that it is my word, not that of most Balinese, that it comes from my discourses, not theirs. This recognition has required a constant effort, since it is also necessary not to assume that Balinese purposes and conceptions are unfathomably exotic or that Western ways of speaking and looking are the only natural ones. I come back to these issues in chapter 6.

However, in the beginning I called the paintings "pictures" and the temple carvings "statues" in my field notes. In setting myself to listen only to the Balinese, I followed the anthropologist Alfred Gell's wise advice in telling researchers to adopt an attitude of "methodological philistinism," that is, of "resolute indifference towards the aesthetic value of works of art." He sees this as paralleling the prevalent anthropological practice of "methodological atheism" in confronting an "exotic religious belief-system."[3] I would prefer to use the term "agnosticism" in both cases, since there seems to be no advantage to denying either the truth of their "religion" or the validity of their "aesthetics." Gell's counsel resonates with me because the folk-philosophical conception of art that is ingrained in me has strong elements of the religious in it, in that experience of

paintings and sculptures is understood as a substitute for religious feelings, a highly un-Balinese notion.

Despite the fact that it was only my own conceptions of "art" that had selected out these carvings as the objects of my research, I wanted to follow John Dewey's advice, to take a detour into the study of "the ordinary forces and conditions of experience" of the carvings' makers and viewers and to center my attention on *their* ways of seeing and interpreting them.

During my stay in Bali, it was relatively easy for me to speak and even at times to think like Balinese, and to convince myself that I was not studying "art." When speaking with those entrusted with the temple's care and renovation, joining in prayers with the congregation, listening to the stories suggested by certain carvings, I found it easy to talk as my fellow villagers did. My questions then rarely came out of Western art historical frames, but usually followed from Balinese statements and acts, following up on certain words or narratives that came up; and with only a little imaginative stretching, I was able to stay close to Balinese ways of looking at, and speaking about, the architectural forms and carvings.

A proposed way out of the dilemma of inappropriate foreign interpretive frames is to rely on "native voices," to quote directly the explanations and interpretations given by the people concerned. When I moved into Batuan, I was already fairly fluent in Indonesian and Javanese, both of which languages have contributed much vocabulary to Balinese. Although most Balinese speak Indonesian, I decided to learn to speak Balinese, beginning with three months in Pliatan in 1981, and then after my move into Batuan, continuously. From the outset I used tape recorders extensively, both for language-learning and for interviews. I built up a whole team of tape transcribers who typed up each interview, in Balinese, for me. They were high schoolers who lived in a distant village and knew none of those interviewed.

My Balinese became strong enough to do interviews on my own, but I continued to learn a great deal from subsequent close listening-cum-reading of the materials from the tape recordings of those interviews. A major technique I developed was the eliciting of oral life histories from a cross-section of villagers, nearly eighty of them, which I later mined for all sorts of information—linguistic, religious, historical, and aesthetic.

Whether responding to structured interviews or more casually discussing with me aspects of the temple carvings, my consultants faced unfamiliar questions about matters they were not accustomed to putting into words. Usually, rather than inventing new kinds of answers, they reached for ready-made answers drawn from existing discourses on other subjects. Those who were artisans—carvers and painters—responded in technical terms such as "depth" and "precision of cut" or "verisimilitude." Many people's responses drew on the narratives of the stories illustrated. Others—most of them —chose as "best" those shadow puppets or carvings that they thought had been made by "inspired" craftsmen whose spiritual gifts were such that the gods guided, blessed, and perhaps even inhabited their works.

Others—some of my more worldly consultants— spoke with me using terms drawn from Western discourses of "art." As we conversed, comparing this carving with that, they nimbly invoked aesthetic criteria that were fusions of their own with mine. In recent years art museums, art dealers, critics, and the apparatus of art education that all sustain and give specific content to the Western category of "art" have been introduced in Bali. Many Balinese, especially dealers and painters, have adopted fragments of these new Western discourses as their own.

In talking about religious subjects, most people also spoke in new terms, ones they had learned in school about what was being newly called "Balinese Hinduism." This too was a developed Balinese discourse: a

common way of speaking, dotted with familiar figures of speech, in which topics are well defined and terminologies conventionally set. Its dominance in the 1980s, when most of this research was done, made difficult the recognition of the earlier (and I believe deeper-lying) conceptions of the spiritual world within which the temple took its life. I discuss these in chapter 3.

The constant repetition of such clichés also led me to recognize that my interviews themselves generated the joining of several markedly different discourses, partaking of every one and producing a sort of hybrid mixture, of "double voicing." Mikhail Bakhtin developed the notion of "double voicing" to describe the speech forms presented by Dostoyevsky in his novels of social life in nineteenth-century Russia. He shows how words and patterns of speech are co-opted by speakers from their interlocutors. For Bakhtin, diverse speech-worlds are delineated according to local speech communities (occupational and class groups, typically), which may contrast on moral and even cognitive grounds.[4] This contrast is all the more powerful when elements from such sharply different worlds as the Balinese and the American are fused when speakers adopt elements from one another's speech, not only in conversations in Bali but also in the writing of books. Both verbal products are hybrid, and the main difference is which of the fused discourses is dominant.

Relying heavily on direct verbal explications and interpretations by Balinese, I found, was a seriously limiting procedure, and in the end I have pieced this book together from fragments of talk and close observation of practices, from hints and clues wherever I could find them. But I was constantly alert to the dangers involved in making generalizations based on such layered speech. And I have been correspondingly aware of the intricacy of the rhetorical task of writing about other people's discourses and practices, and the risk of giving an impression of simple consensus.

The solidity of stone carving also gives a false sense of communal consensus, either in the past or now. Today the several contesting points of view from which Balinese see their temples occasionally generate interpretive dissonance. Sometimes this dissonance also creates social conflicts, but often such differences are ignored, on the culturally emphasized ground that everyone's knowledge can only be partial, and, in any case, the many apparent contraries may all be true.

The makers of these carvings were aware of the diversity of the viewers of their handiwork, from the differences among the many deities themselves to those of the inhabitants of their world. They knew not only that different beings (human and nonhuman) see these carvings differently, but also that they see them differently at different times. Scholars' "reading" the meanings and virtues of these artworks should attempt to take into account that semiotic and social complexity.

The research reported in this book was conducted within circumstances of a great confusion of tongues: the talk of commoner and noble, priestly and folk, of politicians of various ideologies, of older and younger generations. Navigating through the rocks and shoals and whirlpools of contemporary Balinese life and speech has taught me a greater respect for social diversity and history.

In any case, perhaps, it is impossible to describe fully in words those aspects of everyday human communication and interaction that rely on nonverbal media of the senses: on vision, of course (such as color and figure-ground relations), but also on the kinesthetic senses (musculature, movement, spatial perceptions, proportional relations to viewer's size, feelings of confinement versus freedom), and on the aural and the tactile. These modes of expression might be lumped under the term "Balinese practices" and contrasted with "Balinese theories." Therefore, practices as well as theories, what people do as well as what people say, must be exam-

ined. To do that is to study also the social institutions that govern those actions, and in particular the standard arrangements though which Balinese learn about making and meaning-making of their carvings: not only how craftsmen are trained, but also how audiences and patrons learn what they need; how priests and laymen learn the lore that goes into planning for new temple carvings and into executing those plans; and how people learn how to interpret the iconography and larger meanings of older carvings.

Those Who Carry the Temple on Their Heads

The people who built and decorated the temple called Pura Désa Batuan—its "owners," as they say—live in the village of Batuan and have a special particular tie to its gods. Its architecture and carvings were the product of tight and complex collaboration among them all.

In the 1920s and 1930s, when the greatest part of the temple rebuilding was accomplished, there were probably only about a thousand adult men and women available for this work. No one was brought in from outside the village. How the artisans were trained and rewarded, how the images of the future temple and its carvings were brought forth, how the materials were assembled, and how the functions of patron and critic were filled are the subjects of this chapter.

Those responsible for building, maintaining, and rebuilding a Balinese temple are its worshipers. They are said to own *(druwé)* the temple, but it could be equally said that the temple "owns" them. They are tied *(kaiket)* to the particular deities of that temple. They usually but not necessarily live in its immediate vicinity.[1] They are also said to be those who carry the temple on their heads *(sané nyungsung pura,* or in this particular case, *sané nyungsung désa)*. "Nyungsung" means "to carry on one's head." *"Pura"* means "temple." The term *"désa"* here means both "the village temple" (more explicitly,

the *pura désa*) and, by extension, "the village." The term *"désa"* is also used as a euphemism in everyday speech to refer to "the gods of the *désa* temple," since it is dangerous to speak directly about or to name deities. In fact, it is not the "temple" or the "village" that is being carried on one's head, but the gods themselves, and the figurative reference is to the ritual act of carrying small figures of the deities on one's head or shoulders.[2]

It is the responsibility of that congregation to keep in mind their obligations to the deities, to *ngéling,* a transitive verb meaning "to remember or pay attention to someone." That term is in the high register, indicating that the person who is being attended is of high status.[3] The members of the temple are the ones who, if any misstep is taken by them or anyone else, who are likely to be *kapongor,* punished by the gods.

One who remembers his gods is protected. An old professional clown who frequently toured Bali and Lombok told me that once he was forced to leave Batuan just as the Désa Odalan was about to begin, and, as he went off on the bus, he wept. "I cried as far as Tegaltamu because I was missing the festival. I was afraid that when I performed I might say something wrong" —meaning that in making an impromptu joke he might unintentionally offend the gods of the place of his performance. Attending the annual ceremonies in his own village would enlist the protection of his own gods, even when he was abroad.

All work for the gods is called *ngayah* (to serve a higher being), a term that applies also to work for kings. It applies to manual labor such as sweeping and cooking, supplying material goods such as bamboo and rice, and also performing dances and carrying out priestly rituals, whether for a noble or for the gods. Counted as *ayah* also is engaging in a cockfight for the temple (in the past some cockfights for the king were required on pain of serious punishment). Harvest labor when the product goes in part to the temple, and, in recent years,

contributions in cash, are all counted as *ayah*. Another word for "work," *karya,* which is in the higher register indicating that it is "work for a higher being," is a common term for "work for the gods," or "rituals."

Building or restoring a temple, crafting the small god-images that serve as temporary housing for the divine beings, carving the stone figures that fill the temple, decorating the temple with banners and paintings —these are all *ngayah*. They are all acts of homage, attempts to please the gods, and payments or repayments or inducements to the gods for their blessings (and their acts of refraining from angry cursing).

I will first describe the villagers of Batuan, then their social arrangements for *ngayah,* for mobilizing their labor, assembling the supplies for making the temple, and bringing together work teams of artisans of varied levels of talent. The project is always one of collective enterprise in which everyone has a part. The temple is not the product of individual star artists or the result of a mythical Balinese propensity for harmony, but of complex, highly institutionalized collaboration.

The work is ideational as well as material, and in both cases, collective. In the last part of this chapter I address the ways in which fragments of talents in artistry and imagination were assembled and united. The iconographic and narrative knowledge of different members of the congregation were tapped, and images of the future temple were brought into reality.

I write in this chapter mainly in the present tense, because the materials were gathered in observing present-day (1980s) practices, but mainly because most of the formal institutions described here have probably been much the same throughout the time of this history. However, major changes were going on in the last decades of the twentieth century, especially in the informal practices involved in the building and rebuilding of the temple, and these will be reported in the historical chapters in the latter part of this book.

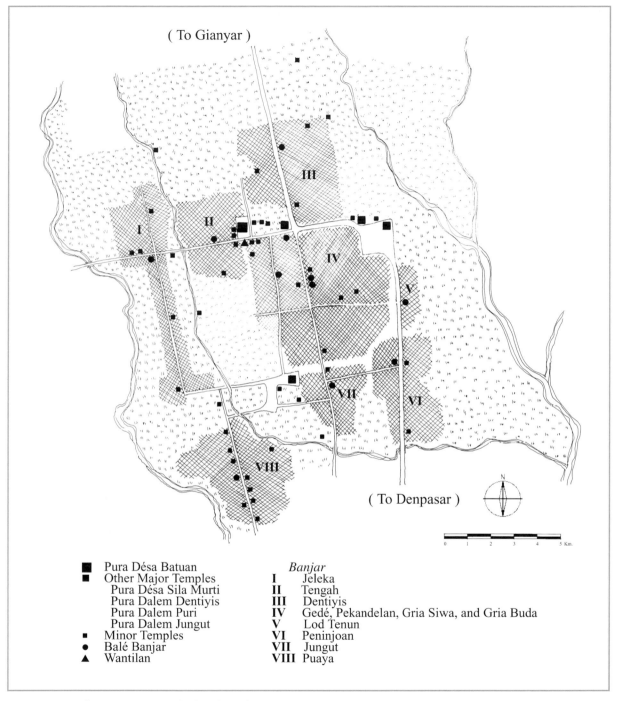

(To Gianyar)

(To Denpasar)

N

0 1 2 3 4 5 Km.

■ Pura Désa Batuan　　　　　*Banjar*
■ Other Major Temples　　**I**　　Jeleka
　Pura Désa Sila Murti　　**II**　　Tengah
　Pura Dalem Dentiyis　　**III**　　Dentiyis
　Pura Dalem Puri　　　**IV**　　Gedé, Pekandelan, Gria Siwa, and Gria Buda
　Pura Dalem Jungut　　**V**　　Lod Tenun
■ Minor Temples　　　**VI**　　Peninjoan
● Balé Banjar　　　　**VII**　　Jungut
▲ Wantilan　　　　　**VIII**　Puaya

Figure 2.2. Map of Batuan: *Banjar,* rice land, and temples.

The Villagers of Batuan

You can walk down from the northern edge of Batuan, where the Pura Désa stands, to the southern end in about twenty minutes, and you can go in the transverse direction from east to west in even less time. There's a spot out on a rice field on the way where you can look up and see a cloud-wreathed volcano, Mount Agung. And if you are a strong walker, it is only two hours to the sea.

The total population of the village was about forty-seven hundred in 1984, of whom about half were children. Back in 1917, when the temple was little more than rubble, there were only about eight hundred adults.[4] This little group, with no outside help, amassed the materials and skills needed for building and rebuilding their temple at many times during the twentieth century. How, despite their continuous poverty, the villagers were able to do this is partly due to the way they were organized, to the special Balinese institutions called the *krama désa* and its components, the *krama banjar,* and the *prajuru désa,* to be discussed below.

Most visible to a walker in the village—aside from the brightly decorated "art shops" that line the main roads—are the coconut palms and flowering fruit trees everywhere. However, there are many fewer trees and gardens to be seen in Batuan today than there must have been in 1917, when the story of the rebuilding of the temple begins. At that time there were wild clumps of bamboo and brush in many places throughout the settlement, and the roads and pathways were of dirt—alternately dusty and muddy. In 1915 a gravel road was laid down through Batuan, linking it to Denpasar to the south and Gianyar to the east, and some paths were widened to allow for the passage of ox carts and, later, trucks. By 1995 it and several other roads within the village had been paved, and many villagers owned cars and motorbikes.

The village is bounded on east and west by two deep ravines, with shallow streams along their bottoms. Out of the rocky walls of these ravines flow springs, sources of drinking water. The settlement is crisscrossed by streams and irrigation ditches carrying water from dams further upstream to and from the many rice fields encircling it. When I asked my consultants to help me make maps of the village, it was striking how great a place in their minds these village waterways took—even more than the paths at times. The ditches, of course, are, even today, in constant use, as bathing places, toilets, and laundries, although they've been considerably improved lately with concrete.

Back in 1917, I am quite certain, all the villagers were farmers, carrying their plows and hoes out to both the rice fields surrounding the village and the dry lands within the village.[5] This farm work was supplemented by a smattering of small-scale crafts and peddling. There was, and is, a small marketplace in front of the central noble house, where local women sold, and sell, minuscule amounts of fruits, vegetables, and meats, no more than they can carry in baskets on their heads, for only a few hours every morning.

Here and there along the village streets are coffee stalls where people congregate at all hours of the day, for a snack of food, a glass of strong coffee, or a drink of rice wine or beer. Housewives stop in briefly on their way to pick up a small package of salt from a little grocery shop, men drop in on their way to and from the fields, peddlers with motley collections of cloths offer their wares to the coffee drinkers, and children run in and out everywhere. In certain stands a daily coterie of palm-wine drinkers cheerfully hangs out. The roads, the bathing places, and the coffee shops are the living room of the village, where the long conversation that is Batuan's history flows and eddies, most commonly in the forms of gossip and banter.

Scattered throughout all the neighborhoods of Batuan are the temples, each with elaborate gates, and serene inner courtyards, open to the sky. The Pura Désa

is the biggest and most elaborately decorated, but right down the road from it is a strong visual competitor, the new *pura désa* of the nobles, established and built in the late 1960s. The Pura Dalem Dentiyis and the Pura Dalem Puri, two other major temples, not quite as impressive, stand on the main road; but many other temples, large and small, are hidden among the houses and fields of Batuan. In earlier days it was hard to distinguish from the temples the "palace" *(puri)* of Batuan's leading noble family, for it too had large carved gates and spacious empty courtyards; but in the 1990s it had been converted into a hotel, with signboards and a large pavilion out front within which paintings for sale were exhibited.

In Batuan, there are four or five large performance pavilions—cement-floored, many-columned, with high, pitched roofs—where dance and drama shows are put on. Perhaps this is an unusually large number, a result of the development in Batuan of performing groups. One of these pavilions is in front of Pura Désa Batuan, the others next to other important temples. But throughout the village, from time to time, temporary shelters for smaller performances sprout up. Even today with stiff competition from films, radio, television, and video receivers, these stages are the prime arenas for the larger "conversations" among Balinese about Balinese matters, the main loci of village intellectual life, providing forums for arguments about theology, politics, social and moral dilemmas, and, I think, indirectly, art criticism. Wrapped in comedy, in fantastic tales, in linguistic play, these shows were above all a place for resistance against the pomposities and blindnesses of political leaders, a zone for questioning authority of all kinds. Bali's theater is a precisely accurate example of a Bakhtinian carnival.

Many of the players in these shows are Batuan people, for the village has always been a breeding and training ground for musicians, dancers, and actors. Even when a show is rented from elsewhere, there is always a sort of curtain-raiser in which children from the neighborhood try out their newly gained skills. Throughout this century, Batuan's performers have traveled all over the island.

Batuan was probably economically self-sufficient at the beginning of the century with no important movement of foodstuffs and the like either into or out of Batuan, except for the food products that were taken in tribute to the nobles of Negara, Sukawati, and Gianyar. (In the nineteenth century only the major kings did any important commerce into and out of Bali, mainly importing opium and cloth and exporting slaves, rice, and pigs.) By the 1990s, if not long before, Batuan was definitely part of the world economy.[6]

The population of Batuan, like that of Bali, has doubled since 1900, mainly because of the near eradication of smallpox, malaria, cholera, and typhoid, and adequate maternal and infant health care. But the amount of land available for living and farming has not changed. The pressure for residential land has meant giving up much of the unirrigated agricultural land within the village, where formerly coconuts, hay, and vegetable crops grew.

By 1995, urbanization was proceeding apace. Along with telephones, electricity, running water, television, and schools have come many jobs outside the village, notably in the tourist industries and in the government bureaucracy. Several two- and three-story buildings have gone up. Nonetheless, Batuan's life is still strongly focused within its bounds. Neighborhoods remain tight networks of closely related kin, marriages are still made mainly among fellow villagers, and temples remain the center of social activity.

The settlement area of Batuan, which does not include rice fields owned by villagers, is about six square kilometers in size. In its center live those whom I have called gentry or nobles and the Balinese call the *triwangsa,* or "three kinds." The commoners or *sudrawangsa* or "lowest kind," more usually referred to as the *jaba,* or

"outsiders," live in the rest of the village. *"Wangsa,"* sometimes mistranslated as "caste," is used today in Bali as a classificatory term for ranked social titles. The *triwangsa* are people with such titles as Déwa, Anak Agung, Gusti, and Ida Bagus (and, in other villages, Cokorda and Gusi). The *sudrawangsa* are people with no title, at least in direct address.

The houses of the gentry of Batuan, the Déwa and Gusti families, are clustered together in a central ward called Batuan Gedé, and in neighborhoods near it. They have lived there since the beginning of the eighteenth century. To their immediate north and east is a community of Brahmana priestly families (with the titles of Ida Bagus) who probably came at about the same time, and on the immediate south and west of Batuan Gedé are a number of commoner households who were in the past retainers of the royal houses. These latter are, for the most part, Paseks in title—that is to say, they are commoners of higher status, claiming in some cases descent from the gods as do the nobles and priests.

Around this core settlement lie a number of other linked dwelling clusters, where only commoners live. They are organized into *banjar* (an untranslatable term that can be rendered for the moment as "wards" or "neighborhoods" or "hamlets"). Most *banjar* are territorial units, but sometimes they are not, as within the section called Batuan Gedé where the people of four *banjar* live interspersed among one another, identified as Banjar Batuan Gedé (consisting of noble people of the Déwa title), Banjar Brahmana Buda (priestly nobles of the Buda persuasion), Banjar Brahmana Siwa (priestly nobles of the more numerous Siwa persuasion) and Banjar Pekandelan (commoners, Pasek in title, former retainers of the nobles and priests).

The largest of the outlying *banjar* is Puaya, which is to the southwest of Batuan Gedé. This is, in composition, entirely commoner, and I've been told that there are even no Paseks in Puaya, or at least none that would admit to such a higher status, because of the commu-

nity's stern commitment to egalitarianism. Historically, Puaya, despite its unwieldy numbers, has resisted subdivision into several *banjar*.

Socially, Batuan is best understood as an ensemble of partially overlapping communities and groups of various sizes, most of which are institutions for the mobilization of labor and materials for the worship of one or more local deities, enshrined in a temple. The largest of these is the group that is responsible for everything that happens at Pura Désa Batuan, but it does not include all those who live in the settlement of Batuan. All of those who work for the temple belong also to other temple communities that make equal or greater demands on their resources and times. Every household belongs to a number of other temples: one of three temples linked to cemeteries (the *pura dalem*), their household temple (the *sanggah* or *mrajan*), their *dadia* or *panti* temple of their clan, the temple of their *banjar,* one or more temples of the rice fields where they work, plus various *pamaksan* (temples with mixed membership).[7]

Every household has constantly to juggle its labor, money, materials, and talents to meet this range of heavy obligations. So also, the community of a temple must also find ways to do the same, in the face of compelling demands on these resources from other, equally legitimate institutions.

. .

If, in your first walk around Batuan, you stopped in front of the Pura Désa, you might not find it as impressive as the cathedrals of Europe and the museums of America, yet, as I will show, in the eyes of its makers it has an electric presence that is cosmic in scope. The spirits of their own ancestors are alive there, as is a host of local deities as well. The villagers and their forebears have made the temple themselves. The temple demonstrates, embodies, and facilitates the combined power of the ancestors, gods, and human beings of Batuan.

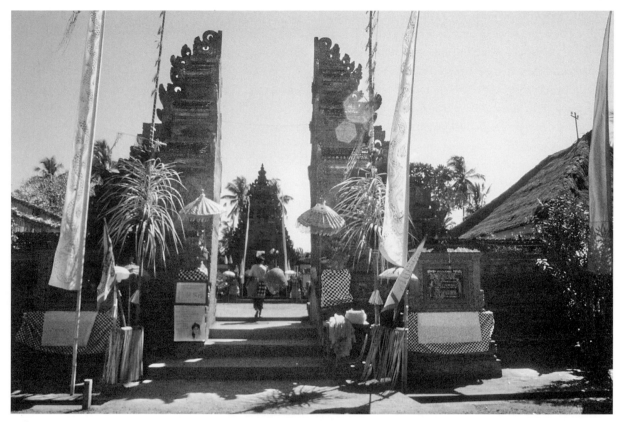

Figure 2.3. The two great gates of Pura Désa Batuan. Photographed in 1988.

When you approach the temple by day, the first thing you would probably notice, other than the great dance pavilion across the road, is the carved outer wall and the tall gateway set in it. This gateway is dramatically oversized and intricately decorated. In many temples, including Pura Désa Batuan, this first opening is a "split gate," whose two sides look as though they had once been joined then cut down the middle and pulled apart.

Looking through the twin towers of the split gate, you see a large courtyard with flowering trees and a number of statues standing about. Behind it is a second great gateway, this one with an elaborately carved arch closing its top, inset with bas-relief figures garlanded with vines, and a closed door. That there are not

one but two gateways to pass through on your way into the heart of the temple where the altars are emphasizes the importance of the divine presence within the last walls.

The altars are the places where, during a sacred festival, the gods are enthroned. At these major ceremonies, the priests of the temple formally invite the deities of the temple to "come down into this world" and visit their worshipers. They are then treated as royal guests, spectacularly feasted and entertained for several days.

The altars themselves are small seats or miniature houses set high on brick or stone pedestals, where the gods not only receive the petitions of their worshipers, but also relax, bathe, dress in new clothing, eat, sleep,

and talk with visiting gods who have come from other temples, both nearby and distant. These god houses are placed in relation to one another much as the living pavilions of humans are situated within Balinese domestic houseyards.

The whole of a temple ceremony, as will be shown in chapter 5, resembles a royal visitation and reception, in which a group of deities assembles, and each god is accompanied by a whole entourage of other lesser spiritual beings, who are also worshiped, fed, and entertained. The temple then becomes a royal palace for the deities and their holy guests, an abode prepared and maintained by their human worshipers.

The Organization of Work on Pura Désa Batuan

The glass-covered sign in front of Pura Désa Batuan reads:

Pr Puseh Pr Desa
Desa Adat Batuan
Saka 944

The "PR" on the sign stands for *"pura"* or temple, and this sign says that there are two temples here, the Pura Puseh and the Pura Désa. The bottom line gives the date of the temple as 944 according to the Indic

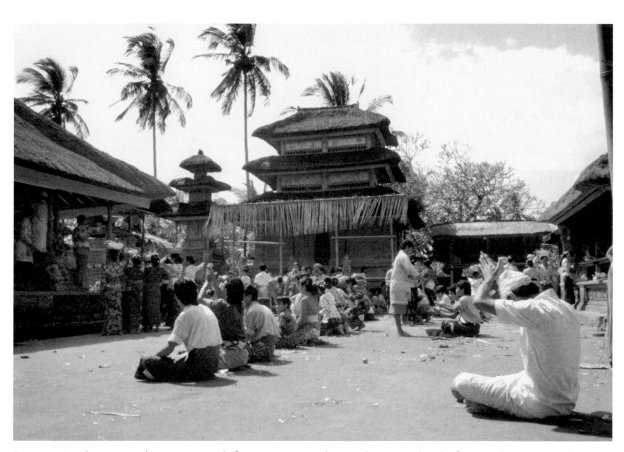

Figure 2.4. People praying in the inner courtyard of Pura Désa Batuan during Galungan ritual. In the foreground is a priest performing a personal prayer. Photographed in 1988.

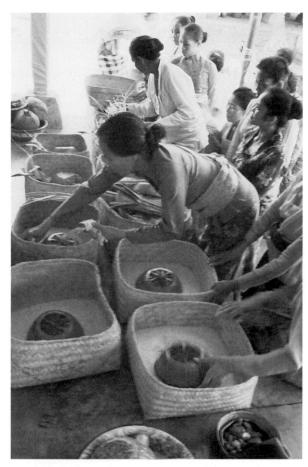

Figure 2.5. Village women preparing baskets of rice to be given on behalf of the temple as a whole. Photographed in 1988.

Saka calendar (which is the equivalent of 1022 C.E.). (I will come back to the names of these temples in chapter 3, and to the date of "founding" in chapter 4.) The middle line names the organization Désa Adat Batuan as that responsible for the temple, the set of people who are the worshipers of its gods, the supporting congregation of the temple.

If this sign had been painted in the early part of this century, the group would have been named merely Désa Batuan. When the Dutch appropriated the term *"désa"* to indicate their new local administrative villages, they immediately introduced a confusion. It was not a serious muddle, however, for no Balinese is in doubt about his responsibilities to his temple. To distinguish the community that owes its fealty to the gods of Batuan from the community that must pay taxes to the government of the Netherlands Indies (and later to that of Indonesia), the first came to be called the *désa adat* and the second *désa dinas.* "Adat" comes from the Arabic term for "custom" (set in contrast to *agama,* or religion) while *"dinas"* comes from the Dutch term *dienst* or "service" (to the government).

But in ordinary conversation, even today, the term *"désa"* is often used alone, and the context indicates which one is involved. In Batuan the *désa adat* and the *désa dinas* have quite different memberships, the latter including many more settlements than the former.[8] In everyday speech the people of Batuan use the unmarked term *"désa"* to signify only the *désa adat,* and I use the term "village" as its translation.

A *désa* is, officially, governed by an institution known as the *krama désa,* or "council of the *désa.*" The members of the *krama désa,* which includes most adults in the village, are the people who determine and carry out any construction and reconstruction of the temple. It is they who decide what parts of the temple are to be renovated, what forms those renovations should take, which craftsmen will do the work, how the materials and labor for the work are to be mobilized, and what quality of carving is to be sought.

In practice, however, the *krama désa* of Batuan rarely if ever meets as one body. Instead, meetings are held by its component *banjar,* in their meeting pavilions. Each *banjar* then sends a representative (called the *klian banjar*) to a regular monthly meeting with the head of the *désa,* the *bendésa,* and his assistants. This second tier group is the executive committee or managing team of the temple. The older term for the managing team is the *prajuru désa,* but in everyday speech it is usually referred to by the Indonesian words *pangurus* (organizers) and *komiti.*

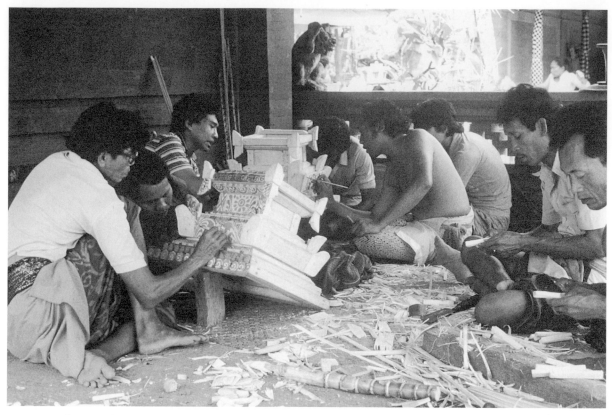

Figure 2.6. Village men building and decorating a support for a special offering. Photographed in 1986.

A *bendésa* is the head of the *désa adat* and of the *prajuru désa*. His was an important office in the precolonial period, but since then it has become increasingly limited to matters pertaining to the temple. Before the Dutch established the apparatus of a bureaucratic state, with police, land registration, and a judiciary, the *bendésa* adjudicated most civil and criminal disputes in the *désa*. Even then, serious cases were taken not to the *bendésa* but to either the *banjar* council or up to a high noble, usually, for Batuan, the Raja in Gianyar. Nonetheless, the *bendésa,* even today, is a guardian of the village's moral structure, since many offenses affect the proper conduct of temple affairs. The *bendésa* and the *banjar* councils control who may or may not be a member of the temple, and through that who may live on *désa*-owned

land and who may be buried in one of the *désa* graveyards.

Supervision of temple maintenance and renovation activities and of material aspects of temple festivals are, today, the most important duties of the *bendésa,* and, as I will show, the person who played that role was very influential in the look of Pura Désa Batuan at different historical periods. It was, probably, the *bendésa* and his assistants who assembled the teams of master carvers and apprentices who built the temple.

But a *bendésa* could never be autocratic (or at least not for long). He must work closely with the various *banjar* councils, through the meetings of the managing team, the *prajuru*. It is this representative group, normally, that makes decisions concerning temple building

matters. However, before any important decision is made, each *banjar* representative, or *klian banjar,* brings the issue back to a specially called *banjar* meeting to discuss, and if there is dissent, raises the issue again among the rest of the *klian banjar.*

A household membership in the *krama désa* and *krama banjar* requires two people, usually a husband and wife *(kuren),* who together own and inhabit a bit of houseland in Batuan. Other couples such as mother and son or even mother and daughter are accepted. Children, adults who are temporarily living in the village, and single elderly people are not members, but participate in temple activities along with the member couple (the *pangarep)* who represent the household as a whole. Families who do not own a separate houseyard (usually younger siblings and married children) are called *pangémpélan,* and they are partial members, with partial duties of the *krama désa.* These latter give the same amount of rice, money, and labor, but not the raw materials needed to make offerings.[9]

Most of the duties of the members are set out in a charter, the *awig-awig,* which, in the case of Batuan, was never written out until 1986. This charter spells out sanctions to be made against any members who do not fulfill their duties or who commit certain crimes within its boundaries. The sanctions are primarily monetary fines, but severe infractions may be punished by expulsion from the *krama désa* and the *krama banjar,* and hence, effectively from the community, since the *krama désa* controls not only access to the rituals of life and death, and therefore spiritual and material well-being, but also residence on houseland in its realm.[10]

Normally, each representative serves for a specified term. The *bendésa* has a five-year term, while *klian banjar* normally serve 420 days (the period from one major *odalan* ceremony to the next). The result of this rule is that there is considerable turnover in the composition of the managing team, and many of the villagers have a chance to be on it during their lifetimes.

It is this changing set of *banjar* representatives, headed by the *bendésa,* who organize the work of ceremonies and of temple repair in the name of the entire temple membership. They are the ones who usually make the aesthetic, practical, and theological decisions involved in temple renovation.

The managing team determines, as circumstances shift, the kind and amount of raw materials needed and, with the agreement of all of the *banjar* councils, takes care of their collection. They supervise the labor required for projects chosen collectively. They select artisans for carvings and plan and instruct them. Certain constant tasks, such as daily sweeping of the temple, are assigned in rotation to members of the group of *banjar* currently on deck.

The heavy work during the *odalan* is divided by rotation. The *désa* has been divided into four sets of *banjar* called *témpek,* and in each ritual year, one of these groups does all the work, while the members of the others contribute only goods. Each day that the members spend at the temple—putting up temporary altars and dance shelters of bamboo, making special offerings, and so on—they are given a noon meal called *pica* (gift bestowed by deities).[11]

The religious nature of these responsibilities and these councils must be stressed. When a man has been chosen to be *klian banjar* or *bendésa* or one of their assistants, he is first ritually consecrated *(mawinten),* usually by a Brahmana priest during the temple *odalan.* Further consecration rituals are held from time to time. No one, if chosen by the *banjar* to serve, may refuse without serious punishment.[12]

The managing team meets monthly on a significant propitious day. In Batuan this is on the same day in the month that the major ritual worship of Batuan's gods is held. This is Tumpek (Saptu Kliwon), which comes around every five weeks. Once every thirty weeks on the same day, the Tumpek of the week *(wuku)* of Catur Wariga is the Odalan itself.[13] At this meeting, offerings

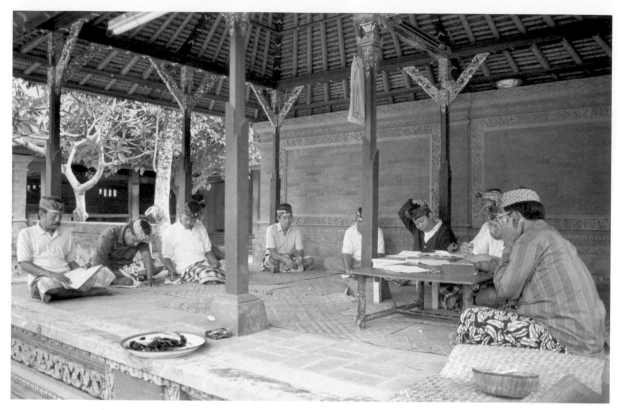

Figure 2.7. Meeting of the temple managing team. The Bendésa is seated at the right. Photographed in 1995.

are always first set out on the altar to the god Ida Be-gawan Panyarikan (see figure 4.6), which stands apart from the major altars of the temple, respectfully south and west of them. The deity oversees the work of the congregation, the *krama désa*. Before each meeting of the organization, he is given offerings of *cané* (ingredi-ents for betel-nut chewing) with the prayer *(pangastawa)* that their work will go well. He is said to guard the *awig-awig* of the *krama désa* and to make sure that they are obeyed.

The priestly functions—communicating with the gods themselves—are directed not by laypeople alone but by specially designated priests. There are two main kinds of priests, *pamangku* (temple priest) and *pedanda* (Brahmana priest) in Batuan. The first are local priests who serve local deities; the second are translocal priests who serve the higher translocal deities. Every temple has a *pamangku* who officiates only there, but *pedanda* serve in many temples, where they are invited. In lesser rituals the *pamangku* may perform the worship alone, while in any important rituals the *pedanda* must officiate. The *pedanda* is said to "complete" the ritual started by the *pamangku*. A small ritual carried out only by a *pa-mangku* must include *tirta* (holy water) made under the auspices of a *pedanda*. Only Brahmana may become *pedanda*.

Pamangku, in their rituals, request that the gods of the temple bestow holy water on their worshipers, while *pedanda* can create holy water themselves, in their own household temples. At the height of a *pedanda*'s prayers,

the highest god Siwa enters him through his fontanel and acts through him to consecrate the water. A *pamangku* cannot do this, but addresses the gods as representative of the congregation. Because of their close ties to local gods, *pamangku* may not participate in burial and cremation proceedings, while *pedanda* may.[14]

In Pura Désa Batuan there is one *pamangku* responsible for all its rituals, who has his position from his father, who had it from his. This *pamangku* family was brought into Batuan from another village sometime in the nineteenth century, when the previous line came to an end. He is, of course, a commoner. He serves with his wife, as do all *pamangku,* and during the 1980s did all the rituals together with his oldest son and the son's wife, who will replace the older couple in due course. The *bendésa* and his *komiti* decide which *pedanda* to bring in for each major ceremony; in the 1980s they alternated between one in Kenitén and one in Celuk (who had been born and brought up in Batuan). In the 1930s, when most of the temple was built, there were five *pedanda* living in Batuan, and some of these may have officiated in ceremonies in Pura Désa Batuan.

The Pamangku of Pura Désa Batuan seems to have a special personal tie with the gods of Batuan. It is he who takes the god figures from their storage altar, who attends to their elaborate toilettes, who carries the highest ones on his own head.[15] However, in most rituals, even very small ones, there is a whole group of *pamangku* at work. Present are *pamangku* from other temples in Batuan, some times one or two, sometimes as many as twenty, all taking turns with the prayers or the distribution of holy water or the handling and arranging of offerings. Their wives are usually present as well. At the highest ceremonies there may be more than one *pedanda,* together with various assistants to each one.

In the intricate preparations and complex sequences of worship there is a constantly fluctuating flow of people—priests, ritual specialists, laypeople—working together to bring off the desired results. The responsi-

bility falls on the *krama désa* as represented by the *bendésa,* his managing team, and the *pamangku.*

. .

But how have the villagers, through their *banjar* councils and managing teams, actually made their decisions about the temple, its building and renovation? How do they choose their leaders, and how do the leaders in turn choose and direct the craftsmen who rebuild the temple walls and gates and altars and make new carvings? Do the formal arrangements govern the actual way people work, and have these practical procedures changed over the years? These are crucial questions for an understanding of the architecture and carvings of the temple.

They are basically historical questions, most properly answered through detailed accounts of particular decisions and projects in particular eras. However, the only direct glimpses that I have had of the way these sorts of decisions were made came in the 1980s, when the running of temple affairs had changed considerably from that of the colonial period. Religious conceptions and canons of aesthetic taste also must have changed considerably during this century. But usually the *krama désa* and its representative subgroups have served as the effective forum and agency, mediating and channeling the effects of wider changes in the larger society.

The internal organization of the *krama banjar* and the *krama désa* is based on what I have called "the *seka* principle."[16] "*Seka*" means "as one" and refers to a group in which all rights, duties, and compensations are divided equally, and decisions are reached through a search for consensus. In such a group all members are equal, regardless of external distinctions. For instance, in a cockfight, gentry gamblers must crouch down with everyone else, disregarding the fact that others are insultingly standing over them. The same is true of gamelan orchestras, in which all players are equivalent,

sharing the same food and sharing sitting places. Similarly, while some people are more articulate than others, all have a potential voice in the decision. The resolute egalitarianism of a *seka* contrasts with the clearly structured lines of authority, respect, and precedence that characterize all other social institutions in Bali. The distribution of social control is nowhere else as level as in a *seka*.

Formal votes are not taken in the *krama désa* or the *krama banjar,* but discussion is held until the group reaches a place of agreement where no one objects. Detailed reports on how such consensus has actually been attained are almost impossible to come by, since there is a pervasive Balinese reluctance to continue a controversy after it is over, to recognize past disputes openly. It is for this reason that some people have concluded, erroneously, that there is little dissent or that those arrangements that Balinese can easily describe to a foreigner, such as the *krama banjar,* are all that there is.

But the debates conducted in the forums of the *krama banjar* and *prajuru désa* are much less important to the decision-making process than those that go on prior to their meetings. In impromptu talks among all participants held while bathing in the river, marketing, sitting in coffee stalls, working and idling among kin and among neighbors, candidates and competing policies are opposed or promoted. The persuasiveness of a strong personality, of a clan with powerful economic or political resources, or of a person with a reputation for unusual access to the invisible spirits may swing the undecided toward a particular point of view. In any case, long before the formal meeting of the *krama banjar,* all issues have been extensively debated by everyone. The intimate social life of every *banjar,* in which few ever move in or out and most marry within it, means that everyone quickly knows everyone else's opinions on every issue. Carol Warren and Mark Hobart, who have studied the workings of the *banjar* at length, both stress that in the meetings all discourse is ordered by very formal rules limiting the expression of opposition and that the rules provide only a firm structure within which informal modes of discussion get things sorted out.[17]

Hobart showed how complex processes of social influence and factioning centering on several village patrons worked themselves out informally on each issue until a stable point of "unanimity" was reached through the silencing of opposition. Warren, who reported on a longer stretch of time, stressed the fluidity of the process and the fact that influence and power structures can change greatly and even rapidly.

The bases of patronage in Hobart's village, as in Batuan, were of several different kinds. Some patrons' strength was internal to the community (the large landowners who employ many local sharecroppers, for instance, although in Batuan in the 1980s there were few of these) and some was external (e.g., those patrons with ties to the regional government). But in any case, no patron, for all his effective domination over his clients, seemed able to dominate for long the community that Hobart studied. The same seems to have been true in Batuan, although the noble house with its connections to the king in Gianyar may have dominated the discussions for the first part of this century. As will become clear in chapter 9, economic shifts in the latter part of the century may have changed the patronage pattern considerably.

The *krama banjar* and *prajuru désa* may be seen as filtering devices through which cultural, social, and economic forces are constantly being sorted out. Their religious goals provide the organizing frame of their work and also impart a measure of urgency and collective concern that makes the achievement of consensus something to be ardently worked for.

The operation of the *seka* principle within these groups means that every member has an equal voice

and that no single authority establishes a single true way of doing things. The regular rotation of the job of representatives of the *banjar* and of the *bendésa* prevents the buildup of influential governing factions. The dispersed nature of decision making insulates the temple group from the concentrated effects of single pressures from people with strong economic or political power bases. For instance, through much of this century the local noble house exerted considerable influence on temple-making decisions, but that influence was limited at all times, and finally completely rejected. It was a similar situation with the many priestly houses. This will become clearer in chapter 9.

Also, according to the *seka* principle everyone must participate. But not everyone is equal in talent, and it is here that deviations from strict egalitarian principles occur. For instance, every household must give a certain amount of money, labor, and materials, called a *pesuan,* at every *odalan.* But certain specialists are excused from this donation: the *pamangku* of all the temples, the *klian banjar* and the *bendésa* and other members of the managing team, and the *pangrombo désa* (a group of women, two from each *banjar,* who make all the small offerings that are presented every five days to all altars of the temple, throughout the ritual year). Some categories—for instance, the lesser *banjar* officials who aid the *klian banjar*—are excused from one-half of the donations.

Similarly, the craftsmen, the stone and wood carvers, are exempt from the *pesuan.* Like all the other workers on *odalan* preparation, they are given a noon meal each day that they work. Today the stone carvers are also given a small amount of cash, with a larger amount for those who come from outside the village. From earliest times it has always been possible to hire outsiders for skilled temple work, such as the Brahmana women who make specially complicated offerings, although in the colonial period they were paid not in money but in food-stuffs and clothing. In many other villages, outsiders are hired to do the architectural and sculpturing work. In Batuan, however, especially in the Pura Désa, almost all the carving has been done by members of the village.

Any account of formal social institutions such as this could create a completely false impression of collective harmony and changelessness in Bali. Despite the strong threat of disaster brought on by angry gods, there is always some dissent and conflict. A detailed history of any village would reveal cases of major disagreements and refusals to follow *désa* decisions, resulting, in extreme cases, in expulsion from the village of individuals or whole groups. The social arrangements of sequential meetings and collective leadership seem, in fact, invented to enable dissent to find a place without giving up commitment to consensus and to ensure that all, in the end, contribute to temple activities.[18]

The formal institutions provide complex guides to practice and allow communication to take place not only among the villagers but also, as I shall show, between human beings and spiritual beings. They permit the exercise of innovative agency, both collective and individual, both diffuse and focused.

This account of the social organization within the temple has been, so far, concerned with collective responsibility and authority in the rebuilding of the temple. But keeping up a temple is not just a matter of the management of labor, craftsmanship, and materials, but also the mobilization of imagination.

The Social Organization of Imagination

The building of Pura Désa Batuan was a collective effort; also collective (in peculiar Balinese ways) was the conceptualizing and imagining of its forms and spaces. Yet Pura Désa Batuan was not merely a replica of other temples in Bali. There are no simple cultural blueprints

for temple making that provide a single overall guide. The ways of imagining a temple and its contents are many.

The sources of imagery, iconography proper, and more general religious conceptions need to be explored, and I will do so in subsequent chapters, but first I want to outline how temple communities marshal their members' information about images, their meanings, and their associative webs and how people acquire those images and learn the practices of creating new images. In Bali this kind of knowledge is never taught systematically, and few people have more than vague and fragmentary understandings of the images that they see around them.[19]

There are cultural specialists of various kinds to whom the people could turn during the reconstruction of the temple—when they were faced with questions about the placement and shape of altars, the appropriateness of content or style of carvings, details of iconography, and the like—and who could guide them in imaginatively responding to the already existing carvings in the temple.

As the members of the *krama désa* made their decisions, the gods would first have been consulted. If the way that such matters are conducted today is any guide, the leaders of the temple would have used two different communicative channels to their deities. The first employs possession, in which the gods themselves enter certain people in order to speak directly to their local worshipers. Sometimes, for instance, deities approach senior members of the village in dreams and tell them what is needed, an act called *pawisik*. Sometimes someone in the congregation goes into trance and the god speaks through his or her voice. In Batuan, in the present day at least, such trancing by lay members of the temple is rare; more commonly the temples call in professional spirit mediums, or *balian tapakan*. These are healing specialists who, in conversing with the invisible (*niskala*) beings, allow their own mouths to be used by ancestral or godly beings to converse with their descendants and worshipers directly.

For example, in Batuan in about 1994 a thief broke into the high altar of one of the other temples and stole a god-figure *(pratima),* an act of frightening sacrilege. As is customary in such cases, several spirit mediums were called to the temple. They allowed themselves to be possessed by one of the temple gods, and each produced a (slightly different) diagnosis. One announced that it was futile to chase after the thief, that in fact the god of the temple had permitted the thief to enter because the god was irritated at the temple's congregation for neglecting the god. The prescription was that the temple must hold an enormously expensive ritual, a *karya agung,* to appease the anger of the temple's god. The congregation discussed this diagnosis, found it persuasive, and then duly carried it out.

The other main method used by temples in such moments of major building decisions is to consult a *balian wisada* or diviner whose techniques center on reading and interpreting of sacred texts, in a way similar to divination using the I Ching. Some of these learned diviners are commoners and some are *pedanda*.

For instance, in 1995 I watched while a new wall and gate were made for the small *panti* temple that is inside the Pura Désa, the Pura Buda Manis. The gate had to be moved from its west wall to its southern side, said the Bendésa, to match the small temple opposite it, the Ulun Balé Agung. A *pedanda* was brought in, and he prescribed certain offerings, and then the laying out of the walls was begun, a process requiring offerings and mantra by the *pedanda,* as well as special calculations. Without such sacralized measurements, no temple or pavilion will be free of evil spirits.[20] Present were the *pamangku* of Pura Désa Batuan and of the enclosed Pura Buda Manis, a *pedanda* from another nearby village, the Bendésa and his assistants, and their wives.

The first step was the establishing of a unit of measure, which should be the actual hand span of someone

directly linked to the building project. In this case the hand span of the Pamangku of Pura Buda Manis was chosen, and a sequence of his hand spans was marked out along a stick of bamboo. This custom-made ruler was then used to lay out the wall, the gate, and the two altars that flank the gate according to the dictates of the plan (*nyikut karang*) as given by the *pedanda*.

However, the numerologically sanctified layout was not entirely acceptable to the representatives of the congregation, for it put the new gateway right in front of an already existing building, making the door almost impassable. When the laymen reverentially protested, the priest recalculated and came up with a more practical set of specifications. In this way both practical and divinatory concerns were taken into consideration.

These measuring-out procedures, like anything else in Bali, are not exempt for contention. Apparently there are several different schools of temple layout and measurement, and when the death temple for the Triwangsa of Batuan (the Pura Dalem Puri) was rebuilt in the 1950s, a controversy blew up over which *pedanda*'s doctrine to follow. There were a number of *pedanda* in the congregation and each one came up with a different plan. There was much debate among everyone, and, by ways no one would or could tell me, one plan was finally accepted by the congregation.

In these cases, as far as I know, although the authority of written sources was invoked, the actual *lontar* or books were not consulted or quoted. I have the impression that few consult the physical books in these circumstances. In fact, the information on temple forms in the books themselves is limited. A number of *lontar* with the words *asta kosali, asta bumi,* or *sikut ing umah* in their titles are taken to be about building placement and construction. However, these manuscripts—which mainly provide lists of appropriate offerings and the right mantra to be uttered—are primarily about the consecration of new buildings, not their making.[21]

The *pamangku* may be another important source of advice on lesser matters. However, many *pamangku* have no specialized knowledge; they have been chosen to be priest simply because an entranced diviner has named them or because their father had been the priest. They have only to memorize a handful of mantras and gestures that are the building blocks of most rituals, and they are ready to present the offerings to the gods on behalf of the villagers. Those who, like the present *pamangku* of Pura Désa Batuan, come from a long line of *pamangku,* learn from their fathers through assisting them. This knowledge is sometimes secret, and often left unexplicated and perhaps inexplicable.[22]

Pamangku, as commoners, are almost always members of the village of their temple, while *pedanda* are from the noble Brahmana title groups, and usually not members of the congregation. They may be brought in from another village for a few hours to perform the close of a ritual. *Pamangku* are always bound to worship one particular temple, while *pedanda* travel around the whole region, and are called in to officiate in the larger rituals of specific local temples. *Pamangku* have little or no training, while *pedanda* are given lengthy spiritual and literary training. Many Brahmana houses in Batuan had extensive libraries of palm-leaf manuscripts the *pedanda* could consult. Advice given to laypeople by a *pamangku* would draw primarily on his memory of orally imparted lore about what sorts of offerings are made to which deities and where, and about the scenarios of the rituals performed in the temple.[23]

Also consulted might be the women called *tukang banten* (*tukang,* "specialized artisan"; *banten,* "offering") who know how to make the most elaborate offerings. There are *tukang banten* in every neighborhood and of all titles, but Brahmana households have the most of them. In her own temple, a *tukang banten* works without compensation, but when requested by another temple to work for days or weeks preparing for a ceremony, she is paid in kind and small amounts of money. She also guides the work of the less skilled women of the

village. These *tukang banten* learn their trade at the feet of their mothers and aunts, by imitation. They know the names and composition of hundreds of offerings and can recite the offering requirements of almost any ritual. Since most rituals are known and discussed mainly by their offerings, the knowledge of the *tukang banten* is essential for mounting any major ritual and for knowing what rituals to plan for.

Another kind of expert whom the villagers might have consulted on temple renovation are the professional carpenters *(undagi)* and stone and wood carvers *(tukang pahat, tukang ukir)*. The most experienced of these may be quite learned in the lore of temple building, having many times consulted with the various ritual specialists in the course of their work. A few can read the *lontar*. They acquire their skill and knowledge as apprentices, either to their fathers or to master craftsmen. In Batuan, several of today's finest stone carvers told me that they learned their craft working several years on Pura Désa Batuan as apprentices.

Two other categories of specialists who might be consulted on temple matters are the shadow puppeteers and the members of dance-drama ensembles, who can advise on iconographic conventions and symbolic associations that may be appropriate for temple carvings and paintings. Some of these dance-dramas are nearly integral parts of the temple rituals (such as the *rejang* and the Calonarang, to be discussed later), while others are optional supplements (such as the *arja* and the *drama gong*).[24] While there are dramatic troupes in villages all over the island that may be brought to Batuan for the occasion, most of the time Batuan has been able to mount its shows entirely with local talent, and even to export some.

Some of these performance specialists, particularly in shadow plays and *topéng pajegan* (the sacred dance by single dancer with many masks), regularly present didactic episodes and even sermons within their shows that pertain to the temple, its functions and forms. Most

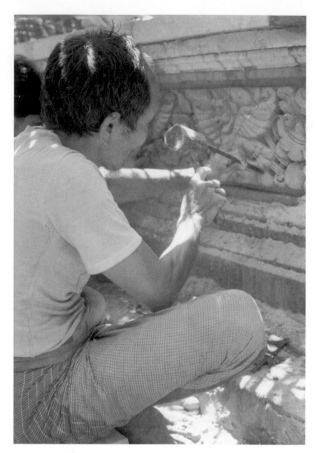

Figure 2.8. Déwa Nyoman Cita, master carver, at work. Photographed in 1986.

have considerably studied and thought about theological matters, for these pervade the narratives and characterizations of their own performances. During the 1980s, the carvers and painters I interviewed told me that they frequently consulted shadow puppeteers and dancers about their projected temple works. Many were dancers themselves. Shadow puppets themselves are occasionally used as models for statues.

. .

Diverse cultural specialists are consulted on iconographic matters by the builders of a temple, but the

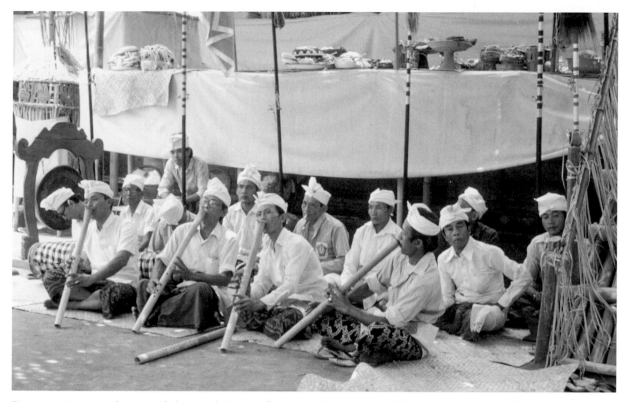

Figure 2.9. Musicians playing *gambuh* music during a performance within the temple. Behind them is a table of offerings. Photographed in 1985.

knowledge that each one has is only a part of what is needed. Some know only one fragment—one kind of *banten,* one particular range of mantra, how to make one kind of statue, or one genre of shadow-play.

Complex social fragmentation of knowledge and a wide scattering of snippets of information among many people is characteristic of most forms of activity in Bali, at least before the 1970s. Further, the main channel for preservation of expert knowledge is primarily oral, despite the availability of written texts, themselves fragmentary. The consequence of dependency on oral transmission and retention of specific lore, rather than on general principles, is ease of loss of cultural guidelines. Should a person holding a key piece of information die without transmitting it to someone else, the loss must be filled up somehow, and sometimes this means improvisation.

The structure of responsibility in the *krama désa,* the *krama banjar,* and the *prajuru* managing team puts weight on the decisions by members of the nonspecialized majority population. They must find ways to pull together the fragments of sometimes conflicting advice of specialists and come to consensual agreement on all major, and many minor, choices, despite their own lack of in-depth knowledge and experience.

The acts of choice and interpretation in the building of a temple are crucial at every step, but also important are the acts of assemblage, bringing together partial bits of information to produce a single whole. The practice of assemblage is a major type of creative act in Bali.

The best example I have of the assembling process comes from the world of dramatic performance, as I observed it in Batuan in the 1980s. In the production of a musical dance-drama, each of the many participants knows only a small component of the whole (a certain dance, a particular melody, a certain story line, or how to make a complex kind of costume), and no one knows all of them. When a play is planned, all of those who know part are brought together, and if there are gaps in the communal pool of knowledge or competence, help may be sought elsewhere, or parts improvised. If necessary, the overall story line may be adapted to whatever resources are available. If there is no one around who can act the part of, for instance, a romantic princely hero, a performance may be devised in which he is omitted. It is because of this reliance on locally available competences that villages have always specialized in one sort of performance or one sort of artisanry and have sometimes borrowed from elsewhere. In many dramatic plays, the various performers are assembled from widely separate places to join a local core troupe.

Under those circumstances, the repertoire of dance-dramas in any particular locality and time is limited by the vagaries of available memory and skill. The history of drama in Bali is never one of steady accumulation because with no written records much is lost through social erosion. Innovations constantly appear to fill in the gaps.

In dance-drama, the *penasar* (clowns) are usually responsible for the assemblage of a whole performance. Usually there are two *penasar*. While they do not have competence in all of the dance roles, they choose the story, and in the course of their own acting and dancing, advance the progress of the plot. In music, the drummers are usually responsible for the coherence of the whole. But this responsibility is always only partial.[25] A large Balinese dance-drama has a kind of coherence, but it is not of a formal integration of Aristotelian "uni-ties," but rather of a kind of cumulative assemblage of many fragments.

The same could be said of the building of a temple. The job of the *bendésa* and the rest of the *prajuru désa* is to make sure that all the artistry and all the remembered lore necessary for rebuilding a part of the temple are present. They not only assemble the material necessities, but also bring together teams of master carvers and apprentices, each of whom has a fragment of the necessary knowledge, and give them headway.

Imaginative creativity becomes an inevitable element in temple building, despite, or because of, the multiplicity of sources, the oral nature of the transmission of knowledge, and the gaps and vagueness of those sources. Rather than being variations from a detailed cultural template, Balinese temple building, alteration, and renovation are a series of imaginative acts, guided by various cultural conceptions, acts that are also responses, sometimes improvisatory, to social and religious contingencies, which together build an unpredictable product.

Many hands go to work in the making of a temple, and many kinds of artistry and imagination are mobilized. The making of a Balinese temple is a collective achievement, but it is not a simple product of some sort of "group mind" or "communal artistry" that some Western fantasies of Bali would have it. The process is not one of smooth social harmony. The sometimes conflicting variety of interests and purposes involved is guided and controlled by an intricate set of social institutions. Nor is it true, as the tourist literature would usually put it, that "every Balinese is an artist." There is a complex division of labor.

The sociologist Howard Becker has shown that the production of Western "artworks" is also collective and tightly organized: "Works of art, from this point of view, are not the products of individual makers, 'artists' who possess a rare and special gift. They are, rather, joint products of all the people who cooperate via an art

world's characteristic conventions to bring works like that into existence."[26] An "art world" for Becker is "a group of people who cooperate to produce things that they, at least, call art."[27]

Joseph Alsop, approaching the study of art from a related, also sociological angle, stresses the interlinking of major institutions that have enabled that cooperation: art collecting, art history, art markets, and art museums. Professions such as art dealer, connoisseur, art historian, and museum curator are part of these activities. Alsop shows that such institutions were to be found in full development not only in modern Europe, but also in ancient Greece, Rome, and China and in Renaissance Italy. Emphasizing the centrality of an art market in defining the social activity he studied, Alsop calls these the "rare" art traditions.[28]

Balinese society, at least until the 1990s, lacked all of these, since the making of temple carvings was never an activity directed at the production of "art," whether rare or fine. In the 1980s the rudiments of art history, art collecting, and art museums were developing; these centered on the market in high tourist art. However, it is clear from my description of the social aspects of temple building that another set of important institutions is involved: the priesthoods, the various *désa*-based organizations, and the dance-drama world, among others. Rather than a kind of "art world" in Becker's terms, these add up perhaps to a "temple world."

While the social institutions that Becker and Alsop describe center on the making of objects, the Balinese institutions are oriented not around artifacts, but around various social projects, from the organization of worship to increasing knowledge of the sacred writings to the dramatization of spiritual and moral tenets. In these projects the artifacts produced are not ends but means or by-products.

I have focused here on social processes. There are, or have been, of course, some general cultural ideas about the purposes and meanings of a temple and its carvings, ideas that govern judgments about appropriateness, appreciation, evaluation, and interpretation and about the kinds of pleasure that might be aroused in a temple. These are best approached through a study of the rituals held within and around the temple.

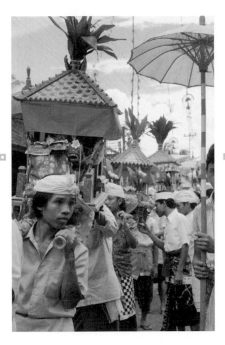

The Purposes of Pura Désa Batuan

Why were the stone carvings of Pura Désa Batuan made the way they were? Why were some of the walls and gateways so elaborately decorated that I was easily led to label the works in the temple "art"? What purposes were fulfilled by the manner of their making? What were the members of the temple doing within it, and how did these activities affect the making and arranging of the temple's carvings? Answers would be background information that is crucial to any interpretation of their meanings or evaluation of their appeal. Understanding such activities and the indigenous ideas associated with them should enable me and my readers to avoid, at least partially, imposing our own, perhaps farfetched, interpretations on Balinese artifacts, activities, and events.

To find out what were the culturally available ideas with which the people of Batuan make sense of the temple's form and carvings is to explore what we call its religious purposes and uses. But an adequate history and ethnography of Balinese ritual practices and ideas has yet to be written.[1] There is an urgent need for further research by Balinese scholars and theologians, by those who have the personal involvement, experience, and linguistic familiarity to produce authoritative reports and conceptualizations. To make such studies more diffi-

cult, Balinese everyday religious life has been, in the last quarter of the twentieth century, undergoing important changes that made retrospective comments about temple forms and carvings anachronistic.

These are contested matters. Not all Balinese agree on the nature of the beings who are worshiped in the temple and on the purpose of that worship. During the period of my field research, the 1980s, some people in Bali were developing new ideas about their temple practices. It is likely, however, that throughout Bali's history there never has been a settled orthodox doctrine accepted by everyone. Although Bali has entertained a variety of Hinduisms and Buddhisms over the centuries, none of these major religions has a strong institutional framework for delineating and enforcing orthodoxy. Besides that, the equally strong indigenous practice of communicating directly with "gods" and "demons" and their like constantly undermines efforts after orthodoxy and uniformity of belief. For these reasons, any systematized account of "the" Balinese religion is suspect.

Since this book is about the "art" of temple construction and decoration, I focus on the grounds upon which the makers and remodelers of the temple made their creative decisions. A major concern in this chapter is therefore about what functional requirements their ceremonies entail, needs that directly affect the architecture and spatial layout of the temple.

Another concern is what its ritual activities tell us about the nature of the audience the planners and artisans had in mind as they worked on the temple decorations. Of course, they might have aimed to please their fellow villagers, and, perhaps, people from nearby settlements, local royalty, government officials, or even tourists. The argument of this book is that the primary audience toward whom the artistry and imagination was directed was, and is, the gods and demons of Batuan. Who the intended audience is sets up a cultural interpretive frame that encompasses all others, that determines the appropriateness of various choices of form, subject matter, style, and the like. Who the gods and demons of Pura Désa Batuan are and what their tastes are becomes a pressing topic for research.

The English phrase "gods and demons" is a poor term to cover the beings with whom Balinese interact within the temple. The closest to a general word for them is *"niskala,"* which means, roughly, "invisible and intangible." This term is not a noun, however, but more like an adjective, indicating an important characteristic of such beings, who might then be referred to as *sané niskala* ("those who are invisible" or "the *niskala* beings"). The phrase "*niskala* beings" can be used to refer to everyone from the highest deities (Siwa, Wisnu, and the like) down through local gods (the gods of Pura Désa Batuan) to the littlest imps and spooks that inhabit small streams and clumps of bushes.

In this chapter, I present my current understanding of the ritual activities that are conducted in and around Pura Désa Batuan and the implications they carry for the nature of its deities and for the character of the temple. My account moves from more general statements about Balinese religion toward the specificity of Pura Désa Batuan, leading up to part 2, the historical description of the works found within its precincts.

I start with the conceptions of temple worship that have been taught by the Balinese Hindu Dharma theological movement in Bali's schools since the 1970s and that are shared by much of its population.[2] This discourse has served as a major interpretive screen through which contemporary research on Balinese religious ideas has had to be carried out, a major source of conventional Balinese talk about religious purposes and meanings.

This doctrine does not exclude other sorts of understanding of the form of the temple and the nature of worship, those commonsense notions that are implied in the rituals carried out within and around the temple as I have observed them and that I describe in the latter part of this chapter. Before going into the rituals them-

selves, I explore how ordinary Balinese learn about the meanings of their practices outside of school and television sermons. They learn from daily enactment of the rituals themselves and also from specific instruction by ritual experts, notably the healers *(balian)* whom everyone consults in time of trouble—from disease to political disaster. These diagnoses and prescriptions often entail the gods and demons of Balinese temples.

I then go to an analytic description of the two major ritual cycles of Pura Désa Batuan, the Odalan and the Taur Kasanga, repeated ceremonies through which both participants and anthropologists can learn much about the purposes of the temple. But ritual-based knowledge of "what goes on in the temple" comes always in fragments. It is a kind of practical understanding (how to worship) that is only partially verbalized, not a discursive or intellectualized understanding (how to talk about worship).

As a kind of summary of the rituals of Pura Désa Batuan I give a description of the "gods" or *niskala* beings of Batuan, in all their individuality. The final section of this chapter concerns the architectural form of the temple as seen through its rituals.

Cosmic and Social Order

The Hindu Dharma movement is a major stream of thought and writing about Balinese religion that has profoundly affected the ways that most contemporary Balinese speak about their religious ideas. It teaches a theology that sets up a model of Balinese temples as plots of pure, sacred land protected by walls from the surrounding impure world and oriented toward the mountainous center of Bali as the purest point in both the world and the cosmos. It is a theology of cosmic order, but it is strongly linked to an ideology of social order.

Doing research on temple worship in the 1980s, I found that many of my consultants answered my questions in Hindu Dharma terms they had learned in school about the nature of the Balinese cosmos and the place of human worship within it. Some people stressed notions of cosmic and earthly order in the form of a mandala centering on the mountains, with purity above and pollution below in the sea, and of ritual efforts to maintain that order. But other people pointed to elements in the rituals that contradicted those notions of cosmic order.

The Hindu Dharma movement was well under way in the 1950s. F. L. Bakker has suggested that already in the 1930s a rethinking of Balinese religion by young students may have started the intellectual dialogue with Christianity in missionary high schools. Bakker stresses the importance of European ideas on the first germination of the Hindu Dharma theology, most especially ideas of modernizing religious practices and notions of personal mystical devotion to a single God who encompasses all particular Balinese gods.

It was, however, only in the 1950s that a small but influential group of students was attracted to the modernizing Indian spiritual movement of Arya Samaj and went to India to enter Rabindranath Tagore's experimental school to study the new Indic philosophies and theologies.[3] On return from India they began to teach and publish, joined by others who came to the Indic sources through priestly texts in Bali, giving the Hindu Dharma conceptions a strong Indic tone. Important influences entered from Javanese modernist Islam, notably the stress on a single, all-powerful god, Tuhan Yang Maha Esa, an Indonesian translation of "Almighty God" and "Allah Akbar." The political necessity in the 1950s, with the establishment of the Muslim-dominated Republic of Indonesia, was for Balinese to persuade the new Ministry of Religion officials that Balinese Hinduism was a monotheistic doctrine, for without such a commitment to a single God, the Balinese were at risk of being classified as a nonreligion and prevented access to governmental funds.

The effort to establish a monotheistic interpretation of Balinese religious practices was, at least on paper, successful, and Balinese intellectuals from the Hindu Dharma movement were among those who worked together with a group of *pedanda* to set up the Parisada Hindu Dharma (later, the Parisada Dharma Hindu Bali), a quasi-governmental organization; it united all the private nationalistic theological groups in Bali in the 1950s for the advancement of the Hindu religion not only in Jakarta but also among the people of Bali. Since 1959 the Parisada Hindu Dharma organization has developed a teachers' college and a theological school to train those teachers who give daily instruction in Agama Hindu Bali, "the Hindu religion of Bali," in all schools from elementary through the universities.

According to the teachings of the Hindu Dharma movement, the throngs of gods that attend a temple festival are only temporary manifestations of the one God, who is all-pervasive, indeed who is the cosmos. He is sometimes identified as Siwa or as Sang Hyang Widi Wasa, "the Almighty God." Here, for instance, is a statement from a 1985 Indonesian textbook for high school students issued by the Ministry of Religion: "The Almighty God (Tuhan Yang Maha Esa/Ida Sang Hyang Widi Wasa) exists everywhere; there is no place in the material world that is empty of Almighty God. . . . God (Tuhan or Sang Hyang Widi) gives life to the world and all that is in it."[4]

Hindu Dharma teachings liken the multiple deities of everyday rituals to the refraction of a beam of white light from the sun into a blaze of varied colors. To worship individual deities is to honor the single divine within all beings. To make representations of particular deities, since ultimately they are formless and unknowable, is to make images that only metaphorically suggest certain attributes of the single divine being. These symbolic representations are necessary for ordinary human beings because they cannot comprehend or feel close to an "abstract" god. The temple with its carvings is

needed for the general population to provide substitute images for an essentially unknowable deity. Some go so far as to feel that temple rituals are unnecessary for those who have developed personal meditation forms of worship.

This idea is explicitly expressed in the same government-issued textbook on religion quoted above: "Because the world is the throne of God in truth, therefore the world is very abstract *(abstrak)*. The world cannot be seen as an undivided whole by human beings. Because of that the Hindu community *(umat Hindu)* has created symbols *(simbul)* that are more concrete *(kongkrit)* of the earth as the throne of Ida Sang Hyang Widhi Wasa."[5] The authors go on to say that through the contemplation of symbols such as the mountain, the *lingga,* the *candi,* and the temples, "the feelings arise of greater closeness with Ida Sanghyang Widi. These religious feelings *(rasa ketuhanan)* become steadier and stronger when Ida Sanghyang Widhi is given the form of symbols *(simbul-simbul).*"[6]

Not only is the word *"simbul"* derived from English but also, I suggest, the concept as well, along with the notions of *abstrak, kongkrit,* and metaphor. These ideas contrast greatly with Balinese common sense, which sees all visible and tangible phenomena as potentially vehicles not for meanings or symbols but for the materialization of *niskala* beings, and sees all communication with them as pragmatic, practical, and social.

Monotheism and symbolism were not the only new themes introduced in the Hindu Dharma movement. Even more important was the idea of cosmic and social harmony, balance and order. Here, for instance, is an articulate formulation by a Balinese intellectual, Dr. L. K. Suryani:

The Balinese believe that three factors are crucial to a person's well-being, happiness and health: (1) the microcosmos *(buana alit),* which is made up of individual persons; (2) the macrocosmos *(buana agung),* which comprises the

universe; and (3) the supreme God (Sang Hyang Widi Wasa). In their daily lives, at home, in the market, or at the offices (parts of the macrocosmos), the Balinese strive to keep the three factors in equilibrium, a concept called *tri hita karana*. . . . The practice of harmony and balance from the Balinese Hindu principles *(tri hita karana)* results in not showing too much vigour of emotional expression of any type and relates to the concept of a centre for all things. . . . Centre, harmony and balance are unconsciously striven for in many aspects of thought, emotion, and behavior in daily knowledge. . . . Peace is attained by doing good deeds and by maintaining balance. . . . The Balinese believe that one's soul is involved in illness and that they will become vulnerable to illness if the three factors are not in equilibrium.[7]

Equilibrium is sought also between the cosmos and the individual, called, in a common borrowing from Western thought, the "macrocosmos" and the "microcosmos." These medieval European terms have been introduced to translate the Balinese phrases *buana agung* and *buana alit*, which can be shown to have other, quite different meanings.

Suryani also mentions another sort of cosmic order, that of the mandala, a star-shaped ritual form in which the eight arms point to the eight compass points, with each point identified with a color and an Indic god, and the central or ninth point identified with "all colors" and the highest god, Siwa. This central point for Hindu Dharma theologians stands for the achievement of balance. For Suryani and others, the mandala diagram serves as a map of the fundamental order of the cosmos, with its star of arrows pointing in the directions of the seats of the major gods and at its center the one unknowable god who combines within himself all of the others.

Suryani stresses that Balinese also strive to find balance between the two directions, "*kaja* (towards the mountain) [which] leads towards the sacred" and "*kelod* (towards the sea)[which] leads to demons or evil."[8]

With that equation of spatial directions with moral pressures, the Hindu Dharma movement has introduced an ethicizing of landscape and space that has implications for its interpretations of the meanings of the forms of the temple.

For Suryani, as for many of Balinese Hindu Dharma adherents, these notions of order and equilibrium are bound up in personal responsibility and internal control of one's emotions and an individualized, devotional ritual. For some, this idea is linked to a moral battle between good and evil, the struggle with the demons within one. Here is a slightly different statement by another Balinese intellectual, Ida Bagus Oka Puniatmaja, one of the group who studied in India:

> Good and evil; right and left, gods and demons are banded into two opposing factions, constantly at war, in which the weapons are their magic powers and the stakes are the lives and interests of the people, compelling the people to propitiate both sides so as not to attract the wrath of either party. Only by proper balance between the negative and positive forces are they able to maintain the spiritual harmony of the community.[9]

Puniatmaja's extension of the notion of cosmic harmony to community order is typical of Hindu Dharma teachings. Here is a statement by a long-term Western student of these matters, who may have been in contact with some of the first Hindu Dharma thinkers:[10]

> The cosmic order also finds its expression in the legal order: it is a moral good, just as its reversal into disorder produces a moral evil.[11] . . . Just as in social matters one must know the usages of *adat* and the rules of the vocabulary of courtesy in associating with superiors and inferiors, in matters of religious life and activity one must be familiar with the proper principles of order. Only then can an individual know his place and attempt to arrange his life so that it is in harmony with the cosmic order, or at least does not run counter to it. A Balinese tries to imitate

the cosmic order, and so to give that order form in his own life, convinced that in such a way he will be able to obtain greater control over the complex of supernatural forces which dominate all of life.[12]

The form of some Balinese temples would, in the Hindu Dharma view, be dictated by an attempt to imitate the cosmic order, with its mandala form of single center and radiating arms. But only one or two do, and these have been built since 1968. The first one was the Pura Jagatnatha in Denpasar. It has one high altar set in the middle of a single square courtyard and is dedicated only to Sanghyang Widhi Wasa. Pura Jagatnatha, unlike most temples in Bali, may be attended by anyone, regardless of residence. A military commander, with the advice of the Parisada Hindu Dharma, suggested it be erected for the use of soldiers from outside Bali. Today, I understand, the greatest number of worshipers are students away from home.[13]

But the Jagatnatha temple is a great exception in Bali. Most temples have several courtyards, are not arranged concentrically, and contain not one central shrine, but rather clusters of shrines in various places.[14] Rarely are the temples arranged symmetrically or in anything resembling a mandala form.

. .

The notion of cosmic order (in Hindu Dharma thought and also in some Western writings) is founded on a metaphor of spatial, even geographic, order. The centrality of the volcanic mountains on the island of Bali, its encirclement by the sea, and the everyday practices of orienting all activities by the directional terms translatable as "toward the mountains" *(kaja)* and "toward the sea" *(kelod),* are taken by these theologians as a model of cosmic geography.[15] Ethicizing the distinction between mountains and sea into good and evil further elaborates this model. The notion of a cosmic and moral geography is given a further wrinkle through linking it to the familiar verbal distinction between the "great world" *(buana agung)* and the "little world" *(buana alit).*

But in everyday speech and practices *kelod* is not strongly associated with the demonic nor *kaja* with the divine. The sea is a *tenget* place, an area where *niskala* beings congregate, but like all *tenget* sites, the spiritual beings concentrated there are of all kinds, benevolent and malevolent to humans, and of all strengths. The seaside is not a polluting sewer, but a common site for ritual purification. Images of the gods are regularly taken to the sea for purification, as are powerful masks, gamelan instruments, shadow puppets, and dancers' headdresses. The sea is a source of very powerful holy water and of strong healing materials. The sea is also the final repository of the ashes after a cremation, in their last cleansing separation from the material world. On the reverse side, the peak of Mount Agung, the highest of Bali's mountains, is inhabited not only by the most powerful gods but also the most powerful demons.[16]

None of these so-called cosmic directions are absolute or stable in everyday speech; they are always relative to the speaker or actor, just as left and right are. Upstream means "upstream to me." My *kaja-kangin* house temple is right across the wall from my neighbor's *kelod-kangin* latrine and pigsty. The men of any village bathe upstream from their polluting women, but they are downstream from the women of the village above.

There seems to be no cosmic blueprint, no complex symbolic ground plan of temples in Bali. The similarities among them are a pragmatic working out of answers to functional requirements in the worship of the highly varied *niskala* inhabitants of Bali. This point will become clearer when I look closely at the form of Pura Désa Batuan.

The Hindu Dharma interpretation of the Balinese terms *"buana alit"* and *"buana agung"* as setting up a contrast between the inner psychic world of an individual

and the rest of the cosmos is also contrary to the everyday meanings of the two terms. *"Buana alit"* and *"buana agung"* are found in priestly mantra and have been given a variety of mystical meanings. A common one is that *"buana alit"* refers to the little world of local life, the village, the royal court and realm. Another is that it refers to the world of material experience, the *sakala* or known phenomena versus the *niskala* or invisible phenomena. In mystical terms, *"buana alit"* may also refer to the region within which a practitioner of the arts of the left side, a sorcerer, has established control, while *"buana agung"* would mean those realms of the various gods and demons. All of these present alternatives to the notion of personal, social, and cosmic order.

It is my opinion that the Hindu Dharma ideas were novel ones in the twentieth century, not reaffirmations of pervasive inner meanings of traditional ritual practices. Whether, during this present century, the Hindu Dharma persuasion will prove to have brought about a full and lasting reformation of Balinese beliefs remains to be determined.

Practical Exigeses of Rituals

How can an anthropologist arrive at an understanding of the purposes of a temple and its rituals when much of the verbalized commentary on them by Balinese themselves seems to go counter to one's experiences of living in Bali?

One research strategy is to study closely the tales that Balinese tell to one another—both informally at home and via their dramatic productions—tales that place temple gods and priests in contexts both marvelous and everyday. I carried out such a strategy in the preparation of my book *Images of Power,* and I won't repeat my findings here.

A second route is to study closely the temple rituals themselves—the details of offerings and their place-

ment, priests' mantras, gods' stand-in figures, temple altars, processions, and the like. These aspects of ritual practices can be examined along with the vocabularies, names, and figures of speech employed by participants, most of whom don't reflect on theological generalities but take their own practices at face value. This I have done and report on, schematically, in the remainder of this chapter.

Before I do so, however, I want to discuss a third research procedure aimed at comprehending the meanings of what the people of Batuan did and do in their temple. This is the study of the teachings of Bali's many healers, or *balian.*

In every village are several healers and diviners who may be consulted about particular troubles. It is through their diagnoses and prescriptions for action that most Balinese, I believe, learn their basic understandings about what happens in a temple ritual. This is knowledge that is pragmatic and specific, unlike that which they learn in the schools.[17]

People consult *balian* for specific reasons, ranging from large communal disasters, such as drought or the choice of a new temple priest, to personal illness or loss in love. These *balian* divine the sources of the sufferer's troubles in a variety of ways—consulting mystical writings, studying subtle clues on the sufferer's face, serving as a spirit medium to allow a *niskala* being to speak directly with the sufferer. Whatever way the diagnosis is reached, the *balian* usually offers an interpretation of it for the client, then works out a proper therapy. Often the solution suggested is the carrying out of a ritual in a temple. Sometimes the cause of the trouble is said to be a botched ritual, which must be redone. In some big cases, brought to a *balian* by a whole temple community, the remedy may be a major ritual festival added on to their regular *odalan.*

Linda Connor's meticulous report and film of a *balian*'s seance in 1978 and 1983 serves as an excellent example.[18] The group of villagers who came to the healer,

Jero Tapakan, did not tell her their reason for consulting her. The first *niskala* being who spoke through Jero Tapakan was a minor houseyard deity. This deity expressed anger—"I'm filled with anger and misgivings at your past incompetence"—and asked the petitioners what their ritual plans were. When they told the deity that they were about to do a cremation, the god sternly told them not to forget to place offerings within the houseyard for its deities. The actual discussion (not fully translated in the film, but provided by Connor in her book) gives details about the offerings the deity demanded, not only for himself, but also for some unnamed "vengeful spiritual forces" that have been invading the houseyard and causing trouble.

Jero Tapakan came out of trance, asked the petitioners who came and talked with them, and gave them a little interpretation about the offerings demanded. She then was possessed again, this time by the spirit of an older man, whom the petitioners took to be their father. In their conversation with the spirit, the clients revealed that their concern was the death of a young boy, grandson of the visiting spirit. The unmentioned assumption, probably held by all concerned, was that the death of someone so young must have been the work of a sorcerer.

Jero Tapakan went again into trance, and the next *niskala* being to speak was the boy himself, who cried pathetically for his mother. The boy, speaking through the medium, told his parents that he himself would seek revenge against the sorcerer. To do this, he said, he needed permission from certain deities, who were to be given offerings in a temple by his living kin.[19]

In this case, and in others reported in the literature, the solution to suffering is through ritual offerings, which serve several purposes. In the case of the household deity who first appeared, his anger at their neglect of him was understood to have motivated him to permit the killing of the boy, and the offerings are a means to mollify that anger and prevent further damage. In the case of getting revenge on the sorcerer (who, as in almost all cases, was presumed to be a particular kin or neighbor of the suffering family), the boy's spirit took it upon himself to do the counterattack, but he needed the agreement of both his living kin and the higher *niskala* beings. He named the kind of "redemptive offering" needed and to which deities it should be dedicated in his name. In this case it was to the trinity of Brahma, Wisnu, and Iswara.

Connor's analysis of the cultural logic of the healer's ritual is illuminating. She sees the fundamental idea behind the seances of a spirit medium as one of making contact with spiritual beings so that the clients can negotiate with them.

> Within the structure of the séance, accommodation to the will of the deities and spirits is assumed but can be achieved only at the expense of considerable effort by the petitioners. . . . Humans are not merely the pawns of deities, however: The existence of spirit mediums such as Jero Tapakan bespeaks the possibility of compromise and of bargaining with supernatural wills. . . . This linkage permits the petitioners some leverage in the supernatural realm, thus diminishing their perceptions of their own powerlessness.[20]

A close reading of Connor's transcript of the entire seance shows that exactly such a negotiation process has gone on. In a discussion of the offerings made in the course of a healing ritual, Connor speaks further of negotiations between human and nonhuman beings:

> The idiom of the marketplace is often used to describe the meaning of offerings in ritual. Offerings are a currency that is acceptable to spirits and deities. . . . Sins and omissions of petitioners are referred to as "debts" *(utang)*. Petitioners who have not fulfilled past ritual obligations have to "redeem" *(nebus, nebas)* these debts with offerings.[21]

A *balian* when acting as a medium serves as a channel for negotiation between humans and *niskala* beings. However, in her role as healer, the *balian* also can act di-

rectly against the causes of the troubles the client has brought. Connor shows that the *balian* uses offerings, mantra, gestures, incense, holy water, and meditation, always together with direct statements of intent and wish (much as a priest does). None of these acts are efficacious in themselves, but all are needed in concert. The most important is the verbal statement of intent, for the *balian*'s rituals are direct messages to gods and demons, invitations to confer.

A *balian* may also be a temple priest, but this is not the source of his or her spiritual authority or healing abilities. These are considered gifts of the gods, and are sometimes spoken of as the *sakti* of the *balian*. This is the ability not only to heal and bring well-being, but also to harm fellow humans. It is also the capacity to make negotiations with *niskala* beings, effectively—to discover who is involved in a particular suffering, to make contact with them, and to persuade or force them by threats, blandishments, and other measures to desist.[22]

The diagnoses and prescriptions of a *balian,* as in the case of Jero Tapakan, often include concern about gods of the temples of the afflicted person, their possible anger, and the means the family might use to propitiate them. The *balian* herself may carry out certain rituals for healing or for preventing further harm to the patient.

A close study of what *balian* tell their clients should produce many insights into the nature of Balinese deities and their actions toward and with humans. If the practices of Jero Tapakan are typical, it can be seen that the gods are involved in day-to-day events—even sorcery—if only by permitting human malevolence to be effective.[23] The sorcerer's freedom to work on someone in the family may be due to mere inattentiveness on the part of the deity or it may be due to his vexation at his followers for neglecting him. The entry of the *balian* into this tangle of relationships—among humans and gods and demons—is felt to be dangerous to the *balian* herself. That danger, and the steps that the *balian* takes for self-protection, is itself further revealing of

the quality of contacts of humans with *niskala* beings and the nature of the negotiations carried out among them.

Temple rituals differ from *balian* rituals in that they are on behalf of the congregation as a whole, not individuals, and in that they are predominately preventative rather than curative in purpose. Nonetheless, they could be further illuminated by systematic study of *balian* practices and ideas. Connor very perceptively once called the *balian* "peasant intellectuals," by which she meant that "they organise and disseminate practical knowledge as well as re-creating and interpreting world-views which are in accordance with the peasantry."[24] While perhaps the term "intellectual" is too Western in its connotations, nonetheless the insight is one worth following up in the context of further studies in Balinese religion.

The Nature of *Niskala* Beings as Shown in Their Rituals

The rituals carried out by the people of Batuan within and around their village temple are perhaps the best source for a circumstantial view of *niskala* beings and their tastes.[25] We learn a great deal about the specific characters of Batuan's *niskala* beings from what is done to, or rather, with, the gods and demons—how these beings and their worshipers make use of the temple's spaces, altars, and gateways, how they come and go, and how they converse with one another. This may lead us to understand better some of the Balinese commonsense understandings of what it is about the stone carvings and the figures decorating the temple that may be thought to please these varied beings that are so closely tied up with the local populace.

In Batuan's Pura Désa Batuan, the two most important ritual festival sequences are the Odalan (the coming out) and the Taur Kasanga (the payment of the

ninth month).[26] The Odalan is held every 210 days, while the Taur Kasanga comes once every lunar year, at the end of the ninth month.[27]

In Batuan's Odalan, its five major *niskala* beings *(betara-betara)* and hosts of lesser gods and demons *(buta-buta)* are invited to emerge and are then engaged in an interchange with their human devotees of worship and blessing. The assembled *niskala* beings feast on proffered food and bless pure water, and transform that food and water into potent protective substances. When the transactions are finished the *niskala* beings disappear again.[28]

At Batuan's Taur Kasanga, the same group of gods and demons is invited to emerge. They are first taken to the sea, where they are given elaborate food offerings. They respond by blessing seawater, which then becomes holy water. Then on coming back to the temple, the gathered deities witness another major prestation of offerings—the Taur proper—after which they all again vanish.[29]

Like an *odalan,* a *taur kasanga* is an elaborated, intensified version of daily transactions made with *betara, buta,* and their like by priests and householders. While there are important differences, the two ritual cycles share many of the same ritual building blocks and scenarios. Both require mobilization of materials and labor by the entire temple community, the whole *désa adat* of Batuan. And both rituals address, personally and as a group, all the local *niskala* beings of Batuan.

The *taur kasanga* series is not usually considered a temple ritual because it is classified, by Balinese scholars, as a *buta yadnya,* a ceremony addressed to the local demons *(buta)* in purifying preparation for other rituals that are addressed only to the gods. In contrast the *odalan* is categorized as a *déwa yadnya,* an offering ceremony addressed to *déwa,* or "gods." But the distinction is misleading since neither ritual is addressed "only to the gods" or "only to the demons."[30] Both rituals call on all the gods and demons of the *désa adat* of Batuan.[31]

Both ritual series take place primarily within Pura Désa Batuan, but both also entail actions that take place outside it. Certain other temples near it are also involved. The Odalan takes place primarily within the innermost courtyard of the temple, the Jeroan, while the Taur Kasanga is held mainly in the front courtyard, the Jeroan Tengah Kelod, where the Balé Agung stands. The diagrams of the temple on the end sheets and figures 3.2, 3.3, and introducing part 2 should help orient the reader to various locations of the following events.[32]

. .

The overall scenario of both the Odalan and the Taur Kasanga in Batuan is that of a formal visit to the temple by most of the gods and demons of the surrounding area. Their hosts are the five gods of Pura Désa Batuan. During the time of the visit, the assembled gods and demons are paid homage, feasted, and entertained by their human followers. When the ceremony is over, they are bid farewell, and they all return to their more distant places.

The Odalan scenario has six main steps:

1. the notification to *niskala* beings of the coming ritual festival
2. the presenting, to *niskala* beings in demonic form, of offerings of food on the ground in the center (the Jeroan) of the temple (the *caru agung*)
3. the emergence and gathering of the *niskala* beings
4. the enthroning of the *niskala* beings in the Jeroan
5. the presenting of offerings to, and receiving of blessings from, the *niskala* beings in the forms of music, song, dance, drama, and prayers (the *maturan piodalan*)
6. the closing ceremonies and the departure of the *niskala* beings

The Taur Kasanga ritual sequence has nine main steps:

1. the notification of the *niskala* beings
2. the emergence and gathering of the *niskala* beings at Pura Désa Batuan

3. the procession to the sea (the *makiis*) and enthroning them there (This step and the next are not performed in every *pura désa,* but in Batuan they are considered a necessary part of the Taur Kasanga.)

4. the presenting of offerings to the *niskala* beings at the sea (the *maturan ring segara*), and the distribution of *tirta* on return to the village

5. the enthroning of the *déwa-déwa* on the Balé Agung in the Jeroan Tengah and the Méru Agung in the Jeroan

6. the *taur* (the presenting of offerings to *niskala* beings in demonic form and to the high gods, witnessed by local gods) in Pura Désa Batuan, in the Jeroan Tengah (Smaller *taur* are offered elsewhere in the village, and very large *taur* at crossroads near royal centers.)

7. the offering to gods and demons of Batuan's special sacred dance performances, the *rejang* (This is not actually a separate step, but runs concurrently with all the others throughout the ritual period.)

8. the "silent day" (Nyepi) of no activity, no fire or lights or work

9. the closing festivities, the last *rejang,* and the departure of the gods and demons

Rather than describe each of these festivals I will discuss the important ritual units common to both the Odalan and the Taur Kasanga under the following rubrics: (1) notification and invitation, (2) emergence and procession, (3) enthronement, and (4) homage.

First Ritual Unit: Notification and Invitation

The initial step, about a month before the ceremonies, is the notification of the five gods of the temple that the festival will be held. These are small rituals carried out by the Pamangku of Batuan and his wife, several assistant *pamangku,* and members of the temple's *komiti,* the group of village officials responsible for the ceremonies. They are held in front of two altars: the main altar, the Méru Agung in the innermost courtyard, the

Jeroan; and the altar where their god-figures are stored between rituals, the Panyimpanan, in the temple priest's home just east of the temple (see figs. 3.2 and 3.3).

These notifications are often referred to as *pakéling,* from *éling,* "to bring to the mind" (addressing or speaking about someone of high status). Notificational offerings always include an item called a *pajati,* whose name comes from *jati,* which means "truthfulness and sincerity," stressing the reliability of the speaker's statements. Each time the *pamangku* addresses each god, he tells him of the community's continuing plans to proceed with the Odalan and asks his blessings on the project.

Even before these main gods are notified, a brief prayer is held at the shrine of a local deity called Ratu Ngurah Agung, whose tiny temple is just to the east of Pura Désa Batuan. Often also called Ratu Sakti, he is the guardian of the territory of Batuan, a sort of steward or representative of Betara Puseh, the highest local god. He is said to be the *pangamel* of the *désa,* the one who "holds" the village, and to be especially beloved of Betara Puseh. He always plays an important part in all major rituals, and, at times in the past, he possessed some of his worshipers. Without Ratu Ngurah Agung's support, the villagers' efforts to contact the gods would be to no avail. He is the one who was consulted by the head of Batuan's royal house when the *rejang* dance may have been first instituted about the beginning of the twentieth century.

· ·

The gods of Pura Désa Batuan who are first informed of the coming ritual are by name Ida Betara Ratu Puseh, Ida Betara Ratu Désa, Ida Sanghyang Aji Saraswati, and two gods with one name, Ida Betara Rambut Sedana.[33]

Ida Betara Puseh is said to be the god of the *gumi,* or realm, of Batuan. In contrast, Ida Betara Désa is considered to be the ancestor or ancestors of the people there (the *leluhur*), perhaps the people who first opened

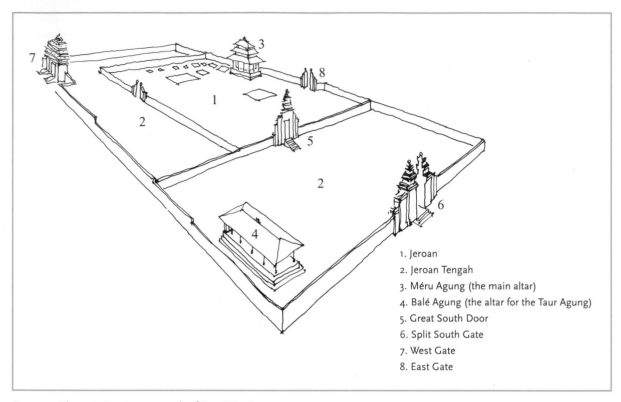

Figure 3.2. The main interior courtyards of Pura Désa Batuan.

1. Jeroan
2. Jeroan Tengah
3. Méru Agung (the main altar)
4. Balé Agung (the altar for the Taur Agung)
5. Great South Door
6. Split South Gate
7. West Gate
8. East Gate

up the forest, planted rice fields, and built houses there. But in common talk, these original *leluhur* have been joined by most of the recent dead after each one's final cremation ceremonies are finished.

The identification of Ida Betara Désa as the ancestor of the earliest villagers, who are presumed to be commoners, was a major reason for the dispute between the nobles and commoners of Batuan discussed in chapter 8. The nobles refused to pray to Ida Betara Désa, because their ancestors are higher than he.[34]

Ratu Sanghyang Aji Saraswati has no god-figure or *pratima* into which she can descend when in this world, but she manifests herself in the copper inscriptions of the ancient royal edict of 1022 C.E. (to be described in chapter 4). These are lovingly wrapped in cloth and inserted in a wooden box, which itself rests on a carving of a goose named Ida Ratu Sakti. The goddess is also referred to, in Batuan, as Ida Betara Prasasti (The God of the Inscriptions). Ratu Sanghyang Aji Saraswati comes out into this world whenever Ida Betara Puseh and Ida Betara Désa come out, but she also has a special *odalan* of her own. Saraswati Day is also celebrated all over the island, by anyone who has anything to do with books, including the youngest of schoolchildren, but in Batuan she is given an especially big festival.

The two gods with a single name, Ida Sanghyang Rambut Sedana, have two god-figures made, from Chinese coins, for their manifestations. They provide commercial and agricultural prosperity.

Invitations are sent out to other deities throughout Batuan. The gods of two of the temples next to the graveyards (Ida Betara Dalem Jungut and Ida Betara

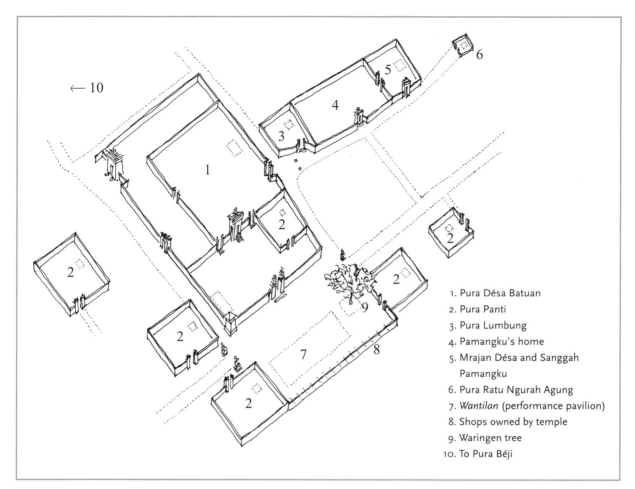

1. Pura Désa Batuan
2. Pura Panti
3. Pura Lumbung
4. Pamangku's home
5. Mrajan Désa and Sanggah Pamangku
6. Pura Ratu Ngurah Agung
7. *Wantilan* (performance pavilion)
8. Shops owned by temple
9. Waringen tree
10. To Pura Béji

Figure 3.3. The temples adjacent to Pura Désa Batuan.

Dalem Dentiyis) are invited. The gods of the Pura Dalem are classed together with Ida Betara Puseh and Ida Betara Désa as the Kahyangan Tiga, "the Three Great Gods." It does not matter that in Batuan there are four of these Three Great Gods. The term "Kahyangan Tiga" is usually but erroneously translated as "the three temples"; a better translation is "the three holy beings."[35] *"Tiga"* means three. *"Kahyangan"* can mean "a place where *hyang* or 'holy beings' are," but it can also mean just "holy being" and it is this person-focused meaning that is paramount, I believe. The recognition that the "three" are gods, not their places of worship, clarifies what appears to be a great inconsistency in Bali—that in most villages there are only two temples for these three gods, for often several gods double up in one temple, or as in Batuan there are four gods in three temples.[36] Implicit in the notion of Kahyangan Tiga is the idea that these three gods reign together over a specific locality and its community.[37]

Also notified are all the commoner kin-group temple gods of the village, called in Batuan *pura panti*. I have called *pura panti* "kin-group" temples, but while many

pura panti have deities who are clan ancestors, others have congregations who are mixtures of kin groups.[38] Most of the gods of these temples do not attend the Odalan but are present at the Taur Kasanga.

The two Barong of Batuan, named Ratu Anom (from Puaya) and Ratu Gedé (from Peninjoan), are also sent invitations and are important participants in both the Odalan and the Taur Kasanga.[39] These two are local *niskala* beings that manifest themselves in Chinese-dragon-like masks. They are, like the gods, animated and cared for by particular local congregation communities. Each Barong has his own *pamangku* and his own entourage of humans and other *niskala* beings, some of whom have masks of their own. The two Barong of Batuan never dance commercially, for they are *tenget*. In the 1980s, the mask and costume of Ratu Gedé was old and in tatters, people said, and for that reason was never used to perform. "He is too embarrassed to go out," they said. Some called him *cacad* ("disfigured" or "crippled"), a condition that would exclude any human being from active ritual office. Each of these Barong is the special guardian of the particular *banjar* that supports him. They are also thought of as the *panjak* Betara Puseh (subjects of Betara Puseh).

Two lesser gods join the group of visiting deities at all major rituals. These are Ida Betara Sélakarang and Ida Betara Buda Manis. The first one comes from a village a little distance away across the large river Wos, the village of Sélakarang in Kediri near Singapadu. Why he always attends the Odalan of Pura Désa Batuan is unclear to all, although one person told me that there used to be a temple in Batuan to him, but that the people who supported the temple moved to Sélakarang.

The other one is Ida Betara Buda Manis, from the small *pura panti* that is inside the southern courtyard of Pura Désa Batuan. No one knew why he is honored in this way.

Several other deities are notified of these rituals but do not have god-figures and do not accompany the oth-

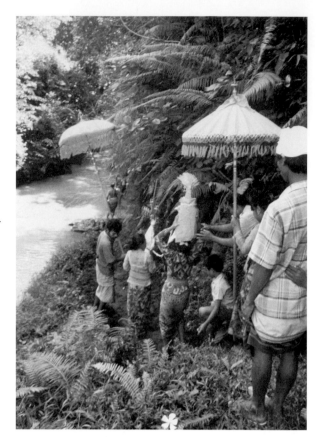

Figure 3.4. Procession going by stream to the sacred spring, Pura Beji. Photographed in 1988.

ers to the sea. One of these is Ratu Ngurah Agung mentioned above. Another is Ida Betara Siwa whose empty throne is the Padmasana, as the high witness over all. And up on the temporary bamboo high altar next to it, the *adegan surya,* is Ida Betara Surya, the sun, as another high witness. And then there are the gods of the kitchen, the *suci,* where all the cooked offerings are to be made.

Yet another important god of Pura Désa Batuan who does not have a god-figure is Ida Betara Beji, the god of a holy spring carved out of the rocky ravine wall of the nearby river, about a mile away, whence comes the pure water to make *tirta* during the Odalan, and where the rice for the offerings is washed.

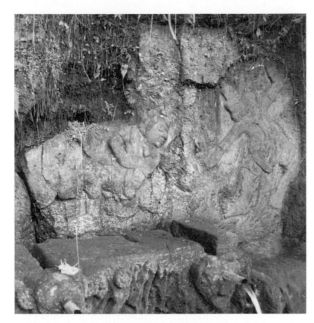

Figure 3.5. Carvings in the ravine wall at spring, Pura Beji. Carvers: unknown. Date: unknown. Photographed in 1995.

Two more deities honored in the Odalan of Pura Désa Batuan are the gods of a temple next to Pura Désa Batuan, called the Pura Lumbungan, which is an agricultural temple for a set of rice fields next to Batuan called Subak Batuan Dauh. However, its *odalan* is on the same day as Pura Désa Batuan's, and its gods are notified and given offerings at the Odalan, although they do not accompany the rest of the gods in the trip to the sea in the month of Kasanga. These gods are Ida Betari Sri and the double god of Ida Rambut Sedana. The first one does not have a god-figure, but enters there an ancient stone mortar and pestle.[40] I do not believe that it is usual for such agricultural gods to be regularly included in the ceremonies of a *pura désa*.

In addition, an indefinite number of high gods are invited to witness but not expected to actually visit. They may merely receive the messages from the priests and congregation as a distance *(cawang)* or briefly stop in *(simpang)*. These witnessing deities usually include the high Hindu deities—Siwa, Brahma, Mahadewa, Wisnu, and Iswara—but sometimes only three of these, or, with additions, nine of them. They are not given god-figures to inhabit, but they are presented with festive food and artful offerings. One of these high gods, Betari Pretiwi, the goddess of the earth, whose abode when visiting is in the earth under the temple, is given offerings on the ground.

But these are still not all the spiritual beings who come to a ritual festival. A host of lesser beings come too. In the same way that a king has a huge entourage of nonhuman allies, and a *balian* can call on a range of spiritual helpers, so also every deity appears to have an entourage (the *pangiring betara*), referred to usually as *buta-buti widiadara-widiadari* (the demons and the angels). Some of the minor *niskala* beings who lurk in rivers, streams, large rocks, bushes, and trees in the neighborhood are also attracted. And always there is Betari Pretiwi, who is everywhere and does not need a god-figure, who is given offerings several times during every ritual in the form of wine and *tirta* poured on directly on the ground of the temple (an exception to the notion that only *buta* and not *déwa* are fed on the ground).

Several other deities also attend by proxy of their holy water. At the time that announcements and invitations are sent to the gods of Désa Batuan, a *pamangku* and several members of the village committee travel, usually by car, to two temples, one seaward from Pura Désa Batuan (Pura Aer Jerok, south of Sukawati) and one upstream from it (Pura Tirta on the River Wos). They go there to address the gods of each temple and to obtain holy water (*tirta* or *toya panglukatan*) that carries the purifying and protective blessings of the gods of those temples for the ceremonies of Pura Désa Batuan. The importing of holy water from other temples further expands the network of deities that the people of Batuan engage in their rituals.[41]

An invitation to a god to visit Pura Désa Batuan is made in the form of an offering of a meal *(maturan aju-man)* very much like the little meals *(jotan)* sent around by a household to its neighbors and kin as announcements or invitations just before any major family ceremony. These notification and invitational ceremonies do more than pass on information; they draw the attention of the local *niskala* beings to their worshipers and they obtain the blessings and protection of the gods on the activity of preparing for the major ritual ahead. These notifications also serve to tell each deity's congregation and each *pamangku* that the ritual series has begun so that they can plan to give time for the strenuous preparations ahead within Pura Désa Batuan.

After this set of rituals is completed, the Odalan or the Taur Kasanga series is considered to have begun. The gods and demons are not yet close, but in an important sense they are much nearer than before. Some ritual steps performed during the waiting period (such as the *caru agung* of the Odalan described below) are understood to be witnessed by the still distant *déwa-déwa*.

Second Ritual Unit: Emergence and Procession

When the gods are to emerge and materialize themselves, each deity is "awoken" by his or her *pamangku* and invited to "come out." *Niskala* beings, since they are immaterial, need tangible and visible objects in which they can manifest themselves to humans. In rituals, they are provided with small carved god-figures—commonly called *pratima, prarai,* or *arca*—into which the god may enter if so inclined; these are placed high on the altars. When the deity has entered the god-figure, he or she can be bathed, perfumed, and dressed in new clothing. Flowers are used as sponges to lave the god-figure, the water being then called *banyu cokor* (the water of the feet of a high person) and later used to bless the worshipers of that god. (*Banyu cokor* is one type of *tirta,* of

which there are many specific kinds with different sources and uses.)

When a god-figure is carried a short distance it is placed on the shoulder or head of his particular *pamangku* or that of one of his *klian,* and a small group bearing offerings, banners, and parasols, accompanied by a gamelan, escorts him. The photograph at the head of chapter 2 shows the Pamangku of Pura Désa Batuan carrying the highest local god, Ida Betara Ratu Puseh, on his head.

When a god is to travel a long distance, as, for instance, from Batuan's Pura Dalem Jungut at the southern end of the village up to the Pura Désa, his god-figure is carried on a sedan chair *(jempana)* decorated with yellow cloth, flowers, and green leaves, and he is accompanied by a retinue bearing banners, parasols, and musical instruments. The photograph at the head of this chapter shows a row of these god-figures.

When there is more than one deity in a procession, they go in a fairly strict order of precedence, with those of highest status at the end of the procession and those of lowest status leading the way. In one I witnessed (a march to the sea), one of Batuan's Barong came first, then the gods of the kin-group temples, followed by the gods of the two Pura Dalem, then Ida Betara Rambut Sedana, Ida Betara Desa, Ida Sanghyang Saraswati, and finally, Ida Betara Puseh. Since there were many gods in this procession, there were also many human escorts. There was a row of women carrying on their heads the equipment needed for the various rituals at the sea, and another group of women, all dressed in white, carried empty jars that were to be later filled with *tirta* made from seawater. There were also people in the line carrying many kinds of ancient weapons: spears, tridents, maces, clubs, *cakra* (the wheel-like weapon of Siwa). One Barong was preceded by young men brandishing daggers and spears, an act that in some villages, but not Batuan, ends with dramatic self-stabbings. These gestures of belligerence give a military look to the ritual

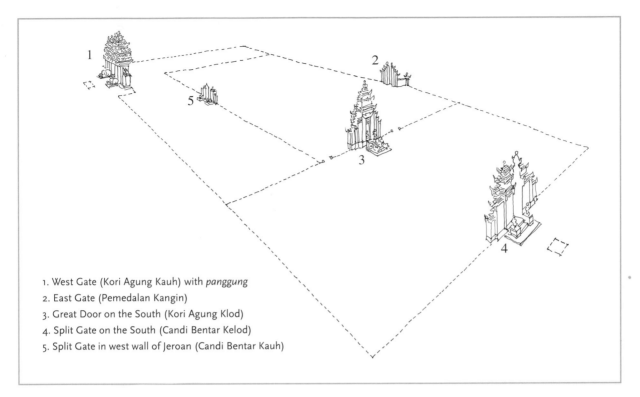

1. West Gate (Kori Agung Kauh) with *panggung*
2. East Gate (Pemedalan Kangin)
3. Great Door on the South (Kori Agung Klod)
4. Split Gate on the South (Candi Bentar Kelod)
5. Split Gate in west wall of Jeroan (Candi Bentar Kauh)

Figure 3.6. The gates of Pura Désa Batuan.

parade. In addition, every household in the *désa adat* sent at least one member. To escort the gods *(ngiring betara)* is highly valued for it conveys great spiritual benefits to those who do so.

. .

When the gods and demons are about to enter the temple, there is always a small but important welcoming ritual homage in front of the gate. As with other rituals, these vary in size depending on the god involved. The five gods of Pura Désa Batuan, whose god-figures are stored just outside the temple in the temple priest's home, always enter the temple through the East Gate. The East Gate is simpler in form than the West and South Gates and opens directly into the innermost court-

yard of the temple, the Jeroan, where these five gods are seated during the Odalan.

Visiting deities during the Odalan enter by the West Gate. A large temporary altar, a *panggung,* is erected just outside that gate at the times of the Odalan and the Taur Kasanga. Offerings to the incoming visiting gods are placed on this platform and those to their demonic entourages at its feet (ground offerings are usually called *caru*). Each of the visiting deities stops in front of the *panggung,* circles it, acknowledges the offerings, and then enters the temple.

At the time of the Taur Kasanga, the visiting deities and demons first enter the temple through the West Gate, then come out again and proceed around the temple to enter again through the South Gate. A similar *panggung* is built in front of the South Gate, and a simi-

Figure 3.7. A *panggung* altar.

lar welcoming ritual is held for them there. They then proceed through the South Gate since they are to be seated in the courtyard just inside it, on the large pavilion called the Balé Agung.

Third Ritual Unit: Enthronement within the Temple

There are several kinds of altars on which the gods may be seated during a ritual. The distinctions among them are not necessarily ones of form but rather the uses to which they are put by the *niskala* beings and their human followers. The differences devolve on various kinds of relations between humans and *niskala* beings, largely those that are close and those that are distant. Some of

these beings are understood as immediately involved in dialogue with humans and some are confined to listening from afar. The forms of these altars may be small seats or miniature houses or tiny open pavilions, and all must be above the level of the worshipers' heads.

The first kind of altar is a *panyimpenan* (a place in which something can be stored); it is used for keeping the god-figures during the periods between ritual festivals. The second kind is a *pasimpangan* (a place to stop over temporarily during travels), where more distant gods stay briefly during a ceremony where they are to serve as witnesses to what is happening to the main gods of a temple. The third kind is a *panyawangan* (a place to concentrate one's thought so as to make contact with a god), used for reaching a *niskala* being who stays away but still may receive messages from his worshipers. When an altar is employed as a *panyawangan,* the worshiper, rather than inviting the god to stay a while, instead sends off, by means of focused meditation, the essence of the offerings to the god in his distant place.[42] Another kind of altar is the *panangkilan,* from *tangkil,* "to visit a higher being." There are two of these in the Pura Désa, one behind the Méru Agung and the other behind the Panyimpenan, in the Pamangku's home temple. I was told that these are places where gods from other places can visit the gods of Batuan during the off-seasons when their god-figures are in storage there. All of these kinds of altars are used during the Odalan and the Taur Kasanga.

The last, and most important, kind of altar is a *palinggih* or *palinggihan.* The term comes from *linggih* (to be seated). It is in the highest register, indicating that the term refers to an action of a most highly revered person, so that "throne" rather than "seat" is more precise, for these are the places where the five highest gods of Pura Désa Batuan are seated during their ceremonies.

During the Odalan and the Taur Kasanga, only the five main gods and a few guest deities are considered fully present and enthroned on *palinggihan.* All the rest

are considered either to be momentarily stopping off on a *pasimpangan* or are sent prayers via a *panyawangan*.

. .

During the Odalan of Pura Désa Batuan, the god-figures are placed on four *palinggihan*, which stand in a square facing one another in the center of the Jeroan. The two highest gods, Ida Betara Puseh and Sanghyang Saraswati, are placed on the eastern side of the square on the Méru Agung, an impressive building with three stacked roofs and a large compartment with a carved and painted door. The two then are higher than the other god-figures. Ida Betara Désa and the pair of gods called Sanghyang Rambut Sedana are enthroned on the Pangaruman. The visiting gods at the Odalan are placed facing them and slightly lower yet on the Semanggén (also called the Balé Piasan Agung). This is a long pavilion, a *balé* much like pavilions for humans but with a higher floor than usual, above human heads. On its western end sits the Pedanda when he is performing his rituals. The god-figures enthroned on the Semanggén are those of the visiting deities, in the following order from north to south: Ida Betara Dalem Jungut, Ida Betara Dalem Dentiyis, Ida Betara Buda Manis, and Ida Betara Kediri. Furthest downstream in that row of *niskala* beings is a basket containing a set of masks for the *wayang wong* (the human shadow play), which is performed during the Odalan.

On the fourth side of the central ritual square is another *balé*, called the Balé Peselang. Of the four *palinggihan*, this is the lowest one. During the Odalan the two *barong* and their attendant *rangda* are enthroned here.

It takes only a little stretch of the imagination to see this set of four *palinggihan* as analogues to the domestic arrangement of four pavilions facing one another within a home courtyard, where the members of the family and their guests can sit and converse. In fact the name of one of them, Pangaruman, means "meeting place." Another humanlike attribute of the deities of Pura Désa Batuan would seem to be their sociability. They come together as hosts and guests to enjoy being with one another.

. .

During the Taur Kasanga the enthronement of the gods is more complex, because there are two enthronements, one by the sea where the gods have been brought for the Makiis ceremony, and the other in Pura Désa Batuan. When by the sea, the god-figures are placed on a temporary bamboo platform. When they are in Pura Désa Batuan, most of them are placed on the Balé Agung.

The Balé Agung is a long and high pavilion in the southernmost forecourt of Pura Désa Batuan between the two highest gates. This pavilion is different from the ordinary domestic *balé*. The space between the floor of the Balé Agung and its roof is too small for human beings. "*Agung*" is the high-register term for "great," indicating that the Balé Agung is a pavilion for beings of high status. The Balé Agung has no deity of its own.[43] During the homage rituals of the Taur Kasanga (discussed below), most of the *niskala* beings, those of the kin-group temples, plus Betara Pura Désa, are placed on the Balé Agung. But a few, the highest ones, are placed inside the Jeroan by themselves.

The highest local deity, Ida Betara Puseh, is enthroned on the Méru Agung within the Jeroan, for he is so sacred that he must be kept hidden from view. With him are Ida Sanghyang Aji Saraswati, and on the Balé Semanggén, Ida Betara Dalem Jungut and Ida Betara Dalem Dentiyis. Below them, sometimes, on the Bale Peselang, are the two *barong*. My consultant stressed that conceptually, during the Taur Kasanga all the deities are seated in a row on the Balé Agung, but there just isn't room for all of them there, so the highest ones are enthroned within the Jeroan. During the several days of

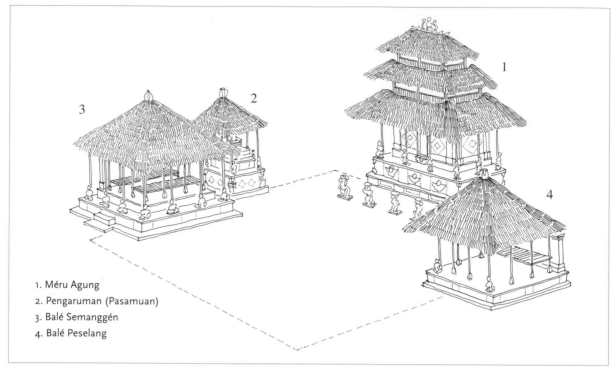

Figure 3.8. The central ritual square for the meeting of the gods.

1. Méru Agung
2. Pengaruman (Pasamuan)
3. Balé Semanggén
4. Balé Peselang

the Taur Kasanga, each of these deities is presented with small *maturan* offerings, acts requiring more space than can be found by the Balé Agung.

During the homage rituals by the sea, the gods are enthroned on a specially prepared altar on the beach, a long platform made of bamboo, stretching along the shore from east to west. The higher gods are placed toward the easternmost end, the lesser ones toward the west. Also set up temporarily are a high altar for Ida Betara Surya (the god of the sun), a table for placing offerings to Batuan's gods, and a roofed platform for the Pedanda to sit on during his prayers.

Fourth Ritual Unit: Homage

What I call "homage," and Balinese call *maturan* and *macaru,* is the most important act of all Balinese rituals,

the climax toward which all the previous acts are preparation. *Maturan* is often translated as "presenting offerings to the gods" and *macaru* as "presenting offerings to the demons."[44] But they are ritual steps that are more similar than different, and the *niskala* beings they address are more similar than different.

Whenever a *maturan* is performed people also perform a *macaru,* either just before it or just after it. It seems that the acts of *maturan* and *macaru* are thought of as almost joined and certainly complementary. The one ritual appears to require the other.

A *maturan* consists of the presentation of offerings on high platforms or altars of decorated dishes of cooked food and fruits to the gods, officiated by a priest (a *pamangku* or a *pedanda,* or both at once). A *maturan* may be of any size, ranging from brief placements of a tiny offering to lengthy and elaborate performances.

The offerings (called in general *aturan,* or *banten,* but in everyday speech by more specific terms) are displayed on large tables between the priests and the altars. They are of two sorts, often intermingled: one made with materials and work by each household and presented on its behalf, and the other presented on behalf of the *krama désa* as a whole, of materials from the temple's supply and made by offering-making specialists *(tukang banten)* and the women of the working *témpek* of that particular Odalan. After the priests have finished the prestation, each family brings its decorated platter of blessed food home to eat. The general (or nonhousehold) offerings, after having been blessed, are divided up among the priests, the offering-making specialists, and the villagers who have helped in the preparations.

Macaru is the act of presenting a *caru* offering on the ground. This type of prestation ranges in elaborateness from the small *segehan* through the *caru* to the very large *taur* and the even larger *taur agung.*[45] They are ranked by the size and quantity of animal meat presented; the largest *caru* require water buffalo and cattle. Some of this meat is cooked, but some raw meat and a mixture called *lawar,* which contains raw blood, are always included. The offerings in a *caru* are never eaten but are thrown away, and holy water is not generated through this ritual. A photograph of a minor *macaru,* performed by the Pamangku of Batuan, is shown at the head of this chapter.

. .

At the 1985 Odalan at Pura Désa Batuan, the *macaru* was as grand as the *maturan.* It was presented the day before the emergence, when the gods were not yet standing on their thrones, but it was done in the innermost courtyard with a strong feeling that they were watching. It was called the Caru Agung (Great Caru) to distinguish it from the many others in the cycle. The next day was a very large *maturan* (called the Maturan Piodalan, to distinguish it from the many others).

In that *macaru* of the 1985 Odalan, a *pedanda* sat on the high Semanggén, facing east toward the Méru Agung altar, while a group of *pamangku* sat on the ground toward the Pangaruman. While the *pedanda* and the *pemangku* did their rituals, ringing their sacred bells, a gamelan orchestra played noisily at one side, while on the other a chorus sang a *kidung* with a hymnlike cadence. Just outside a cockfight was in progress. At the back of the Jeroan courtyard, on the north side pavilion, was a *mabasan* group—five seated men with an open palm-leaf book set on a pedestaled platter chanting a classic poem line by line and translating it to one another. Elsewhere within the Jeroan, with two xylophones chiming out their own tunes, was a daytime shadow play, a *wayang lemah,* with no screen and no oil lamp. Out in a forecourt, another gamelan was clanging loudly. A large group of villagers filled up the rest of the space, and when the ceremony was over they all reverently made the *sembah* gesture of worship with two hands palms together above the head.

Most of the offerings for the *macaru* were placed on the ground in front of the Méru Agung, arranged in a mandala cross and circle. As in every *caru,* offerings are also made to the five high gods; these are placed above the ground on five temporary altars of bamboo. These altars stand on single stakes (Siwa's at the center), which were pulled up ceremoniously at the end of the ceremony.[46] Small offerings were placed on every other altar within the temple, for the absent gods.

The *maturan* of the Odalan, the next day, was done in the same location, with the Pedanda and the Pamangku in the same places. A large crowd of worshipers filled the Jeroan behind them. By that time, many more offerings had been put out, including the tall ornamental offerings of fruits on pedestaled platters, and other elaborate special constructions. Hundreds of offerings of small meals had been laid out on great tables built of bamboo in front of every major altar. I counted twenty-four of these tables within the temple in 1985. Each

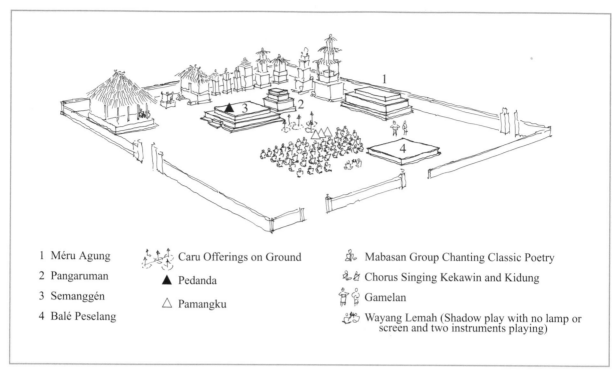

1 Méru Agung

2 Pangaruman

3 Semanggén

4 Balé Peselang

⚶ Caru Offerings on Ground

▲ Pedanda

△ Pamangku

♒ Mabasan Group Chanting Classic Poetry

♒ Chorus Singing Kekawin and Kidung

♒ Gamelan

♒ Wayang Lemah (Shadow play with no lamp or screen and two instruments playing)

Figure 3.9. The Caru Agung ritual of the Odalan (1985).

such table has as many as a hundred small decorated dinners on it, put out fresh each day that the gods are present.

The Pedanda began quietly chanting prayers, burning incense, ringing his bell, tossing out flower petals, and making graceful hand gestures. His seat on the Semanggén faced the main gods, enthroned in their inner square of four altars, but he also quietly addressed all the gods on the peripheral altars, either by name or by implication.

During the prayers, as with the *macaru,* songs were sung, both by a chorus seated near the Pamangku and on tapes broadcast loudly over the temple's public address system. Another series of cockfights was held. Three different dance performances—a *wayang wong,* a *gambuh,* and a *topéng*—were put on, either just before the *maturan* or during it.

The first of these dance offerings, the *wayang wong,* was a masked presentation of episodes from the Ramayana epic, and the second was the *gambuh,* which presents episodes from the Panji cycle of tales. The third, the *topéng,* was a solo performance of characters from Balinese dynastic history, ending with a masked dance of an old man with a white face and gray whiskers called Siddha Karya, whose name means "to make the ritual effective."

All three dances—this particular *gambuh,* this particular *wayang wong,* and this particular *topéng*—are considered special to and necessary for Batuan's Odalan. The masks for its *wayang wong* and for its *topéng pajegan* are sacred heirlooms (*pusaka*) of the Désa. They are so *tenget* (haunted, dangerous) that no one who is not spiritually purified may handle them, and no one may photograph them, except when they are being danced. These masks

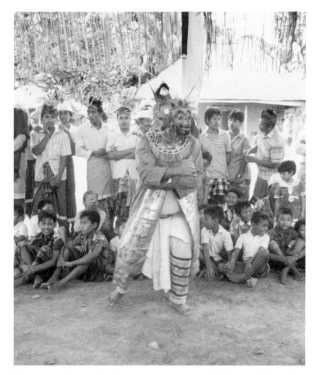

Figure 3.10. Dancer in the *wayang wong,* one of the members of the monkey army, allies of King Rama. Photographed in 1988.

are treated much like god-figures. During the period when the gods are out but the masks are not being used, they are enthroned next to the god-figures on the Semanggén and given daily offerings.

After the priests completed the prestation part of the *maturan,* the villagers, who had been arriving throughout this time, were asked to seat themselves for their own personal worship. They sat facing north toward all the altars and were led by a ritual specialist (with a bullhorn, because there was so much other noise going on) to say silently specific prayers to certain gods (Ida Betara Puseh, Ida Sanghyang Saraswati, and Ida Betara Désa) and more general prayers to the rest. First, several *pamangku* sprinkled the villagers with *toya panglukatan* to purify them; then each person performed the *mabakti,* presenting with a *sembah* gesture flower petals and coins to the gods; then they were again sprinkled

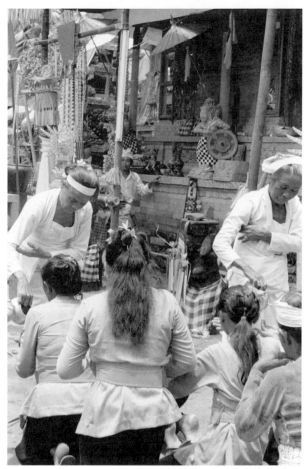

Figure 3.11. *Pedanda* giving *tirta* to worshipers in front of the Méru Agung. Photographed in 1986.

with holy water by the *pamangku,* this time *banyu cokor,* to receive the blessings of the gods. Both times they received the *tirta* on their open hands, then wiped it on their faces, then were given more to drink. They then picked up their personal household offerings and took them home to eat.

Before entering Pura Désa Batuan for the *maturan* ceremony, each householder brought an offering (a decorated plateful of food, or *soda*) to the small shrine outside the temple of the deity Ratu Ngurah Agung, the temple gods' chief steward, who, in their name, "rules"

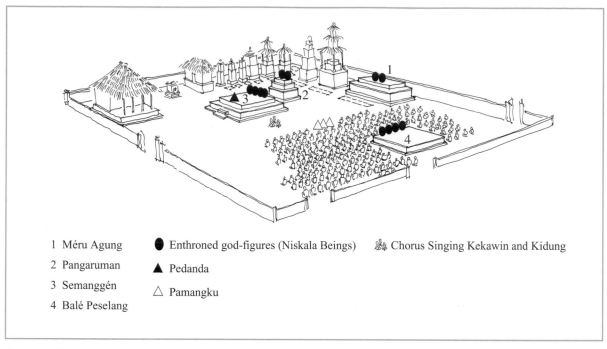

Figure 3.12. The Maturan ritual of the Odalan.

1 Méru Agung ● Enthroned god-figures (Niskala Beings) 🎵 Chorus Singing Kekawin and Kidung

2 Pangaruman ▲ Pedanda

3 Semanggén △ Pamangku

4 Balé Peselang

over the village. This meal was also taken home later to be eaten by each family.[47]

The attending deities are considered to eat the essence of the food offerings presented to them. Their human devotees are then allowed the honor of sharing the remainders. To eat someone's leftover food is an act of identification with and subordination to that person, as when a child shares a plate with a parent.

After having been presented to the deities and blessed by them, the many offerings made by the *komiti* and the working segment of the *krama désa* on behalf of the whole community were taken home to be eaten by the work group and the priests. The guest gods were brought special offerings by their own priests, and these offerings when they are blessed were taken home by those same priests to eat, and therefore to receive their particular blessings.

The deities are "out" for the Odalan for one to seven days. During this period they are served new offering-dinners every day, and they are never left alone. As honored guests they are never allowed to feel lonely. Designated members of the congregation are present with them even throughout the night.

. .

In Batuan's Taur Kasanga of 1997, the same gods on god-figures as in the Odalan attended, accompanied by those of the kin temples of the village. The gods assembled at Pura Désa Batuan, and some were given small *maturan.* They then marched down to the sea where a large *maturan,* the *maturan ring segara* (*maturan* by the sea) was held; holy water (called here *amerta kamandalu*) was created and later sprinkled on homes and people throughout Batuan and on the offerings that were to be presented in front of the Balé Agung in the Taur Ka-

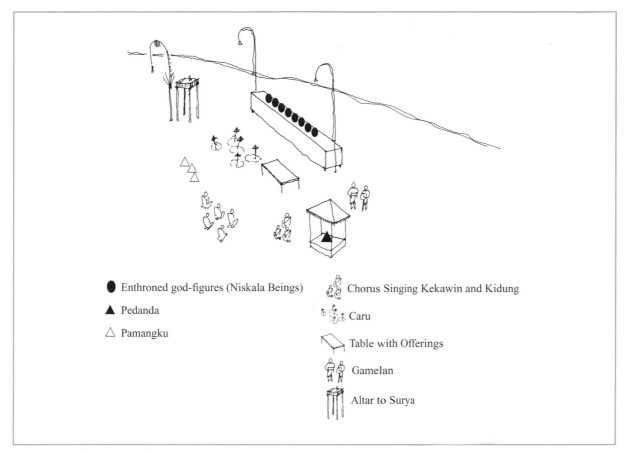

● Enthroned god-figures (Niskala Beings)

▲ Pedanda

△ Pamangku

Chorus Singing Kekawin and Kidung

Caru

Table with Offerings

Gamelan

Altar to Surya

Figure 3.13. The Maturan ritual by the sea.

sanga, the next day. The ceremonies by the sea included a minor *macaru* as well as the large *maturan;* the ceremonies within the temple contained a minor *maturan* and a major *macaru* (the Taur).

In the *maturan ring segara,* a *pedanda* performed the prayers, first to the gods of Batuan assembled there, then to the god of the sea, Ida Betara Baruna, notifying him that the *maturan* was about to take place and requesting from him some holy water. The next step was a *macaru,* a fairly large one with five chickens and a duck. After that came the peak ceremony of the *maturan* itself, in which first one set of offerings was presented to the gods of Batuan, then another set was thrown into

the water for Ida Betara Baruna, who during the days leading up to the changeover from the ninth to the tenth month had been meditating in the center of the ocean. His spiritual exertions augment many times his own strength, which he then infuses in the holy water that he gives in return. After an offering prayer to Ida Betara Surya, the *pedanda* presented the offerings to him, then led the villagers in individual prayers *(mabakti).*

At two points in the procedures by the sea, the *pedanda* requested *tirta* made from seawater from Ida Betara Baruna. The first was at the beginning of the ceremonies, and the water was called *tirta panglukatan,* a "purifying" holy water, which was then sprinkled every-

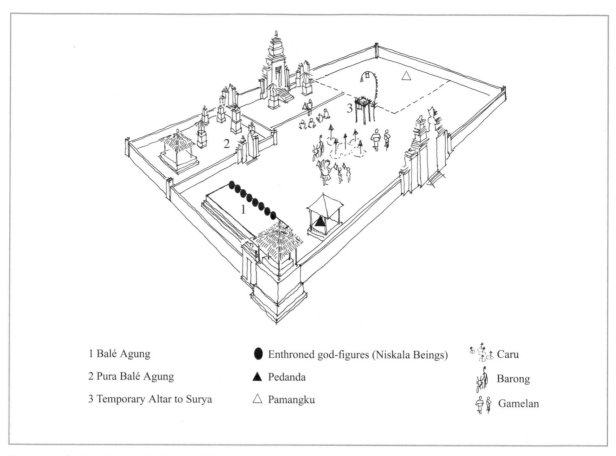

1 Balé Agung ● Enthroned god-figures (Niskala Beings) Caru

2 Pura Balé Agung ▲ Pedanda Barong

3 Temporary Altar to Surya △ Pamangku Gamelan

Figure 3.14. The Taur Kasanga ritual in Pura Désa Batuan.

where to purify all the participants and their offerings before beginning the ritual proper. The second, after all the offerings had been presented, was called *tirta kamandalu,* and it is said to give spiritual strength to everyone sprinkled with it. This *tirta kamandalu* was brought back to the village and sprinkled everywhere.

The Taur Agung itself, performed the next day in Pura Désa Batuan, in front of the Balé Agung, was very much like the large *macaru* of the Odalan, but of even greater spatial expanse and plenitude. It too was presented by a *pedanda* and at the same time also by the group of *pemangku*. Gamelan music accompanied it. Larger animals were butchered for it, including a water buffalo.

As with the *caru* of the Odalan, a cockfight is begun at the same time. And also as in the *caru,* offerings are made both on the ground and up on temporary bamboo altars.

The gods of Batuan, seated surrounded by offerings, are said to be witnessing or guarding over *(nyaga-nyaga)* the *taur* ceremony. The gods invoked in the four small raised bamboo altars of the *taur* are not the local gods, but Ida Betara Iswara on the east, Ida Betara Brahma on the south, Ida Betara Maha Déwa on the west, Ida Betara Wisnu on the north, and Ida Betara Sanghyang Sadasiwa in the center. These also are said to be witnesses and guards. A high altar of bamboo, with a tall *pénjor* above it, was set up on the northeast corner of

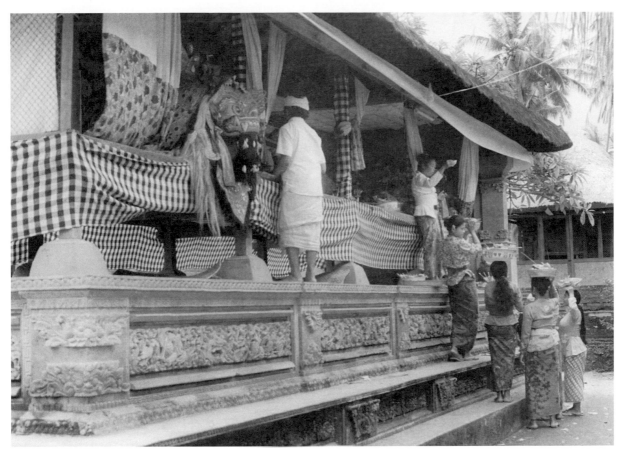

Figure 3.15. *Maturan* to Pura Panti gods on the Balé Agung being given by householders just before the Taur Kasanga. Photographed in 1986.

the *taur*. This was to Ida Betara Surya, who is another witness. During the ritual of the *taur* in which the food is given to the *buta kala,* these *betara-betara* are also addressed by the priest, who asks them to give witness *(saksi)* and consent *(lugra)* to the transaction.

While the overall form of the Taur Agung is that of a *caru,* there are important *maturan* elements in it. Plates of *maturan* food were presented to the assembled gods on behalf of individual householders (who placed them briefly up on the pavilion where the gods were enthroned and then took them home again). Communal offerings made to the gods on behalf of the entire temple community and placed on high bamboo tables within

the adjacent Pura Ulun Balé Agung were taken home as *lungsuran* by the *pamangku* as signs that the *maturan* had been accepted.

After the *pedanda* finished, the *pamangku* poured the *tirta kamandalu* into the small jars and bowls brought by individual worshipers, who each then did a *mabakti* prayer as in the Odalan. This *tirta* is a mixture of the *tirta kamandalu,* made from seawater; *tirta pedanda,* made by the *pedanda* himself; and *tirta betara kahyangan,* made in the village temples of Pura Désa, Puseh, and Dalem.

During the preparations for the Taur Agung ritual the Barong from Puaya, Ratu Gedé, had been standing within the Jeroan of the temple, facing the throne of

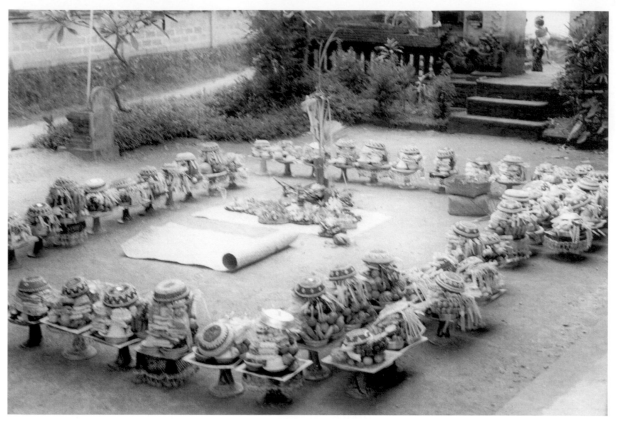

Figure 3.16. *Maturan* at time of Taur Kasanga, at a *banjar* altar; offerings called *prani* set on the ground around the *taur,* at the *balé banjar.* Photographed in 1986.

Ida Betara Puseh. Just before the Taur began, he came and stood on the north side of the Taur, together with his human followers with parasols and gamelan instruments and one of his *rangda,* Ratu Ayu from Puaya. When the *pedanda* had completed his prayers over the *taur* laid out on the ground, the Barong Ratu Gedé and his followers noisily circled the *taur* several times, while the *kulkul* drum beat rhythmically; suddenly, Ratu Gedé dashed into the middle of the offerings on the ground, stamping on them. He then pranced around the temple, asking leave of various altars, especially the Méru Agung where Betara Puseh is enthroned. Lastly he stopped at a nondescript small altar in the outer courtyard on the south, that of Ratu Alit, who is the Barong's special protector. Finally, Ratu Gedé and his shouting entourage went home. And soon after that all the deities, hosts, and guests were escorted back to the altars where their god-figures were to be kept until their next manifestation.[48]

After the main Taur Kasanga was finished, many other *taur,* large and small, were carried out throughout Batuan, as they are throughout Bali. At every main crossroads and in front of every *banjar* meeting hall, the people assemble the offerings, and *pemangku* offer their prayers. An enormous *taur,* usually called the Taur Agung, is carried out in front of every major king's palace.[49]

The Niskala Beings of Batuan

In describing Batuan's temple ritual sequences, I have gone into considerable detail because these particulars are not trivia but rather the very stuff of the ongoing relationships among the human and nonhuman participants. At every step and turn in the ceremonies each *niskala* being is treated slightly differently from all the others. Over and over again the gods and demons are shown to be not abstract forces, but particular human-like persons who act and are acted upon in diverse, material ways.

Each of the worshipers has room to express slightly different ideas about how to communicate with the various gods and demons. In fact, the variations themselves demonstrate that what is going on is communication. The conventions for worship may set out a language-like code of appropriate and inappropriate actions, but the ritual actions themselves have the modulated character of speech in all its particularity. In this view, displays of carvings and performances of dances are aspects of utterances along with spoken statements in the transactions among the crowds of humans and nonhumans that attend such ceremonies.

Crowds they are, of *niskala* beings of all sorts, moving around, eating and drinking, watching shows, perhaps also jockeying with one another for status position, and listening to unspoken human entreaties. Some are more involved in human lives than others, some are more likely to be destructive than others, some are more potent and some less potent than others, but they all have intricate social relations among themselves and with the humans.

Another characteristic of Balinese deities and demons shown in these rituals is their capacity to distance themselves or bring themselves near in an instant and to move about the landscape just as quickly. They are also able to transform themselves at will, to take any

material form they want. All this gives them an air of unpredictability and accounts in part for the cautiousness with which they are treated.

For these rituals to make sense, it must be assumed that the *niskala* beings and their guests enjoy the food, the drink, the entertainment, the bright colors, and gay clamor of the festival. The food offerings must be understood not as sacrifice but as a generous sharing of delicious meals, sweets, and drinks. Some deities eat only fowl; some eat pork and water buffalo meat as well; some drink only spring water, while others enjoy palm wine.

And the gods must love music and laughter, dramatic reenactments of events in the lives of their kindred deities, and new original creations. The temple gate leading out to the performance area is always opened up so that the deities can see the show through it.

The number and variety of the spiritual beings who attend the festival mean that diverse demands are made on their followers. All kinds of foods, worship, and entertainments must be supplied. Each hospitable act must be repeated numerous times so that every one of these deities and demons is served. Every god, from the highest to the lowest, must be recognized not only once but over and over, so that no one of them feels forgotten and angrily retaliates.

Each of these gods and demons may respond to human communication and propitiation, with beneficence or with harmful actions. Sometimes a negative response is immediate: a *niskala* being may break into the ritual, enter the body of one of the participants, and state forcefully his complaint. More often there is a delay until someone in the congregation suffers a major disaster, goes to a *balian,* and finds out that there has been an omission or inadequacy in the ritual offerings. A person with an illness thought to be caused by a *leluhur* or a *betara* is said to be *kapongor*.[50] Worshipers often make vows to Ida Betara Désa, promising that if cured of illness or helped in other disaster thought to be caused

directly by the anger of the god, they will donate something to the temple—a new parasol, for instance, or a silver dipper for holy water. Dance-drama plots often depict angry ancestral spirits, local *niskala* beings, and high gods and demons as perpetrators, generating the dramatic action. While *caru* and their lesser cousins the *segehan* are sometimes interpreted as "cleansing" rituals, the fact that they are performed repeatedly within a larger ritual cycle shows that they do not "purify" participants or "chase away" demons who always stay around; rather, the rituals are attempts to get the demons to change their attitude toward these particular humans devotees into one of benevolence. *Déwa* and *buta* are not opponents but collaborators and allies, and perhaps even transformations of one another.

Support for the idea that, for most Balinese, *déwa* and *buta* are indistinguishable and not essentially "good" and "evil" can be found in an analysis of the ritual of the Eka Dasa Rudra by the Balinese anthropologist Dr. Gusti Ngurah Bagus. This islandwide ritual was an expanded Taur Kasanga, performed on the day of Taur Kasanga at the temple of Besakih in 1979.[51] Eka Dasa Rudra means "the eleven [highest] demons." In the Taur Kasanga, these demons are only five, but the two rituals are basically the same. Bagus stated that the defining climax of the Eka Dasa Rudra occurs

> when the malevolent forces of the Eleven Rudra transform into benevolent deities and are reunified as Siwa. Because Siwa is the supreme god and it is He alone that [the priest] invokes. This is confirmed by two inscriptions in the center of the arrangement (on the tepas [altar] with figures of Siwa and Uma): Siwa metu saking Kala; Uma metu saking Durga, that is to say, "Siwa comes out from Kala, Uma comes out from Durga," which allows us to understand that the buta yadnya are only variations of the déwa yadnya and not a separate category."[52]

Thus, according to Professor Bagus, at the Eka Dasa Rudra ritual, the greatest demons of the universe were

presented with offerings as gods are, and—this is the crucial point—they are requested to transform themselves from demons into deities. What is true for the Eka Dasa Rudra must also be true, on a different scale, for its lesser versions, the *taur, caru,* and *segehan,* which are "only variations of the *déwa yadnya,*" that is, ceremonies for deities of all sorts.

It may be, as Bagus suggests, that all *buta* are understood, at least by some Balinese, to be unstable transformations of *déwa,* and that, as I have suggested, the English terms "gods" and "demons" unnecessarily imply that they are different kinds of beings. Perhaps *buta* and *déwa* are not different species of beings, but different states of existence of the same beings.[53] It may be, of course, that some of the *niskala* beings are always malevolent toward humans, and, if so, always in combat with the benevolent ones. I have found no definite evidence for this last interpretation. This issue seems to give little trouble to the Balinese or to their Western visitors, but for different reasons.

The gods are also seen as highly sociable—they come together for conversation around the Paruman (meeting place) altar. They have various kinds of social relationships among themselves. People say, for instance, that Ida Betara Désa has many wives, including the gods Ida Betara Dalem Jungut and Ida Betara Dalem Dentiyis (the latter being the younger wife) and the gods of all the *pura panti* (independent small temples, sometimes of kin groups) of the village. Ratu Saraswati is said to be the first wife of Ida Betara Puseh. I was told that Ida Betara Désa is very fond of cockfighting and that "when he loses and has no money he goes to his wives to ask for more." Someone from Pura Dalem Dentiyis said that that wife loves Ida Betara Désa very much and gives him whatever he asks for. But when he goes to the wife in Dalem Jungut, he has to pay for what he wants, because Ida Betara Dalem Jungut has a *"bizniz"* attitude, while the other two don't.[54] Some gods are said to be *bares* (good-natured and kindly), but, I be-

lieve, most are treated as though they are proud and quick-tempered.[55]

The deities seem to be organized into chains of authority and effectiveness. I have pointed out how in the processions, enthronements, and prestations there is always an explicit ranking or precedence system. But analysis of the rituals further reveals that many of the lower spiritual beings seem to serve as mediators between the human petitioners and the higher and more distant beings. For instance, Ratu Ngurah Agung, who inhabits a tiny shrine just to the east of Pura Désa Batuan, is addressed before and during every ritual; he is said to be a sort of "prime minister" to the gods of Batuan.

Another example is the Barong of Puaya, who comes to *nangkil* (to come before, to pay respects to) Betara Puseh. Demonic in form but nearly always benevolent in attitude toward his followers, lovable and comic in his actions but considered capable of killing those who might hurt his followers, the Barong can carry messages between the villagers and the higher gods.

These two *niskala* beings seem to specialize in traffic with humans and serve as mediators toward the *niskala* beings. Perhaps the conception is that those spiritual beings who are more capable of material action in the world can communicate on behalf of humans with those who are so distant and refined as to be unable to intervene directly in the sensible world. *Niskala* beings can't act in the world unless they can find ways to manifest themselves (or their proxies). By definition, lower manifestations are cruder, but at the same time more immediately potent than their superiors. The lower beings are the ones who pay attention to human requests, the ones who make their presence known through possession or mediums.

Perhaps during the Odalan and the Taur Kasanga the gods of Batuan are also understood as go-betweens to the highest gods, Siwa, Wisnu, Brahma, and their like. However, there is counterevidence to suggest that, in

this ritual context, the local gods are more important than the high gods. While the approval of the high gods is necessary at the outset, and they serve as authorizing witnesses, still they do not participate in the ritual transactions, nor do they bestow their blessings on the congregation. This is a puzzle to me, given the stress placed on the Indic high gods by members of the Hindu Dharma movement and the contrary stress on the potency of the local "lower" gods within the vocabulary of ritual action.

It may be that, during an *odalan,* the guest gods are conceived of as entering into a temporary alliance with the host gods. That would mean that the ritual transaction is not simply one carried out between one "side," the humans, and another "side," the gods, as I have been putting it; rather, within each "side" a number of lesser transactions must also be made.

In any case, mediating relationships account for some of the ambiguity in the nature of particular deities and the consequent worried attentiveness of their worshipers. The status system among the gods is not a hierarchy in the Dumontian sense of the term in which each higher being or category encompasses all lower ones. It may be, further, that sometimes relative rank is contested among the deities.

All the gods and demons are, from first to last, treated as high royalty, as a noble group that itself is internally differentiated according to honor, certain ones worth higher elevation and respect than the others. Royal and military imagery is pervasive in these processions. Not only are sedan chairs, parasols (the prime sign of royalty), and banners always required, but also men carrying spears and daggers. In the nineteenth century, kings were always carried in the same way. Taken together these insignia seem to convey a sense of the glory of victory in battle.[56] People talk about Ida Betara Puseh as if he were the reigning monarch over all these *niskala* beings. They call those local gods who come to visit during a ceremony the *manca* of Ida Betara Puseh. *"Manca"*

is a term used to describe a prime minister of a king, or an allied lesser prince of another locality.

However, the *niskala* beings that participate in the ritual festivals of Pura Désa Batuan are not treated *like* royalty; they *are* royalty. They are kings and queens, princesses and princes, courtiers, warriors, priests, slaves, and villagers. Those of the highest rank are not necessarily present but have sent representatives (just as, in the past, kings and important household heads never personally attended the rituals), who are given the highest seats (just as, even today, visiting officials are seated on one of the pavilions above all the rest of the congregation, who are seated on the ground).

· ·

Ritual acts are open to diverse interpretations. The Hindu Dharma theologians take many of these practices as metaphorical or allegorical, stressing a coherent monotheism and an ethic of inner discipline and social order. Others take them to be straightforward responses to particular human and cosmic personalities, encounters with local deities and ancestral beings all of whom have strong ties to the local congregation. The rituals are then understood as continuing communicative two-way dialogues with crowds of spirits who are not so much "worshiped" or "exorcized," as most accounts have it, but propitiated and placated through the offering of pleasure—with food, spectacle, and entertainment. These powers come and go in the everyday world and switch in and out of various material forms. The many sorts of rituals strive to affect this traffic.

Diversity of understanding of the rituals has probably always been present in Bali (since it has no strong institutions enforcing orthodoxy), but the degree of dissension is probably greater in some historical periods than others, and probably, as Balinese society itself has been diversifying, greatest in recent times.

In the past, before the appearance of the Hindu

Dharma movement, there were probably other kinds of differences in interpretation of the rituals, largely depending not on theological speculation, but rather on the personal social position of the devotee vis-à-vis certain deities. In other parts of Bali, certain subgroups of the Pasek and Pandé have claimed different roles in rituals based on their special descent from certain deities.[57]

In Batuan, in this century at least, some of the gentry may have viewed the rituals slightly differently from their commoner fellows. Certainly by midcentury, these differences became serious, as is recounted in chapter 8. They turned on a theological argument regarding the highest gods, those with Indic names—Siwa, Brahma, Visnu, and others. These deities are addressed in the Odalan and the Taur Kasanga only by way of *penyawangan*. They never manifest themselves in the little *prerai* or god-figures. Nor, to the best of my knowledge, do they ever possess a worshiper or *balian* to address directly their human clients. Only rarely and indirectly are they addressed, and then primarily verbally in the priests' muttered prayers.

The Indic gods are understood to come from farther away than the local deities, and this contrast is tightly bound up with two social distinctions, that between the literati (who are largely *triwangsa*) and the laypeople and that between the *triwangsa* and the commoners.

The first social distinction that rides on the contrast between local and distant deities is that between laypeople and what might be called the literati, those who can understand the prayers of the priest and the classical literature, those who can read and write in the Balinese alphabet. This distinction sets out a very small minority, which includes most of the priests, some non-priestly adepts (e.g., the *ulaka* Brahmana men who have not become *pedanda* but are lesser ritual specialists), some of the healers *(balian),* and some of the shadow puppeteers.

The second social distinction is that between the

two kinds *(wangsa)* of people, the *triwangsa* and the *su-drawangsa* or *jaba.* The *triwangsa* (three peoples) are the gentry of Bali, those who have titles that are classified as Brahmana, Satria, or Wésia. The *sudrawangsa* are all the rest, the commoners. Some of the *triwangsa* are literati, and, in fact, the ability to converse with the highest gods lies at the base of the claim of all the *triwangsa* to nobility. The claim goes further: the high Indic gods are the ancestors of the *triwangsa,* some of whom, the Brahmana, are descended directly from the deities.[58] It is on these grounds that a *pedanda* may address the high Indic gods directly, while a commoner *pamangku* normally converses only with the local deities.

According to various Balinese accounts, the lowest commoners are the descendants of the original indigenous population, while the *triwangsa* and the Pasek descend from newcomers from overseas, who came bringing with them the means of access to the highest gods —the knowledge of writing *(kawi)* and of literature *(sastra)*. The fact that most *triwangsa* cannot read the sacred language does not diminish the religious importance of the *triwangsa,* at least in their view.

Can the Indic gods, in all their majesty, overrule the lesser local gods? Or is it that they are not so much higher than the local gods, but different from them? I don't know the answers to these questions, but it is clear that Indic gods and local gods are considered complementary, each in their own way necessary for the effectiveness of a ritual. The *pedanda's* prayers to the Indic gods are needed in any major ritual to "complete" or "make perfect" *(muput,* from *puput)* the work of the commoner *pamangku.*

The nature of the tie between a *pedanda* and the gods he serves is a personal tie of genealogy as well as one developed through daily acts of reverence. If this is so, the family tie converts what might be thought of as a "universal" deity into one more like the other particularistic gods of Bali.

With all this, it can be seen that the *triwangsa* have a considerable social stake in proper theological recognition of the importance of the high Indic gods. Exactly what those stakes were must have varied in different times and places in Bali, historically, but I think they were quite important during colonial times, when most of the renovation of the temple was accomplished.[59]

The rituals of Pura Désa Batuan have been intricately bound up with the social and political life of the village throughout its history. These rituals also enact a complex web of social relationships among both the *niskala* beings and the humans who attend them. The rituals, taken as wholes, not only mirror those social relationships, but also generate, tend, and acknowledge them.

The Purposes of Pura Désa Batuan

Culturally established intentions may set up ground rules or expectations, but they can't determine what people do over and above those minimal needs. Like genres, they establish meaningful guidelines of appropriate and inappropriate, effective and ineffective, and pleasing and displeasing constructions. But some acts of artistry and imagination can add new elements and meanings to the older, conventional ones, can gradually or suddenly revise traditional conceptions. These processes of revision, embroidering, and enriching of earlier works are historical and need to be studied chronologically, as I do in part 2.

The overall purpose of a Balinese temple, the primary interpretive frame for its architectural form and ornamentations—according to the rituals of the 1980s —is to provide a place for diverse *niskala* beings to stay while they visit this material world. A temple is a palace where royal personages may meet their subjects. The congregation must find ways to respond to the responsibility of providing worship, food, and entertainment to that highly potent multitude. Accordingly, the exi-

gencies of the busy social world in which *niskala* beings and human beings address one another have established, for the carvers, the basic intentions that oriented their artistry and released their imaginations. The desires and tastes of the *niskala* beings of the vicinity have been paramount in the eyes of their constituents. The overall look of Pura Désa Batuan has been created largely through its uses.

Other considerations that the makers of the temple might have entertained—such as displaying their comparative wealth and talent to their peasant neighbors or providing religious education to their ignorant members or demonstrating their own taste or displaying their obedience to convention or perhaps instead their originality or even attracting money-spending tourists to visit their village—all of these were certainly present, but they were subsumed under the overriding purpose of pleasing the deities, as part of conferring and negotiating with them.

One is tempted to think of the spaces, walls, gateways, altars, and other structures of a temple as a stage set for a great ritual drama, but in Balinese views they are the rooms and furniture in a palace visited periodically by its distant owners and their guests. The theatricality of Balinese rituals is one not of creating simulacra of other actions; rather, it is part of the actual stuff of living, in which the dress and performances and decorations are necessary aspects of action itself. At this level these acts are not artful, not self-aware mimesis, but the real thing. There is no passive audience to applaud or jeer, since everyone is both audience and actor.

. .

The form of Pura Désa Batuan is that of a cluster of rectangular courtyards, open to the sky, enclosed by walls of brick and limestone that are ornately carved in places and have elaborate gateways cutting through them. The whole area within its walls is only a little more than an acre. In each courtyard are various kinds of altars and pavilions that serve as thrones for the visiting *niskala* beings, all decorated with carved bas-reliefs, stone figures, and multicolored paintings.

The innermost court, the Jeroan, is for the major altars. Around this inner courtyard is a set of forecourts, where a number of other altars also stand. These, the Jeroan Tengah, form a buffer between it and the outer world, the Jaban (outside) (see figure 3.2).

The configuration of the walls, then, is conceptually concentric and is understood in Balinese terms as marking stages between inside *(jero)* and outside *(jaba)*. The core area where the gods are usually enthroned during their visit to this world is also sometimes referred to as the *pajeneng* or *pajenengan*—from the word *"jeneng,"* which is the highest-register term for "to live or to reign"—thus "the place where very high beings live or reign."

The gathering of gods and demons in one spot makes the innermost part of a temple *tenget*. The presence of the gods, in all their *sakti* (spiritual powers), is both a terrible threat and a marvelous protection, and therefore must be somehow contained. The walls provide protective barriers, both to keep out disrespectful persons and to keep in the dangerous radiations that emanate from the visiting gods. The walls, then, are not visual correlatives of the orderly architecture of the cosmos.

Many Balinese sometimes discuss the difference between *jero* and *jaba* as one of comparative *suci,* a term usually (mainly within the Hindu Dharma theology) translated as "purity." The innermost part of the temple is said to be the most *suci,* where nothing impure, *(letuh* or *leteh)* is permitted. While one base meaning of *suci-letuh* and their synonyms is "pure-impure" or "clean-unclean," I believe another equally important meaning is "safe-dangerous." Being close to powerful and potentially malevolent beings is very dangerous, unless

one is protected by those deities themselves or by other strong beings. To be *suci* implies having the blessings and protection of one or more gods. And that means that one is permitted to approach them.

When Pura Désa Batuan was flattened by the earthquake of 1917, the first efforts of the villagers were directed at rebuilding those altars and pavilions necessary for receiving the *niskala* beings of the village. The walls and gates were left in shambles for some years. I have seen this happen in neglected temples: the last element to go when a temple loses its congregation (by their dying off or moving away) is the altars, even after the walls have fallen down. The altars, thus, are the most important part of any temple—not the walls or the spot of land on which it lies.

The altars of a Balinese temple are usually described as backing up to its north and east sides as the most holy directions of the temple, toward the mountains and toward the rising sun. But analysis of rituals shows that another important orientation, in some ways more powerful than the cosmological geometry usually invoked by scholars, is at work—that of centering on the thrones of the *niskala* hosts and guests during a ritual gathering.

I have shown that the most important *niskala* beings who participate in the Odalan are enthroned facing one another in a rough square in the center of the temple's inner courtyard. This arrangement is reminiscent of the arrangement of an ordinary houseyard, with four main pavilions facing onto the central courtyard. Within a houseyard, the four pavilions are ranked in the same way, with the eastern one for the highest-ranking members, the northern one for other members of the family, the western one for high guests, and the south pavilion for the lowest guests.

During the Odalan, with all the gods present, the Pedanda is seated facing all of them from the east side; the Pamangku is on the ground facing them from the south; and the assembled villagers are behind the Pamangku. Most of the other altars in the Jeroan are within view of all. Along the north wall and the east wall of the Jeroan are other altars, none of which are graced with god-figures. Rather they are considered to be *penyawangan* through which messages are relayed far away or *pasimpangan* where distant deities might stop off briefly.

Conceived of as talking among themselves, the visiting *niskala* beings seem to form a highly social community. The places where they sit are decorated with paintings, carved wall panels, and statues set around. With the two highest-ranking local deities seated on the Méru Agung and the others on lower seats around them, the impression might be of a king, his court, and their entourages, with the human worshipers as the lowest of these last.

The courtyards of the Jeroan Tengah also contain decorated altars—in the kitchen and its working pavilions, the space for cockfights, by a reservoir of water called the Taman. The most important of these courtyards lies in the front of the temple, between the great split gateway of the temple that looks out onto the road and the even greater gateway into the innermost courtyard, the Kori Agung Kelod (Great Door). This large courtyard, the Jeroan Tengah Klod, is not only an anteroom to the Jeroan but is also the courtyard of the Balé Agung throne, which plays a major role in the significant ritual of the Taur Kasanga. During that ritual, the courtyard between the two southern gateways is referred to as Pura Désa, while the Jeroan is then called Pura Puseh.

There appear, then, to be two throne rooms, one in the center of the temple, the Jeroan, and the second next to it, the Jeroan Tengah Klod. In the Odalan, the gods are seated in the Jeroan, while in the Taur Kasanga, most of them sit in the Jeroan Tengah Klod.

The gateways of the temple are a major material recognition of the *tenget* presence of *niskala* beings within

it. The grandeur of the gateways is thought to add to the splendor of the whole. But there is a puzzling lack of fit between the ritual functions of each gate and its form.

The most splendid gates are those on the south side of the temple, next to the road, the Great Split Gate and the Great Door. But their imposing size and elaborate carvings and statuary are not matched by ritual function. The Great Split Gate is used only by lesser gods, and then only during the Taur Kasanga, when they come to their thrones in its courtyard. The highest and most elegant of all, the Great Door on the South, is used only rarely and then only by the gods Ida Betara Désa and Ida Rambut Sedana. The gateway through which all visiting gods enter the temple, the Great Door on the West (Kori Agung Kaoh), is off on the side, away from the road; it was in complete ruin, an unkempt heap of stones surrounded by weeds, until 1993, when it was restored. And the smallest and least impressive of the gates, the East Gate, is the point of entry by Batuan's highest gods, those whose god-figures are stored just outside it. These anomalies can only be addressed through historical analysis, to come in the next chapters.

The geographical spaces of the village of Batuan are interpretable through the frame of proximity and distance from the powerful *sakti* center of Pura Désa Batuan. The temple stands on what was once the most mountainward side of the settlement, on a slight hill. All the territory of Désa Adat Batuan is sometimes referred to as the *gumi* or "realm" of Pura Désa Batuan. The term *"gumi"* here is not a geographical one, though it can be used that way; more precisely it means "subjects" a reference to the people of, the worshipers of, the gods of the temple. By extension, perhaps, the term *"gumi"* indicates not only the congregation, but also all the other gods of the region beholden to the gods of Pura Désa Batuan.[60]

The land immediately next to Pura Désa Batuan, for several hundred yards, partakes to a stronger degree of its *tenget* quality, and a number of lesser temples have been built there. These lesser temples are said to lean against it *(némpél)*, or they are said to be *panangkilan*.[61] This *némpél* pattern of lesser temples clustering around a central one is also found in the placement of lesser noble houses around a central one, as is the case in Batuan (see figure 2.2).

The temples that are close to Pura Désa Batuan include the Pura Lumbungan, a water temple for the irrigation society of rice fields just a bit south of the Pura Désa, which has an unusually close connection to Pura Désa Batuan. There are also six clan temples, *pura panti,* adjacent to the temple (see figure 3.3). None of these *pura panti* have their *odalan* on the same day as Pura Désa Batuan. However, their gods join the gods of Pura Désa Batuan whenever they are taken in procession to the sea for purifying ceremonies and are witnesses at the Taur Kasanga ritual. The Pamangku of Pura Désa Batuan assists their priests, brings them small offerings from the larger temple, keeps their god-figures in the Pura Désa Batuan's Panyimpanan in his house-temple, and does a special closing ritual *(nguntap)* for them at their own *odalan*. The priests of these *pura panti,* together with those from other temples in Batuan, serve as assistants during the Odalan and other major festivals of Pura Désa Batuan. The congregations of all of these *pura panti* that "lean against" Pura Désa Batuan have status titles that Balinese classify as Pasek. Their rank is often debated, since they consider themselves higher than commoners—because their ancestral origins are the same gods as the nobles—but not nobles. One of the *pura panti* next to Pura Désa Batuan is for the Pasek Bendésa, from whose clan was always chosen the Bendésa of the temple—at least until 1966, when much was changed and an ordinary commoner took the position. In Batuan, there are only one or two Pasek temples that are not next to the Pura Désa; one of

them is for the Kabetan clan in Dentiyis, which launched a futile claim to noble status to the Dutch in the early part of the twentieth century.

The pattern of "leaning against" explains in part also the geographical distribution of social groups within the village. Not only are the temples of the Pasek clans next to the temple, but their homes are not far from it, mainly in the *banjar* of Pekandelan, Tengah, Lod Tenun, and Dentiyis. So too the homes and clan temples of the Triwangsa clans are all clustered just south of the temple, in the *banjar* of Batuan Gedé, Gria Siwa, Gria Buda, and Tengah. Almost all the commoner homes and temples are in the outlying *banjar* of Peninjoan, Jungut, and Puaya (see figure 2.2). Proximity to the temple (of gods as well as people) is the source of the pattern that connects the gradient of the land to high social and religious status.

Ias and *Wibawa*: The "Beauty" and "Glory" of the Temple

Thus, the purpose of a temple, at least for most Balinese, is to provide a palace for the gods to stay when they materialize themselves on earth, a place where their worshipers may feast and entertain them while here and where these gods may in turn feast and entertain the visiting deities who come to pay them homage. It is for these reasons that the walls, gates, altars, and pavilions are covered with ornaments. The Balinese say that the temple is *maiasan,* or "decorated," or, more exactly, "made to be *ias.*" Translating *"ias"* is difficult, but "ornamented" or "beautiful" will have to do for now, with the understanding that there are many conceptions of "beauty" even in the West and that none of them may exactly fit the Balinese.

It is not necessary for a temple to be *maiasan* for the rituals held in it to be successful. Some carvings on new temples are merely blocked out, not finished off with details but left as blank forms. These are not yet decorated and are called *calonan* (unworked). (The term *calonan* is also used in Batuan for a "preliminary pencil sketch for a painting.") The makers usually plan to complete the statue at some later date, but many temples are left in this temporary state more or less permanently. Further, major altars can be found in some temples that have been made of simple bamboo, much like the high altar to Betara Surya of Pura Désa Batuan. And there are many older temples with altars made of brick or stone that are austerely simple.

And yet I believe that the carvings and paintings are more than mere decoration. They are not dispensable trimming. There is a strong culturally defined motivation to make the temple *ias* to please the gods, a motivation that is directly connected to the rituals held within the temple.

Any Balinese ritual, of whatever size or scope, whether personal, pertaining to one's household, or held by some larger community, can be carried out at one of three levels. This is a classification of the amount of effort and goods put into the accomplishment of the ritual, but it also amounts to a certain scale of aesthetic value. The lowest level of input is called *nista,* or "humble." The next level is *madya,* or "middle." The highest level is *utama,* or "majestic, exalted." Everyone is expected to devote as much to their personal and household rituals as their resources permit, with the poor then giving much less than the wealthy. The same is true for poor and wealthy village communities. One of the rationales for this idea, that each community or person should give as much as they can afford to their temple, is that great wealth and control over other people's labor and deference exposes one to envy, not only from other human beings, but also from ancestral spirits, deities, and demons. The latter expect greater attention from the prosperous and respond to neglect with the special

sort of anger that the Balinese call *juari,* a mixture of rage and shame and feelings of affront. For this reason the rich (individuals or communities) must put on greater rituals and finer dance performances and build more beautiful temples.[62]

Whether one chooses to put on a ritual at a simple or an exalted level, or somewhere in between, is therefore according to a sense of fitness or appropriateness *(patut).* One's station in social life, actual or striven for, must be in keeping with the size and ostentatiousness of one's rituals. One's own view of oneself must be close to that of one's peers. This rule of propriety holds whether the ritual is that of a householder, a king, or a community.

Another related rationale for the *nista-madya-utama* scale of value has to do with the relative importance not of the worshipers, but of the gods themselves. The most potent gods require the most glorious ceremonies. One of the measures of the greatness of a god is the wealth and well-being of his worshipers. If a village is fertile and prosperous, it is because it has powerful and attentive gods. This complex mutuality is not only expressed but brought into being through communal effort. Great worshipers have great gods, and great gods have great worshipers.

A Balinese word for the quality of greatness or glory and exaltation that I have been speaking of is *"wibawa."* A number of Batuan people boasted to me that their Pura Désa is *wibawa,* meaning that their gods are exalted. The greatest kings in Balinese legends are said to have *wibawa.* I once heard the word used for a human being, a local commoner who had great wealth and who gave much money and effort to his temples for new carvings and repairs. Villagers stressed that the opposite of *wibawa* is stinginess, *kikir,* a quality, they said, this man clearly lacked. It seems that those kings and deities who are said to be *wibawa* are not only powerful, but also generous.

It is this circular process that makes sense of the continual massing of communal energies to make ritu-

als that are *utama* and to create great carvings for their temple by the people of Batuan. They are asserting and ensuring the grandeur and potency of both their deities and themselves, the realm and people of Pura Désa Batuan. They are praising their gods and at the same time, through gratifying those gods' self-esteem, bringing further benefits upon themselves.[63]

Much of the imagery employed in these carvings and in the way that the people of Batuan speak about their temple is one of royalty and authority, of fealty and magnanimity, prowess in war and grandeur in the arts. There seems to be an analogy that is constantly invoked between the village temple, the *pura désa,* and the royal castle or palace, the *puri.* This analogy at times almost collapses into an identity.

This use of imagery both to understand and also to exercise *wibawa* appears metaphorical. But since in traditional Balinese epistemological formulations the fusion of the model and the modeled is not impossible, a metaphor may be more than a "mere" figure of speech, and speech may be more than "mere" wind. The potential reversibility and conflation of metaphors is part of reality. It is only Western epistemology—which splits the imagined from the real, thought from action, the semantic from the pragmatic, culture from social interaction, the religious from the political—that makes this Balinese use of *puri* and *pura* imagery and the historical shifts between them appear to be matters of mere rhetoric.

However, Balinese themselves sometimes make a distinction between what might be called "the performative," in Austin's sense, and the "merely symbolic" use of images. An image that is intended, and used, as a vehicle for the manifestation of a divine being is different from one that is intended merely as a representation of such a being. An example will be found later in the placement of what was called "a *simbol"* of the highest god above the throne of Ida Betara Puseh on the Méru Agung. A mask may be merely a representation of de-

monic being (and sold safely to any tourist), but after the proper rituals have been performed (the ceremonies of *mlaspasin* or *masupatin*), and after acceptance by the deities, it is transformed into an engaged agent within ritual action (and therefore dangerous to treat casually).

Thus, while all the carved and painted figures within the temple are potential vehicles for divine beings and are given offerings in recognition of that possibility, many are not likely candidates for that activation, but rather are considered merely representations of the world of the divine. Since the primary audience of the artwork of the villagers is the divine visitors, those figures that are not the main ones to be entered must have been made and placed where they are to please the deities.

The carvings of the temple may please the gods with their sensory beauty, but the content of the carvings and paintings also may please them through praise. The subject matter and manner of figurative carvings and paintings may allude to godly strength, anger, and compassion. Drawing on a treasury of Hindu literature, augmented by Javanese and Balinese literary writings, provides one a pool of associations and images (e.g., the Ramayana) from which to derive an iconography of praise by association.

But there is a dark and cruel side to the notion of *wibawa*. The idea, when applied to human beings such as kings, is tightly linked to the nearly synonymous notion of *sakti*, the dual competence to heal and to hurt, to fructify and also to destroy—and to be able to surmount or divert the destructive efforts of other *sakti* beings. The power of *sakti* is more often attributed to holy men, sorcerers, and kings, but it may be understood that the gods too are *sakti*, meaning that they have capacity to cause suffering and disaster and that their capacity varies in strength.[64]

In this view the energy within Balinese ritual draws not so much from the respect and the worship given the cosmic potency of their gods as from the terrible anxieties of impending or continuing physical suffering due to godly anger, demonic greed, ancestral anger, or the anger of other human beings. I believe that all Balinese rituals are at base propitiations of potentially destructive spiritual beings; these propiations are followed by rituals of gratitude to the beings and forces that have accepted propitiation and are willing to desist from hurting their people and to actively protect them. These feelings of fear are not given visual expression in the carvings of the temple, but they are much dramatized in the plays presented within its ritual festivals, most particularly in their broad humor, but also in some of their plots.

The decorations of the temple—the intricately interwoven vines, the bizarre animal forms, and, most particularly, the nearly human-size figures of kings and warriors—are all intended to convert the mundane, dusty, and small set of courtyards into a grand, even sumptuous palace of many rooms and grand gateways, suitable for such a magnificent throng. The largeness of the temple's spaces and the relative permanence of its stone and wood structures iconically represent both its claims to all-inclusiveness and to continuity in time, as do the various beings and actions represented in its carvings.

The intended practical effects of any Balinese ritual are the well-being *(rahayu)* of all in the immediate world of the worshiper—the humans, the animals, the plants, and the land around them. These effects, according to my theory, are accomplished primarily through the ritual establishment and maintenance of ties of clientship and alliance with specific spiritual beings. Each temple congregation, and every priest or *balian* who performs individually oriented rites, works to persuade these beings to grant the divine gifts of fertility, vitality, and protection.

The feelings of security that some Balinese have suggested to me that arise on participation in a temple

ritual would seem to me to be traced to this idea of the *wibawa* and *sakti* of their local gods. One of my Batuan consultants once remarked that in the time of his childhood in the 1930s, Pura Désa Batuan was the most *tenget,* the most *sakti* and *wibawa,* of all the temples around.

Perhaps a *pura désa,* like a king, can only make a claim to have *wibawa,* to be able to bring about destruction or communal solidarity and glory, and, in Balinese thought, such states are always problematic and hence transitory. Like the material form of the temple itself, the impermanence of its soft stone and gold paint, the state of well-being can never last but must be constantly renewed. If there are conflicting interests among its makers, if there are alternative views, these have been encompassed and integrated. In effect they are silenced or nullified. But of course, that accomplishment of comprehensiveness and safety can be only momentary. While the form of the temple and its parts may be silent about conflicts and heterodoxies, it does not do away with them, and other modes of expression or enactment, such as the dramatic performances that are part of the temple ceremonies, give them voice.

Thus a temple and its carvings cannot say everything about the life of a community and its deities, but can express only a privileged aspect of it. That version represents a series of reachievements of unity and security in the face of experienced uncertainties, ambiguities, and conflicts. A *pura désa,* I suggest, is culturally constituted in such a way that there can be no representations in its carvings of threatening beings before their co-option or encompassment by the superior power of the higher divine. Some of the "demons" in the carvings, if they have been malevolent to humans, have all surrendered to and become servants of the local deities.

As far as I can tell, Pura Désa Batuan's layout and architecture were not determined by the operation of abstract principles of cosmic order or by a general desire to recreate a geometric order that microcosmically mirrors an orderly macrocosm. Rather, the temple's architecture should be seen primarily as a set of practical arrangements for dealing with, interacting with, a host of local *niskala* guests who are both godly and demonic, and all very dangerous. The temple's population of stone figures must also be seen in this light.

Balinese deities (at least as imaged through their rituals) do not have fixed places in the firmament, but shift according to circumstances, human and celestial. In my view, Balinese rituals are not ordinarily seen as restoring a prior cosmic order, but rather as temporarily establishing safety through gathering in one place the most potent and locally effective deities. At that moment of created order, the other deities in the region (and possibly elsewhere as well) pay reverence to the local deities.

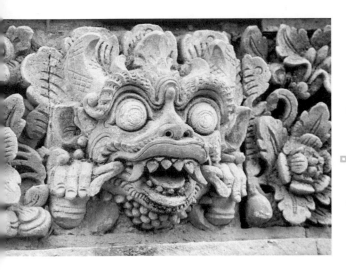

Part II. Works

▫ ▫

concerning those aspects and parts of

Pura Désa Batuan

and its carvings

that might be called artworks

studied historically

The Age of the Balinese Rajas (before 1908)

With this chapter and its sequels, I shift from an examination of general cultural intentions that may guide acts of artistry and imagination to a study of specific artworks selected—for the moment at least—as those material artifacts that might fit with Western notions of what might be at home within an art museum. The particularity of these artifacts calls out for historical research into the circumstances of their making, in both their immediate contexts and also their wider societal horizons.

I have tried to find out what has happened to each of these carvings—when they were first being planned and made, and later when decisions were made about their preservation or restoration. I wanted to know who the artists were and who the audiences known to the artists and taken into account by them might have been. I asked how the participants in each first making may have made sense of their own actions. This search has necessitated an attempt to construct a history not only of the social acts of their production, but also a history of the preconceptions that may have guided those acts and a history of changing modes of sense-making themselves.

Some Balinese today speak about their precolonial past as *jaman raja-raja Bali* (Ind., "the age of the Balinese rajas") in order to contrast it with *jaman raja-raja Belanda* (Ind., "the age of the Dutch rajas") when the Dutch installed various members of the nobility as puppet heads of regions and districts of Bali, newly conquered in 1908. The period of the Japanese occupation, *jaman Jepang* (Ind.), and the nationalist struggle for independence broke the Dutch control briefly; it was reestablished in 1948 and lasted until 1950, when the Republic of Indonesia was established and the Dutch left. The first years of independence are often called *jaman merdeka* (Ind., "the age of freedom"), which is considered to have come to an end in 1967 when President Suharto replaced Sukarno. There are of course many names for the ensuing period, since we are still in it; I have chosen *jaman turis-turis* (Ind., "the age of the tourists") to point up the most obvious socioeconomic characteristic of Batuan today.[1]

Within this indigenous periodization scheme I will explore in the coming chapters some aspects of the various pasts of the temple and its carvings. My account tells something about general historical trends of Bali and Indonesia, but since the focus is on one rather unusual village and one temple, it is rather selective. Interspersed in these social histories are descriptions and discussions of the main architectural features of the temple and the most important carvings and paintings, for each of these has a story of its own. Very little is known about Pura Désa Batuan before this century. But one thing is certain: its architecture and carvings, and even the rituals held within it, most certainly have changed repeatedly during its long existence. Given the diversity and dispersion of religious authority in Bali, there is no way that it could always have stayed the same. The shape of the temple undoubtedly underwent more rapid changes in the twentieth century than before. But there is no evidence, other than the continued existence of the temple and of fragments of early carvings, of the ancientness of its forms.[2]

The Age of the Prasasti Text (1022 C.E.)

The written document called the Prasasti is inscribed on a set of small copper plates kept in the temple. For the people of Batuan, these plates are the material embodiment of the goddess of writing, Sanghyang Aji Saraswati, and they serve as her god-figure during the processions and worship in Pura Désa Batuan. They are preserved, but no one reads them. Few in Batuan knew anything of the contents of the Prasasti until I wrote about it in the local newspaper.

At some time in the 1920s, the Dutch Archeological Service forced the priest, against his better judgment, to take the copper plates of Sanghyang Aji Saraswati from their sacred storage place and allow them to be photographed. Subsequently the text was published by Roelof Goris. It is this printed version that I read.[3]

The Prasasti consists of an edict by a Balinese king concerning the temple of "Baturan" and its village. The text states that it was written in Saka year 944, which is the year 1022 C.E. It is quite circumstantial in its details.

The picture of Batuan as it may have been in the eleventh century that emerges from a close study of this text is one of an agricultural village whose members maintain the temple of "Bhatara I Baturan," the God of Baturan. It is clear that "Baturan" is present-day Batuan (with the "r" dropped), since the names of adjacent villages and rice fields specified in the document are much the same as today. The king who issued the edict had his capital, most probably, in the region that the archeologist Stutterheim called "Pejeng" after one of its present-day villages. It is about ten kilometers northeast of Batuan as the crow flies. The king named was the son of the great King Udayana, whose

dynasty, the Warmadéwa, ruled in Bali from the tenth century through the twelfth century, and the brother of King Erlangga, who ruled in Java in the eleventh century.[4]

The edict states that the villagers must continue to maintain a place for the king to worship the God of Baturan, buildings where pilgrims can stay overnight during their visits, and five *petapan,* presumably pavilions for meditation by the pilgrims or by the king himself. It lists the king's extensive gardens in Baturan and states that certain people were required to farm them.

The edict further announces that because they are already burdened with the maintenance of both the temple and the king's gardens, the people of Baturan are to be given a special royal dispensation. They are expressly excused from paying any other kinds of tribute or taxes to the king and his retainers, of the sort presumably required from all other villages in the region. The sorts of work for the king and the members of his court from which the people of Baturan are excused includes building palaces, caring for royal livestock, making offerings, painting and carving in palaces and royal temples, and entertaining the court with music.

The social world of the eleventh century within which Baturan and its temple lay, it is clear, was not one of closed, self-contained village communities. Even though Baturan's temple was not a very special one (such written charters were bestowed on a large number of such temples), it appears that outsiders frequently visited Baturan. The visitors mentioned are mainly officials from the court: an overseer of cockfights who collected taxes on them, an official in charge of the five places for religious meditation in Baturan, an overseer of the fields of the raja, an official in charge of lands of those villagers who die without heirs. And, of course, there were the religious pilgrims, some of whom may have come from as far as what are now called India and China, bearing with them religious ideas of what are now called Hinduism and Buddhism. The edict men-

tions provision of housing for religious pilgrims, which no longer exists today. No side temples were mentioned in the inscription, nor any other deities.

The language of the inscription is not the Balinese of the villagers, but Old Javanese. Its vocabulary and figures of speech are the same as edicts found elsewhere in Bali and in Java in the same time period. It may be that even in Java at the time Old Javanese was a sacred and literary language quite distinct from the vernacular; certainly in Bali this was the case. The inhabitants of Bali must have felt that this foreign language was both intelligible and authoritative. However, its use must have required the presence of Balinese who could translate and interpret it.

The edict mentions a man of the court whose title and name, Dang Acarya Tiksena, indicates that he was a religious teacher or priest who was learned in the Hindu scriptures in their Old Javanese forms. It names two people from Baturan who also seem to be literate, since they are given the title of *bhiksu,* which in Old Javanese means "scholar." Their personal names, Widya and Sukaji, like Tiksena, are drawn from Sanskrit, and further support the deduction that they were learned men who could interpret the text to the people of village and court. The other people from Baturan who are mentioned by name (and there are about twenty-four of them, mainly sharecroppers on lands owned by people from the court) have neither titles nor non-Balinese names. In contrast, the fifteen people from the court who are listed as aides to the king or as witnesses to the making of the edict all have titles of various sorts, and most have Sanskrit-derived names.[5]

Reading this text with eyes taught by experience in twentieth-century Bali, I see many similarities between then and now. Too much must not be assumed in the way of historical continuities, however, for much must have happened to the political economy of Bali during the nine hundred years that have passed since. Cer-

tainly, political and social institutions in Bali must have been greatly reorganized several times, from the advent of world trade in the archipelago in the fourteenth century and the subsequent shift from the open international mercantile trade of that time to the colonial economic and political forms in the nineteenth century.

One thing is clear: the material subsistence activities of rural Bali, notably the techniques of agriculture, textile production, and transportation, probably remained much the same for most villagers from before the eleventh century until the late 1970s. Evidence for this lies in the similarities to today's subsistence techniques of those mentioned in the eleventh-century edicts.

Another similarity between the social circumstances of then and now is suggested by the wording of the edict, which identifies the petitioners to the king as the *"karaman I Baturan"* (the *krama* [village council] of Baturan). The use of the particle *"I,"* which indicates respectful personal reference, could mean that they were assuming that the *krama* served a person, "I Baturan," the god of the temple. The use of the term *"krama"* suggests the antiquity of the institution of the present-day *krama désa.*

There is no mention of subsections or *banjar* in the text, so it can be assumed that the population of the village was small enough to do the temple work without complex organization. If this is so, it can be guessed that the emergence of the *banjar* is a consequence of increased population.

A similarity of considerable importance is the frequent mention in the edict of status distinctions marked by titles, and the unequal distribution of these titles between villagers and court. Further, the edict shows that farmed land in the village area that was owned by titled people and that titled people had some sorts of rights to demand, as tribute, or as taxes, various village agricultural products. But none of these titled people (presumably an early version of today's *triwangsa*) appear to have lived in Batuan, although several owned rice lands

and gardens there that were sharecropped by the local farmers, who were probably commoners, inasmuch as their listed names are not Indic like those of the nobles.

Clearly the village of Batuan and its population had social relationships of both autonomy from and interdependency with communities and personages of the outside world. These relationships had their counterparts in the religious sphere. The god of the temple named in the edict, Bhatara I Baturan, was not a Hindu deity, but rather a locality-bound god who was worshiped and protected by a king with an Indic name, from outside Batuan. The king's authority extended over the village in regard to work and taxes, although the basis of that authority, since it is taken for granted in his edict, is not entirely clear. A clue, however, is found in the final section of the text, which is a magnificent curse *(pamastu)* laid on anyone who did not abide by the edict. This curse invokes all the powers that be in a great list of Hindu deities and forces, but notably it does not mention the God of Batuan. The external king invokes a series of deities to whom he and his holy men have access, but to whom the people of Batuan do not, asking his Indic gods to give spiritual protection to the village and its local god.[6]

Works Made from the Ninth to Fourteenth Centuries

Little is known about the "artworks" that remain in Batuan from the centuries prior to the 1917 earthquake. Who their makers were and what may have been their conceptions of the temple and its visitors is information lost to the memories of present inhabitants of Batuan. They must be dated by style alone or with consideration of content, both somewhat untrustworthy and imprecise procedures. Some of the fragments of statues that are kept so carefully today by Batuan people may have been made at the time of the edict or in

the centuries soon after it. The ones I show in this chapter were all known by Batuan people only as having been made "before the earthquake." They are all revered for their great age, or more exactly, for their *tenget* qualities, for over the centuries many different *niskala* beings have chosen to hover around or within them. There are many stone fragments of these early carvings still in Pura Désa Batuan. Some are today considered so *tenget* as to require concealment *(pinget)*. The rest have been gathered neatly together on the ground at the back of the temple near the West Gate. They are considered *cacad* (crippled or disfigured), a word also used to characterize human beings who are, because of their physical defects, not allowed to serve the gods.

It is likely that the overall layout of Pura Désa Batuan was different in the time of Prasasti, smaller, and consisting perhaps only of the inner courtyard and one forecourt on the west, inside the Great Door of the West. I discuss this layout together with the changes that were made in the 1930s in chapter 5.

The form of the principal altar, the Méru Agung, may have been established from that early time as well. It is an unusual rectangular shape, called a *kehen,* identified by archeologists as ancient. Since the Méru Agung was almost entirely rebuilt in the 1920s, I discuss its form in connection with the works of that period.

Similarly, the West Gate, which was restored by the Indonesian Archeological Service in 1991–1993, is thought by many to date from the edict era, but it is more likely from the thirteenth or fourteenth centuries. I will describe and discuss it in chapter 9, for in many ways in its present form it is a twentieth-century product.

The Statue of Ida Betara Siwa within the Méru Agung

Two statues that, from their style, may have been made during the "Pejeng period" from the ninth century through the fourteenth, have been preserved behind closed doors. These are the statues of Ida Betara Siwa and Ida Ratu Saung. The temple priest did not want me to see or photograph them, but the Archeological Service has released some drawings.

The first, identified by the Pamangku of Batuan as Ida Betara Siwa, looks something like one studied by the Dutch archeologist Stutterheim found in a temple in Pejeng with a date carved on it of 1342 C.E.[7]

The Batuan statue may be several hundred years later than that from Pejeng. It is much simpler in its workmanship, but it shares the same stiff posture and has a similar headdress. The Pejeng statue is a woman, and Stutterheim identifies it as a queen. After studying many of these, some with explanatory inscriptions, Stutterheim believed that figures of this sort at the time of their making "were not images of gods, but representations of dead kings, serving as a means of magic contact between the soul of the dead and the survivors. Hence was chosen the shape of the particular god of whom the deceased was supposed to be an incarnation."[8]

Stutterheim further spoke of "another typical appearance manifest in the antiquities—the peculiar stiffness and cramped appearance of some figures, a rigidity which, in the course of development, becomes more pronounced, lending the figures a corpse-like aspect. Yet the reason for this is clear. These figures were erected for dead kings."[9] Whoever this figure was originally, today it is Ida Betara Siwa, but its look is irrelevant since the statue is never seen by anyone except the Pamangku. The statue is clearly not one of the gods of Batuan; it is never brought out and dressed and paraded around and feted.

The Altar of Ida Ratu Saung

Ida Ratu Saung is concealed inside a simple stone building with a plain door. It is never opened, and hardly anyone in Batuan has ever seen the carving. But they all know that it is a statue of a man holding a fighting

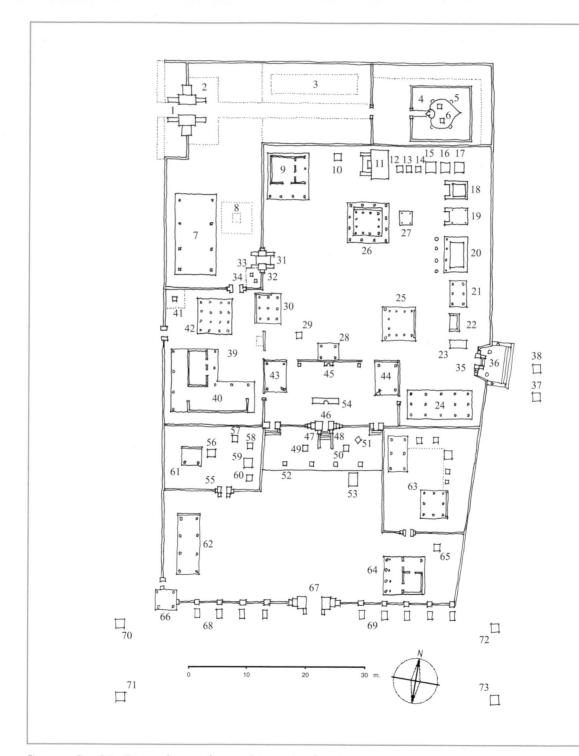

Figure 4.2. Pura Désa Batuan: altars, pavilions, and statues (as of 1995)

The Jeroan (inner court)

17. Altar: Ida Ratu Atma
16. Altar: Gedong Sari
15. Altar: Peliangan
14. Altar: Gedong Tarib
13. Altar: Taksu Agung
12. Altar: Ratu Nglurah (Sédan Nyarikan)
11. Altar: Ida Ratu Saung
10. Altar: Sang Hyang Basuki (Ratu Nini Besukih)
18. Altar: Padmasana
19. Altar: Méru Alit
20. Altar: Méru Agung (Gedong Rum)
21. Altar: Pingkupan
22. Altar: Ida Ratu Pandé, Ida Ratu Jempaling, and others
23. Altar: Ida Ratu Selimpet
29. Pavilion: Balé Peselang
28. Pavilion: Balé Pelik
29. Altar: Ida Begawan Penyarikan
30. Pavilion: Balé Piyasan
9. Pavilion: Balé Penegtegan (Lumbung)
26. Pavilion-altar: Semanggén
27. Altar: Pengaruman
43. Pavilion: Balé Gong
44. Pavilion: Balé Gong Semar Pegulingan
24. Pavilion: Balé Pesanekan (Nyelam)
25. Pavilion: Balé Peselang

4. Taman (reservoir for water)

5. Altar: Paso Ngeleb
6. Altar: Pelinggih Taman

39. Suci (kitchen)

41. Altar: Ida Ratu Ngadeg (Madeg)
40. Pavilion: Balé Suci
42. Pavilion: Balé Piyasan

Miscellaneous structures in Jeroan Tengah (outer courtyards)

65. Altar: Ratu Alit
64. Pavilion: Penyimpanan Gong
8. Cockfight ring
3. Collection of fragments of antique statues
7. Pavilion: Balé Piyasan

62. The Balé Agung

55. Pura Ulun Balé Agung

60. Altar: Batu Alam
59. Altar: Gedong Nglurah Gumi
58. Altar: Pesimpangan Ratu Batur
57. Altar: Pesimpangan Ratu Batukaru
56. Altar: Arip-arip
61. Pavilion: Balé Piyasan

1. The West Gate (Kori Agung Kaoh)

2. Statues: Elephants

35. The East Gate (Pemedalan Kangin)

36. Statues: Gambuh dancers
38. Statue: Apit Lawang
37. Statue: Apit Lawang (Balé Pelik)

31. Split Gate on the West of Jeroan (Candi Bentar Kaoh)

32. Statues: Snakes
33. Altar: Ratu Pasek
34. Altar: Ratu Pandé

46. Great Door on the South (Kori Agung Kelod)

47. Statue: Rawana
48. Statue: Kumbakarna
49. Statue: Detia Maya (Sedahan Apit Lawang)
50. Statue: Detia Maya (Sedahan Apit Lawang)
52. Statues: Parekan Rawana
51. Altar: Balang Tamak
53. Altar: Memorial for Pependeman Bagia
45. *Aling-aling* wall with statue of Rawana meditating

66. *Kulkul* tower

67. Great Split Gate on the South (Candi Bentar Kelod)

68 and 69. Statues: of Rama's and Rawana's followers
70 and 71. Statues: by Déwa Nyoman Cita
72 and 73. Statues: by I Jedag

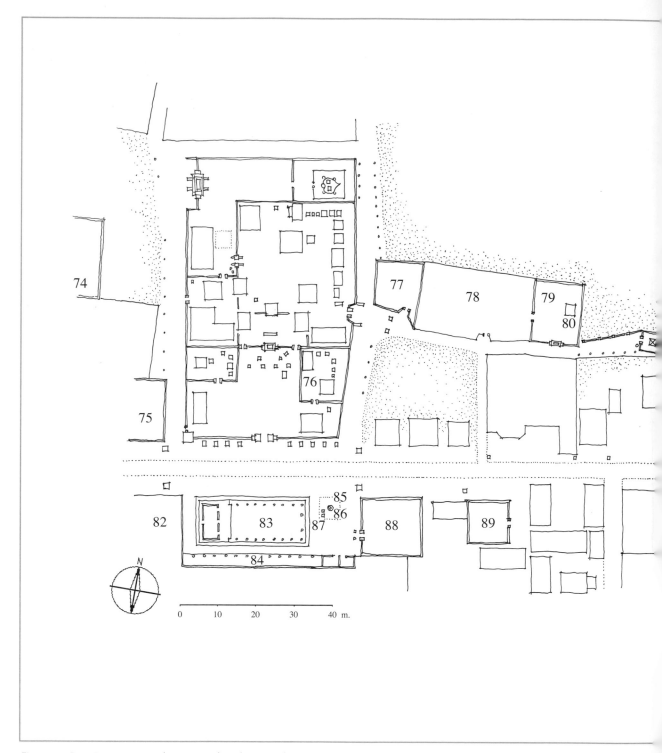

Figure 4.3. Pura Désa Batuan: adjacent temples, altars, pavilions, and statues

90

cock, and some gamblers place offerings here in the hopes that the dagger like sharp steel spurs they tie on the legs of competing cocks will be efficacious. *"Saung"* means "gamecock," and giving a person or *niskala* being (or king) such a name implies that he is of unusual *sakti*.

During the Odalan this deity is virtually ignored, with only a few offerings placed on the steps of his house.

The Altar of Ida Ratu Selimpet

The altar of Ida Ratu Selimpet holds another very ancient carving, somewhat broken, identified as two figures of the Garuda bird standing back to back. They are referred to as Ratu Selimpet (which I cannot translate) or as Ratu Garuda Kembar (Lord Twin Garuda) or as Ratu Garuda Putih (Lord White Garuda.) People come and make offerings to them during times of great illness, followed by offerings at the Méru Agung. During the Odalan of Pura Désa Batuan, many offerings are given to these beings, on temporary platforms on both sides of the altar.

The Altar of Ida Ratu Jempeling, Ida Ratu Pandé, and Others

One altar looks very much like a museum case, with a square base, a flat roof, and one open side; it contains, at about eye level, a miscellaneous collection of older stone carvings. The "case," referred to as a *babataran,* meaning a floor or pedestal, was made in late 1940s.

The two figures standing guard at each side of the opening are probably much more recent, but the others may date back five hundred years or more. The altar derives its name from two particular stone artifacts, the first, Ida Ratu Jempaling, at the far right, behind the guardian, which is in the shape of a round stone mortar, decorated on the outside with small, tight spirals like snails. The other, in the middle, is a long object,

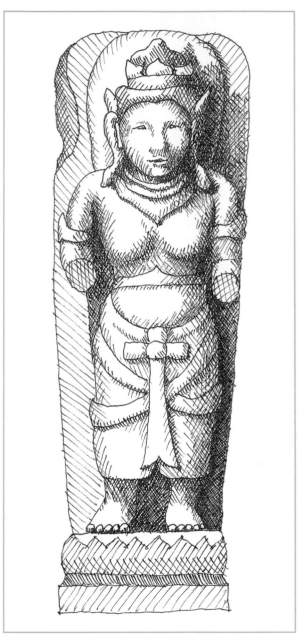

Figure 4.4. Statue of a deity, hidden within the Méru Agung, considered to represent Siwa. Sketch taken from a report on Pura Désa Batuan by the Proyek Pelita Pemugaran dan Pemiliharaan Peninggalan Sejarah dan Purbakala Bali, Departemen P & K, Bali, 1981–1982.

Figure 4.5. Statue of a deity called Ida Ratu Saung, shown with a fighting cock in his hands. Sketch taken from a report on Pura Désa Batuan by the Proyek Pelita Pemugaran dan Pemiliharaan Peninggalan Sejarah dan Purbakala Bali, Departemen P & K, Bali, 1981–1982.

which may represent a stone pestle, named Ida Ratu Pandé. These two objects may date from centuries ago, and art historians might identify them as an ancient *lingga* and *yoni,* symbols of the Indic Shiva and his consort, Shakti. Since they are considered *palinggihan* of Pandé ancestors, the clan of Pandé Besi of Batuan place family offerings here at time of the Odalan of Pura Désa Batuan.

There are other statues in the case with them, but no one knows their identities. Whenever there is a holy day

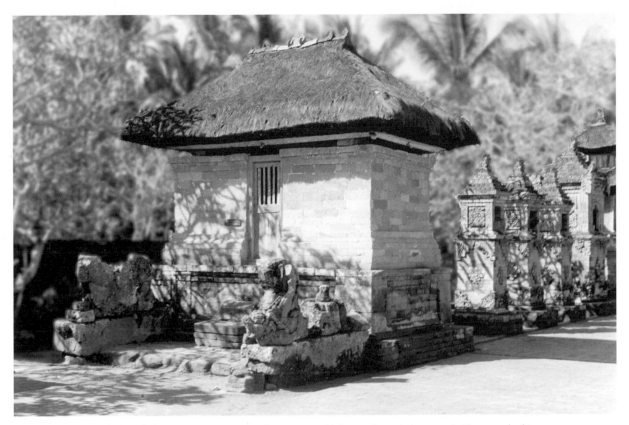

Figure 4.6. The closed altar of Ida Ratu Saung. Carver: unknown. Date: Unknown (twentieth century). Photographed in 1995.

the priest places a few offerings on this altar, as he does for all important altars, but otherwise it is not selected out for special attention.

The Altar of Ida Begawan Panyarikan

Another set of ancient fragments, including a *lingga* that may date from the eleventh or twelfth century, is kept on the top of a tall plinth dedicated to the deity Ida Begawan Panyarikan. I have discussed this deity in chapter 2. *"Panyarikan"* means "secretary" or "he who keeps a record." Other names for this being are Ida Sedahan Panyarikan, Ida Betara Ratu Nyarik, both meaning "record keeper," and Begawan Manik or Jogor Manik, who is the record keeper in Suarga, the other world. At the Odalan a table of offerings is placed before him. The location of the altar, in the southwestern corner of the inner courtyard, indicates that this *niskala* being is subservient to the main gods of Batuan.

A *lingga* is an erect penis and was the ancient symbol of Siwa.[10] I believe that the *lingga* form of this altar is not meaningful to present-day Balinese, who may see the carving merely as ancient and therefore saturated with powerful spirits from the past. It serves to identify, in their minds, the past worship of the gods of Batuan with that of the present.

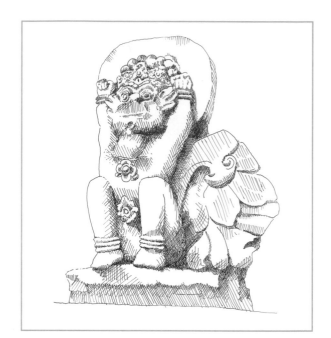

Figure 4.7. *(Right)* Statue of Ida Ratu Selimpet on a plinth of recent construction. Carver: unknown. Date: unknown.

Figure 4.8. *(Below)* The altar to Ida Begawan Panyarikan, deity of meetings of the *krama désa,* on right. At left is a meeting in progress of the *prajuru désa* (managing team). Carver: unknown. Date: unknown. Photographed in 1995.

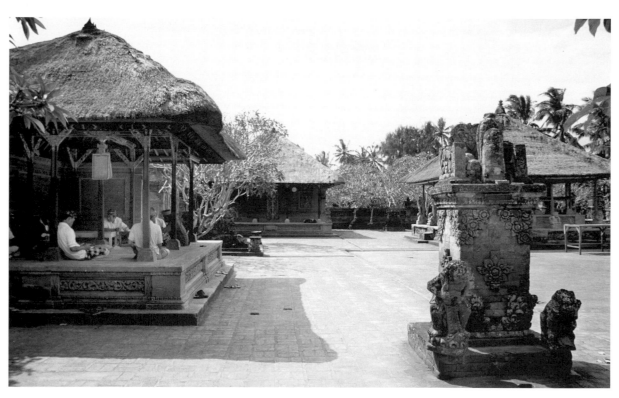

The Altar of Ida Ratu Atma

It is tempting to suggest that the small altar in the furthest northeast corner holding two slightly carved smooth rocks was the first one of Pura Désa Batuan and that the stones date from a pre-Indic period, before the ninth century. These could have been carved and sanctified in the prehistoric era of the making of the great stone sarcophagi, to be seen today in the Archeological Museum in Pejeng.[11] However, it is possible that, while the stones themselves may have originated very early in Bali's history, they may, alternatively, have been introduced into the Hinduized temple at a much later date. There is no evidence one way or the other.

The two stones of Ida Ratu Atma appear to have been slightly carved into cubic forms, one a barrel and the other a rounded cube. You can see slight chisel marks on them. Much larger stones, with similar minimal carving, are found in many temples in Bali and are also highly revered. There is very little artistry employed in their making. They are viewed as *palinggihan,* or vehicles for the manifestation of deities, and offerings are placed on a table before them during the Odalan. This altar stands in the spot that is the closest to the mountains and the easternmost in the whole Pura Désa Batuan.

The gods (or god) Ida Ratu Atma do not play a central part in the annual Odalan ceremonies, but they are always given respectful offerings, and they may also be called on for help in times of terrible epidemics, when people also pray to Ida Betara Puseh. The Pamangku referred to the stones as *arca,* that is, god-figures who might be entered by *niskala* beings. However, neither he nor any else in Batuan knew much about this altar. The design on its pedestal, which is probably of eighteenth- or nineteenth-century making, is of a *saé,* the stylized face of a demon with one eye and large teeth.

Oral Accounts of the First Building of Pura Désa Batuan

The Pamangku of Pura Désa Batuan told me that he had heard that the temple had been first built by the Javanese king Erlangga. But this is not the opinion held by all, since today's gentry in Batuan are certain that their own ancestors (of whom Erlangga is one) were not involved in its establishment.

A more popular story is that of Kebo Iwa, which I give as told me by several people in Batuan. Kebo Iwa (also called Kebo Truna) was a commoner, a man of incredible strength, who built many of the ancient temples in the vicinity as well as Pura Désa Batuan. Kebo Iwa was born in the nearby village of Blahbatuh from the clan of Karang Buncing. His parents, rich but childless, went around to many different temples, praying for a child. "Why are you so persistent in your request?" asked a god. "We would give anything to have a child." The god took pity on them, and granted them their wish.

From the time he was an infant, Kebo Iwa was a giant and ate enormous amounts of food. On the day he was born he ate six large *tipat* (packages of cooked rice). As he grew he ate more and more. Everything his parents had went to feeding their child. When he was fully grown, he'd eat ten whole pots of steamed rice at once. He was so tall that when he was in the Batuan area he had to sleep in the long Balé Agung in the temple Pura Panataran in Sukawati, just to the south.

In despair of having the wherewithal to continue feeding him, Kebo Iwa's parents tried to kill him. They sent him to cut down some *jaka* trees in the forest, thinking that the limbs would fall on him and kill him. But when even whole trees fell down on him, he just caught them and carried them back to his parents.

Finally the father said, "Badah! I can't take care of this youngster anymore!" So they sent him away. And that's how he came to travel around looking for work for food.

Figure 4.9. The stones of Ida Ratu Atma. Carver: unknown. Date: unknown. Photographed in 1988.

Kebo Iwa built many temples in Bali, including Pura Désa Batuan. The first temple he built was in Canggi, a village near Batuan. The people there gave him some steamed rice to eat in payment, but because they didn't have a proper steaming pot, they cooked the rice wrapped up in leaves, over a fire, a method called *don panggang*. Kebo Iwa was angered, and he placed a curse on them that their temple should from then on be called Pura Ganggang, a name thought to be derived from the word *panggang*.

After Canggi, he went to Batuan and built Pura Désa Batuan. As he worked he kept asking for more and more food to eat, and the people couldn't bring him enough. The *banjar* of Jeléka was assigned to feed him, and to fill out the rice they added rocks. When he ate it, he cursed them with the name Jeléka (from the word *"je-lék,"* meaning "bad") and gave the village of Batuan a new name, Batuan, from *batu,* meaning "rock."

Kebo Iwa's story goes on from here, telling of a series of further superhuman exploits in other villages that infuriated both the populace and the king. Finally the king himself said, "How is it that Kebo Iwa is so powerful *(sakti)*? He can't lose in any battle." So the king sent Kebo Iwa to the king of Majapahit in Java, entrusting him with a secret letter that the king of Majapahit was to kill the bearer. After a number of failed attempts to murder Kebo Iwa, he himself told his Javanese would-be killers that only burying him in white lime could do the job, but that "after I die I'll conquer and control this land. I'll come back as a person with white eyes." The lime turned Kebo Iwa, his hair, and his eyes white. And so it came about: Kebo Iwa returned in the form of the Dutch colonizers, who had white hair and eyes.

These stories of Kebo Iwa, told often today both informally and in the *topéng* performances, are accounts of why some of the statues are the way they are.[12] The tales provide an explanation to the Balinese for both the crudity of the ancient carvings ("He made them with his own fingernails!") and of their *tenget* quality (Kebo's hand was on these carvings and they are therefore still haunted by Kebo Iwa). In these tales, Kebo Iwa's clan is always named: Karang Buncing, a family today with many members in Gianyar. Several people in Batuan are members of the Karang Buncing clan and therefore are descended from Kebo Iwa, further reinforcing the contemporary immediacy of the presence of Kebo Iwa in Batuan. He is a commoner ancestral spirit who has been, and is now, an important part of the entourage of the *niskala* beings of Batuan.

These tales might be labeled "myths" in anthropological discourse, although the Batuan people don't think of them as untrue. They might also be thought of as Malinowskian "charter myths" establishing the naturalness of contemporary social arrangements, but if they perform that function, it is ambiguous and can only be

for a portion of the population, the commoners, since Kebo Iwa's acts place him in opposition to the kings. As related above, the populace go to the king for help against Kebo Iwa's insatiable appetite, but the king is helpless. It is only when Kebo Iwa reveals his weakness, in Java, that he is defeated. The story explicitly states that when the Dutch arrived, they with their white eyes were reincarnations of Kebo Iwa. To cast the stories of Kebo Iwa as charter myths is to lose much of their ambiguity and subtlety.

Works Said to Be Made by Kebo Iwa

In Pura Désa Batuan are a number of carvings considered to have been made by Kebo Iwa, "with his fingernails": a horse, a lion, a water buffalo, an elephant, a snake, and a double *Garuda*. He is also said to have built the original West Gate. The people don't point out the statues of Ida Betara Siwa or Ratu Saunga made by Kebo Iwa, perhaps because they are hidden.

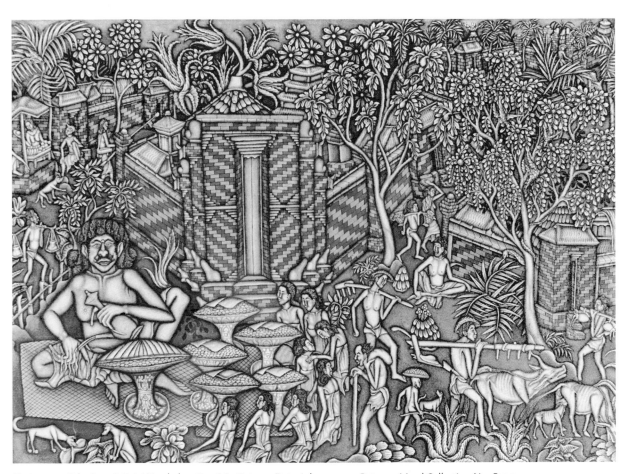

Figure 4.10. Kebo Iwa. Artist: I Tombelos, Dentiyis, Batuan. Date: July 27, 1937. Bateson-Mead Collection No. B 711.

The Elephant Statues at the West Gate

Four elephants were repaired and placed in front of the restored West Gate by the Indonesian Archeological Service. Their rationale for this placement was an analogy with a nearby temple of similar age, Pura Hyang Tiba, which lies several miles north of Batuan and has a carved date on it of Saka 1258 (1336 C.E.).[13]

Elephants are not indigenous to Bali. These resemble a Chinese statue of an elephant from the Ming dynasty, a reminder that with all the scholarly stress on Indic influences on Balinese art, the Chinese links have been neglected.[14]

The Snake Statues at the Split Gate on the West of Jeroan

Another statue by Kebo Iwa is of a snake. It and another like it was placed flanking the small split gate, the Candi Bentar Kaoh, on the west side of the Jeroan leading to a forecourt.

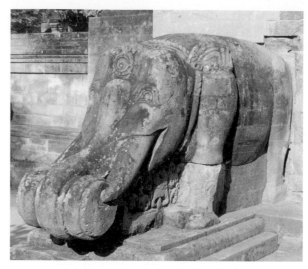

Figure 4.11. Statue of an elephant, attributed to Kebo Iwa. Carver: unknown. Date: possibly from fourteenth century. Photographed in 1995.

Batuan in the Eighteenth and Nineteenth Centuries

The oral histories recited by the families of the gentry of Batuan stress their ancestral origins outside the village. The earliest noble groups to come to Batuan probably arrived in the beginning of the eighteenth century, and the most powerful present-day clan came about the end of the nineteenth century. Outsiders to the temple, their roles within it were always problematic.[15]

The first gentry residents of Batuan were, according to these accounts, Gusti Ngurah Batu Lépang and his entourage. "Lura Batu Lépang" is mentioned in Dutch sources as having attempted to take over the royal palace in Gélgél in 1687.[16] Batuan people today say that Lépang's palace was enormous, that he put it just to the

east and south of Pura Désa Batuan. The area they pointed out covered much of the present-day *banjar* called Batuan Gedé, where most of Batuan's Triwangsa group now live. When Gusti Ngurah Batu Lépang was subsequently defeated, his palace was smashed, and his followers, their titles lowered, fled to all parts of the island.

No gentry families living in Batuan today trace their ancestry to Batu Lépang or his entourage, except a single family with the title of Gusti who say that they were mystically called from their homes in Singaraja to Batuan to serve as *pemangku* of the former clan temple of Gusti Ngurah Batu Lépang. Today, descendants of his followers are said to come back yearly to *odalan* in that temple, which is now called the prosaic name Pura Dangin Pasar (the temple east of the market).[17]

It was the king of Klungkung, the Déwa Agung, who defeated Batu Lépang and scattered his followers, at the end of the seventeenth century. He is said to have then sent to Batuan his own kinsman, Déwa Gedé Anom, to govern the region. Déwa Gedé Anom brought with him a large entourage, including his own close rel-

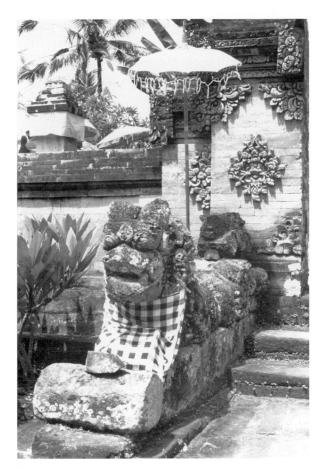

Figure 4.12. Statue of a snake, attributed to Kebo Iwa. Carver: unknown. Date: unknown. Photographed in 1986.

atives and some more-distant kin and a large group of commoners, many of them artisans *(sangging)*.[18] Déwa Gedé Anom is mentioned in Dutch records as living in Batuan in 1712 and as moving to Sukawati, a village just to the south of Batuan, in 1718.[19] Local oral tradition corroborates this, saying that Déwa Gedé Anom stayed in Batuan only about three years, and then moved to a new palace in Sukawati, where his descendants live today. But some of his commoner artisans remained in Batuan, as well as some of his royal followers, ancestors of some present-day people with the title of Déwa.

Sometime in the late eighteenth century, an upstart royal court in Gianyar was established by a charismatic leader named I Déwa Manggis, and sometime later, a close kinsman of Déwa Manggis was sent to live in Batuan, perhaps to set up a military bulwark against the nearby rival kingdom of Negara (now a village just across the river from Batuan) and against the prince of Sukawati, who with his courtiers had the title of Cokorda with connections to Klungkung.[20] The current highest-ranking noble clan of Batuan, living in Jero Gedé (today called Puri Batuan), say they came to Batuan only four or five generations ago, perhaps at the end of the nineteenth century, put there by the raja of Gianyar, replacing an earlier Gianyar noble house that had no heir.

The Brahmana, or priestly group, in Batuan consists mainly of two large clans. One is identified as Brahmana Siwa, and its people in Batuan say that some of them arrived with Déwa Gedé Anom, or soon after, coming from the south from the former court of Pinatih in Badung. One family of the Brahmana Siwa told me that four generations ago, the raja of Negara, the princedom just across the river from Batuan that was destroyed in the late nineteenth century, brought his ancestor, a *pedanda,* from Sanur to be his court priest. The other Brahmana clan in Batuan is Brahmana Buda, who are a very small minority of priests in Bali. They say they came to Batuan from the north, from the village of Banjar in Buleleng to which they had originally moved from Budakling in Karangasem.[21] In the first half of the twentieth century, Batuan had five *pedanda,* two Buda, and three Siwa; there may have been as many in the nineteenth century. Their clients *(sisia)* were scattered over a wide region, mainly outside of Batuan.

Commoner family histories, on the other hand, do not usually tell of immigration, but rather speak of incoming royal and princely houses competing for the loyalties of the indigenous local people as they entered Batuan. They usually give nothing of histories earlier than that.

The result of these various gentry family movements was that each time a number of lesser gentry families were left behind in Batuan. These were often poor and usually intermarried with the commoners and, it is likely, observed, at least partially, many of the commoner temple obligations. However, there is no direct information on the manner in which these gentry families performed their obligations to Pura Désa Batuan. They were probably in the village, but not entirely of it, in an anomalous situation that was not to cause problems until the middle of the twentieth century.

According to these same oral histories, when Déwa Gedé Anom, the prince who lived first in Batuan and then in Sukawati, died, he was cremated in Batuan, on land that has now become the cemetery and burning ground for all the nobles of the region (from Sukawati up to Sakah, north of Batuan). That must have occurred in the middle of the eighteenth century. Some time after that a new *pura dalem* for nobles was set up next to the cemetery. Usually referred to as the Pura Dalem Puri, this temple has served the Triwangsa population of the Batuan region ever since.[22]

Having a separate Pura Dalem for all in the category of *triwangsa* has meant that, in matters of death and the Pura Dalem, the nobles were emphatically marked off, as a class, from the commoners. However, this in itself did not bring about religious disunity. The conception of the Kahyangan Tiga is one of community unity under a three-in-one guardianship. Diverse allegiances to other gods, both internal to the village (for instance, the clan gods) and external to it (for instance, the gods from whom *tirta* is requested for Pura Désa Batuan's rituals), do not interfere with this unity. Even the institution of multiple cemeteries need not disturb the oneness, as long as the gods of the several *pura dalem* join the others at the Odalan.

I do not know whether or not in the past the god of

Pura Dalem Puri sat with the others within the throne room of Pura Désa Batuan. I was told that prior to the 1950s, the god of the nobles would always accompany Ida Betara Puseh down to the sea for the occasional *melasti* rituals, joining the procession not at its starting point in the Pura Désa's Jeroan Tengah Klod but rather down on the road, when the procession passed by the Pura Dalem Puri. The continued existence of a separate Pura Dalem, based on status title, must have created a strong marker of social distinction.

Bali in the nineteenth century was a checkerboard of competing kingdoms, princedoms, and fiefdoms of lesser lords, whose activities moved across a landscape of local communities, each anchored to various more-or-less-local temples. The relationships between the temple gods of Pura Désa Batuan and those of various noble houses both within and outside the village, in the nineteenth century and before, must have fluctuated wildly with the ebb and flow of the fortunes of specific royal houses in the vicinity. At times, a rising or dominant royal court might have involved itself directly in the affairs of the temple, as a means for gaining allegiance of the villagers or of the gods of the temple or both.

For example, the family of the present Pamangku of Pura Désa told me the story of their moving to Batuan from the court of Mitra. The new *pamangku* was brought through the mediation of Puri Negara, the former kingdom just to the west of Batuan that was strong during the first part of the nineteenth century. According to them, the king of Mitra made the king of Negara promise that if anyone in the priest's family did wrong, they would not execute him, but send the culprit back to Mitra, for they were his *panjak,* his retainers.[23] This family history suggests that the royal houses near Batuan considered the gods of Pura Désa Batuan worthy of

their attention, that they considered themselves (and perhaps were considered) the temple's patrons. This impression is borne out by events in the twentieth century.

These kingdoms drew their manpower from villages in their surrounding regions. At the end of the nineteenth century, the people in the settlement of Désa Adat Batuan held allegiances to at least three different royal houses. Aside from those who were the retainers of the local Gianyar-linked gentry houses (mostly living next to them in the *banjar* of Pekandelan), a number in Puaya were dependent on the royal house of Sukawati, whose ties were to Klungkung, not Gianyar. And in the *banjar* of Dentiyis were some followers of the royal house of Negara, a mile or so west of Batuan, whose political ties were to the former kingdom of Mengwi.

In times of conflict among these competing royal groups, each commoner family had to go its own way. One carver, I Ruta of *banjar* Puaya, remembers his father telling him that when he was a child (probably around 1900) his father had to prepare for a battle between the Cokorda royal house of Sukawati and the Déwa house of Batuan, when the young prince of Batuan, Déwa Gedé Oka, eloped with the daughter of the Cokorda of Sukawati. Ruta's grandfather was a *panjak* of Sukawati and had to join the crowd carrying krisses and sharpened bamboos to demand the girl back. There was, apparently, in the end no open battle, and the young couple succeeded in fleeing. They went to Tabanan, where they stayed for three months, and, the story goes, the young Déwa Gedé taught the noble princes there how to do the *gambuh* dance. If violence had broken out, it would have lined up some of the villagers of Batuan Gedé against some of the villagers of Puaya, all of them members of Pura Désa Batuan. Ties between king and subjects were, largely, not territorial but personal or particular. One's fealty to a lord or king depended on the individual relationship between the person and his family and the noble clan, and it could be disrupted at any time.[24]

However, it is important in understanding Balinese political organization to recognize that all of these ties among humans were not utilitarian at base but what some might call "religious." As I have shown in the analysis of the rituals of Pura Désa Batuan, the social community consists of *niskala* beings as well as humans. The claim of a Balinese king to authority over his subjects is at base a claim to access to powerful *niskala* beings and to his *sakti* ancestors, who may be incarnated in the body of the king himself.[25] Each court had to convince its commoner neighbors that they needed the blessings of the ancestral gods of the royal house.[26] On the other hand, every royal and noble house, large or small, needed not only the support of the local population but also the blessings of the local gods.

Thus a primary project of any king, prince, or lord is the carrying out of rituals that engage commoners in their success and the building and maintaining of temples that enlist the commoner allegiance to the special gods of the noble clan. Thus, as soon as a rising royal clan reaches sufficient strength, it builds a *dadia* temple outside its household temple, dedicated to the gods of the clan; subsequently, a state temple or *pura panataran,* dedicated to the gods of the locality, is either built or, more often, reconsecrated by the upstart king.[27]

The manner in which the ancestral gods of royal houses relate to the gods of local temples such as Pura Désa Batuan needs further research. The first are ancestral gods, while the second are, for the most part, gods of a specific territory. There is, of course, a difference in such matters between the ritual observances of a major royal house within its own immediate locality and the ritual observances of minor noble houses that live within local communities. This latter is the case of the gentry living within the boundaries of Batuan's *désa adat.* As residents they should pay homage to the gods of Pura Désa Batuan; as nobles with ancestors in a distant village, their sources of spiritual strength lie elsewhere.

The tie between worshipers and a *pura désa* is largely

territorial, since, with certain exceptions, those who re-side within its *gumi* must pay some sort of homage to its deities. Even anthropologists temporarily resident in a village should, for the sake of everyone's safety, make some sort of indication of homage. Since the village gods include beings ancestral to current inhabitants, this territoriality is considerably qualified, and commoner families who have moved away from Batuan may re-turn to pay homage to their ancestral origins. The gen-try resident in Batuan said, in the 1980s, that they would worship the god of the locality (Ida Betara Puseh) but would not worship the ancestors of the commoners (Ida Betara Désa), since these latter were lower in status than their own ancestral deities.

Works Made in the Eighteenth and Nineteenth Centuries

Of the carvings and fragments in Pura Désa Batuan made "before the earthquake" most may have origi-nated in the two previous centuries, but there is no way to date them. It may be that most of those already dis-cussed above are later than I think.

One bas-relief frieze, around the base of the Méru Agung, very likely belongs here. I show and discuss it in the next chapter, however, so that I can compare it to its replacement of the 1930s.

The Altars along the North Wall of the Jeroan

The altar to Ida Ratu Atma discussed above is the first in a row of six small altars to diverse deities who are, in spite of their location along the north wall, supposedly the holiest side of the temple, oddly unimportant. Dur-ing ceremonies they are virtually ignored, aside from the provision of trays of offerings. They remain out-side the center of activities, as a sort of divine witness-ing chorus, along with a scatter of other shrines in other parts of the temple.

Perhaps because their pillars were small, they were not damaged in the earthquake. The ones that were there in the 1980s had been made, most likely, in the nine-teenth century. In their simplicity and lack of polish, perhaps, they represent the major style of carvings be-fore the present era. One contemporary painter charac-terized this style as *polos,* or "simple," and contrasted it with contemporary work with all its curlicues as *rumit,* or "entangled."

The first in the row, on the east, is the altar to Ida Ratu Atma. Second in the row is an altar called the Ge-dong Sari. A *gedong* is any building that is enclosed with a door. This altar, tallest in the row, may once have been the place where the figures of the double god, Rambut Sedana, was kept between ceremonies, until it was de-cided that they would be safer in the *panyimpenan* altar in the house temple of the *pamangku,* the Mrajan Mangku. During the ceremony, the *arca* of Rambut Sedana are not enthroned here but in the Balé Semanggén.

Third is an altar called Paliangan. It has no god-figure, and the *pamangku* said he did not know what it was for. He said the name meant "calmness." Fourth is the Gedong Tarib, also known as Gedong Sarén, which the *pamangku* said meant "place to sleep."

Altars like the fifth and sixth are to be found in nearly every temple, including household temples, usually in about this location. The fifth is called the Taksu Agung. Offerings to its god request success in whatever project you are about to begin. The sixth, the Sedehan Nyari-kan or Ratu Nglurah, is thought of as a court official, someone to whom you go at the beginning of a temple ritual, to give preliminary notification that you are go-ing to request audience with the higher gods of the tem-ple. None of these altars have god-figures placed in them during rituals, but they are all given offerings. I believe these deities are thought of as attending and observing the rites but from a distance.

The carved decorations on these altars are restrained and rather abstract. They seem to be predominantly

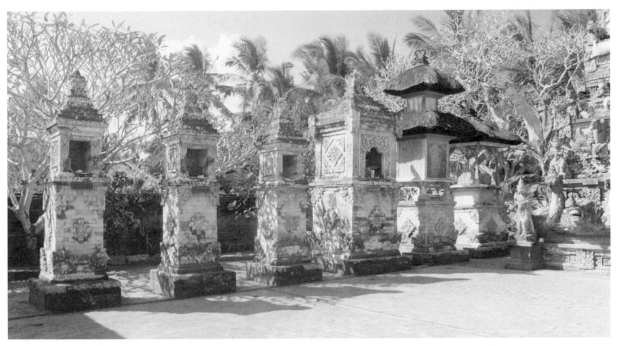

Figure 4.13. Row of altars along the north wall of the Jeroan. Carvers: unknown. Date: unknown. Photographed in 1995.

Figure 4.14. Floral design of a demon on one of the altars on the north wall. Carvers: unknown. Date: unknown. Photographed in 1995.

flower and leaf designs, although a closer look shows that certain animal-like images are suggested. The two illustrated closely resemble the common pattern called *karang bintulu*.[28] This image is at base one of a demon with one popping eye, grimacing lips, two fangs flanking four square teeth, and a protruding tongue. But it has been converted, through abstraction, into a flower. As with the more figural carvings of the Méru Agung and other altars, these flower-demons represent fierce members of the entourage of the deity of each throne.

The Altars to Detia Maya, the Architect of the Gods

Two statues placed in the front of the Great Door of the South (the Kori Agung), as guardians of the gate, are a pair of squatting men, dressed as commoners, with white sashes across naked chests, set up high on two altars with roofs protecting them. These were called by the *pamangku* the *sedahan apit lawang* (officials in charge of the gate). Others, however, told me that they were

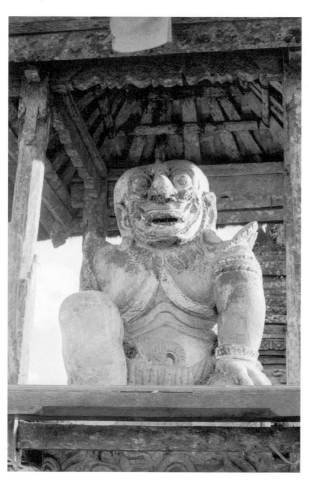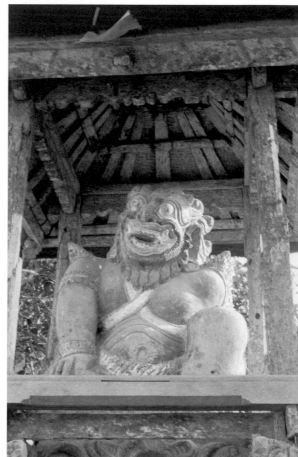

Figure 4.15. Two statues of Detia Maya, temple builder to the gods. Carvers: unknown. Date: unknown (before 1917). Photographed in 1995.

two representations of the same being, Detia Maya, otherwise known as Undagi Swakarma or Wiswakarma, temple builder and carver to the gods, in a story told in the classical shadow play. Mentioned in the *asta kosali* handbook for architects, Swakarma built a great palace for the Pandawa brothers. Undagi Swakarma did the *sikut* in laying out their palace. He is crouching because he is a commoner, a servitor of the gods. The figures themselves are pre-1917, although the structures holding them were built in the early 1930s at the same time that the rest of the gateway ensemble was made.

These two *niskala* beings are given large quantities of offerings during the Odalan, set up on a large platform before them. The other statues around them, also guardians of the gate, are not given such offerings.

. .

The fragmentary statues that have survived the earthquake, treated so respectfully today by the people of Batuan, reveal little of the circumstances within which they were made and first viewed. The copper inscriptions—whose contents were unknown to the villagers—concern a time period much earlier than the carvings. The oral accounts of Kebo Iwa tell only that the carvings were made by a commoner and that they are considered somehow miraculous in their craftsmanship. With these sorts of materials, an anthropological resurrection of the precolonial temple is not possible. What it may have looked like, what ritual practices and social institutions sustained and created it, remain out of reach. Without further circumstantial evidence, speculation based on analogical equations between present-day ritual and social practices of the previous centuries would be too far-fetched. That sort of information—on attitudes, discourses, and actions involving the statues, their imagery, and their artistry—is available only in the twentieth century.

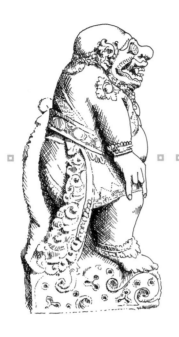

The Age of the Dutch Rajas (1908–1942)

Two earthquakes, one geological and the other social, shook the temple at the beginning of the twentieth century. The first initiated a period of renovation (even, perhaps, a re-imaging) of the physical temple. The second, the Dutch occupation of Bali, began a much longer and in the end more drastic series of transformations of Balinese society, with perhaps even greater consequences for the temple. At first a mere quiver of the ground, this social seismic movement did not reach its convulsive climax until the 1960s. Its reverberations are still felt today.

A Colonial Order Constructed

When the Dutch conquered South Bali (1906–1908), they drew new maps of Bali that delineated with sharp boundaries their new administrative districts. The Dutch governmental divisions only partially coincided with the indigenous ones, and in any case, they introduced a totally new conception of political authority based on a simple hierarchy of increasingly larger territorial units, each headed by an official, and culminating in the top colonial official in Batavia (now Jakarta) and in Holland, in the Dutch parliament.

In Bali, the Dutch set up a colonial administration made up of local Balinese officials under a few higher Dutch administrators. In the beginning they chose, and chose to train for the jobs, members of the Balinese titled groups, whom the Dutch considered to be a natural aristocracy. These great and little native officials were the ones that the Balinese popularly called the *raja raja Belanda*. Their authority came from the Dutch (the *Belanda*), but they thought of themselves and behaved as rajas toward their subjects.

The Dutch gave their new administrative posts Balinese names drawn from the language of the indigenous royal courts.[1] They called their new village head a *prabekel* (or *perbekel*) and his territory a *désa*. The term *"prabekel,"* which had signified a personal vassal of a raja, now meant the representative of a centralized colonial government. *"Désa"* had meant the population served by a *pura désa, pura puseh,* and *pura dalem,* but now it meant the territory administered by a *prabekel* in the new sense. Above each group of *prabekel* came a *punggawa,* again a term formerly meaning a personal vassal of a raja. Above the *punggawa* were placed the regency officials — the *regen* and the *residen*.

The old terms thus acquired new meanings, and the Balinese quickly learned to shift easily between old and new meanings, but when they needed to be explicit they invented new verbal distinctions, for instance between *désa dinas* for the new governmental unit (*"dinas"* comes from the Dutch word *dienst,* "service"), and *désa adat* (*"adat"* comes from Malay, and ultimately Arabic, and signifies here "customary") for the earlier ritual unit. A similar distinction developed, at the *banjar* level, between *klian dinas* and *klian adat*.

The Dutch introduced another novel social distinction, which was to have far-reaching consequence in the latter half of the century, when it served as the impetus for the growth of a modern social class system. Again infusing old terms with new meanings, the Dutch made a distinction between *pangayah* and *pamijian*. *Pangayah* indicates those villagers who were required by the new colonial government to work on building roads. This was particularly onerous and demanding labor, since the Dutch made it a priority to complete a network of roads over the entire island during the first decade of their sovereignty. *Pamijian* were those who were excused from this corvée work. *"Pangayah"* is the Balinese term for "work for the gods or for kings." *"Pamijian"* comes from an old word meaning "a person who is under the direct governance of a raja." Those whom the Dutch called *pamijian* were the *triwangsa,* the nobility. *Pamijian* were governed directly by the district governor, not by the local *prabekel* or by the *punggawa* above him. All over the island, of course, many people tried to be classified as *pamijian*.

Excusing the *pamijian* from the corveé was one step toward a new sharpening of the distinction between *sudrawangsa* and *triwangsa*. The second was the establishment of a civil service in which *triwangsa* held most offices. The third was the opening of a few schools in which select Balinese would learn the language (Malay) and the skills of government work. Here, too, most of the pupils were *triwangsa*.[2]

With these three acts—the systematic exemption from corvée road work, the selection of village chiefs from among the nobility where possible, and the training of noble youths for administrative jobs—the Dutch marked Bali's nobility out as a "ruling class." (Of course, in practice, during the Dutch colonial period, some commoners rose high in their civil service, but their numbers were always few.)[3]

At the same time, the Dutch further strengthened the local community by abolishing the kingdoms and their warfare, thereby eliminating a major motive for movement of families (primarily *triwangsa*) about the island, and setting up the road-building corveé on the basis of local communities. All of these administrative moves re-

inforced the importance not only of the local communities themselves, but perhaps that of the local temples as well.[4]

Building roads, of course, had consequences of a contrary sort—that of opening up social life. Villagers living along the roads, such as Batuan, were from then on drawn into the commercial life of Bali as a whole, as peddlers of foodstuffs and, as the century wore on, of tourist products (wood carvings and paintings that were soon produced on a mass scale, and dance and musical entertainments of all sorts).

In Batuan, the Dutch-appointed *prabekel* was the highest-ranking man of the village, Déwa Gedé Oka (Ukiran), the head of Batuan's noble house, Jero Gedé. When the Dutch set up an elementary school in Sukawati, just to the south, in the 1920s, his sons and nephews attended. In the next decade, some selected Brahmana boys and a few wealthy commoners were also chosen. This was the beginning of the development of a new kind of social class based on education and the consequent access to offices in the government administration. One of Déwa Gedé Oka's sons became, by the 1930s, the assistant to the new *punggawa* in Pliatan, and his other sons had government jobs such as foreman on the road crews. The full differentiation of an educated *pegawai* (Ind., "civil servant") class did not take place, however, until after the 1950s.

But in the first part of this century the relationship between individuals who were *triwangsa* and others who were *sudrawangsa* must have been highly variable. There was no distinction between them based on way of life, and most of the gentry were no richer than the commoners, while there were always a few commoners who were, by local standards, quite wealthy. Since the *triwangsa* regularly took commoner wives, and therefore many had commoner mothers, aunts, uncles, and cousins, commoners and nobles intimately intermingled even within their families.

As far as I can tell, mainly from oral accounts, in the first half of the century the members of the highest gentry house, Jero Gedé, had much more agricultural land than anyone else, but most of the other gentry had little. Any noble family stationed by a king in Batuan must have been granted rice land and subjects who were obliged to do much of its farm labor. Bali's kings claimed ownership of all undeveloped land and any rice land *(sawah)* and dry-garden land *(tegal)* that was not claimed by a legitimate heir. In times when illness and violence made life spans short, a great deal of agricultural land often may have been left with no living heir, and selling land to nonfamily members was restricted. In consequence, every local king had a continuing source of land in nearly every village. This explains, perhaps, why the kings and their followers always had a great deal of land of their own. Even today in the Batuan area, a great deal of (largely dry) land is owned by the king of Gianyar and by the nobles of Sukawati. Some of that had been seized from Negara, when that kingdom was defeated in 1891. But as the century wore on, with sources of new land no longer accessible to them and with a new distribution of what there was in each generation, the gentry houses in Batuan grew poorer. They sold or pawned much of their land to pay for the education of their sons and to maintain a standard of living commensurate with their status.

. .

The Dutch saw their colonial enterprise as one of establishing peace and order (*rust en orde* in Dutch) among the indigenes, not only at the level of interisland commerce, which was their primary concern, but also at the level of regions and villages. Peace and order, which were necessary for the development of Dutch commercial interests, entailed the construction of a new kind of judiciary system, the institution of a tax-collecting system, and, with it, a register of land ownership.

In implementing these changes, the Dutch weakened the power and influence not only of the various rajas, but also of the *désa adat* councils. Where formerly the *bendésa* had been a position of important judicial functions, now most of the administration of criminal and civil justice was transferred to Dutch courts. Below that, the *bendésa* together with the *krama désa* and *krama banjar* had been empowered to rule on such matters as theft, adultery, inheritance and selling of land, even on cases of suspected witchcraft. Their sanctions ranged from fines payable into the temple treasury to expulsion from the village residential lands, and even, in the witchcraft cases, to execution. Convicted criminals could appeal to a nearby prince or king, who could take them under royal protection—or exile or execute them. Land, the most important economic resource, was closely controlled by the *désa adat* and the raja. Use of house-land and dry-garden land was largely determined by the meetings of the *krama désa,* since such land was considered the property of the gods of the *pura désa* and to be used only by those who kept up their worship responsibilities. Rice land was more easily bought and sold; but since temples owned some rice land, and raja owned even more, and since both allowed it to be sharecropped, they governed much of its use.

It is important to recognize that these governing functions carried out by the *désa adat* and the raja were not distinguishable from their "religious" functions. The contrast between sacred and secular was introduced by the Dutch. The authority of the *désa adat* was the authority of its gods, as the authority of any raja was the authority of his gods.

When the Dutch conquered militarily the kingdoms of south Bali in 1906–1908, they confiscated all the wealth of the defeated kingdoms, including their lands, and exiled their leaders. A number of southern kingdoms (among them, Gianyar and Karangasem, plus some smaller ones) had allied themselves with the Dutch and survived with their wealth untouched. Nonetheless, as the colonial regime matured, it became evident that even these prosperous former raja-doms had lost almost all their governing functions. The Dutch gradually replaced the judicial activities of the *désa adat* and the raja with a rationalized bureaucratic judiciary regulating crime, tax collecting, and land tenure.

The loss of governing functions of the *désa adat* did not diminish its social importance or that of the temples it served. In Batuan, as will become clear, the Pura Désa as a community seems to have flourished during the colonial time. While the Dutch governmental innovations had successfully imposed a distinction between secular and sacred domains in practice, the temples continued to reject it. The colonial government imposed its "peace and order" in Bali (at least until the rise of nationalism), but the temples continued to hold the monopoly on the achievement of *rahayu* (well-being and safety), a very different and much more important kind of peace and order. The theology of cosmic order had not yet, I believe, been developed.

The Basic Layout of the Temple Revised

The earthquake itself, in 1917, was brutal. Temples and houses were knocked down all over southern Bali. Some Batuan people remember vividly how the rubble of the fallen walls filled the paths of the village. One old woman told me how she just missed being killed when the wall fell on the place where she usually slept because she had naughtily insisted on staying up late with her grandmother, working on offerings.

The quake, which also wreaked havoc in the irrigation system, was followed by a serious plague of mice and then an epidemic of influenza.[5] The village took a long time to recover. The community nonetheless immediately began the arduous work of cleaning out and restoring the temple, even before they worked on their own houses.

In 1915, according to a Dutch controleur's report, there were only 396 families in the whole village of Batuan. A hundred of these were *pamijian*. These latter all lived clustered at the north end of the village, not far from Pura Désa Batuan. At least twenty-one commoner families who were the traditional retainers of the nobles *(roban jero)* lived interspersed among the gentry. Many of these had rice fields called *pecatu,* which meant that their use of the field was contingent on their providing service to their lords. Of the hundred nobles, about half were Brahmana.

This was a very small population on which to draw for the extensive work to come on the Pura Désa Batuan. Four hundred families probably meant at most a hundred adult men, of whom about one-fourth were excused from heavy labor, not only by the government but also by the customary rules of the Pura Désa Batuan.[6]

The villagers worked rapidly in the first few months to rebuild the main altars in the Jeroan first. The innermost chamber of Pura Désa Batuan is the throne room, where the highest deities in the vicinity congregate during ritual festivals. On a central square of four roofed altars they sit and stand, facing one another and the crowds of their entourages and worshipers. The major transactions of the Odalan are conducted in this inner room of their palace. The urgency in rebuilding the central altars was great. Not only was it necessary to regain the general protection of the gods of Batuan, but also, without their *tirta,* no one could hold any other ceremonies, such as cremations, tooth filings, or even *odalan* of clan temples within the realm of Pura Désa Batuan.

The smaller altars on the north wall had been mostly unhurt, and the Méru Agung was, miraculously, only shaken. It must have been by early 1918 that they had up again, at least roughly, the ritually crucial central square of altars: the Méru Agung, the Pengaruman, the Balé Semanggén, and the Balé Peselang. They left until later the work of decorating them in the form we see them today. The three great roofs of the Méru Alit

(smaller *méru*), which had been of stone (not the black palm fiber of today), were dislodged. Several attempts were made to fix them, but a strange force prevented the workers from moving them. It must have been at this point, right after the earthquake, that the congregation ceased using the Méru Alit as a god-throne. Someone finally succeeded in moving the roofs, and they were replaced with new roofs made of black palm fiber *(ijuk)*.

The fragments of thrown-down old carvings were repaired or propped up again with new masonry around them, and new roofs were made where necessary. Some of the most ancient carvings (the statues of Ratu Saung and Ida Betara Siwa) were placed within closed altars, behind elaborately carved doors.

Oral history says that when the minimum structures were up the villagers then put on a *caru agung* in which the meat from a whole cow was offered, and then a *melaspas* purification and dedication ceremony for the renovated altars. Only after that was done could they have an *odalan* inviting the divine to return. One old lady remembers a special Calonarang performance at the Pura Désa in which the evil queen she called I Rangda Dirah tried to destroy the kingdom using a volcanic eruption, and how a spectacular tall replica of a flaming volcano made of bamboo and colored paper was brought out on the stage.

The walls around the temple were not rebuilt for a decade or so after the altars, an indication that walls are not as important as altars. Temple walls do not define a space, but simply surround the area where the gods are enthroned. The walls and the two grand gateways on the south, the *candi bentar* and the *candi kurung* that frame the courtyard between them, were not completed until about 1936.[7]

．．．．．．．．．．．．．．．．．．

The first major really novel undertaking was the introduction of an entirely new altar, placed among the main

altars, in the holiest northeast corner. This was the Padmasana, dedicated solely to Ida Sanghyang Siwa, the highest of the high gods (also called Ida Sanghyang Widi Wasa, "the Almighty God").

The addition of the Padmasana, perhaps around 1920, may say something important about the community of Batuan of the time. The Padmasana has special meaning for the Brahmana people of Batuan, since it is the only shrine within Pura Désa Batuan where the Brahmana people may worship *(mabakti).*[8] I was told that there had never been a *padmasana* in the temple before that.

As I have shown, a *pura désa* is dedicated primarily to the *niskala* beings of the immediate locality and the ancestral spirits of its first inhabitants and their descendants. A *padmasana,* however, is a shrine for the invocation of a transcendent deity, one who is superior to all other forms of the divine, a universal spiritual force encompassing all personal and local powers. Of course, Betara Siwa is called on and recognized over and over in the words of the Pamangku's prayers, but only as a witness of the proceedings.

The introduction of an altar to Siwa in the early 1920s may have indicated a new popular stress on the greater cosmology of the larger world outside Batuan's boundaries. It may, however, have been a response to a quite contrary pressure to localize, for the presence of a *padmasana* in a temple means the new inclusion of Brahmana worshipers where none were before. Had the Brahmanas of Batuan been worshiping there wrongly and had they suddenly become newly aware of their error? Or had they never been worshiping there and now wanted to be included? I could not find out. In either case, whether the introduction of the Padmasana into the temple was a universalizing or a localizing move, it certainly must have meant that, at that time, the Brahmana were in a strongly influential position within village life.

Was there controversy about inserting a *padmasana* in

the old temple? No accounts remain, but knowing the prevalence of argument in Bali today, I would say that there could easily have been conflicts about it that have since been erased from memory. On the other hand, the Padmasana may have been easily accepted by the *krama désa* because of the prestige of the priests. It is very likely that the intense conflicts that were to arise between the commoners and the noble Brahmanas in the 1960s were not foreshadowed in the 1920s.

The present commoner inhabitants of Batuan feel no incongruity, of course, in regard to the presence of a *padmasana* among their other altars, since it represents respect paid to one more god among many.[9]

. .

Another, even more striking, innovation planned perhaps in the early 1920s was the reorientation of the entire layout of the temple itself, so that the main entrance would be on its south side. Exactly what the layout of the temple was before the 1917 earthquake has been impossible to determine. But it is certain that just before the earthquake the main entrance was the still intact West Gate, and there was only an unbroken wall on the south. Alternatively, there may have been only an unwalled area there on the south, in which were the Balé Agung and the small private *panti* temple, Pura Buda Manis.

One might easily imagine that at one time (how long ago would be impossible to determine) Pura Désa Batuan had only one large courtyard, with its main (or only) door on the west. Only one deity, Ida Betara Baturan, is mentioned in the Prasasti text. In subsequent centuries other lesser shrines and temples must have been added, "leaning up against" the main temple. One of these, against its then southernmost side, might have been the little temple for the Balé Agung, the Pura Ulun Balé Agung. The altar itself, the Balé Agung, could have been in an unwalled area there. The other small temple

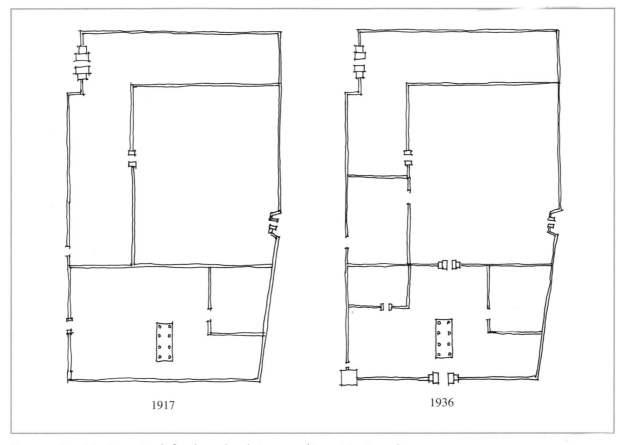

1917

1936

Figure 5.2. Pura Désa Batuan just before the earthquake in 1917 and in 1936 (conjectural).

against its then southernmost wall would have been the Pura Buda Manis, of a mixed Pasek group. Later a wall could have been built around these two, with possibly its gate opening to the west.

I was told that just before the earthquake the temple's southernmost wall, made of large blocks of *paras* stone placed with open spaces between them in a kind of grillwork design called *ancak,* had no gate in it. This wall was knocked down in the earthquake. To replace this wall and the one behind it with two gateways in such a spectacular fashion could have had important theological implications. As I have shown, a study of the rituals themselves shows that these southern gates are hardly used by the gods. Why then were they thought of?

I can only make some guesses. One major, if indirect, impetus to the decision to reorient must have come from the colonial government. Immediately after the earthquake, the Dutch Archeological Service did a number of surveys of the damage to Bali's temples. The West Gate of Batuan's temple was declared a valuable ancient site, and the villagers were prohibited from touching its ruins. For years, until 1993, the processions of the gods went out and in between two weed-entangled piles of rubble.[10]

Under the enforced abandonment of the ritually

most important gate on the west of the temple, the people of Batuan might have felt that building two new gateways on the south side was a compensatory gesture toward the gods. However, certain nonspiritual concerns must also have been considered. One of the older villagers ventured a guess as to why the people chose to introduce the southern gates. He said that when the gods went out through the western gate, they came immediately to a small empty field, while if they emerged through the southern gates they would find ample spaces for dances and dramas, as well as a main path leading through the village. This would be a better place to build the dance pavilion and to attract larger audiences.

. .

Who made the decisions? The *krama désa* was the responsible entity, materially as well as spiritually. They had to provide most of the materials and all of the work. The gentry, excused from these material dues and all heavy work at that time, may nonetheless have had a strong influence on the deliberations.

Through the first part of this century, Batuan's reigning prince was Déwa Gedé Oka. His father before him had been ruler of Batuan. After the previous noble lord of Batuan from the Gianyar clan had died without heirs, he had been given a palace and rice land in Batuan by the Déwa Agung in Gianyar in return for his service as Gianyar's representative there. Although Déwa Gedé Oka was born in Batuan, he was raised in the Gianyar royal court, where he learned literature *(sastra)* and the dance (especially the *gambuh*). He was the ruler in Batuan when the Dutch took over, and he and his sons and protégés remained rulers, formally and informally, well into the 1950s. In 1915 he was appointed by the Dutch to be the first *prabekel* of Batuan.

Déwa Gedé Oka, in the 1970s and 1980s referred to respectfully as Anak Agung Lingsir (Great Ancient One), had a residence called the Jero Gedé Batuan (the Great

House of Batuan; today upgraded in popular speech to be Puri Batuan [the Palace of Batuan]). As the representative of the Dutch, Déwa Gedé Oka had some influence, but as head of Batuan's royal house he may have had a great deal, especially since he himself had strong spiritual leanings.

Even in the 1980s, Déwa Gedé Oka was remembered as a healer and a seer. He was said to be able to diagnose and cure the sick using only a piercing glance at their eyes. He was also a great teller of tales and an exciting dancer of *gambuh*. Déwa Gedé Oka meditated regularly at the altar of Ratu Ngurah Agung. It was revealed in his dreams that he had a special relationship with the demon-king Ratu Macaling from the island of Nusa Penida, who invaded every year, strewing epidemic diseases and crop failures everywhere. Déwa Gedé Oka met with Ratu Macaling's followers and made a contract with them to protect the people of Batuan and divert their greedy rampages to neighboring villages, an act that proved his *sakti*. One of his descendants said that Déwa Gedé Oka taught the villagers how to dance the *rejang* sacred dance as a special propitiation to Ratu Macaling (see chapter 3).[11]

The Bendésa, during the entire rebuilding of the temple from 1917 through 1940, was I Nyoman Pageh, a commoner who must have been pushed forward by Déwa Gedé Oka. He was his close friend and protégé. Pageh's houseyard adjoined Jero Gedé, for his father had been a *prabekel* to the Gianyar royal house in the precolonial time. One of Nyoman Pageh's daughters married a nephew of Déwa Gedé Oka. Nyoman Pageh was himself a stone carver and builder *(undagi),* a dancer (in *topéng*), a healer whose skill was based on the use of sacred texts (a *balian wisada*), and a literary man who attended *mabasan* readings.

One older man phrased the relationship between Déwa Gedé Oka and those who did all the work, the Bendésa and his team of carvers, as one in which Déwa Gedé Oka "acted as *ratu,* or king, over them" *(ngrat-*

unin). The same consultant and several others stressed that in those days, everyone lived in a state of fear. They were afraid of the *tan ana,* the invisible spirits that lived in every clump of bushes and trees (of which there were many in the lightly populated village of that time). They were afraid of the *hyang,* the gods. And they were afraid of the *anak agung,* the leading nobles, especially those supported by the colonial government.

It is also apparent that the commoners looked to the *triwangsa* for guidance in what might be called "high" religious matters, for some *triwangsa* had a near monopoly on reading and writing and therefore on the sacred texts. A commoner such as Nyoman Pageh could only have learned his literary and spiritual skills at the foot of a learned Brahmana or Satria man. During the 1920s, one of the *pedanda* held a continuous daily class in reading and writing, mainly for the sake of the Brahmana youngsters, but also some Satria and some commoners were allowed in.

I believe that the decision making of the *krama désa* and its component *banjar* was largely consensual, but also strongly influenced by members of the royal house of Batuan. For instance, the selection of a new *pamangku* in about 1945 was led by the *triwangsa,* who sponsored the present incumbent of the office. The Pamangku told me that after the *triwangsa banjar* expressed its choice, the *banjar* of Puaya and Peninjoan voted to accept it, thus tipping the balance.

Once the *krama désa* had made up its mind, the layout had been complete, and the proper initiating rituals had been accomplished, the heavy work began. Wood was collected. Bricks were made. Large chunks of specially hard stone for the *candi bentar* and for the largest statues were brought from a more distant ravine. One man remembers going repeatedly to the nearby Petanu River east of Batuan to get stone for the carvings. Each large rock was placed on a latticework carrying litter with everyone shouting, as at a cremation; twenty people were needed people to carry it.

The stone and wood carvers, if present-day experience applies, were chosen by and supervised by the Bendésa. As a carver himself, Pageh was an ideal supervisor. He (aided by other educated people, including the prince, Déwa Gedé Oka) must have conceptualized every major piece of work, such as the great gateways. But the individual carvers must have also made significant suggestions, and in any case were fairly free in carrying out details. My interviews in the 1980s, which centered each time on particular figures and specific architectural features, produced a surprising agreement that there were both an overall team and also important master carvers. Everyone stressed that the making of temple carvings is a group effort, with even the apprentices making suggestions. These last, of course, became the next generation of master carvers, in the 1950s and beyond. It is possible that when the temple fell in 1917, there were a few Batuan stone carvers who had been trained in one of the royal houses nearby (Sukawati, or Blahbatu, or Gianyar, or Pliatan), but their followers in the 1930s all, I believe, had served their apprenticeships right in Batuan, working on its temple.

The carvers were all commoners. They included the Bendésa himself, I Nyoman Pageh from *banjar* Batuan Gedé; I Wayan Ramia and I Madé Rata from *banjar* Tengah (both of whom were also *bendésa* for a while); I Wayan Krepet, I Wayan Gerek, I Purna, and I Yasa from *banjar* Peninjoan; and I Wayan Wina from *banjar* Puaya. It is significant that the workers had been drawn from a number of different *banjar*—not, I think because of a shortage of trained carvers, but rather because of a conscious policy to have every portion of the *désa* represented.

People's memories differ about what kind of work the gentry did on the temple renovation. Some say that during the 1920s and 1930s they all labored just as hard as the commoners, putting their shoulders to the great stone-carrying litters, digging and sweating like everyone else. The Triwangsa themselves say that they did

no heavy labor, but helped with the thousands of offerings needed, with the cooking, with technical advice, and, later, with providing all the music and dance at the festivals. I think that the relationship of people of gentry and priestly families to the temple—at that time—depended a great deal on the individual and his or her particular talents, rather than their seeing themselves as a bloc of *"triwangsa."*

Some people today sometimes speak nostalgically of this time as "the time when Batuan was still whole," in which nobles and commoners worked together as one on rebuilding the temple and carrying out its rituals, before the 1960s when everything fell apart, a story that I will come to in chapter 7.

Below I present and discuss the works made during the age of "the Dutch rajas." Since the villagers had virtually to recreate their temple, it was in the colonial decades that its main form and style was set. In the postcolonial times, the vision developed in the 1920s and 1930s was only refined and completed.

The Altars of the Jeroan

I start my examination of "artworks" made in the colonial period with the structures of the innermost courtyard, the Jeroan, which had been given priority by the village: first, because of its importance, the Méru Agung, then the Pangaruman, the Méru Alit, and the Padmasana.

While the Padmasana has not been renovated since its first carving, the others have been. In describing the Méru Agung I include much that was added to it in later years, including some features added in 1993, in order to give a truer picture of the whole conception of this altar. However, two other thrones of the central ritual square, the Semanggén and the Balé Peselang, were re-erected at this time, but paintings and carvings were not added until later, and I discuss them in chapters 7 and 9 respectively.

The carved figures and paintings that decorate these thrones are more than decorations. They represent participants in the proceedings, but are more than representations. They are potential manifestations of the *niskala* beings who have come to the ceremonies. They are not contemplated but are treated as part of the events. As manifestations of the entourages of the royal guests, these figures are enabling, even empowering personages.

The Méru Agung, the Main Throne

The Méru Agung is, as I have shown, the throne for the two highest deities of the temple, Ida Betara Puseh, the god of the locality, and Ida Sanghyang Aji Saraswati, the goddess of learning and of the temple's ancient charter, written on copper plates. Its black three-tiered roof *(méru)* reaches far above the other buildings in the temple.[12]

The form of Batuan's Méru Agung is ancient, but its present stone carvings and paintings were made in this century. While it did not fall down in the earthquake, it has since been renovated so often that the whole is virtually new. Every era in the history of the temple renovation has left its traces on the Méru Agung, a story of changing human fortunes and tastes that are important to an adequate understanding of the temple's carvings.

Some of the carving and painting on the Méru Agung was done in the 1990s, but I discuss them here, since they are essential to an overall understanding of this important altar. You can't always tell from visual evidence which carvings are ancient and which are new. The four statues carrying offerings, on the ground in front of the Méru Agung in the 1995 photograph (figure 5.4), although weather-beaten and mottled with lichen, are not old at all but were made in about 1984 by Déwa Nyoman Cita.

The Architectural Form of the Méru Agung

The shape of an altar as a small rectangular, rather than square, house, with the door in the longer side facing west and high multiple roofs, is rare in the Gianyar region and is probably ancient, possibly more than a thousand years old. The form was called by the government archeologists a *kehen,* an archaic term not spoken in Batuan. *Kehen* altars are found mainly in the Karangasem region, dedicated there also to Ratu Gedé Puseh. In the great temple of Besakih, for instance, a *kehen* is used for the storage of the god-figures when not in use.[13]

The function of containing the dangerous energies of the hidden gods is reflected in the alternate name of the altar, the Gedong Rum (*"gedong"* means "enclosure" and *"rum"* means "fragrant"), putting the stress on its form as a small room with a closed door. Inside the altar, behind the carved door, are several ancient statues (among them Ida Betara Siwa, discussed above) that are said by the Pamangku (who is the only one allowed to come near them) to give off a sweet scent.[14] It is likely that the Méru Agung of Batuan was, once, the place where the god-figures were stored when no ceremony was in process. Today they are not kept there but rather outside the temple in the *panyimpenan* within the house-temple of the Pamangku of the Pura Désa Batuan.

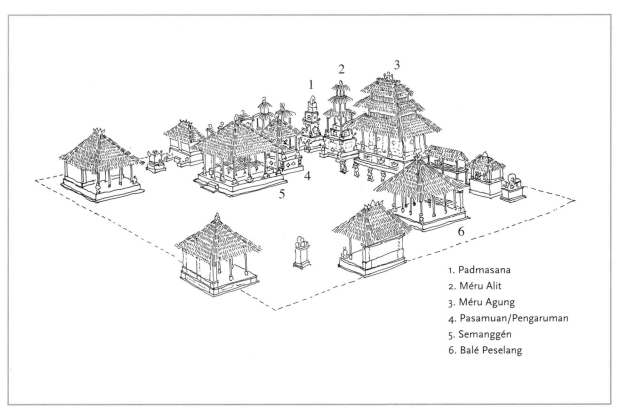

1. Padmasana
2. Méru Alit
3. Méru Agung
4. Pasamuan/Pengaruman
5. Semanggén
6. Balé Peselang

Figure 5.3. The Jeroan of Pura Désa Batuan and the main altars.

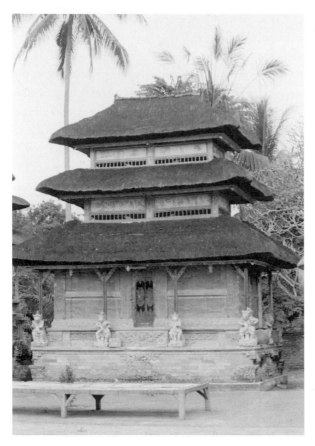

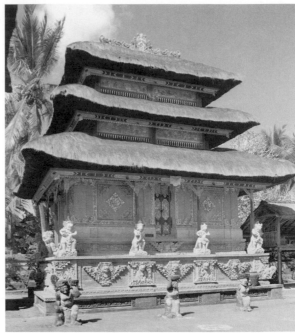

Figure 5.4. The Méru Agung. Left—Carvers: I Nyoman Pageh and team. Date: 1920s. Photographed in 1983. Right—Carvers: unknown (1990s). Date: 1920s; 1995. Photographed in 1995.

Since the altar is oriented toward the west, when the two highest Batuan god-figures (Ida Betara Puseh and Ratu Sanghyang Saraswati) are enthroned in it, their backs are to the east, with their left hand toward the south, as they may have been placed during the entire existence of Pura Désa Batuan. They face the other gods enthroned nearby and their worshipers, with members of their retinues standing below them or hovering about, also face toward the other worshipers.

All architectural structures are conceptualized by Balinese artisans as built up in horizontal strata or *palih*. This holds not only for buildings such as the Méru Agung, but also for gateways and thrones such as the Padmasana.

The structural layers of the Méru Agung are clearly visible. There is a base, then a level on which are placed the columns supporting the roof, and in front of them, as a kind of column-support, a series of carved figures (of characters from the Ramayana; see below). The next level up is that of the *gedong*. Above that are three more levels, each with a roof.

Accentuating these layers are numerous small carved rows of repeated motifs, resembling snails, leaf forms, rosettes, or other small figures. These are usually referred to as *karang* ("design " or "pattern"). In addition, most corners and some flat areas have more ornate *karang* on them.[15]

The overall effect of the layer-cake construction is to give the Méru Agung a look of great stability. Its marked horizontals pile up to the three diminishing trapezoids

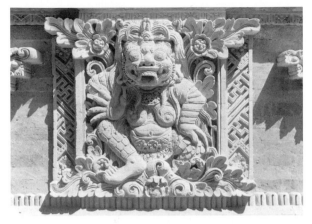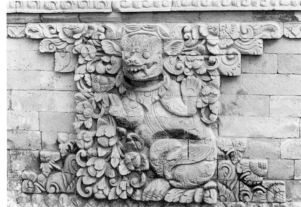

Figure 5.5. Bas-relief carvings, replaced in 1993, on the base of the Méru Agung. Left—Carver: unknown. Date: 1993. Right—Carver: unknown. Date: before the earthquake (1917). Photographed in 1995 (left) and 1983 (right).

of the rooftops. Its clear balanced symmetry further gives a feeling of solemnity and dependability to the whole.

The Bas-Relief Carvings around the Base of the Méru Agung

A frieze of strange composite animals, with heads of cows, bears, and elephants, circles the base of the Méru Agung. In 1983 when I began my research, these carvings had been preserved from before the earthquake. A new set replaced them in the early 1990s. A comparison of the styles of carving of the two versions, and with the frieze on the Balé Agung from 1974, provides a clear vision of how the styles have changed in this century.

The older carvings were probably made in the latter part of the nineteenth century, judging by the stone from which they were made, which was quite soft. The animals were carved in shallow relief in an angular, abrupt manner. The new ones are cut deeply, and the lines and shapes are smoothly rounded, but they follow closely the original content. The carvers of the 1990s appear to have desired to be faithful to the vision of their predecessors, in presenting animal-like demons, but were constrained to work within their own much

greater technical proficiency, aided by their better steel tools. One of the new carvings is humanoid in form.

In both styles, the fantastic beasts have popping eyes, snarling mouths with great sharp tusks, and paws with claws on them. Balinese would term them *aéng* (fierce). But for all their ferocity, I am convinced that they, much like the medieval griffins they resemble, are not intended to frighten the onlooker, as I had thought at the outset of my study. Rather, if one accepts the argument that the decorations of the temple are made primarily to please the eyes of the deities—both demons and gods—then these are not evil and dangerous monsters but ferocious members of the entourages of the deities. If the gods of Batuan are benevolently inclined toward their human worshipers, so too are these. The lionlike being on the north wall of the pre-1917 version had its hands in a position taken by dancers representing a divine or royal being giving instructions or blessing.

I believe that these demonic representations, here and elsewhere in the temple as followers of the gods above them, are not meant scare away malevolent beings, any more than the *caru* activities are intended to do so, but rather to stand for the *sakti* of the gods themselves. In this interpretation, the very ferocity of these

animals would be a kind of flattery or praise of their masters, evidence of their great powers.

The Door of the Méru Agung

The opening into the compartment where the god-figures had been stored and that is now used as a throne for Batuan's highest gods has a carved and painted wooden door. As a door it not only hides what is behind it, but stands for the idea of secretiveness. The statue of Betara Siwa and the god-figures are said to be *pingetang* (kept secret or hidden). (When the god-figures are enthroned, and even when they are on their sedans to be taken to the sea, many flowers and offerings are placed before them, as a kind of screen to keep them from the view of other humans and deities.)

The gold-painted designs carved on the door show images of deities surrounded by vines and flowers intermixed with animals. They are similar to those of intertwined foliage to be found in other doors and walls elsewhere in Pura Désa Batuan, and throughout Bali. These designs stand for, I've been told, the vitality *(idup)* of growing things and the plenitude *(ramé)* of life. The entangled quality, called *rumit,* is thought also to express the same qualities of profuse vigor.

The interwoven style echoes Indic designs and links the present day and place to far-distant shores. Yet when the designs are understood within the ritual narrative of praising the gods through depicting the world that they have vitalized, it is evident that their makers have made these Indic images their own.

The Paintings around the Top of the Méru Agung

The long paintings around the eaves of the two upper roofs of the Méru Agung were planned earlier but not done until the 1950s, when a new roof was installed.

The spaces for them had been left blank, for years, like a *calonan* stone.

The paintings illustrate a myth concerning a struggle between the highest gods and demons, and the creation of the great demon Kala Rau, who periodically attempts to swallow the moon, causing an eclipse. I was told that this subject is very appropriate on the Méru Agung since the altar as a whole is a representation of the holy mountain Méru and the heavens above it. In 1983 the paintings had almost completely faded away, but in the early 1990s they were repainted, the artists deliberately staying close to the original paintings, rendering the new as if it were old.

Here is the story of Kala Rau, as summarized by H. I. Hinzler from the Old Javanese manuscript of the Adiparwa:

> The gods and demons churned the ocean in order to obtain the ambrosia, called *amrta* in Old Javanese. After many difficulties the god Wisnu was about to distribute the ambrosia to the gods. A demon with the figure of a god had joined them. He was recognized by the Sun (Surya) and by the Moon (Candra). They warned Wisnu when the demon was about to swallow the ambrosia. Wisnu cut off his head after he had swallowed a drop of the liquid. The demon's body dropped to the ground dead, but the head stayed alive forever, because it had already been in contact with a little ambrosia. He takes revenge on the Sun and on the Moon by swallowing them regularly. This happens when there is an eclipse.[16]

In talking with I Madé Jata, one of the artists of the 1950s version, I became convinced that the source was not the Adiparwa text, but most probably a shadow play. He stressed that the *merta* (the present-day term for *amrta* or *amerta*) gave everlasting life and that the gods in distributing the ambrosia were not giving any to the people (the *rakyat,* an Indonesian term that has entered the Balinese language). Jata, in speaking here about the

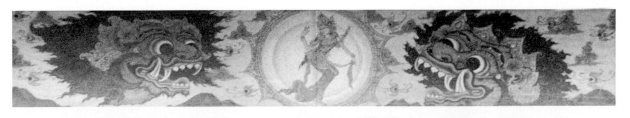

Figure 5.6. Paintings around the top of the Méru Agung. Painters: Déwa Nyoman Cita (Banjar Batuan Gedé); I Ketut Karawan, I Madé Tubuh, and I Naka (Banjar Pekandelan); I Mustika, I Madé Gendra, and I Wayan Regug (Banjar Dentiyis); I Wayan Jaya and I Barak (Banjar Tengah). Date: 1993. Photographed in 1995.

"people," suggests that, at least in contemporary times, some Balinese felt that the distribution of *merta* for well-being was not always fair. One demon disguised himself as a god. The goddess of the moon, Ida Sanghyang Ratih, who is pictured weaving, recognized him as a non-god, and Ida Betara Wisnu cut off his head with an arrow through his neck. But Wisnu's shot was a little late, and the demon's head with the *amerta* still in his mouth was given eternal life. The demon was originally named Detia Pretinti, but he was renamed Kala Rau (or Rahu) after losing his body. The rebellious Detia Pretinti who becomes Kala Rau is never fully defeated and returns periodically to attack the moon and the sun.

Figure 5.6 shows the paintings as they appeared in 1995, after having been repainted in 1993 because the originals, made in the 1950s, had faded. The new painters followed the originals closely.[17]

The Figure on the Roof of the Méru Agung

In 1995 a bright gold-painted image of Ida Sanghyang Widi Wasa was added, on the top roof ridge of the Méru Agung. I first, erroneously, guessed that placing Sanghyang Widhi Wasa above the gods of Batuan was an act of adherents of the modernist Indicising Hindu Dharma movement, intending to indicate that the gods of Batuan are manifestations of that highest invisible god. However, when I asked a knowledgeable member of the guiding *komiti* why it was there, the answer was a firm, "That's just an ornament, not a *pelinggihan*. We could not put an image of any other being above Ida Betara Puseh." This anecdote demonstrates that Balinese can, when they want to, make clear distinctions between a *pelinggihan* into which a god may descend and a mere representation of a god (today referred in Indonesian as a *simbol*).

The Figures of King Rama and His Court on the Méru Agung

The nine figures that stand on the lowest floor of the altar, below the enthroned god-figures but above the heads of the worshipers, come from the Indic epic tale of the Ramayana and represent the great king Rama

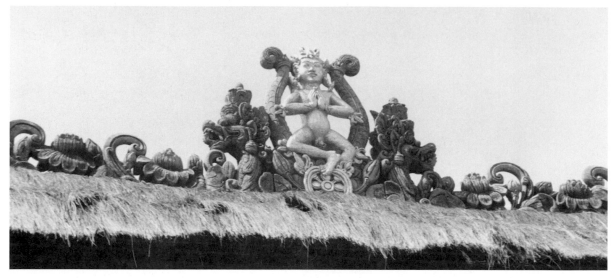

Figure 5.7. Gold-painted clay image of Sanghyang Widhi Wasa, placed on the rooftree of the Méru Agung. Carver: unknown. Date: 1993. Photographed in 1995.

and his monkey allies in his great war against the demon Rawana, who had kidnaped Sita, Rama's wife. This tale with all its many episodes is (or was until the present generation) common knowledge in Bali, for episodes from it were enacted in the shadow play and the dance genre called *wayang wong* (human shadow play), and were retold orally within family circles.[18]

King Rama and his brother, slim and graceful with sweet, contemplative faces, stand just outside the door of the altar. On either side stand the monkey generals, Anoman and Subali.[19] Anoman and his troops have demonic-looking faces with tusks, but they are not to be interpreted as "bad," but rather as "fierce" *(aéng or galak)* in contrast to those heroes such as Rama, who are not fierce but "refined" *(alus or manis).* I will discuss these images further in chapter 6.

The Pangaruman, the Meeting Place of the Gods

The Pangaruman was entirely built anew in the 1930s. The paintings were not placed on it until the 1990s. Its winged beasts and the standing figures on it are thought of as guardians and servants of the *niskala* deities enthroned there. They are some sort of anomalous fantastic animals, with parts combined from different species, like medieval griffins or chimeras, in a sense echoing the notion of the composite nature of their goodness and badness.

The Méru Alit

Between the Padmasana and the Méru Agung stands the elegant Méru Alit. Badly damaged in the earthquake, it was repaired in the 1930s, but much modified in the 1940s and 1950s, and in the 1990s completely repainted (see chapter 9). A *méru* indicates the presence of highly respected *niskala* beings. The number of roofs is a signal of the rank of the deities sheltered by them, ranging from three to eleven. The number of tiers in the *méru* may indicate the number of deities: nine tiers conventionally stands for the Dewata Nawa Sanga (the Nine Deities), while three tiers stands for the Tri Purusa (Three Deities, namely Parama Siwa, Sada Siwa, and Siwa).[20]

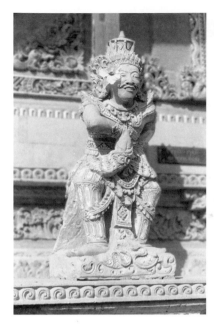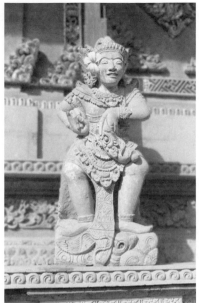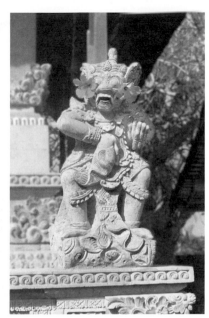

Figures 5.8a, 5.8b, and 5.8c. King Rama and his court on the Méru Agung. (a) Rama, the king; (b) Laksmana, the king's brother; (c) Anoman, the king of the monkeys. Carver: I Ramia, Banjar Pekandelan. Date: 1930s. Photographed in 1995.

The base of the Méru Alit is in the form of a *gedong*. Four grotesque animal-like beings (curious hybrids of lions, birds, and other beings) stand below it. The figures on the altar are, I believe, part of the demonic entourage of the god of the temple.

Curiously, in spite of its central location, its glittering decoration, and its *méru* form, it is not used in any way in any ceremony that I know of. Even the Pamangku did not know what it was for. One old Pasek said he thought it was the *palinggih* of the Pasek's ancestor, Pedanda Wau Rau, and another man guessed that it was for conveying prayers to the distant god of Gunung Agung, the central volcanic mountain of Bali. No gods are enthroned on it and no offerings are placed before it.

Its appearance and location suggest that it once must have been ritually important. Perhaps at one time the Méru Alit was the *palinggih* and *panyimpenan* of Ida Betara Désa, and at the time of restoration after 1917

it may have been decided to enthrone the god on the Pangaruman, along with Rambut Sedana.

The Padmasana: A New Altar to Ida Betara Siwa

The Padmasana is the tall throne to Siwa that stands in the northeast corner of the Jeroan. Its form is that of a "lotus seat" (the term *"padma"* means "lotus" and *"asana"* means "seat"). The arms of the seat are two sacred snakes, Ida Sanghyang Basuki and Ida Sanghyang Antaboga, serving as Siwa's *pangapit* or flanking guards. Carved on the top of the throne in bas-relief is an image of Sanghyang Cintia, a highly stylized figure of a man with one foot raised as in dance and hands clasped in a priest's mudra. From his head, joints, and genitals comes a three-pronged design representing the fire of *sakti*-power. The image of Sanghyang Cintia stands for Ida

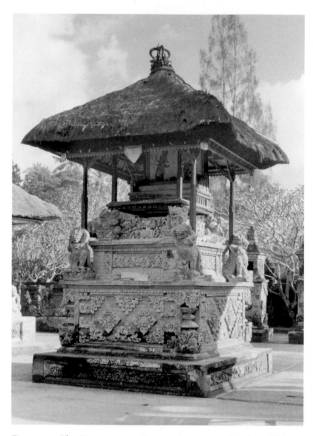

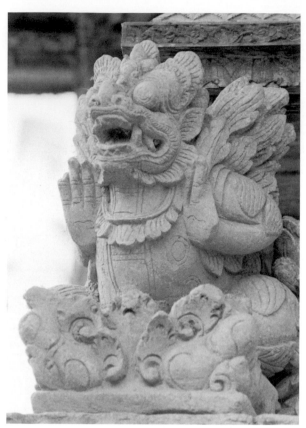

Figure 5.9. The Pangaruman. Carvers: I Nyoman Pageh and his team. Date: 1930s. Photographed in 1995.

Figure 5.10. Figure on the Pangaruman of a composite animal. Carvers: I Nyoman Pageh and his team. Date: 1930s. Photographed in 1995.

Sanghyang Betara Siwa and Ida Sanghyang Widi Wasa, as well.

Part way down the towering altar is a meditating statue of Ida Betara Siwa, with two beautiful women spirits *(widiadari)* at his side. Below him is the Garuda, an enormous eaglelike bird on which the god Siwa rides. A little further down are statues of Ida Betara Mahadéwa and Ida Betara Iswara. Almost on the ground and completing the set of the five highest gods are figures of Ida Betara Brahma and Ida Betara Wisnu.

The whole tower rests on a gigantic turtle named Badawang Nala, who is wrapped in two great serpents, who with their firm coils prevent the world from mov-

ing. (These are different beings from the snakes of the origin myth that were used as ropes to move the churn that stirred up the waters of the cosmos.)[21]

On the reverse side of the Padmasana are carved two birds. Above is Garuda, who is Ida Betara Siwa's vehicle and who played a major part in the creation of the world and the bringing of well-being to humans. The Garuda is renowned for his ferocity, and the tales about him include being able to carry elephants and to defeat an army of one thousand snakes. The unidentified bird below him, in fact, is carrying a snake. These two terrifying raptors give an ominous feeling to the Padmasana.

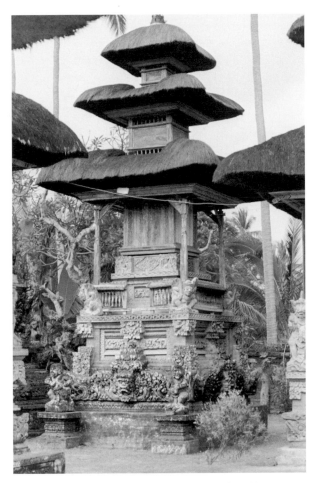

Figure 5.11. The Méru Alit. Carvers: I Wayan Pageh and his team. Date: 1920s, but also renovated since. Photographed in 1983.

Some of the iconography was explained in part to me by an elderly stone carver from Sélakarang, a village near Batuan. He had recently made a *padmasana* for the *mrajan* or house temple of Ida Bagus Madé Togog, the Batuan painter. He said that the general form was dictated by the words of a *wéda* or prayer, which he then wrote out for me:

> Om Kurma geniya ya namah
> Om Anantasana
> Om Singasana

He had made a working drawing of the conceptualization of a *padmasana* for a client, which showed not the stone altar itself, but a turtle with two snakes above it and a lion flying above them. Above all of these was a yellow sun with a swastika in its middle and with long rays coming from it. He said that without this sort of conceptualization, no *padmasana* would be complete.

My stone-carving consultant then partially explained the *wéda*. *Kurma,* he said, means turtle, and the phrase loosely translated means "We provide a place for Sanghyang Widi to be, with our voices." *Anantasana* is the name of the snakes. *Singasanga* refers to the lion, "for a *singa,* a lion, is a place for the gods to sit on." *Padmasana* refers to the sun, and in offerings, it is symbolized by a lotus blossom. *Dewasana* means the gods, whom one cannot see. In the picture the rays of the sun stand for them. In a *padmasana* altar, he said, the figure of Sanghyang Cintia stands for all the gods.

Because there are five lines in the *wéda,* there should be, he said, five levels in a *padmasana.* Many don't have five, of course, because they leave out the lion, who should be there. (The lion seems to be the stone carver's idiosyncratic addition, for I've never seen a *padmasana* with a lion on it.)

Here is a cosmic order interpretation by Ida Bagus Oka Puniatmaja, a prominent member of the Hindu Dharma movement who spent several years studying in India:

Padmasana is a symbol of a microcosm of the enthronement of God (Ciwa, Raditya, Sanghyang Acintya), that represents the Creator, Preserver, and Destroyer (returns everything to its origin) and also is a great witness of all the ceremonies of sacrifice. . . . According to Hindu mythology all the gods stand or sit on the Padmasana, and the leaves of the lotus are described as the eight pieces

that symbolize eight gods who guard the eight directions of wind. . . . Padmasana is also a symbol of the Triloka (the three worlds).[23]

Several people in Batuan told me that the Padmasana as a whole is a symbol of the great sacred mountain Méru, or, through it, of the entire universe. The intricate carvings are then thought of as representing all the life of the universe, as summed up not only in the mountain but also in Ida Sanghyang Widi Wasa. The great altar, the Méru Agung, and the two great gateways (discussed below) are also thought of in the same way, as emblems of Mount Méru.

From the perspective of the ritual narratives, the Padmasana is an empty chair on which no god-figure is ever placed for the god to descend into. This absence suggests that, in the usual view, the altar is not a *palinggihan* but a *panyawangan* or a *pasimpangan*.

From the same ritual point of view, the various godly figures standing on the Padmasana together with the Garuda might be understood as the ensemble of deities who are addressed at the Padmasana. Perhaps they are considered to work as one for the benefit of the worshipers. Since the five highest gods, including Siwa, are placed lower than the throne of Sanghyang Widi Wasa, I wonder whether, in some Balinese eyes, these five are considered lesser than he, as part of his honor-giving entourage.

For rituals, a very large platform is built next to the Padmasana, and sumptuous offerings placed there every day. I have been told that Batuan's Brahmana members used to worship before it.

The main structure of the Padmasana was built probably in the early 1920s, but a number of free-standing stone figures were placed on it subsequently, in the 1930s. I was unable to ascertain who the carvers were.

The whole of the Padmasana is intricately ornamented with every space filled. The intensity of the busy rococo style may have been new in the twentieth cen-

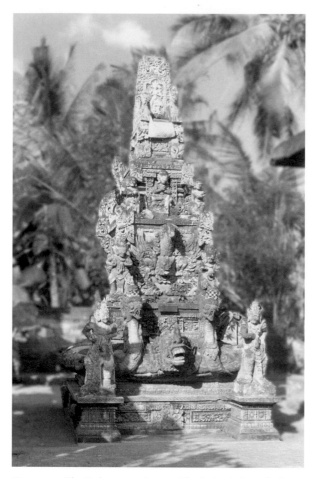

Figure 5.12. The Padmasana. Carvers: The Padanda from Geria Pacung, Batuan, began the carving; the carvers who did most of the work, all from Batuan, are unknown. Date: early 1920s. Photographed in 1995.

tury, replacing a simpler manner. I will return to the question of stylistic shifts in chapter 6.

The New Walls, the *Kulkul* Tower, and the Great Gates

An image of formidable importance is presented by the new southern walls, the *kulkul* tower, and the two southern gates. They face south toward the road along

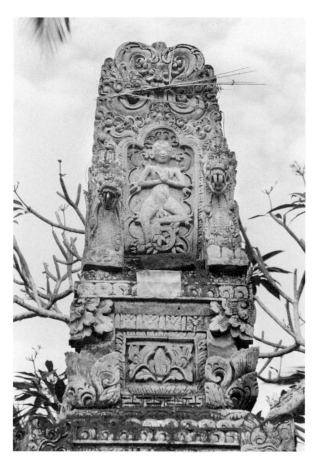

Figure 5.13. Sanghyang Cintia at the top of the Padmasana.
Carvers: unknown. Date: early 1920s. Photographed in 1983.

which pass people from other villages and, past it, toward the village itself. The square tower, which supports the wooden signal drums that announce events at the temple, stands at one corner of the front wall and also attracts attention. Only these front walls of Pura Désa Batuan are ornately carved.

There are two major types of temple gateways, one closed at the top with a lintel, and the other open at the top. A large temple door of the closed type is called a *candi kurung;* a split gate is a *candi bentar.* "*Candi*" means "gate" (also, earlier, "shrine"). "*Kurung*" means "closed, covered over"; "*bentar*" means "split down the middle."

The southernmost gate, nearest the road, is a *candi*

bentar. I call it the Great Split Gate on the South. It is much taller than any other in the temple, and in fact taller than any other temple gate in Batuan. It and the wall that it cuts through are profusely carved; in addition, a row of stone figures stands in front of the wall.

The gate behind it, which the people call the Kori Agung and I call the Great Door on the South, leads from the forecourt into the Jeroan. It is a *candi kurung* with its closeable door set very high up at the top of a flight of stairs. When it stands open, ordinary people may go through the door, but most prefer to use two lesser, lower, gates at its sides, which have been given little or no ornamentation. It is the most elaborate of all the gates. It and the Great Split Gate on the South are the ones first seen from the road, and perhaps this visibility to outsiders was in the minds of the people who built them in the 1930s.

The Great Door is kept closed except when the gods are present. It gives a strong feeling that it is concealing and protecting something of great significance, a feeling that is reinforced by the placing of the door high up with stairs leading up to it on one side and down on the other, the prominent lintel above the door with a complex triangle of carvings over it, and the placing of a screen or *aling-aling* just inside it.

Its name, Kori Agung, comes from *"kori,"* which means "door," and *"agung"* which means "great" in the high register. Grammatically, the term *"kori"* is made up of *k-* and *ori,* in which *k-* is a directional prefix and *ori* means "behind." The term thus means something like "that which is placed to the rear," which suggests that the erection of a door is conceived of as creating a "behind" or hidden area, which here would denote the spaces of the temple itself. When something is called a *kori* it usually can be shut.

The Kori Agung's suggestion of hiding something is reinforced by the building of an *aling-aling* just inside it. This is a stone screen, placed several feet inside a door that opens into public spaces, found in many domestic

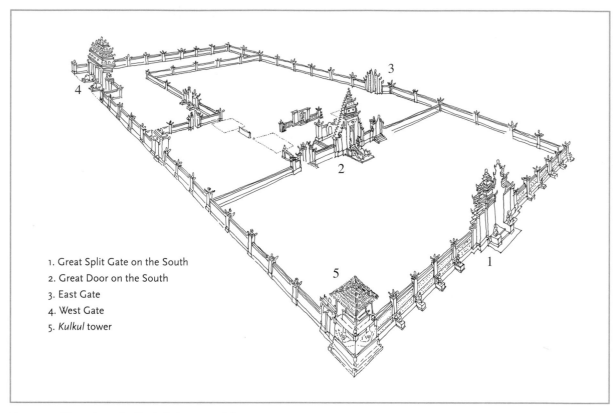

1. Great Split Gate on the South
2. Great Door on the South
3. East Gate
4. West Gate
5. *Kulkul* tower

Figure 5.14. The outer walls, the *kulkul* tower, and the great gates.

dwellings. It is often said by Westerners to have the purpose of keeping demons from entering, "since demons can only travel in a straight line." This rigid singleness of direction is contrary to everything else said about *niskala* beings, and I believe that the *aling-aling* is intended to break their line of sight. Sight itself of course is a powerful weapon, not only for *niskala* beings but also for human sorcerers. The Kori Agung's *aling-aling* is strengthened by a threatening statue placed in a niche in it. Yet further, in the 1970s the temple *komiti* decided to place a building with a high back wall right behind it, with another statue in it, thus creating a second *aling-aling*. What is odd about Pura Désa Batuan is that none of its other gateways have *aling-aling* barriers. Why this is I do not know.

The West Gate is a *candi kurung* too, but more austere in style. When it fell down in the 1917 earthquake, the Dutch colonial authorities declared it an archeological treasure and forbade the villagers to rebuild it. The archeologists did not get around to restoring it until 1991, and when they did, it was in their conception of its original form.

The East Gate is a *candi bentar,* opening hospitably directly into the innermost court of the temple. This is puzzling to me. Why shouldn't it be closed, with an *aling-aling* screen, to protect outsiders from the *sakti* of the *niskala* beings within the Jeroan? I have no satisfying answer, except to point out that outside this door are only another temple (the Pura Lumbungan) and the Pamangku's home and his home temple, the Mrajan Désa.

The two gates on the south side of the temple are taller than any other structures in Batuan. Only the gates in the three Pura Dalem come near them in height, and since they are downhill from Pura Désa Batuan, the tops of all other gateways are below those of Pura Désa Batuan. Their relative height stresses the importance of the deities that visit within. When one approaches the temple one can see both gates at once, one within the other, and they seem to emphasize, in their repetition, the importance of that which is within them. They also mark the north and south sides of the courtyard within which the important Taur Kasanga ritual takes place. Gates are also often referred to as *pamedalan,* which means "coming-out place" or "exit," suggesting that they are not thought of primarily as places for the worshipers to enter but rather as openings for the deities of the temple to emerge—to bless and protect their realm.

Both gates are elaborately carved, and both are flanked by numerous figures guarding them. Each of these gates has not only two great figures on either side of the opening, like sentinels, but also an array of other figures arrayed before them or alongside them. The pair of statues standing immediately on either side of any important temple gate are called *pangapit kori* (those who grip the door between them). In some lesser temples, two small altars can take the place of the figures.

These two statues, on either side of the gateway, are in Batuan only the first rank in a group of statues standing in what is called the *kuuban kori* ("the area around the door" or, more precisely, "that which completes" the doorway). The *kuuban kori* an important Balinese conception that illuminates the intent of many of the figures around the gates of Pura Désa Batuan.

Around and in front of the *kuuban kori* of the Kori Agung, in addition to the two major statues flanking the door itself, are six others in a semicircle in front of it. Just inside the door are two more guardian statues, one in a niche in the *aling-aling* screen and the other fur-

ther within the Jeroan. In front of the Great Split Gate next to the road, in addition to its two *pangapit kori,* is a row of almost life-size statues, lining the wall, looking out at the road.

If they all are understood as elements of the *kuuban kori,* these guardians of the gateway and other decorative carvings are intended to intensify some meaningful associations about the two gates—perhaps their potential for allowing a spirit (or more likely a host of spirits) to come out through them. I believe that all of these statues that surround, and in an important sense, pay respect to, the gateway, must be understood as an ensemble. These statues are all given small offerings every day, although most are not served major meals during ritual festivals. I discuss below first the *kulkul* tower and the carvings on the wall near it and then the two southern gateways and the statues around them. Description of the other two major gateways, the East Gate and the West Gate, will be found in subsequent chapters, for they were erected later.

Wall Carvings in Bas-Relief of Vines and Demon Heads

The bas-reliefs on these walls give these structures their most impressive qualities. These are intricate designs of entangled vines and other floral motifs that merge (transform?) into and from animal forms, usually called by the craftsmen *karang* or *patra,* meaning "pattern" or "motif."

Along the front wall were placed a number of panels showing demonic heads, either *karang saé* or *karang boma,* distinguished mainly by their eyes. (A *saé* has squinting eyes while a *boma* has popping eyes.) Each one of these heads along the wall was done by a different craftsman, and the variations are apparent. I was told that each member of the team made a different one of these "demon" heads. Close comparison of these demonstrates the degree of freedom for personal creativity permitted.

The *Kulkul* Tower

This tall square tower with a roof of black straw sits at the outermost southwest corner of the temple and holds hanging two slit drums (the *kulkul*). These drums are an essential part not only of ritual preparations, when they are used to call people to work, but also of the confrontation with the gods themselves, when they are beaten continuously, forming a ladder of sound that stretches between the upper worlds and the human world. The two drums, made from logs about the size of a man, are treated as sentient beings. They are dressed in cloth sarongs and given daily offerings of food. Every temple has a pair of *kulkul* drums, but only the more affluent temples have a stone pavilion for them. In the 1920s, Batuan's *kulkul* hung from a limb of a great tree just outside the temple.

Architecturally, Pura Désa Batuan's Kulkul Tower resembles, in a reduced version, a palace feature called the *balé bengong*. This is a pavilion next to and higher than the wall in a *puri* where the king and his nearest entourage sit and look down on the populace. It reinforces the temple's resemblance to late-nineteenth- and early-twentieth-century palaces, as also do its great ornamented walls.

The Great Door on the South

The importance of the Kori Agung is indicated by the profusion of statues around it and the many carvings on it. The whole is often spoken of as a mountain. The triangular part rising above the door toward the sky is marked off into three distinct levels, suggesting the sets of roofs called *méru*. (These might be five levels, if you count the two below the door's lintel.) It is these, together with the vinelike forms carved in it, that leads people to say that the gate, like a *méru,* is a mountain. And like the holy Mount Méru, it stands for and is the entire world. For this reason, said several people, the

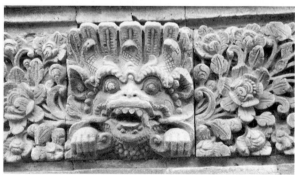

Figure 5.15. Boma heads along the front wall of the temple. Carvers: apprentice carvers in team of I Nyoman Pageh. Date: 1930s. Photographed in 1983.

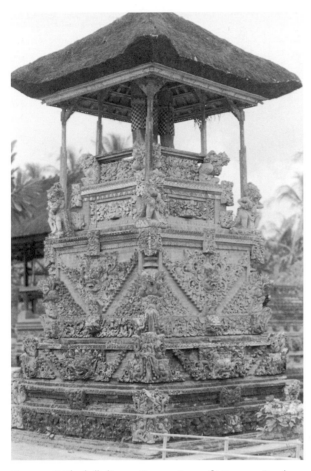

Figure 5.16. The *kulkul* tower. Carvers: team of I Nyoman Pageh. Date: Early 1930s. Photographed in 1983.

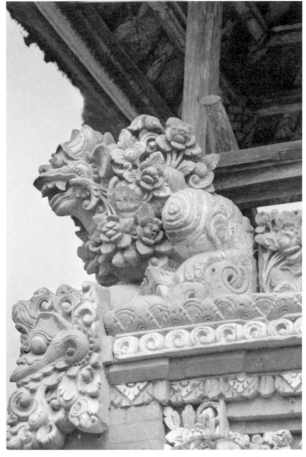

Figure 5.17. Animal figure on the *kulkul* tower. Floral forms indicate (probably) wings. Below, an ornament called a *karang curing*, in the form of a bird. Traces of paint show that these statues were once brightly colored. Carver: team of I Nyoman Pageh. Date: early 1930s. Photographed in 1983.

carvings often contain within them figures of animals and plants, standing for the complete contents of the world. As with the Méru Agung and the Padmasana, already discussed, I have the impression that "the entire world" here stands for the multitude of offerings that the worshipers would like to present to their gods, plenitude or aggregative completeness.

The term *"candi"* in Old Javanese signifies a "temple" or "memorial" that has the form of a tall, solid, pillarlike structure. To call a gate a *candi* here then suggests that it is likened to an altar, that is, to a place within which a god may materialize. However, Batuan's *candi kurung* and *candi bentar* are not altars (no offerings are placed before them), and so they are (mainly) representations of altars. In an important sense they also stand for the deities themselves.

As a deity the Great Door is seen by some dancers as a head with an elaborate headdress *(gelungan)* and long

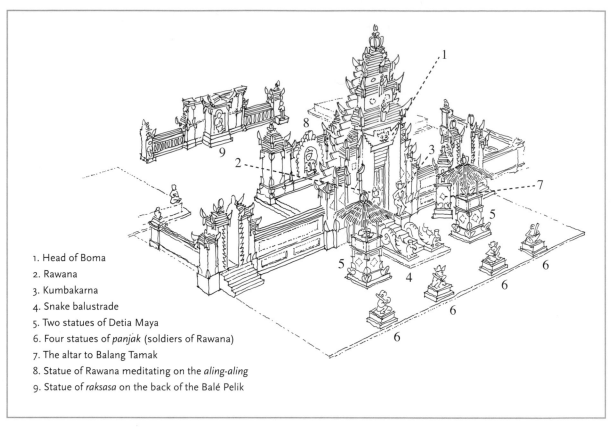

1. Head of Boma
2. Rawana
3. Kumbakarna
4. Snake balustrade
5. Two statues of Detia Maya
6. Four statues of *panjak* (soldiers of Rawana)
7. The altar to Balang Tamak
8. Statue of Rawana meditating on the *aling-aling*
9. Statue of *raksasa* on the back of the Balé Pelik

Figure 5.18. The Great Door on the South and its guardians.

ornamented earrings *(subeng)*. Many of the ornaments in the gate's "headdress" are similar to those found on the costumes of royal *wayang* figures, where heads of demons peer out among the vinelike decorations, in their hair or headdress.

Yet another interpretation of the Kori Agung, given me by many people, is as a passageway between the world of the gods, the *kahyangan,* and the world of human beings. It serves as both an entrance and an exit, and, when shut, to keep out and to keep in. The architecture and the placement of the statues near the door seem to stress that this door is intended as an impressive place where the deities come out into the world

of humans.[24] A variant on this view, stressed to me by members of the new Hindu Dharma movement, is that the Great Gate marks the entry for humans into a place of great purity. Outside is everyday pollution, which must be shed on entering the temple. One should bathe, dress in clean clothes, and wear a sash of respect before going through it. Those who have had recent contact with the dead or who have just had sexual intercourse must not enter without purifying themselves. Women who are menstruating or who have just given birth may not enter at all. All impure thoughts must be left behind when one goes through such a gate. The danger created by violation of these rules is not only to

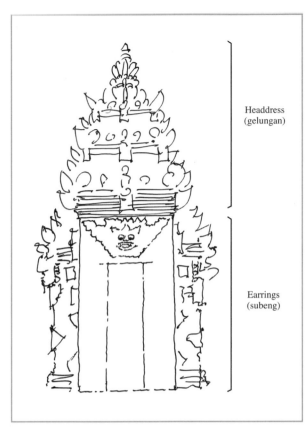

Headddress
(gelungan)

Earrings
(subeng)

Figure 5.19. The Great Door as the head of a deity.

The Carving of the Boma Face on the Great Door

Directly above the lintel of the door on the Kori Agung is a high triangle-shaped set of carvings, dominated by a great demonic face, with popping eyes and great fangs. This is Ida Sanghyang Boma, the son of the gods Betara Wisnu and Déwi Sri.

Here is the story of Ida Sanghyang Boma as told me by a Batuan Brahmana scholar: Ida Sanghyang Wisnu and Ida Betara Brahma were having an argument over who was strongest. Ida Sanghyang Siwa decided to test them. He turned himself into a jewel *(manik),* and when Wisnu tried to pick it up, it grew into a tall treelike object, and he couldn't pick it up. Both gods tried to climb the tree, but they couldn't reach the end of it. Brahma turned himself into a bird to fly up, and Wisnu turned himself into a boar to dig down through the earth. But neither could reach the end, and both were enraged. Wisnu, down in the earth, met the goddess of the earth, Sanghyang Pertiwi, and tried to make love with her. But because he was in the form of a boar, she rejected him, so Wisnu raped Pertiwi. Boma was the child born of that rape. From a philosophical perspective, said my consultant, Wisnu is water and Pertiwi is earth, and it is from the mingling of earth and water that all plants come. Sometimes Boma is shown with plants coming out of his mouth. Boma is appropriate for a temple gateway, he said, because the word for plants, *kayu,* is the same as the word for desire, intention, thought, and heart, *kayun.* Boma is there to remind you as you enter the temple to make your heart pure.

It is clear from this exegesis that Boma is not a "demon," since he is not malevolent. Like all Balinese spiritual beings, he is capable of compassion as well as cruelty. He can be dangerous to human beings. One Boma-decorated lintel was said to have killed several people. During the 1980s when I was in Batuan, one of

the violator, but also to the entire congregation of the temple. Even if it is only a tourist who has polluted the temple, the entire congregation must contribute to a major cleansing ritual (which may be quite expensive) to counteract the insult to the gods. The same thing is also said of the inner gate.

These alternative interpretations of the meanings of the gateway are not felt by Balinese to be contradictory, but complementary. It is not only a doorway for the emergence of the gods, but also as *candi* it is a temple; in addition, it is an especially grand offering of the world-mountain, a representation of a god, and finally a threshold into a pure place—all in one.

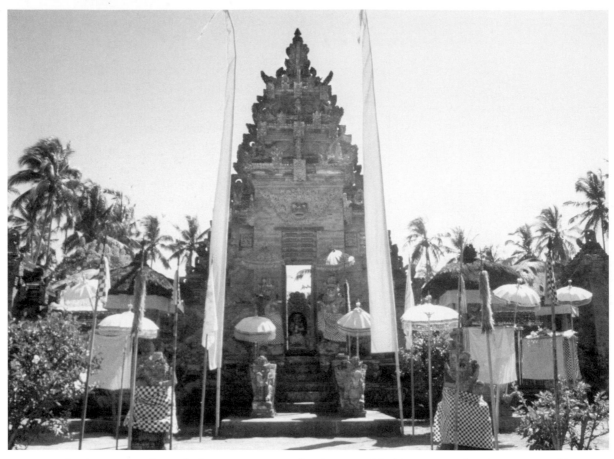

Figure 5.20. The Great Door on the South of Pura Désa Batuan. Taken during an *odalan;* door open to allow the movement of deities in and out. A number of statues, each dressed in a sarong and honorifically provided with an umbrella *(payung),* guards the area immediately in front of the gate (the *kuuban*). Carver: the team of I Nyoman Pageh. Date: 1930s. Photographed in 1988.

the *pura panti* near Pura Désa Batuan had a huge stone lintel lying near its gate, with a great Boma head on it. People said that several times when workmen tried to raise it up and place it above the doorway, it fell down and seriously hurt (or even killed—the story is ambiguous) several people. This was a demonstration of its *tenget* nature—the spiritual being inhabiting it was enraged to be placed on that particular doorway. (The Archeological Service later decided that it was a remnant of the great West Gate of Pura Désa Batuan, and

when they restored that gate in 1993, moved it there and placed it in the lintel spot.)

To some foreign observers, Boma is a "demon," and his representation intended to incite fear; he is likened to the Rangda figure, who is equally erroneously characterized as single-mindedly evil. Such a reading makes sense only within a Christian framework of a fundamental split between good and evil. In a Balinese common-sense understanding, the Boma—and other so-called demonic figures—are fierce yet friendly allies of their gods.[25]

The Statues of Rawana and Kumbakarna as Guardians of the Great Door

Just outside the doorway of the Kori Agung, high up at the top of the stairs, stand two statues said to represent Rama's enemies, Rawana and his brother Kumbakarna. They are the *pangapit kori,* or guards of the door. They were made of especially hard stone, and many people admired them for their workmanship. They are the largest and highest of a set of ten figures that together make up the *kuuban kori.*

When I asked who these two large figures with popping eyes, toothy grimaces, and tall regal headdresses were, several Balinese told me that they were *raksasa* (demonlike guardians). This is the careless answer to an ignorant questioner, not incorrect but incomplete. Others said that they were *panjak Rawana* (the troops or slaves of Rawana), another inexact answer. But the knowledgeable identified them as Rawana and Kumbakarna, the ogre-kings who stole Rama's wife Sita. Why these particular characters stand in front of the most impressive door into the inner court of the temple is not obvious. I will explore that question further.

The Snake Balustrade in Front of the Great Door

Just below Rawana and Kumbakarna, forming a sort of balustrade of the stairs down from the doorway, are two kingly snake demons, with wings and claws. When I asked why the snakes were there, one knowledgeable consultant said he didn't know, but he thought they were there in order to *nguub* the gateway (to mark off the area around the gate; *nguub* is the active form of *kuub,* the area in front of a gate).

It seems also likely that snakes in many carvings are there to provide additional spiritual strength, *kukuh,* to the guardians. When I asked about the small figure stand-

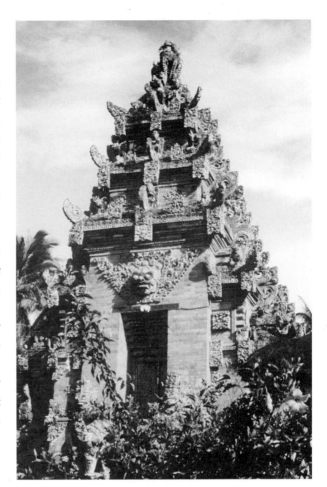

Figure 5.21. The Boma on the Great Door on the South (interior). Carvers: I Krepet of Peninjoan and assistants. Date: 1930s. Photographed in 1986.

ing in the center of the snake's coils, I was told it was there merely for *dekorasi* (Ind.). Smaller figures around or in larger figures (for instance, the beings with the saw at the base of the giant figures by Cita) are often explained as "fillers," "put on to make it busier," *ramé.* One artist said that the figure was there to fill up the spot as a *pangebek* (from the word *bek,* meaning "full" or "complete").

The Six Figures Guarding the Great Door

The statues that form the bulwark of spiritual strength, or *kuuban,* around the Great Door include two seated figures on high plinths and four menacing ones carrying weapons standing below them. The first two were made before the earthquake and were said by some to represent Detia Maya, the architect to the gods (see figure 4.15 and discussion in chapter 4). The lower ones are said to be warriors, *panjak,* in the army of Rawana, the demon foe of Rama. They stand in crouched, threatening postures in a line before the door. Here again apparent enemies are positioned as guards of the temple.

The Altar to Balang Tamak, Trickster-Guardian

Another sort of guardian of the doorway (actually of the lesser doorway for humans to the right of the Kori

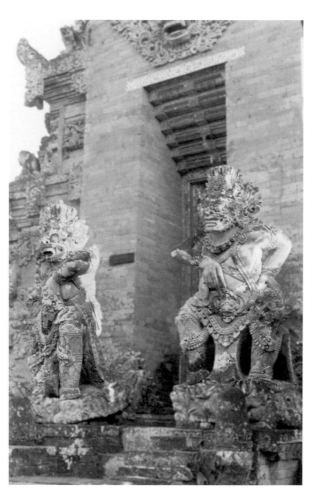

Figure 5.22. Kumbakarna and Rawana, guardians of the Great Door on the South. Carvers: I Krepet of Peninjoan and team. Date: 1930s. Photographed in 1995.

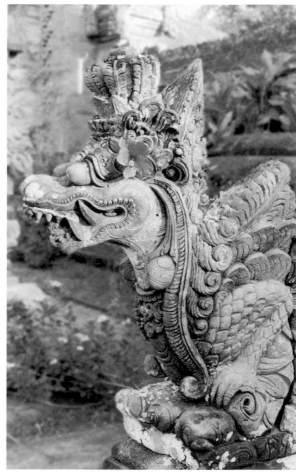

Figure 5.23. The head of the snake on the balustrade in front of Kori Agung. Carvers: team of I Nyoman Pageh. Date: 1930s. Photographed in 1995.

Agung) is a small shrine to Balang Tamak. There are many funny tales about Balang Tamak, who is pictured as a member of the *krama désa* who keeps evading his duties (not doing his work, not paying his dues) and through clever tricks outwits the rest of the *krama désa*. I don't know why there is an altar to him here.[26]

Rawana Meditating, inside the Great Door, on the Aling-Aling Screen

In a niche in the screen behind the door, facing toward the outer courtyard, is a statue of a being in the position of meditation or prayer, with a priest's bell and priestly attire, but with a frightening face with tusks and bulging eyes. Villagers differ as to who this is, most say-ing that it is Rawana, Rama's enemy, from an episode in the Ramayana, where he meditates to gain the super-natural power *(sakti)* with which to defeat Rama.

A Raksasa, on the Back of the Balé Pelik

A statue of a *raksasa,* made, together with its ornate frame, during the 1950s, by I Ruta is on the back of the Balé Pelik. He identified it as Raksasa Panca Maha Buta. However, in the 1980s when the Balé Pelik was moved and renovated, the statue was moved into a new rear wall. This new location converted the back of the Balé Pelik into a sort of second *aling-aling* screen for the doorway of the Kori Agung, and the *raksasa* into yet another guardian of the doorway.

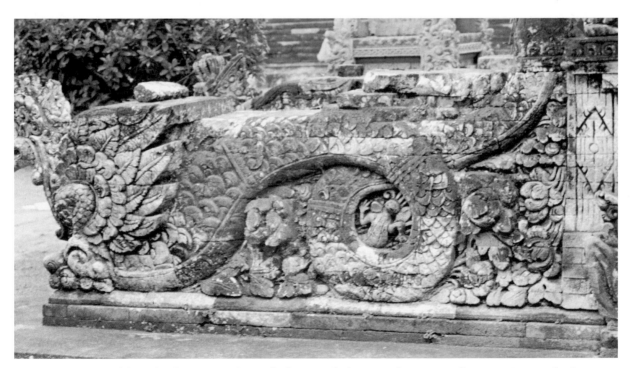

Figure 5.24. Side view of the snake (figure 5.23) with a small "demon" (which seems to have no specific meaning) in its coils. Carver: team of I Nyoman Pageh. Date: 1930s. Photographed in 1983.

The Great Split Gate on the South and Its Guardians

The Great Split Gate on the South is not only a *candi kurung* that has been sliced in half but also a mountain that has been split. This bifurcation of a gateway is sometimes interpreted as standing for all complementary halves, such as male and female. But perhaps more important is the array of stone figures flanking it. As with the Candi Kurung, two statues stand sentry on either side of the gate opening. Its *kuuban* area extends not forward, like that of the Candi Kurung, for there was no room, but laterally along the front wall. The two *pangapit kori* figures are echoed at intervals of about four meters across the entire front of the temple. There are four on the left and five on the right, making nine stone guardians of the gate in all. They all represent characters from the Ramayana.

These statues were probably made after the wall and gateways, possibly in the 1940s; they were, like the large statues of Rawana and Kumbakarna, made out of especially hard stone *(paras)*, which had been carried from the ravine of the river near the *banjar* of Kediri in Selakarang, west of Batuan. They were made by a team

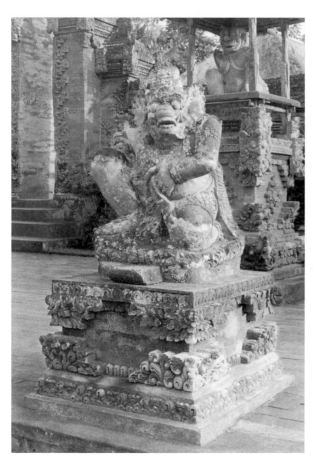
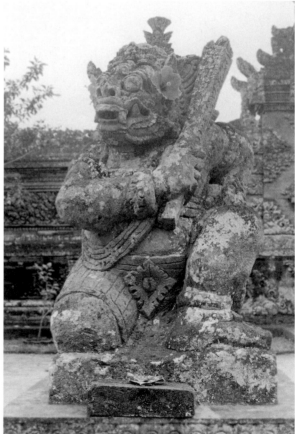

Figure 5.25. Two of the four *panjak*, soldiers of Rawana, in front of the Great Door. Carvers: unknown. Date: 1930s. Photographed in 1995.

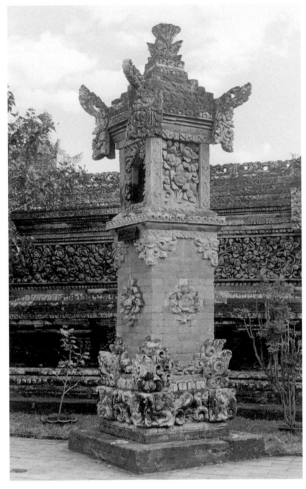

Figure 5.26. The altar to Balang Tamak. Carver: unknown. Date: unknown. Photographed in 1995.

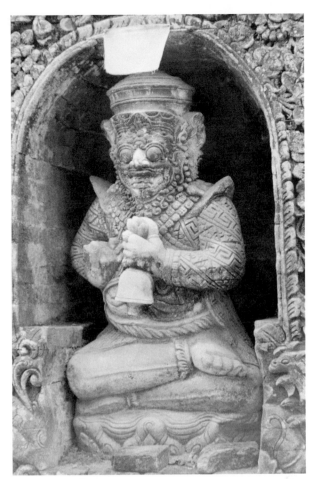

Figure 5.27. Rawana meditating, a statue on the front of the *aling-aling*. Carvers: I Krepet and assistants. Date: 1930s. Photographed in 1983.

most of whose members came from the *banjar* of Peninjoan, which is adjacent to the village of Sukawati, just to the south of Batuan. During the 1930s, there was a workshop of stone carvers in Puri Sukawati who made the very similar Ramayana (and Mahabarata) statues for the great central temple Besakih, completed in 1935, headed by a man from Sukawati, I Kolok. Some of those who worked on the Batuan Ramayana statues may have been apprenticed there.[27]

When I asked people which character each statue represented, some again simply shrugged off the question and said that they were *raksasa*. In fact, they are various lesser characters in the Ramayana epic, but some are members of King Rama's entourage and others of Rawana's. Examined closely, they are all different, and each one can be identified by its costume, particularly the headdresses, and by its facial structures.

The two immediately next to the Split Gate are said to be *patih* (ministers) of Rawana. One consultant said they were both images of the same being, named Desta

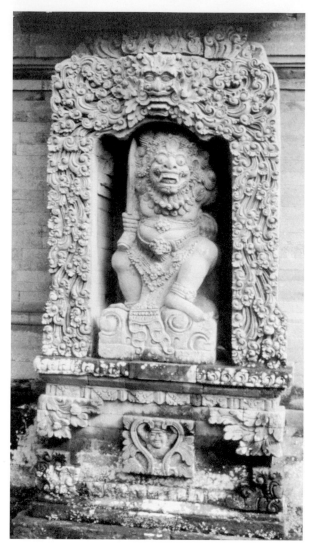

Figure 5.28. Statue of Raksasa Panca Maha Buta, a demonic being. Carver: I Ruta, Banjar Puaya. Date: 1950s. Photographed in 1986.

Rata, while another said they were named Prahasa and Dumaraksa. I believe the latter's identification must be closest to that of the stone carver who made them, for they have slightly different headdresses. Their masklike faces, with wide-open eyes and toothy mouths, give an impression of fierceness on the ready.

At the far ends of the row stand two pairs of comic

servants, the eastern ones the attendants of Rawana, the western ones of Rama. With grotesque bodies and wide, generous mouths, they resemble closely their models, the *parekan* of the shadow play, who are the servants of its heros. *"Parekan"* means "close one" or "personal servant," but these four are no mere servants, and are often referred to as the *penasar,* which might be translated "the basic ones." Merdah and Malén attend King Rama, while Délem and Sangut follow Rawana. These pairs appear also in the shadow play of the Mahabarata story cycle, where Merdah and Malén are the servants of the Pandawa brothers while Délem and Sangut work for their enemies, the Korawa. In the shadow play, and derivatively in the *wayang wong,* these clown figures are not ordinary people, but incarnations of Brahma (Mélem), Wisnu (Malén), Iswara (Merdah), and Mahadéwa (Sangut). Oddly, the statues here do not exactly fit this shadow-play model: in place of the usual Mélem in Rawana's entourage is a personage the people of Batuan called Raksasa Gundul. It was pointed out to me by several as their favorite, and in the 1980s the stone carver Dewa Nyoman Cita chose it as a model for one of his monumental statues on the road. A drawing of Raksasa Gundul heads this chapter.

In the story, the servants of King Rama are higher in status than those of Rawana, yet here, the latter stand on the western—thus less auspicious—end of the row of statues along the wall, seemingly reversing their status. However, from another point of view they stand at the most honored end. From the perspective of a deity standing in the doorway and looking out toward his realm, his most trusted retainers, Malén and Merdah, are at his right hand, the purest and most revered position.

Sangut, *penasar* of Rawana, at the eastern end, carries a rifle. Balinese do not think this is at all incongruous, anachronistic, or comic, since such ironies are only imposed by a Western interpretive frame that sees these stone carvings as expressions of a premodern mental-

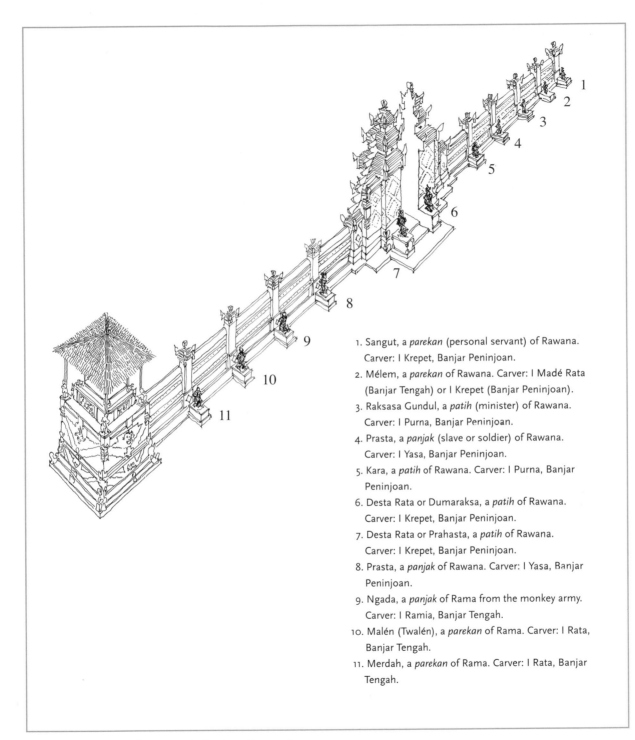

1. Sangut, a *parekan* (personal servant) of Rawana. Carver: I Krepet, Banjar Peninjoan.
2. Mélem, a *parekan* of Rawana. Carver: I Madé Rata (Banjar Tengah) or I Krepet (Banjar Peninjoan).
3. Raksasa Gundul, a *patih* (minister) of Rawana. Carver: I Purna, Banjar Peninjoan.
4. Prasta, a *panjak* (slave or soldier) of Rawana. Carver: I Yasa, Banjar Peninjoan.
5. Kara, a *patih* of Rawana. Carver: I Purna, Banjar Peninjoan.
6. Desta Rata or Dumaraksa, a *patih* of Rawana. Carver: I Krepet, Banjar Peninjoan.
7. Desta Rata or Prahasta, a *patih* of Rawana. Carver: I Krepet, Banjar Peninjoan.
8. Prasta, a *panjak* of Rawana. Carver: I Yasa, Banjar Peninjoan.
9. Ngada, a *panjak* of Rama from the monkey army. Carver: I Ramia, Banjar Tengah.
10. Malén (Twalén), a *parekan* of Rama. Carver: I Rata, Banjar Tengah.
11. Merdah, a *parekan* of Rama. Carver: I Rata, Banjar Tengah.

Figure 5.29. The Great Split Gate on the South and its guardians.

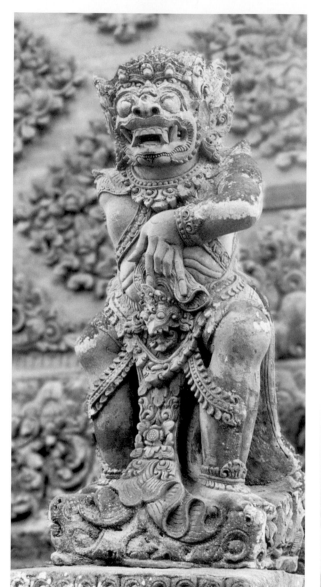
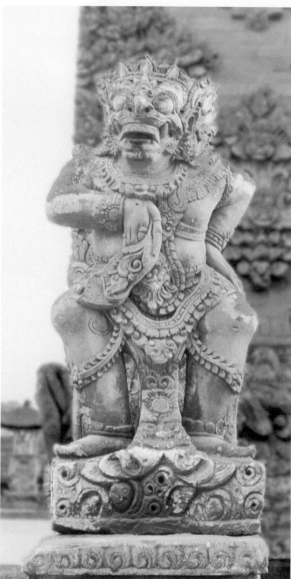

Figure 5.30. The two guardians of the doorway of the Candi Bentar. Said to be duplicate figures of Patih Desta Rata, minister on Rawana's side in the war. Sometimes identified as two different *patih* of Rawana: Prahasa and Dumaraksa. Carver: I Krepet, Banjar Peninjoan. Date: 1930s. Photographed in 1995.

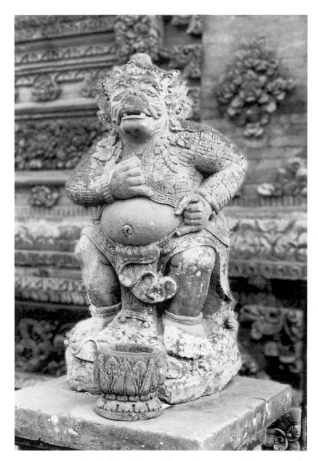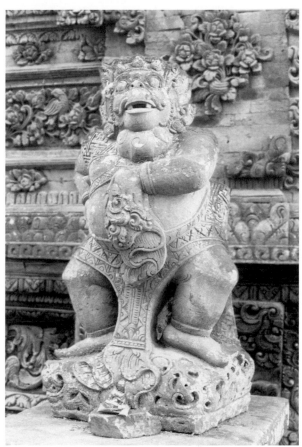

Figure 5.31. Malén (left) and Merdah (right), personal servants of Rama. Carver: I Rata, Banjar Tengah. Date: 1930s. Photographed in 1995.

ity. In the shadow play (but not in the *wayang wong*) Sangut carries a rifle, as a symbol of his potency. In the many Balinese legends about past kings, the rifle plays as important a part as the *kris*. Both weapons can be the incarnation vehicle for a variety of powerful spiritual beings who join the *sakti* entourage of a great imperial leader.[28]

The other figures along the wall are ministers and soldiers of Rawana and Rama. The dramatic narrative of the Ramayana, with its diverse characters and overriding plot of kingmanship and war over a woman, links together a large number of the figures in Pura Désa

Batuan. King Rama himself and his brother Prince Laksmana stand in front of the door of the Méru Agung, together with members of their inner court, including the general Anoman and his aides. Their enemies, the ogres Kumbakarna and Rawana, stand in front of the Kori Agung with some of their own soldiers and builders. In front of the Candi Bentar stand members of Rama's side and also Rawana's ministers, Prahasa and Dumaraksa, who are strengthened by various soldiers and servants.

In the temple are three pairs of guardians of the doorway: the two flanking the door of the Méru Agung, the

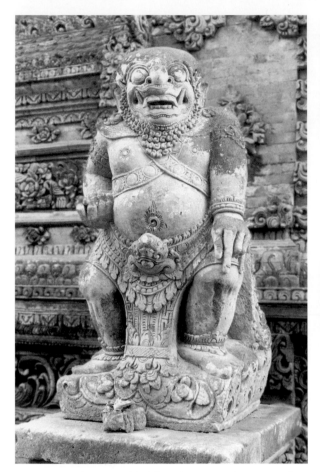 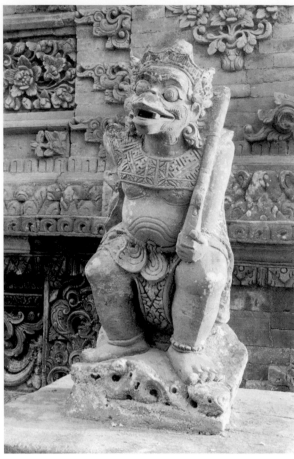

Figure 5.32. Raksasa Gundul (left) and Sangut (right), personal servants of Rawana. Carvers: I Purna (left) and I Krepet (right), both of Banjar Peninjoan. Date: 1930s. Photographed in 1995.

two of the Great South Door, and the two of the Great Split Gate. In each pair the two are almost duplicates of one another—almost but not quite. Rama has a much larger headdress than his brother Laksmana. Rawana has a slightly different crown from that of his brother Kumbakarna. And the two outside the Candi Bentar are distinguishable one from the other. This duplication suggests that when they are characters in the stories they come from, each figure is an individual, but when they have a function within the architecture of

the temple, they become typifications of their functions. Their places as *pangapit kori,* as *raksasa* guarding the temple gateways, may override the distinctiveness they assume in playing specific roles in specific stories. The same typification/individualization dialectic can be seen in the shadow play, where a single puppet can play many similar characters in different stories. This is another example of the way that single statues and other carved elements in the temple are easily given diverse, layered interpretations.

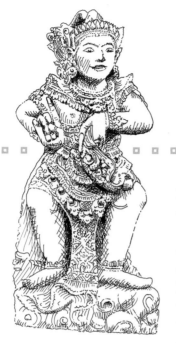

Forms, Meanings, and Pleasures

By 1936 the people of Batuan had rebuilt the main elements of their royal palace for the gods. They had restored and redecorated their main altars and had created two great new gateways and walls on the south side of the temple. From a ritual perspective, the makers had completed the most important aspects of the restoration as they saw it. After 1936, the people of Batuan were to make few major modifications of their temple, confining themselves to many additions of detail, small changes at least if compared to what they had done in the decades immediately after the earthquake. Still ahead, in the postcolonial world of global trade and transcultural talk, were major social changes, shifts even in their religious thought, that may have affected the way that at least some of the villagers saw their temple in later years.

The end of the colonial period, then, is a good place to stop briefly in my chronicle and catalogue of the stones of Batuan to think about the works of the 1920s and 1930s as "art" and to set forth more directly the outlines of my approach to an anthropology of art.[1]

Asking about the characteristics of Balinese stone carvings as "art" is a question that has its source not in Ba-

linese thoughts about worship but in Western conceptions of art; it is nonetheless a question that I have not been able to abandon. In the Preface I quoted John Dewey advising researchers to take a "detour" around the idea of "artistic products." Is it possible, having done this, now to get back to the main road? Or should anthropologists, as Alfred Gell has argued, abandon the conception of "art" entirely?

In this chapter I develop step by step a many-sided inquiry into Balinese "aesthetics" by taking up a series of words that some Western discourses apply to the appearance, significance, and appreciation of the carvings: style, coherence, unity, beauty, representation, self-reference, sacredness, and timelessness. I do not introduce these English words as rhetorical foils with which to contrast some more appropriate Balinese conceptions of their carvings, nor to advocate their abandonment, but rather to illustrate the complex intermingling of discourses and perspectives that occurs whenever one attempts to write about the anthropology of art.

The English terms, from "art" through "style" to "timelessness," are all themselves vigorously contested, not only in the discourses of philosophers and art theorists, but also in everyday talk. In some of their meanings, of course, they don't even suit much of the world's art, especially that of the twentieth century in the West, but they have had, nonetheless, privileged places in much popular talk about art. Rather than attempt to specify ever more precise definitions of such vague words as "beauty" and "representation," however, or to study more carefully their usages in various specific historical contexts, I invoke them merely as stand-ins for all of the terms of Western discourse that took part in a still continuing inner dialogue that I experienced in trying to make sense of my researches in Bali.

On the Balinese side, I have already introduced the word *maiasan,* or "beautified," a term based on the root *ias.* In chapter 3 I suggested that there is an important

Balinese ritual imperative to please the *niskala* beings through the making of offerings and carvings that are said to be *maiasan. Ias,* like the Western notions of beauty, comes in degrees. Which level of *ias* should be striven for is governed by notions of appropriate effort, with *nista* or "humble, low, despised" at the bottom and *utama* or "excellent, exalted, majestic" at the top.

Perhaps these graded standards of *maiasan* could be understood as "aesthetic," since they are values to be used for the evaluation of objects and performances directed at audiences. Can one say that some Balinese, at least sometimes, see their temple carvings in "aesthetic" terms comparable to those of some Westerners? Can one say that these Balinese look for beauty in these works? And that therefore they are, in the eyes of some Balinese, also "art"?

These main discourses, "Western popular" and "everyday Balinese," constantly quarreled—and colluded—not only in Balinese talk, but also within my own mind, and there they were often joined by a third voice, that of theorists in the anthropology and social history of art. I draw on the ideas of such writers as art historians Panofsky, Gombrich, and Schapiro, literary theorists such as Bakhtin, philosophers Mitchell and Goodman, and those anthropologists, such as Gell, Meyers, Marcus, and others, who have attempted to develop a broader foundation for an anthropology of art that is not centered on the so-called tribal arts. All of these writers also aspire at times to a neutral language, above and outside of their own locally bounded discourses. However, I doubt that any so-called objective terms of aesthetics, artistry, and creative imagination are at all possible. Yet, context-bound as they are, some of their terms have been helpful to me.

It is not only one's inner dialogues nor only the conversations between ethnographer and informant that fuse or jumble together words from diverse realms of talk, from different languages and different worlds, but

also all ethnographic writing. This fusion is what Bakhtin called "double-voicing." Bakhtin has shown that when Dostoyevsky and Dickens use indirect speech—the reporting of another's words by a character in their stories or by the author—a kind of condensation or over-determination is accomplished in which both discourses are represented at once, unevenly, in a "double-voicing."[2]

The same layered speech is always present in ethnographic description, in which the terms and semantic realms of the studied group are first contrasted with and then collapsed into the academic terminology of the scholar. Most obvious examples are the history of the uses of the terms *"kula"* and *"taboo"* in anthropological writings and the absorption of Western terms and concepts such as "art" into Indonesian speech. I sometimes employ quotation marks around English words that need careful recognition of their primary anchoring in a specific Western frame of ideas.[3]

Any conventionalized way of talking (whether one calls it a language or a discourse or something else) is reductive, condensing and fixing within its own characteristic terminology complexly ambiguous ideas that only partially fit the matters that are their focus. To verbalize events and objects that are not normally described in words is, in itself, to reduce. Even more simplifying is the effort on the part of most anthropologists to train their consultants to put into words matters they normally do not discuss. And yet, in their highlighting of certain issues, through available words, both the Westerners and the Balinese develop sharper understandings of them, and in confronting one with another may even further illuminate the objects of all that talk.

The various overlaps in meaning between similar but very distant terms and concepts that are grounded in very different discourses, such as *ias* and "beauty," make translation and indirect report possible. In contrast, their differences in meaning in their original contexts make translation and indirect report perilous. Very few terms can be perfectly translated from one language into another; therefore there cannot exist a culture-free, objective, meaning-stable social science language that might enable precise cross-cultural comparisons. Instead, what must be faced and analyzed and understood is the constantly shifting intermingling of languages. The language in which this page, this book, is written, the language in which I spoke with Balinese, even the language in which the Balinese speak among themselves, are all, as Bakhtin's translators put it, heteroglossic. While I could never listen, like a fly on the wall, to Balinese talk, I know from my own conversations with different Balinese that their speech is always a mélange of high- and low-register Balinese, Indonesian, *kawi* (itself a mixture of "old Balinese," "old Javanese," and "Sanskrit"), and elements from new discourses as suggested by the new Indonesian words for "art" and "artist."

I know of no way to escape such a verbal cacophony. One can't analyze it away, but rather must face it and attempt to understand it, as I do in this chapter.

"Style"

"Style," according to Meyer Schapiro, is "the constant form—and sometimes the constant elements, qualities and expression—in the art of an individual or group."[4] However, according to E. H. Gombrich, who rejects much of Schapiro's definition, the concept "style" is better confined to the "distinctive and therefore recognizable way in which an act is performed or an artifact made."[5] The two approaches to style are quite different, one scrutinizing similarities, the other, differences among "artworks." But both writers share one unmentioned assumption—that "style" is, above all, visible, that a description of a style is a summary of the "look" of things.

It is easy to conclude that the Batuan carvings are made in a single, distinctive, Balinese style character-

ized by an intricate complexity of surface usually indicated with intertwined vines and tendrils and leaves. The overall patterning has layering effects, of designs within designs. Smooth areas are rare. Curlicues are introduced in place of right angles. There is a strong emphasis on lines—cut into the stone or drawn on paintings in black with flat color filling in between the lines.[6] Interwoven among the many plant motifs are animal forms, faces emerging from among the leaves or sticking out of the corners of plinths. Human forms are dressed in elaborate costumes, often with the fabric patterns drawn in.

Here is a vivid description of this style by the artist R. Bonnet, published in 1953 but based on an earlier report of 1936 in which he had the newly rebuilt Pura Désa Batuan in mind:

> Between the years 1930 and 1940, when the new accomplishments in music and the dance had become almost common property, an urge to renewal in Bali's plastic art also made itself felt. In architecture this was confined to a greater complication of detail and a more luxuriant and refined ornamentation, which was carved from the soft paras (volcanic tuff) with amazing dexterity. In this superabundance often included were small scenes with people or animals, in which popular wit found quaint expression. This passion for beautification sometimes was so overweening that temple and palace entrances etc. became overwhelmed with carvings, frequently completely unrelated to the general structure. Though the traditional form was kept, the main outline was in this way almost obscured. Further development in this direction is practically unthinkable, and one wonders if this is not a typical symptom of an architectural style in its last phase. Modern Balinese architecture has not arisen.[7]

Examples of this "Balinese" style are the Padmasana (see figures 5.12 and 6.2) and the two great gates on the south (see figures 2.3 and 5.21). This style might also be seen as "Indic" at first look, and the similarities to works

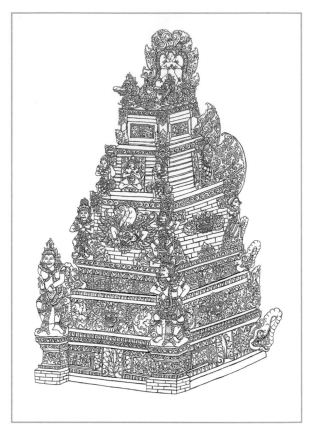

Figure 6.2. The Padmasana. Drawn by I Wayan Naka, Banjar Pekandelan, at request of H. Geertz. Date: 1985.

from ancient Java and Malaysia, contemporary Thailand, and India of many different eras leap at the viewer. The notion that "Indicism" might be the single identifiable "Balinese style" is based on the conception of style as Schapiro's "constant form"—constant over wide geographic distances and enduring over long periods of time.

Such conceptualizations have served art historians well in their efforts to identify the time and place of the making of objects. "Style" as the constant form in the works of an individual over a lifetime can be a powerful diagnostic means for the attribution of maker to an unidentified object. As such it is based on an assumed consistency of form, due perhaps to a persistence of

physiological habits of the hand that leave specific traces behind, irrespective of the will, or even awareness, of the maker. Giovanni Morelli noted and developed this phenomenon into a system of diagnostics for attribution. The system also serves archeologists, who in the total absence of supplementary information on indigenous conceptions are forced to rely entirely on formal characteristics in classifying their finds.

In his formulation, however, Schapiro points out that the art historian uses the concept of "style" for much more than technical diagnosis of provenance: "But the style is, above all, a system of forms with a quality and a meaningful expression through which the personality of the artist and the broad outlook of a group are visible. It is also a vehicle of expression within the group, communicating and fixing certain values of religious, social and moral life through the emotional suggestiveness of forms."[8]

Why or how is it that "the personality of the artist and broad outlook of a group" could be seen, could be visible, through an artwork? To whom? Can an art historian "read" such traits directly from the visible attributes of objects without the help of indigenes providing hints that these are, to them, formal characteristics with local meanings?

Schapiro provides the answer. In saying that "style" is a "vehicle of expression within the group," he suggests that the members of the group would be the first to interpret the formal features of the style as indices and symbols, as expressive of values and ideas "within the group." Once the idea of "expression within the group" is allowed in the door, the conceptions held by the group members themselves become crucially relevant. A constant form of this sort can no longer be entirely outside the awareness of the makers and patrons of the works.

The idea that a certain group might make works with a single style is often linked, in writings of the nineteenth and twentieth centuries, with the notions of national character, ethos, spirit of the times, or the unconscious expression of deep cultural trends. The popular idea that a nation or culture or historical period might have a distinct style that could be linked to a national ethos, as expressed by Bonnet above, keeps coming up even today in writings and thought about art. The style becomes evidence of the culture, and the culture expresses itself in the style. Such a formulation depends on a particular theory of culture as localized, coherent, patterned—a notion, linked to the work of Ruth Benedict and others, that in its extreme form has been powerfully criticized in the anthropological work of recent decades. By and large, there has not been a rejection of the concept of culture in general, but of the more specific version of coherent and homogeneous single local cultures. Coherence may be characteristic of all cultural formations, but most such strongly unified cultural configurations are entertained only by small subgroups in a society. A concept of a pervasive local culture that posits a psychological essence can't deal with internal differentiation or with intentional change by active agents. Today's anthropology stresses the permanently transitional nature of culturally organized vocabularies, judgments, strategies, tactics, and modes of making sense of experience. Sometimes culture is said to be an "arena" for action, dispute, and conflict, but a better conception is of culture as that which enables coordination of action, dialogue, and even contradiction within various social arenas.

An example of the use of the "national" or "cultural" conception of "style," considered as those aspects of artworks through which "the broad outlook of a group" is visible, comes from *Art in Indonesia,* the otherwise perceptive book by Claire Holt. She stated that

no visitor to Bali can fail to perceive the scintillating quality of the Balinese scene—the colors, shapes, sounds, and smells, and the expressive forms into which its people cast

their rituals and spectacles. . . . [There is a] rare harmony between Bali's lush tropical nature and equally lush art. . . . The architecture of temple complexes, the exuberant ornamentation of their gates, walls, and shrines rival the dense and varied flora. . . . In Bali, nature and man's creation seem to have fused to an extraordinary degree.[9]

But Holt supplies no evidence that any Balinese themselves recognize this "harmony" between the lushness of nature and the lushness of their arts. The association is one made by Holt herself alone, one that she considers self-evident and explicable by universal processes of perception. It depends for its credibility on the very lack of information about the meanings and purposes of those forms to those who created them and also on a notion of a diffuse, pervasive, and constant cultural environment. It assumes that those formal features identified as "the Balinese style" were largely unintentional, not matters of the artists' choices but rather a result of an unconscious following of cultural convention. It seems that it is easier to speak about style when you know little about the meanings and uses of artifacts. The less is known, the more "style" seems a useful concept.

If one is to write about style as, in Schapiro's words, "a vehicle of expression within the group," one must know which formal features the community of origin of the artwork recognized, and if recognized, what meanings or emotions they assumed to be conveyed among them by these particular formal features. Taking this position would mean taking Gombrich's stance on the matter.

Gombrich's formulation of "style" is "any distinctive, and therefore recognizable, way in which an act is performed or an artifact made or ought to be performed and made."[10] He stresses not only the distinctiveness of the way something is done, but also its quality of being recognizable. Implicit is the important notion that it is

distinctive and recognizable to someone in specifiable circumstances. Who designates certain visible characteristics as comprising a style becomes important: is it the outside observer or some person or group from within the society? An outside observer is of course free to develop any set of discriminating characteristics with which to sort out a set of artifacts, but there is no certainty as to their relevance to anyone else. Those stylistic discriminations that are made by an inside participant may be quite different, and drawn up on the basis of significant cultural values.

Gombrich points out that "the indiscriminate application of the word 'style' to any type of performance or production which the user [i.e., the outside scholar], rather than the performer or producer, is able to distinguish has had grave methodological consequences."[11] For instance, the assumption that Claire Holt invoked —that Balinese culture makes a pervasive identification of human and natural life and that all of the activities of Balinese people, including their production of artworks, are imbued with that spirit—directs her, methodologically, to ignore exceptions to that theme. Gombrich says that an approach to style that sees it

as an expression of a collective spirit, can be traced back to romantic philosophy, notably Hegel. . . . [According to the romantics] a nation's art, no less than its philosophy, religion, law, mores, science, and technology, will always reflect the stage in the evolution of the Spirit, and each of these facets will thus point to the common center, the essence of the age. Thus, the historian's task is not to find out what connections there may be between aspects of a society's life, for this connection is assumed on metaphysical grounds.[12]

It is just those "connections" that are problematic, researchable, and in need of specific establishment. Gombrich's targets were art historians such as Winckelmann and Panofsky, who saw Greek style as an expres-

sion of the Greek way of life, Gothic style as expression of medieval scholastic philosophy. But he might have been speaking of patternist anthropologists.

Gombrich suggests looking for the local natives' notions of contrasting styles and their links to cultural and social matters.[13] What are the alternative style choices recognized by Balinese (whether self-consciously verbalized by them or not)? These would not be notions of "Balinese" versus "European" or "Thai" style, global concerns that, at least until the 1970s, have not been important matters for most Balinese. Rather, we should look for the existence of indigenous categories such as old-fashioned and modern, noble and common, our village and their village, or those based on differences of ritual.

But these contrasts, as entertained by certain Balinese, are exactly what we scholars know little about. As far as I can tell, based on my experience in Bali since 1957, "style" comparisons were not the topic of any developed Balinese discourse before the 1970s, when the term *"mode"* ("manner" or "mode") was introduced, probably from English, within the polyglot social world of tourist art. (In the 1980s Balinese began speaking of *mode baru* and *mode kuna,* "new style" and "old-fashioned style." A young girl showed me an offering made of folded palm leaves in a *mode baru.*)

One contrast in manner that might be considered "stylistic" is suggested by Roelof Goris, a philologist who lived in Bali for many years and who knew as much about Balinese "art" and "religion" and "history" as anyone. Goris advances a very influential hypothesis concerning the historical links between changes in temple forms and changes in Balinese religion. He contrasts "old"-type and "new"-type temples, the first being very simple in form and decorations, plain and austere, and the second rich and elaborate.[14] Goris does not use the word "style" in his essay, but speaks rather of contrasts in the "design" and "character" of tem-

ples. He suggests that the "old"-type temples are holdovers from a pre-Hindu period and that the "new" style came in with the increasing acceptance of complex Hindu imagery and symbolism, starting in the early centuries of the Common Era. Present-day temples in Bali's mountain areas (and among the Sasak Boda of Lombok, who were somewhat Hinduized), which consist of collections of spirit houses for persons who have died, centered on large sacred stones or consisted of large meeting houses, but many lowland commoner temples especially those of the poorest peasants, have the same simplicity and austerity. These contrast with those temples, such as Batuan's, that are complexly carved.

Citing the archeological work of W. F. Stutterheim on the remains of the Hindu kingdoms of Bali from the tenth century through the fourteenth, Goris says that Bali's first Hinduized kings erected state temples *(pura panataran)* in which "the living unity of the realm was celebrated, maintained, and confirmed by religious means."[15] Only fragments of these early temple carvings remain today.[16] Goris believes that these early state *pura panataran* later became the architectural models for village *pura puseh* and *pura balé agung,* both of which are aspects of Batuan's Pura Désa. As Hinduism "filtered down from the royal courts to the people as a whole," thinks Goris, it may have been adopted by the commoners, together with the "new" temple styles.[17]

Goris' description of a fourteenth-century royal temple strikingly resembles Pura Désa Batuan. He pictures

a large temple containing a great many structures: altars, chapels, offering pavilions, meeting halls, music pavilions, offering kitchens, supply halls (rice sheds and the like), guest houses, and so forth. . . . All the stone surfaces were ornamented, and not only were there gold, silver, wood, and stone images in the chapels, but also the walls and stairs were adorned with stone statues. The woodwork,

too—the pillars, the rear side of the *bales*—and the roofs,—is highly ornamented.[18]

In part, the similarity between Goris' imagined reconstruction of an ancient temple and today's temples is due to the fact that Goris bases his model on his observations of contemporary twentieth-century temples, for there are no surviving temples in their full original stone carvings, even from the nineteenth century. Goris' hypothesis that a pre-Hindu plainness was historically supplanted by Hinduized elaborateness is convincing because it is based on other sorts of comparative materials. It is not my concern to question it, but rather to examine the significance of his observation of this stylistic contrast visible to him in the first part of this century in temple carvings.

Goris takes a perceived contrast in contemporary architectural styles ("simple" versus "elaborate") and converts it into a before-and-after sequence, thus constructing a historical hypothesis. The question is, Who saw and recognized that contrast and for what purposes? Was this a stylistic choice recognized by the Balinese builders of the temple? If so, what meanings, in the first half of this century, were given to the presence or absence of ornamentation?

The contrast, at least in the twentieth century, was not just between highland and lowland temples, as Goris says, or between the architecture of Bali Aga villages and all the others; it could also be found among temples within lowland villages, with those of poorer and lower-status people having little or no ornamentation.

Pura Désa Batuan itself was much "simpler" before the earthquake destroyed it. Several of my consultants clearly recalled that fact. Indeed, it is very likely that all village temples had this same simplicity before the twentieth century. In 1906 W. O. Nieuwenkamp traveled extensively through southern Bali, searching out beautiful temples and palaces known for their stone and wood carvings and paintings. He drew pictures of many of these. He went on foot and horseback and did not seem daunted by distance or difficulty. Of all the temples that he described or drew, only two were commoner or village temples.[19] Assuming that there was no reason for Nieuwenkamp to ignore commoner temples if they were complexly carved, we may take this as evidence that in the precolonial period only those temples directly associated with royalty were elaborately decorated.

The contrast made by Balinese between simple and elaborate temple carvings of today may or may not be a stylistic one. Some Balinese might call the simple style *polos* (simple, plain, straightforward) whereas the elaborate style might be characterized by someone as *ramé* or *maiasan*. Not only were these terms not used to contrast different styles, but they are not confined to visual distinctions. *"Polos"* may be applied, for instance, to someone's personal character, to someone who is honest, straightforward, and unselfish. *"Ramé"* can mean "crowded, noisy," and has certain theological implications.[20] The presence of terms such as these in Balinese vocabularies does not indicate that the Balinese make, or made, a recognized stylistic difference between simple and ornate.

Without the direct evidence from Balinese, one cannot determine whether a particularly simply decorated temple is purposely plain or, rather, considered "not yet decorated."[21] Of course, if it had been a recognized stylistic choice its meaning could not have been, by the twentieth century, "pre-Hindu" or "non-Hindu" rather than "Hindu," for everyone considers themselves "Hindu," including the Bali Aga with the simplest temples, who also use a Hindu-derived vocabulary for ritual and sacred matters.[22]

Any concept of style focuses attention on the visible surface of forms, ripping them out of their social context, stripping away the accompanying understandings of purpose and effect. However, if stylistic features are "communicative and expressive" within a community,

they must also be collectively defined, recognized, and meaningful.

The profoundly collaborative aspects of any activity of expression, performance, or display must be understood and taken into account before formal features can be isolated for study. One can't study such formal visible features alone without first attending to what their makers and first viewers know about what to contrast them with, what they are not.

"Beauty"

Early in my fieldwork I innocently set out to uncover "the Balinese aesthetic system" through interviewing various people concerning their opinions of the merit of certain paintings and stone carvings. An "aesthetic system" in the writings of anthropologists has been thought of as some sort of coherent set of conventional ideas about the value of certain objects, held by the members of a certain group. Such an indigenous conceptual system is usually constructed by the anthropologist out of fragments and clues that have emerged in conversations and events observed.[23]

This sort of research into posited indigenous aesthetic systems has all the problematic uncertainties that any anthropological constructions have; in addition, further difficulties related to its focus on the Western concept of "art." It may be that many of the anthropological attempts to discover and describe indigenous aesthetic systems were at base efforts to convince themselves that other cultures have different conceptions of "art" (albeit bound up in different conceptions of life and different modes of evaluation of their cultural productions). Perhaps they were trying to justify the Western appreciation of artifacts displayed in museums.

Whether or not individual researchers were indeed looking for universal aesthetic standards masquerading as local ones with idiosyncratic twists is a question for intellectual historians. Here I take an agnostic view on the issues of universalism in recounting some of my own investigations.

I set out to devise a shortcut intended to compensate not only for the brevity of the research period but also for my inadequate control of the language by interviewing people, with a tape recorder and specially prepared photographs of artifacts, and asking, which ones were "better" and why.

The first try was with a set of photographs of shadow puppets (six versions by six different artisans of each character: Arjuna, Twalén, Condong, among others). The second was with selected photographs of contrasting temple carvings. I put two or three photographs before each consultant and asked each something like "Which of these do you like better and why?"

Most respondents in my structured interviews did not find the questions interesting, and gave only brief answers. A large proportion of them turned out to have poor eyes and couldn't see the photographs very well. Usually the interview shifted into issues of attribution and iconography, useful topics but not aesthetics as such. Much more fruitful, although few and brief, were the unprompted and spontaneous remarks that came up in other circumstances.

Neither experiment generated the expected verbalized "system of aesthetic values." Further, to my disappointment, I never found a local "art critic" among all my consultants—that is, someone who could give me an extended, thoughtful analysis of the bases for his responses to these works or their parts—with the exception of certain Westernized young men. Indeed, I grew to realize that I was asking people to discuss the objects before us as if they were "artworks" when the people had never thought of them that way. And in my subsequent analysis, I was putting too much burden on analyzing single terms, taken out of their discursive and action contexts and reframed within my own scheme of an "aesthetic system."

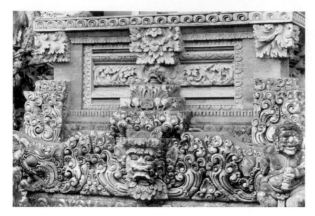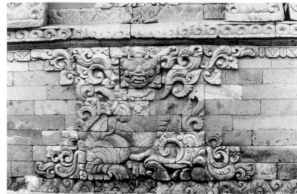

Figure 6.3. Left—Base of Méru Alit. Carvers: I Wayan Pageh and team. Date: 1920s. Photographed in 1983. Right—Base of Méru Agung. Carvers: unknown. Date: before 1917. Photographed in 1983.

Nonetheless, such an analysis of the words that often came up in these interviews may be useful, if only as a demonstration of the ways that my consultants participated in the same sort of Baktinian fusing of discourses as I do. Nearly every one of the comments I report below is double-voiced and overdetermined.

. .

Once when the elderly Pamangku of Pura Désa Batuan, himself an occasional painter, was walking around with me in the temple explaining to me the purposes of the various altars, he interrupted his talk about ritual requirements to point out a contrast between the carvings on the bases of two adjacent altars, the Méru Agung and the Méru Alit. Those on the Méru Agung were older, he said, from before the earthquake, while those on the Méru Alit were made in the 1920s or 1930s and renovated since then.

He said, "Look how the cutting of these are different. The newer one, although cut more deeply and more polished, does not have *cayaha* like the older ones." The Pedanda with his usual taciturnity did not elaborate further, but his remark carried a great deal of meaning.

"*Cahaya*" means "brightness, shining, radiance" and is sometimes used in the phrase *cahaya idup*, (the radiance of life). An almost exact synonym is "*teja*," a term other people often used for carvings they admired. The two terms are associated with another, *byar*, which means a sudden blaze of light, as from lightning. "*Byar*" is an element in the term "*kebyar*," the name for genre of gamelan music that was created in the 1920s and become the most common musical form heard today. *Kebyar* is characterized by sudden bursts of loud and fast playing.[24]

Another, more modern, term for the steady radiance and high value that sometimes comes into conversations is "*karat*"; it has come via Indonesian, from Western languages, linking high estimation to value in gold. "*Karat*" may have entered these languages as early as the nineteenth century, since gold was valuable even then.

The radiance of *cahaya* is closely associated with ideas about vitality, sometimes tagged with the terms "*idup*" and "*urip*," signifying the sense of actual moving life that an admired statue might contain. The opposite of *idup*, for some, is *lemuh* (flaccid, flabby). For instance, one artist contrasting the work of the 1980s (as represented by Déwa Cita; see chapter 9) with that of the

1930s said that "today's work is neat *(rapi)* but *lemuh,* without firmness *(mantep)* and without life *(jiwa)."*[25]

Some educated people engaged with me in a much more elaborate kind of discussion of the carvings. For instance, once, when sitting idly in the temple during one of those long periods of waiting between stages in rituals, I decided to use the time to interview directly two young painters about the carvings around us. I asked them which of the temple carvings they liked best, and why. They were both high school graduates (one was a teacher), and they insisted on speaking Indonesian with me.

The first immediately picked out the row of small Ramayana statues just outside the temple wall (see figures 5.30, 5.31, and 5.32), saying, in good academic form, that they exemplified four main criteria for excellence: *cara bekerja* (Ind., "workmanship"), *ceritra* (Ind., "story"), *kesan* (Ind., "feeling"), and *hidup* (Ind., "alive").

The other young man added, in the same didactic manner and in the same hybrid language, other criteria: *unit* (by which I think he meant "unified"), *kuat* (Ind., "strength"), *cahaya hidup* (Ind., "glow of life"), and finally *detail* (Ind., "detailed"). Such organized summaries of criteria were unusual in my interviews. He chose, as the best carvings exemplifying these attributes, four statues in front of the Padmasana and the Méru Alit, which were made in the 1950s by Déwa Putu Kebes (see figures 7.3 and 7.4).

As we talked further, the two young men used the term *"seni"* (art) repeatedly, speaking of the *seni* of the artisans. This is a relatively recent addition to Indonesian vocabulary, a direct translation of the English term "art." In Bali in the 1980s the term *"seni"* was often heard, and those who used it often could give fairly coherent answers to questions concerning the artistry of specific carvings, or more often paintings, for this was a discourse strongly linked to tourist art. Since this sort of talk was common and easily recognizable, I would call it a well-developed discourse. It centered attention on the uniqueness of individual painters, their originality and their avoidance of copying and collaboration. It was certainly not a kind of talk that could have been engaged in in the 1920s and 1930s.

Nonetheless, the way the two modern young men spoke had its resonances with the talk of the Pamangku and the other older people whom I consulted on the valued qualities of the temple carvings. While both stressed what appeared to be simple matters of technical competence or skill in carving in their choices, on closer analysis these turned out to be what might be called spiritual concerns.

The two young men spoke of their admiration of depth of cut *(renyep),* of complexity of design, of polish and neatness *(rapi),* qualities in part attributable to better steel tools and harder stone as well as better techniques. For instance, one pointed to a panel of intertwined vines and praised it for being *rumit* and for the illusion of movement *(gerak)* of its leaves. *"Rumit"* means "complicated" and refers to the high level of detail and complex intertwining of these depictions of luxuriant vegetation. It can also mean "difficult to carry out," and perhaps he was commenting only on the workmanship. However, I think he meant much more. The term *"rumit"* can also mean *"ramé,"* of which I have already written, the overall desirable characteristic of fullness, copiousness, and busyness, and perhaps, also vitality. Further, both young men also invoked the Pamangku's criterion of *cahaya* (radiance, vitality), saying that the carvings they liked had *cahaya hidup* and *hidup.*

In my interviews centering on photographs, almost everyone mentioned the quality of *tenget.* In nearly every case, the consultant would choose obviously older carvings as preferable. As long as these older carvings were still undamaged, they said, they must be *tenget.* That is, because of the long periods in which they were available, they harbored, or even acted as, one or more *niskala* beings. Newer carvings have not yet had the time.

I believe that *cahaya* is understood as a sign of *tenget-ness*. When the Pamangku said that the carving he liked was *cahaya,* he was implying that it was *tenget,* that spiritual beings were near or in it.[26]

In apparent contradiction, certain newer carvings were also valued as having *cahaya.* The second young man above chose two of the 1950s-made figures as exemplifying this quality (the statues of Merdah and Mélem on the Méru Alit; see figures 7.3 and 7.4). These were made by the master carver Déwa Putu Kebes, who was often spoken of as a man of *sakti.* One consultant said of Kebes that "when he was making a painting or a statue, he could focus his thoughts *(tetuek pekayuné),* then, *ték!* his thoughts spoke." *"Ték"* is the sound of suddenness. *"Pekayuné,"* which I translate here "thoughts," is a complex notion, meaning feelings and intentions as well as thoughts.[27] *"Tetuek"* means to narrowly focus one's thought. It comes from the word *"tuek,"* which means to stab or pierce deeply.

The speaker assumed that when one focuses one's *pekayun,* one obtains the *sakti* competence to do marvelous things. The whole of the statement describes the process of entry into or guidance by *niskala* beings of the work of a brilliant stone carver. To help in that effort, many performers and artisans regularly give offerings to Ida Betara Taksu, who has altars in numerous temples, to help them focus their *pekayun* and to enlist the help of a powerful *niskala* being.

From the perspective of the carver, how one attains *cahaya* and *idup* in one's carvings is a matter of spiritual, not merely manual, training. It is a matter of inspiration, but only in its older Western, nonpsychological sense of the collaboration with or even entry into one's self of a spiritual being.

Tenget and *cahaya* and their ilk are not "aesthetic" qualities. While they seem to be about visible appearances, they are not. *Cahaya* is recognized not by the look of an artifact but by its effects on the viewer, who simply "knows" that the *niskala* beings are there.

Is a construct of "beauty" entirely inappropriate for a Balinese temple? "Beauty" stands for a certain kind of pleasure—pleasure in the relations among forms, between form and meaning, and among qualities such as texture and color, relations that are set up in a certain artifact. Panofsky in attempting to define a "work of art" started with the aesthetic pleasure, quoting Poussin's dictum *"la fin de l'art est la délectation."*[28] Perhaps the Balinese desire to please the *niskala* beings who attend their festivals is aimed at providing them with objects of delectation. Perhaps the *niskala* beings are considered to have a sense of beauty.

Oddly, *ias,* the term I took, at first, to be a key into any Balinese aesthetic system, whether spoken of by itself or in any of its grammatical permutations, such as *maiasan* ("made *ias*"), was never mentioned in any of my talks with Balinese of all sorts about the carvings. Perhaps the term is an assumed and unmentioned background to evaluation, an indication of the overall intent of all carving in the temple as pleasuring the gods through the decoration of their palace.

Centering research on the terms employed in discussions of the artifacts singled out by the anthropologist asks consultants to search for words with which to frame their answers to awkward questions. The anthropologist then assembles these terms into a pattern that may or may not be prominent in their thought.

In their groping around for words my consultants drew from pools of words—discourses or common ways of talking identified and held together by their common subject matter—that normally center on other subjects. One of these conventionalized pools of terms that was invoked several times above is that of the craftsmen.

Yet another fairly developed discourse they sometimes drew from is that of the dance-drama, which I will discuss further below. A third and distinctive dis-

course emerged in my conversation with the two educated young men above. This was the kind of "art" talk that they customarily engaged in with tourists who could speak Indonesian and who assumed that they were looking at "folk art" or "Asian art."

Whether or not these are called discourses, the most important thing to recognize is that my consultants spoke through, and mixed together, a great range of different approaches to evaluation, none of which were purely aesthetic. I think it is fair to say that, with the partial exception of the kind of educated youth quoted earlier, there didn't exist in Bali, even in the 1980s, what might be called a discourse on art or aesthetics, nor was there a developed underlying aesthetic system of ideas.

I had, at first, assumed that I could integrate the vocabularies and figures of speech that Balinese used in regard to their carvings, even though they had been pulled out of context, into a coherent pattern of ideas about the desirable and pleasurable look of artifacts that all or most Balinese share, a set of common notions about "beauty."[29] For a while I assembled words from my interviews, thinking of them as key terms. But I gradually came to realize that these lists of words were "keys" not to Balinese understandings but to my own formulations. They were keystones only to my own jerry-built arches. The citing of decontextualized "native" terms is a common rhetorical technique for conveying an understanding of a broader cultural worldview, and I use it sometimes in this book, but its limitations and potential for misunderstanding must be recognized.

Another reason key terms can be misleading is that any strict discourse approach to the study of art—that is, one centered on the words people use—is only partial, since so much of experience is not normally verbalized. Much, or perhaps most, of life is not spelled out, except when speaking explicitly and didactically to children or foreigners. This is why direct interviewing about the nature and the meanings of the stone carvings resulted only in fragmentary insights.

Scholars, even anthropologists, nonetheless must put everything they know into words for their books and articles. Without those verbal formulations one might say that the insights do not yet exist. But scholars should not deceive themselves into assuming that full and explicit verbalization is the common state of human communication.

How these Balinese might have seen these statues is, as I have said, bound up in their ideas of what the statues are supposed to be and why they are placed where they are. Of these ideas, the paramount ones are the attracting of the gods to the temple (evidenced by the quality of *tenget*) and then the pleasuring of them (through in part making the temple *ias*). This larger project of carrying out of the rituals successfully has provided its viewers, even the most modernized ones, the defining parameters, the dominant cultural frame, for evaluation of the material objects associated with the rituals.

Knowledge of the project of worship and its constraints is similar to a Western artist's knowledge of genre or of a school of painting, in that it provides an overarching predefinition of what the statues are and to what aspects of their context they relate. But these are not genres of a disembedded fine art but culturally defined purposes in social action. Evaluation, in such complex circumstances, cannot be aesthetic alone, but, perhaps, primarily pragmatic, asking, How effective is the product of workmanship in communicating positive messages to the gods?

"Unity and Coherence"

Meyer Schapiro states that one of the "conditions of beauty" often considered by art connoisseurs is the characteristic of "perfection, coherence and unity of form and content." He goes on to question the universality of this criterion for aesthetic excellence.[30] Schapiro rightly notes that form and content are not always united even

in Western art. His example is the presentation on Greek vases, in the same formal modes, of a great range of topics—"themes of myth and everyday reality, the tragic and the festive, the athletic and the erotic"—presented by the same formal means, independent of the formal characteristics of their expression.[31] Schapiro says that when both form and content are understood, coherence and unity "are not strict nor indispensable; there are great works in which these qualities are lacking."[32] Schapiro concludes that the attribution of perfection, coherence, and unity is never stable, even through repeated judgments by the same person: "It is clear from continued experience and close study of works that the judgment of perfection in art, as in nature, is a hypothesis, not a certitude established by an immediate intuition."[33]

This is a helpful attitude to have when approaching a foreign artifact. Every viewer, I suggest, develops hypotheses based at first on largely unexamined preconceptions, tentative guesses that can be matched to further information. If scholarly truth is sought, such hypotheses must be abandonable or at least modifiable as acquaintance develops.

A closely related issue, for the anthropologist or historian of art, is how to determine what the artworks to be studied are, that is, how to separate artifact from context. For instance, when masks or the broken-off heads of buddhas are placed on display in museums, they are automatically taken to be admired as aesthetic unities, but the sense of completeness may be quite false in their original home circumstances. The question for the researcher in Pura Désa Batuan is how do various Balinese viewers isolate parts of it, such as a statue or an altar—or the whole temple itself—for any evaluation that takes into account their visible form.

I will discuss these issues of unity and coherence through the examples of certain carvings in Pura Désa Batuan—first the large central altar, the Méru Agung, the impressive construction that stands separate from the other altars, taller than the rest with its three high roofs (see figure 5.4). Later in this chapter I'll also talk about the aesthetic integrity of groups of individual figures such as those of Rama, Anuman, and their courtiers that stand on the ledge of the Méru Agung (see figure 5.8).

. .

Some of my consultants appeared to invoke a notion of "a complete aesthetic whole" in speaking of the Méru Agung. They pointed out that the three high roofs are the symbol of the holy Mount Méru or Mahaméru. As Mount Méru, the altar stands for the original home of all the gods from which they scattered; it also stands for the entire world as well and all its animal, plant, human, and godly inhabitants. With its strong horizontals of friezes and borders, as well as its strong verticals topped by its three roofs, the altar as a whole can be seen to present a powerful feeling of stasis, order, and unity. Some of the imagery of the carvings and paintings could be taken to further emphasize cosmic inclusiveness: the placing of the sun and moon narratives on the upper stories, human beings and their animal allies in the middle, and the demonic hybrid animals on the bottom, all add up to a comprehensive image of the whole world.

In invoking "the whole world" my consultants may have been implying something about aesthetic unity, but explicitly they were speaking of cosmic unity. They were talking to me in the 1980s when the discourse of the Hindu Dharma movement was common. Were there people around of that persuasion in the 1930s when this was built? I think not, although the ingredients for the Hindu Dharma view were already there then. But nothing my consultants said suggested the idea that through constructing the Méru Agung human beings

could help put the universe in order, or that the whole altar represented that order. This Hindu Dharma theology was probably not present in the minds of the builders of the Méru Agung in the 1930s.[34]

Within the more usual commonsense view a quite different conception of "wholeness" rules. Rather than seeing the altar and the mountain as a unitary, integrated whole that is comprehensive and all-enclosing, this perspective suggests that the Méru Agung stands for the sum of everything, that is, for an aggregative kind of completion. It is not "the universe" that is being pictured, but "all of its members." The notion of "the entire world" is not one of unity, ranked order, and integration. Rather it is one of aggregation and accumulation, adding up to a state of fullness and largeness.

Two terms that could be used in speaking of the "wholeness" of artifacts such as the Méru Agung are *"ramé"* and *"genep."* I have already discussed *ramé*. Often invoked by scholars as an important Balinese value, it has a range of meanings from "busy," "crowded," "noisy," "fun," and therefore "plenitude"; but when applied to visual forms, *"ramé"* may mean by extension "complete" in the sense of "everything is present at once."

"Genep" means "full" or "complete." William Cole presented an insightful analysis of this Balinese conception, which he calls "containing everything" or "aggregation."[35] The two terms point to a general Balinese idea of aggregative completeness, plenitude, and fullness that contrasts with some Western conceptions of "wholeness" that imply integration, visibility (you can "see" it all from a certain distance), and the possession of a recognizable intrinsic essence and center.[36] Why the Méru Agung should "contain everything" is understandable when it is realized that this altar is not only a throne in the middle of a great palace but, like many other Balinese constructions, also an offering.[37] As an offering, the Méru Agung says, "We would like to give you the entire world," and in so doing it contains depictions of elements in that world, including *buta,* humans, and *déwa*. And this magnificent collection of "everything and everyone there is" conveys the highest praise of the gods of Batuan.

"Aggregative completeness" as a guiding conception means that the Méru Agung is understood as a conglomeration of unlike elements. The styles and references of its various parts are highly heterogeneous. On a semantic level there is a great deal of rich interreference among these side-by-side components. The fantastic beasts on the base, Betara Kala on the top, and Rawana (who is not depicted on the Méru Agung, but nearby just outside the Great Gate on the South) all echo one another, as do Rama's images and those of the gods on the top. The Méru Agung was not made all at one time, but in progressive additions over the years, a mode of construction that makes sense as an aggregation.

A carver, in speaking with me of a *kulkul* tower he had made for a different temple, one even more encrusted with diverse figures, said that it was a *gado-gado,* a "mixed salad." An aesthetic based on heterogeneous accumulation is alien to a classical Western aesthetic with its concern for organized harmonies among parts and wholes and to an ontology that seeks sharp distinctions among component elements. Such a classic aesthetic assumes that "art" in its essence is "order" and that architecture and sculpture and the other arts are composed and organized like sonatas.

The idea that the harmonious relation of parts and whole provides an important aspect of aesthetic pleasure might be an element in the frequent Western notion that the overall form of a Balinese temple is based on the structure of the cosmos. The notion that a temple has an overall design might be based on a false sense of the naturalness of a larger all-encompassing order. In trying to comprehend Balinese interpretive stances, we must recognize and question such Western

assumptions about the nature of "wholeness." This is all the more so when we try to imagine Balinese criteria for aesthetic evaluation. The look of something "as a whole" is much less important for Balinese than the idea of its accumulated plenitude.

The search for a quality of unity and harmony of parts and whole in an "artwork" is one example out of many that a Western conception of "aesthetics" might direct one toward. Spatial arrangements, scale contrasts, textures, symmetry, and rhythmic repetitions are some others. These are all characterized by the notion that formal aesthetic judgments and the criteria on which they were based can be insulated from other sorts of judgments by the person making the evaluation, notably those concerning meanings.

The separation of form from content or meaning, even understood as merely analytical, proves impossible. That idea is a unique product of Western critical and philosophical theories (Kant and his associates) and of Western social institutions (museums, for instance) that gives the idea of formal excellence and universality its sense of naturalness. I turn in the next section to some issues of meaning.

"Resemblance" and "Self-reference"

Who do the figures stand for? How well do the statues resemble their models? Do those that are of "monsters" really have human forms at base? To ask about resemblance is to ask about what is represented and also about how it is represented, what kind of representation is involved and what were the intentions of the carvers and their patrons.

I questioned many people about certain statues: "Who or what are these figures?" Aside from the common and dismissive answer that they were ogres *(raksasa),* many named some specific character from the Ramayana or the Hindu pantheon. But once I got an answer that illuminated everything everyone had said before. A man from Banjar Dentiyis said, quite casually, "All the statues along the front wall of the temple are dancing."

"Dancing?" I said, thinking of their stolid blockiness; "they can't be."

"Yes," he said, "they are," and he pointed out the specific dancing position that each one held—how their torsos are slightly tipped forward—and their clothing—they had on the headdresses and costumes of dancers. "For instance," he said, "the statues of Rawana and Kumbakarna outside the great doorway of the Candi Kurung are in the dance position called *tandang tangkep agem"* (see figure 5.22). *"Tandang"* means "posture, movement," as does *"agem." "Tangkep"* means "boldness, strength, energy, and elegance." *"Tandang tangkep agem,"* said he, refers to the position in which "the dancer is standing still, looking down, thinking of his next move, just before he starts to move across the floor."

At other times, when I asked people which statues they preferred, several of my consultants chose ones that they said had more "movement" *(seh).* They said such statues look "as though they are about to step forward." To these people, the statues of Rawana and Kumbakarna embody the vitality and spring of a dancer; they are alive.

Rawana and Kumbakarna are not the only ones dancing; the statues of Rama and Laksmana (on the Méru Agung) and (out on the road) of Merdah and Melem, of Ngada, of Delem and Sangut, and of all the *panjak* of Rawana—every one of them is dancing (see figures 5.8, 5.22, 5.30, and 5.31). Two drawings by someone from Batuan strikingly confirm that the people of the 1930s also saw them as dancing. Made in 1937, signed by I Saweg, it exaggerates the dancing quality of the carvings.[38]

"The dance the statues are performing," my consultant said, "is the *wayang wong,* and the story here is from the great Indic epic the Ramayana." The *wayang wong* is

Figure 6.4. Statue of Rawana in Pura Désa Batuan by a Batuan artist. Artist: I Saweg. Date: 1937. Bateson-Mead Collection.

one of the many genres of the complex dance-drama traditions of Bali. Each of these genres has its own special repertoire of stories, and most dance troupes specialize in only one genre. Batuan has a *wayang wong* troupe of its own, all of its members from my friend's *banjar* of Dentiyis, and the stories they enact all come from the Ramayana.[39] The Dentiyis troupe perform only during the Odalan, wearing the sacred masks that are otherwise stored in a small Dentiyis temple (see figure 3.10.)

My consultant said that the faces on the figures are copies of the masks worn in the dance. Following up on this lead, I looked at the masks, which are stored in a temple in Dentiyis, and saw that they are not, actually, copies of the Batuan dance masks.[40] They were probably not copies of any particular wooden masks, but

imaginative reconstructions of what the masks might look like. He further pointed out the every stone figure is in a different dance position, with the monkeys, for instance, in the dance position called *agem wenara* (stance of the monkey), holding their *saput* or scarf in hand.

"How can one know," I asked, "that these stone figures are performers from the *wayang wong?*"

From their costumes, headdresses, masks, scarfs, and jewelry. And from their postures. For instance, the Melem figure has a bent arm that in the shadow puppet is permanently bent and swings backward and forward when he does his comic dancelike walk. The costumes, too, are for the most part those of the *wayang wong* with some details taken from their original source, the puppet-play figures, the *wayang kulit Ramayana*.

The iconography of these figures (and of others I will come to in chapter 7) is therefore drawn directly from the dance-drama and the shadow play of Bali. There is some circularity to this tradition: The statues are inspired by the look of the dancers and puppets, and the dancers' costumes are sometimes, in turn, drawn from those of the stone figures.

My consultant from Dentiyis went further. He said that the statues were dancing a particular episode from the Ramayana, one that he himself had danced often at the temple rituals. He said it was the tale called "Penetes Ngada" (Ngada's investigation) or "Kutus Ngada" (Ngada's Mission), in which Ngada, the faithful monkey-general, was sent by King Rama to find out how his queen, Déwi Sita, fared in her captivity in the palace of the Ogre King Rawana. Ngada set forth accompanied by Rama's magically powerful servants, Malén and Merdah (also called Tualén and Wredah). The latter pair stand on the left or western end of the row of figures along the road. All the rest beside them are the followers of Rawana they met along the way. Behind them, next to the Great Door, are their two ogre leaders, Rawana and his brother Kumbakarna. Deep inside the temple, standing high on the central altar, the Méru

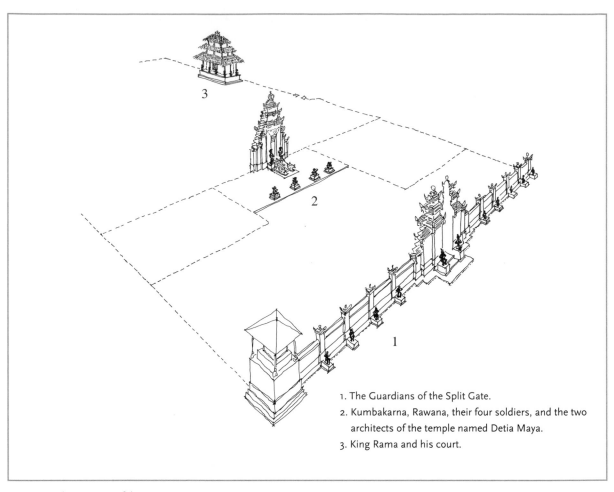

1. The Guardians of the Split Gate.
2. Kumbakarna, Rawana, their four soldiers, and the two architects of the temple named Detia Maya.
3. King Rama and his court.

Figure 6.5. The program of the Ramayana statues.

Agung, are the king Rama and his brother Laksmana, with their courtiers and generals at their sides, awaiting the return of their emissaries.

The ensemble makes up a grand tableau, which stretches from within the heart of the temple out to its exterior. Even though Rama, his entourage, and his enemies cannot be seen all at once, the great and well-known narrative holds together the entire ensemble of statues, makes it into a single, meaning-bearing work of artistry and imagination.

Each set of Ramayana figures flanks an important doorway, accentuating the fact that *niskala* beings may cross its threshold. The three doorways—the Méru Agung, the Kori Agung Kelod, and the Candi Bentar Kelod—are linked or made analogous through their use as a stage for the Ramayana figures. The statues in front of each doorway command the space before them, as if it were full of expectant worshipers waiting for the gods to appear.

· ·

This great tableau can be seen as a single artwork. The ground of its unity and coherence is unlike those of the Méru Agung, which is one of aggregation. Here the organizing glue is narrative. Without the knowledge of the general Ramayana tale, without the knowledge of the specific episode within it, in which each of these figures is an actor, the viewer could not know where the boundaries of the work lie or the nature of its integration.

For the people of Batuan, this particular artwork is is not about the narrative by itself, the story of Rama's war with Rawana, but about a secondary theme suggested by the analogy set up between the stone figures and the human dancers.

The statues stand for the people of the village dancing the *wayang wong* to greet the gods, my consultant said explicitly. These statues are near human size, made so perhaps intentionally to resemble human beings more closely. They are dressed in costumes sometimes worn by the specific community members of Batuan. The use of dance as a greeting is common: even today in the Gianyar palace, during an important ritual festival, dancers welcome arriving royalty in the first courtyards, and at the airport just-landed foreign celebrities are usually met by dancers. Almost all the statues in a temple are dressed up during a ritual festival, with cloth sarongs around their waists and flowers in their headdresses. They are understood as living beings who, like their human viewers, are engaged in *ngayah* to the gods of Batuan.

Thus, the stone figures from the Ramayana story, streaming out of the temple from the high inner altar to the row along the road outside it, are understood not only as godlike beings from a mythic world, welcoming and acclaiming the coming of the local gods of Batuan, but also as their immediate human congregation dancing their worship. The statues, like—or, better, along with—their makers and viewers, are participating in the overall act of communicative engagement with the divine. As I stressed in chapter 2, the work of *ayah* or *karya* is collective, an organizing of contributing roles of all sorts. The image of King Rama and his entourage is an appropriate one for the united people of Batuan themselves, together with the hosts of *niskala* beings, celebrating the visit of their gods.

This Balinese analogy making might entail another component of some Western notions of an "artwork," that is, the idea of reflexivity, the notion that an artwork is distinctive from other visual artifacts in that it calls attention to itself as an artifact, to the processes of its making and to the people who made it. The consciousness that the maker and the audience may have of the human purposiveness of an artifact may be, and here is, given representation within the associations that these statues arouse. The very artificial quality of "art" is thus stressed; the fact that the statues were made, and made by particular people and for certain imagined viewers, is given visible form.

Reflexivity in an artwork can be produced, as this one is, by the representation within the work itself, by means of its own iconography, of the maker and the circumstances of its production. But such an inscription is illegible unless the viewer has the requisite prior knowledge—in this case of the specific Balinese dance of Ramayana and its meanings. Reflexivity (and perhaps any kind of meaning in the visual arts) can occur only when the viewer recognizes it, when the beholder contributes his share.

One might call such reflexivity "self-reference." However, the term "self" introduces some major ambiguities: Who or what is the "self" to which the work refers? Is it the work itself? Is it the work's maker? Is it the "self" of a viewer? Or can it be all of these? The common Western conception of "self," guided by various ideologies of individualism and assumed to be an undivided agent, may blind one to a recognition that, even in much Western art, the "selves" that are imaginatively evoked when a knowledgeable viewer actively

constructs various referents of an object may be multiple, contradictory, and even collective.[41]

This point resembles that made by Howard Becker about the social networks of the "artworld" of collaborating people linked to any particular artwork, but I am speaking here also of the imagined worlds and social networks made up of imagined makers and imagined audiences that each viewer creates.

In the case at hand, the "self" referred to is not only the local troupe of dancers, but also the makers of the carvings—that is, the whole team of artisans. And the term "maker" must also include its planners, the temple committee, and other interested members of the temple community, who are representing the entire worshiping body of Batuan. The "self" referred to, thus, is all the viewers in the community, who, armed with the knowledge that the Ramayana statues are dancing, might see themselves as dancing.

In an imagined world it is easy to see one's self made up of many persons, depending on perspective and project. In the pervasive conventional discourses and practices of Balinese ritual, deities and humans merge in moments of possession and of the exercise of *sakti* competences.

Looking for the ways that the statues resemble or refer to both deities and humans, observers and observed, participant worshipers and worshiped may be easier in Bali, where the line between deity and human often blurs and disappears. This would have been especially the case in Bali in the 1920s and 1930s, before the complications introduced by the incursion of Western conceptions and ideologies about individualism and art came to Bali in the eras after the end of colonialism and the beginnings of globalization.

. .

So—the statues "represent" the characters from the Ramayana, but they are also the villagers dancing. What might this simultaneous construal mean for an anthropology of art? In trying to make sense of the differences between the way I and my Balinese friends saw the statues, I realized that I needed to think further about my ideas on "representation," "resemblance," and "reference" and found them to stand for much more complex processes than my commonsense language allowed.

I started with an understanding of "representation" as one kind of relation of a sign to its object, the ways that a statue resembles or refers to that which it stands for. These statues have double referents that complexly refer back to one another. They are, on the one hand, images of mythic or literary characters and also, on the other, images of people dressed in costumes of those characters. In Balinese terms, at least roughly, the statues show both the invisible world (the imaginative depiction of Rama and his followers and the *niskala* beings that might take their forms temporarily) and also the visible world (the realistic depiction of Batuan people dancing).

To push the idea even further, these stone carvings represent not only certain figures, visible and invisible, but also the acts of their making. These artworks represent, at some level, both the work that went into their making and the work that goes into their viewing.

But to state it this way requires me to personify the artwork, to assume that the artwork is the agent, one who performs the act of representation. A more accurate, and more fruitful (and more anthropological) way of phrasing matters, is to say that the people of Batuan "take" the statues "as" *niskala* beings or "as" themselves dancing the Ramayana.

In "taking" them as standing for those well-known beings, my consultants were performing active identifications and interpretations, not passive registering of iconographic matches. These are acts that I, without their cultural training, could not do. For Batuan people, "characters from the Ramayana" denote more than just

certain protagonists in a traditional story, for the Ramayana was, for them, first and foremost a sacred dance they themselves often performed or witnessed.[42]

A properly anthropological and historical approach to representation and resemblance would study not only what the viewers "see" or "look at" but also the many ways by which they "take" an object and what and who they are "looking for"—and through what sorts of cultural glasses. The question for the researcher is not merely what is being represented, but how the representation is taken, for whom, and for what purposes.

The art theorist E. H. Gombrich called these acts of "taking" or "looking for" "the beholder's share" in his book on the illusion of depth in drawings and paintings.[43] He showed that the nature or characteristics of any particular work is, in part, decided by each viewer who comes across it, guided by "mental sets" or "schemata," which are culturally provided guesses the viewer "matches" to the artifact before him. Gombrich's analysis, while phrased in terms of universal human psychological processes, is actually a study of strategies for making sense of forms on a flat sheet of paper or canvas by a culturally informed viewer.

Gombrich's researches into the psychology of perception of artworks are echoed by work by literary theorists into what might be called "the reader's share" in the interpretation of poems and novels.[44] According to these writers, cues to the reader are provided within each text regarding how to take its meanings, cues that rely on the reader's prior cultural knowledge of genres, of related texts, and of everyday speech.

However, audience responses or practices are notably difficult to elicit, requiring a kind of self-report that may not be, as in this Balinese case, culturally conventional. It is easier to discover—or infer—the cultural guidelines, the standardized interpretive frames and strategies that viewers might bring to bear on making sense of an experience. This latter is the underlying approach of this book. These cultural frames are easier to discern because they are more general in scope and therefore more frequently and diversely invoked than the more specific audience responses. Such cultural guides give each viewer a sense of possible appropriate interpretations, while at the same time they may limit his imagination.

The act of viewing entails not only an interpretation of the meaning of the work, but also an active, imaginative integration of a number of disparate modes interpretation of possible meanings, culturally available to the viewer. The existence of multiple viewing strategies, when taken into account by any one viewer, makes for what are called metaphorically "layers" of meaning —that is, the simultaneous recognition of multiple meanings that enrich each other, within the mind of one viewer.

Such acts of imaginative integration and interpretation are done not only by viewers, but also by makers. In fact, it would be well to consider the maker as the first "viewer" of the artwork, in that his viewing of the carving, as he sees it gradually emerge from the rough stone, must be multiple, as he imagines himself as other kinds of viewers, from his village colleagues, to the specialists he knows of such as a *dalang* or a *pedanda* to the *niskala* beings themselves. When the stone carver comes from the same community of his clients and patrons, he brings to his task the same cultural interpretive frames.

The carver may or may not take into account other, more distant and merely potential viewers, such as people from other villages, governing officials, and foreigners such as tourists and anthropologists. But the readers of this book would have been irrelevant to the image-making of the stone carver.

. .

The approach to an anthropology of art suggested here turns attention toward the viewers (including the mak-

ers) as the central actors and asks for the relinquishment of speaking about such processes as "representation" and "resemblance" as if they were agentless relationships. A viewer is a culturally informed active agent who may take each artifact to represent something. The approach turns attention to meaning-making strategies employed by actors caught up in history, in changing circumstances of unequal differentiated power.

"Representing" would comprise more than one of these meaning-making strategies, many different modes of "taking-as" or looking for and making sense. It would include looking for resemblances, constructing references and associations, metaphors, metonyms, symbols, examples, iconographic matches, and indexes in Pierce's sense, which I will come to shortly. It would also include searching for clues to acts of self-reference, of awareness of the complex play between artist and audience.

The anthropologist's job has always been to discern the cultural guides that inform action. In the case of "art," these frames might include viewers' own notions of "style," "beauty," "wholeness," and "representation," or such notions that may resemble them. The organization, or imaginative integration, of such disparate notions by a viewer would be made within a culturally defined general project of action, as for instance, here, the overall goal of engaging with *niskala* beings, of appealing to them through homage and sensory delectation to gain their help in achieving material well-being, safety, and fertility. Such a major culturally defined project would override lesser ones such as the pleasure of good craftsmanship or impressing one's neighbors.

It would then be the anthropologist's job to see such acts and their products through as many eyes as possible, to adopt many different viewpoints and many meaning-making strategies and report on them—not neutrally, but as a viewer more free to adopt other viewpoints, at least freer than those who are entangled in their own lives, who can take only a few viewpoints. This relative

freedom, this capacity to imaginatively take many different positions and to construct a possible coordinating overview, is the strength of the anthropologist.

"Sacredness"

Do anthropologists and art historians require a different kind of theory for sacred art than for secular art? Do people act toward (or with) religious works in a different way than they do to secular ones? Do viewers differ in what they are looking for in the two cases? Do they speak about as well as act toward "sacred" artifacts differently from secular ones? I don't have definite answers to these questions. As so often seems to be the case, a problem like this has not seemed to bother my Balinese consultants, and for me it has turned out to be more complex than I had thought at the outset.

Hans Belting, the historian of Byzantine and European medieval art, contrasts two ways of interpreting the holy icons of the European Christian churches, as "presence" and "likeness." "Presence" he sees as predominating in the first millennium, an attitude of "veneration" of the beings or Being an image embodies, in consequence of which "images of persons . . . were used in processions and pilgrimages and . . . incense was burned and candles were lighted [for them]. These were deemed to be of very ancient or even celestial origin and to work miracles, make oracular utterances, and win victories."[45]

"Likeness" on the other hand dominates viewer responses when such images are taken to have lost their power, a historical process that culminated in the Reformation, when "the unity of outer and inner experience that guided persons in the Middle Ages breaks down into a rigorous dualism of spirit and matter, but also of subject and world, as expressed in the teachings of Calvin. The eye no longer discovers evidence of God in images or in the physical world; God reveals himself only through his word."[46]

This religious transformation, Belting goes on to show, made possible the new renaissance conception of art, in which

> art inserts a new level of meaning between the visual appearance of the image and the understanding of the beholder. Art becomes the sphere of the artist, who assumes control of the image as proof of his or her art. The crisis of the old image [its loss of power] and the emergence of the new concept of art are interdependent. Aesthetic mediation allows a different use of images. . . . The image, henceforth produced according to the rules of art and deciphered in terms of them, presents itself to the beholder as an object of reflection. Form and content renounce their unmediated meaning in favor of the mediated meaning of aesthetic experience.[47]

Belting demonstrates through many examples how these two attitudes toward images, one assuming that the image is an embodied person, the other that it is an artwork, did not replace one another but coexisted throughout European history—even to the present day—but with markedly different relative weights in the first millennium as against the second. So too, I believe, in Bali, "presence," recognized as *tenget* and *wibawa,* has dominated viewers' responses, but was usually accompanied by an alternative possibility of mere "likeness." But what is it that supports or undermines an attitude toward images that looks for "presence" more than "likeness"? And how can it be that these two orientations are not mutually exclusive forced choices?

The figures of characters from the Ramayana that I have been discussing are an example of this slippery ambiguity, this same shifting vision. They are not sacred icons in the European sense, nor are they lifeless representations.

. .

Rama is not the name of one of the gods mentioned in the usual mantras spoken or chanted by the priests. Nor is Rawana, the demon-king, mentioned in any prayer either. And unlike the gods who are enthroned in Batuan's Pura Désa, who are strongly local, Rama and Rawana are clearly thought of as coming from a distant place. The Ramayana is not, in any obvious way, a foundational myth for Balinese religion and ritual. Rather, the narratives that explicate and situate most of the *niskala* beings of Pura Désa Batuan are of the sort found in oral accounts and in the *babad* scriptures of Bali, where accounts are made of the descent of certain clans from deities.[48]

In Balinese dramatic presentations of the Ramayana in the *wayang wong,* Rama is not a god, but only a human being. In indication of his humanity, he dances barefaced, without a mask.[49] In conversations with me, my consultants did not speak of Rama and Rawana in the same hushed and honorific ways that they referred to *niskala* beings. They often did not precede their names with titles such as Sanghyang, Betara, or Ratu. They are almost completely ignored in the rituals held in the temple.

A solution that comes immediately to mind is that the Ramayana statues, and many others in the temple, are there because tradition put them there. They are found in temples all over Bali (although they may not have been there in the nineteenth century). But to say that a certain subject matter is conventional or traditional or Indic does not explain why it is repeatedly presented, nor what such statues meant to their makers and to present-day viewers. Why are the characters from this story of the mighty war that ensues after a horrible demon abducts the beautiful wife of a noble godlike prince so important to Balinese? To call something traditional or conventional is to deny its engagement in meaningful action.

If, as I have suggested in chapter 3, an understanding of the ritual narratives of the Odalan and the Taur Ka-

sanga is followed, then the engagement between Batuan's population and its local gods should be the primary frame of interpretation of all imagery to be found in the temple. Thus a viewer should look for the roles that King Rama and his courtiers, generals, soldiers, and enemies play in this ritual engagement.

One clue about the ritual significance of the Ramayana statues, at least for Balinese of the colonial period and before it, can be drawn from the dance-drama. When the *topéng,* a genre that treats of the ancestral kings of Bali, is staged, a bamboo-framed doorway with a curtain for a door is erected at one end of the performance area, and the figures emerge through that gateway one by one. They are conceived of as coming out from the hidden *niskala* world out into the everyday world. Each performer enters the stage through the curtain slowly, dancing in the door for a long time. Lower-status characters emerge first, then announce the coming of the higher ones, turning and bowing toward them in welcoming postures. The king always comes out last, when his entourage is already there.[50] The *wayang wong* performance in which Rama and his followers and enemies is presented also has a doorway, but no curtain, but the same hierarchy based on precedence in emergence from within the door to the outside world is seen.

In both the *topéng* and the *wayang wong* an important analogy is set up of coming out from secret, higher, immaterial regions through the doorway into the open, lower, here-and-now of the village. It seems as though the great gateways of the temple also dramatize the emergence of *niskala* beings from their higher places to the lower ones of their visit. The stone figures around the two gateways enact a greeting to the deities as they come into the material world first onto their thrones and then out into the village. King Rama in the play is, in some views, an ancestral spirit whose personification signifies his materialization into the present. While not actually represented as such, the gods of Batuan also

might be visualized as standing in the gateway, motionless or quivering slightly, looking around not only at the villagers but also at the Ramayana statues, which greet and announce and protect the gods and also invoke them.

Another clue concerning the meaning of the Ramayana statues for the people of Batuan comes from their arrangement within the temple. King Rama stands on the highest altar deep inside the Jeroan, with his highest followers at his side; below him and out the main gateways of the temple come his army and his lesser courtiers, with the least ones lining up along the busy roadway outside the temple.

The place of King Rama, his brother, and the closest members of his entourage on the Méru Agung on a step below the throne of Batuan's gods might indicate that they are paying homage to the gods of Batuan. The Méru Agung has only three stacked roofs (unlike some in Bali with nine or even eleven), so Ida Betara Puseh Batuan is not among the highest of gods in Bali. Yet he and Ida Sanghyang Saraswati are the highest ones in Batuan, and King Rama is standing below them. It is appropriate *(patut),* one consultant told me, that Rama, Laksmana, and Hanuman should stand high up on the Méru Agung, since they are the noblest ones, and that the soldiers and servants should be placed outside the temple, since they are the lowest in rank and power.

This placement implies that King Rama and his entourage are understood as guests of the gods of Batuan, perhaps as witnesses to their ritual encounters with one another and the people of Batuan. During those ceremonies, the statues are wrapped in cloth sarongs, a sign that they are considered persons who, like all other participants, should be dressed appropriately. They are engaged rather than passive bystanders, engaged in ritual recognition of the gods of Batuan.

From the perspective of the ritual discourse described in chapter 3, the guest gods who arrive for each

major ritual come to pay homage to the great gods of Batuan as well as to receive homage from the many humans who flock to the ceremony. Just as King Rama appears to be holding court, so also the deities of Batuan are understood as holding court. In both cases they are surrounded, first by their entourages and second by the populace of Batuan and the guest gods from the lesser temples of Batuan.

But why should King Rama be among these beings giving, not receiving, homage? One answer might be that in the story, Rama is a raja of great *sakti,* the mystical competence to hurt or heal, to bring prosperity or to destroy. His allies all have various degrees of *sakti* as well, most particularly Anoman, the monkey king. So too whispers about *sakti* were made about Déwa Gedé Oka, the head of Batuan's noble house in the 1930s, who could cure people with a piercing glance and stave off cholera epidemics with a nighttime encounter in the little temple next to Pura Désa Batuan. The likeness of gods to kings (and the reverse) is played out in the similarity of the architecture of kings' palaces and gods' temples, of *puri* and *pura.*

The portrayals of Rama and Laksmana, slender and impassive heroes with narrowed eyes, resemble those of the gods in paintings such as those on the Méru Alit and Pangaruman (see figures 9.28, 9.31, 9.32). In contrast, the portrayals of the monkey generals, rough and fierce with popping eyes and sharp fangs, resemble those of demons in such paintings. The two are contrasted modes of *sakti,* one contained like a coiled spring, and the other threateningly on the ready to attack. The serenity of the gods and the highest kings is thought of as evidence of their self-confidence; they have no need to display their ferocity and power.

And how is it appropriate that among these attendants and defenders of King Rama stand also Rama's chief enemies, Rawana and his brother and their troops? The place of Rawana and Kumbakarna in this stone tableau is just outside the main gate in the important position of *pengapit lawang* (guardians of the gate). And just inside that gate, on the *aling-aling* screen, sits a another statue also identified by some as Rawana, but here not threatening but in a position of meditation and prayer. His tusks identify him as demonic, as does his place in the Ramayana story.

I asked a Balinese healer why Rawana and Kumbakarna could be proper guardians of the temple door. He said that a *pangapit kori* must be a figure that is magically powerful (*nyidiang ngelarang kewisésan,* "able to control sorcery"), one with the ability to transform himself into the monstrous forms that sorcerers take when in combat, to have the most *pangléyakné* (ability of a *léyak* or sorcerer). Rawana and Kumbakarna are exactly that for him. Rawana is a sorcerer, like Rama, and like human *anak sakti.* He is also like gods (if they are indeed sorcererlike).[51]

When viewed within the framework of the story of the war between King Rama and the ogre-king Rawana, it might seem odd that the troops of Rawana were chosen to form the outermost guard-line of the temple and that Rawana himself and his brother Kumbakarna stand guard at the very door to the inner court of the temple. However, in view of the ideas developed on the commonsense understanding of the rituals of Pura Désa Batuan, this is not a contradiction at all, but an affirmation of the bi-valent character of all spiritual beings as both malevolent and benevolent toward human beings, and, crucially, toward one another. The tableau of Ramayana characters standing in and in front of Pura Désa Batuan is a moment when all of these beings (from Rawana's side as well as Rama's) are positively oriented toward the gods of Batuan, as part of their entourage.

Perplexity about how enemies might become allies merely reveals a Western presupposition that spiritual beings must be either bad or good, and constant in their attitudes. In the Ramayana epic, Rawana is defeated. Does this mean that Rama then converts him

into an ally? I have no evidence of such a transformation, but to me it makes sense. Perhaps it does also to some Balinese. That one of the Rawana figures wears the same headdress as Rama and another sits in a meditating position in a place of great protectiveness of the temple (see figure 5.27) might be clues. Much more research is needed.

A third approach to the meanings of the Ramayana figures—which pertains also to the Méru Agung, the great gateways, indeed the whole Pura and all its *maiasan*—is to see them as standing for the authority and trustworthiness of the gods of Batuan, for their *wibawa*. I have discussed this quality in chapter 3. Thus the presence of King Rama, his courtiers, and his military entourage might be understood as both a recognition of the *wibawa* of the local gods and a contribution to it, as can the images of the noble "demonic" beings carved into the base of the Méru Agung and those of the sun and moon above the altar. That strength may also be spoken of as the *sakti* of the deities, their capacity to destroy or vitalize the lives of their human worshipers whenever they so desire.

Conceived as single works, the two great gateways and the stone retinues standing before them proclaim the presence of the deities of the Méru Agung and of their *wibawa* and *sakti*. In this view, the mythic personages of the Ramayana, their placement at the gates and on the most important altar, and their associations have all been carefully chosen to convey this impression.

The *wibawa* of kings (and of gods) is an attribute not of their persons but of their relationships with other persons. Like charisma, *wibawa* inheres in the mutual interchanges between the gods and humans. Achieved, this quality is a consequence of effort on both sides.

There is a complementary message that the *wibawa* of a deity, a king, and a community contrasts with the weakness of all their neighbors. The *wibawa* or *sakti* of a king is always relative to the qualities of his competitors. The tall gates on the south, newly built in the early 1930s, seem to me to proclaim the *wibawa* of the gods of Batuan vis-à-vis the rest of those in Bali.

If a community's gods have *wibawa* and *sakti*, then that community is not only safe but prospering. If the community is prospering, then its gods have *wibawa*. The people are said to be in a state of *rahayu*, of well-being, health, and security, both in the negative sense of being protected from harm and in the positive sense of being blessed with fertility and vitality. It is the gods as a group—that is, the main deities together with their various entourages, allies, and patrons—who may bestow *rahayu*, and their blessings fall on the community as a whole.

The Ramayana figures thus are seen as having both likeness and presence, even though the presence of *niskala* beings is uncertain, and from the perspective of the rituals, those that might arrive are subordinate to the powerful, local *niskala* beings. They are never really forgotten ritually. During all ceremonies, and indeed daily, each figure has a small offering placed at its feet. Even the most recently made carvings that I saw in the 1980s were given this respectful "feeding"—after, that is, they had had the consecration ceremony called *mlaspas*. Although in all my talks with people of Batuan about the carvings of the temple, none of the Ramayana statues were called *tenget*, people nonetheless seemed to have a wait-and-see attitude toward them, a careful watchfulness that they might be more than a likeness but instead be filled with the presence of *niskala* beings.

. .

Balinese have not made a cultural distinction between sacred and secular, at least until recent years. And as is evident in the notions of *tenget* and *wibawa*, they conceive of statues as potential social actors.

The Ramayana figures are both things and persons, both likenesses and presences. Alfred Gell developed a general theory of art that places this dual potentiality at

its heart, a theory that would apply to both secular and sacred art.[52] His model focuses not on the objects themselves, nor on their makers, but primarily on the viewers of the object. As I have been arguing, Gell pointed out that artifacts, made by humans, once launched into action may be taken by their viewers as part of social actions and events. In Gell's words "works of art, images, icons, and the like have to be treated, in the context of an *anthropological* theory, as person-like; that is, sources of, and targets for, social agency."[53]

The viewer's recognition that both maker and viewer are actors bound up with one another in series of reciprocal responses results in a fundamental indeterminacy. Just as Balinese can't be sure whether a given material object is *tenget* or whether their closest *niskala* beings are *wibawa,* so also they also have the same uncertainty about the people around.

It is the Western formalist separation of objects from their interactive context that converts artifacts into lifeless objects, incapable of action. The view held, I believe, by most Balinese, and also by Gell, is that all human artifacts—whether sacred or secular—are understood by their makers and users first of all as part of social action. The procedures of interpretation and evaluation, as I have stressed, are at base social and interactive. Certainly this is the view that makes sense of Balinese notions of *tenget* and *ias* and *wibawa.*

Gell came to his approach through his earlier work on Melanesian conceptions of magic, via Marcel Mauss' own inspired reading of Maori ethnography of "idols" and taboo figures and the exchange of such objects. He began with a recognition that this sort of artifact, for its makers and primary audience, has whatever "aesthetic" force it may have as an aspect of its "magical" force. A Melanesian canoe blade is designed to and considered to frighten the adversaries (human and spiritual). Gell's first essay in this regard rejects the use of the term "art" and puts forward words and concepts concerning "technology" and "enchantment." At that

time it seemed as though he was developing a theory that would be appropriate only to those societies that were in Weber's terms still "enchanted," and only to those that may have a notion of magic as an impersonal force.[54] But in 1998 in *Art and Agency,* Gell developed an approach that would be appropriate for secular arts as well as sacred.

To break radically with his readers' habits of thinking of such objects as special and out-of-action, Gell introduced a set of deliberately difficult philosophical terms. "Artworks" he renames "indexes" following the distinctions of C. S. Pierce. An "index" for Pierce is one of three logical kinds of relationships between signs and objects. The first of these is the "icon," which is understood as representing something by way of resemblance, similarity, and analogy. The second is "symbol," which is understood as standing for something by way of convention, thus entirely arbitrarily. The last is "index," which is the link made by the taking of a perceived object as standing either for its cause or its effect.

The usual example of an index, says Gell, is smoke taken as indicating the presence of fire, but another kind of example is a smile, which can be taken to mean friendliness. The inference of fire or friendliness can, of course, be quite mistaken, and therefore the inference must always be understood as a temporary hypothesis.

In other words, Pierce's (and Gell's) "index" is not a class of objects but of actions. An index is a kind of inference, a kind of human meaning-making strategy that is tentative and awaiting confirmation from the social response of other people. This is the sort of act I have called "taking as," or "looking for," that is, a social act of interpretation. For Gell, an artwork is a human-made object that is understood to ask for a social response, as an index. For instance, he says, "Aesthetic responses are subordinate to responses stemming from the social identities and differences mediated by the index. . . . The aesthetic response always occurs within a social frame of some kind."[55]

This approach is very close to the way that most Balinese view temple carvings, especially when the word "social" is expanded, as they would have it, to include the multitudes of *niskala* beings that are active elements in their world. Both humans and nonhumans use artifacts to mediate among them, as elements in their continuing social engagement with one another.

The temple statues for Balinese are in Gell's terms indexes of the *sakti* and *wibawa* of their makers and of their *niskala* patrons. They carry on them the traces of acts of their makers and are assumed to have an effect on their viewers.

Gell adopts Pierce's philosophical term "abduction" to refer to the mental process of the viewer, the interpretive strategy I have called "taking as." He wants to get away from the pervasive anthropological assumption that art is a matter of meaning and communication, and replace it with one that art is about doing.[56] Art objects are elements in acts by agents, actors performing actions that are then the object of inferences and interpretations by responding other actors. Gell contrasts abduction with "semiotic" modes of interpretation that he says are the ones used in understanding language, through the observation of conventional links between signifier and signified, in the form of codelike lexical systems and grammatical organizing principles. While Gell would like anthropologists to abandon semiotic interpretation in favor of abduction of social implications, I see no reason for the complete exclusion of meaning. Gell unnecessarily downplays the importance of local cultural guidelines and associations along with symbols and meanings.[57]

"Indexicality" refers to a viewer's search for clues about the identity of the maker or instigator of the carving and about that person's characteristics and intentions. This search for traces left on the object is guided and informed both by cultural knowledge and by immediate social experiential information regarding the present interactive context of such action. The search, however, might be directed not only at characteristics of the maker, but also at the maker's intentions and attitudes toward the viewer. As with smoke and smiles, the link between sign and significance is understood to be causal.

Emotion, its expression or evocation, is another of the hallmarks of "art" as understood within popular (and some scholarly) discourses. Within a model of indexical interpretations, such emotion could be thought of as caused by the social actors involved.[58]

Many different kinds of feelings might be looked for, aimed for, or experienced and attributed to the object and its makers. They might include adoration (of a lover, of a saint), desire (as in advertisements), lust (pornography), rage and terror (political graffiti), security and peace (stained-glass windows), and many others such as disgust, awe, wonder, astonishment, respect, pride, and pleasure.

Such emotional responses, whether sought, intended, or experienced, are all social and conventional at base. That is, as in any social act, response and counterresponse are all expected and understood as confirmation and authorization of the interpretation of aspects of the social relationship itself.

A person coming on an artifact in circumstances from out of the loop of the original social context, for instance in a museum, may react to it in ways that would be foreign to most Balinese. For instance, the many statues within Pura Désa Batuan that have ferocious faces, with grimacing grins, tusks, popping eyes, might be read as terrifying. On the contrary, as I have pointed out in regard to the figures of Rawana and Kumbakarna (figure 5.22) and of Boma (figure 5.21), they are intended to arouse a sense of safety.

Deprived of the requisite cultural guidelines and social entanglements, the foreign observer is at the mercy of his or her own projections, but should not develop

a theory of art based on the idea of expression. "Expressiveness" is not inscribed in artifacts for anyone to respond to; like cognitive identification of referents, it is, at least mainly, imputed to the object by the viewer, who takes into account its context according to cultural guidelines. Of all culturally inscribed contextual conditions, intention is by far the most important, with the proviso that several quite different intentional schemes may be considered appropriate by the participants.[59]

I have stressed that the overriding intentional frame for the building, rebuilding, and decorating a Balinese temple is to provide a royal palace for the temporary visit of *niskala* beings, one in which humans and *niskala* beings can meet socially, with the long-term goal of providing the human "owners" with material well-being. Efficacy in gaining that goal therefore becomes the major evaluative measure, but since that goal is diffuse (comprising the pleasure and goodwill of the *niskala* beings), it does not contradict other goals such as entertainment, sensory delight, or even education. However, it does specify the audience, organized into primary and secondary viewers. The primary viewers in this case are the local deities and ancestral spirits, secondary are the more distant deities, and third come the host of lesser *niskala* beings of the vicinity. Only after all of those come the various human audiences. Since *niskala* beings have desires and responses much like those of human beings, the extension in imagination to responses of human viewers is easy, within this Balinese cultural framework.

Alfred Gell's attempt at building a vocabulary that places artifacts at the nexus of social interaction, objects as social mediators among social actors, and puts interpretation of social intentions also within this nexus, suggests a fruitful way to conceptualize the work not only of Balinese temple worshipers but also of Western museum-goers within their own temples, their museums.

To place social relationships, guided by cultural notions, at the center of a study of "art," to study first the various viewers' procedures for apprehending and evaluating artifacts as collaborative acts, to look for the various kinds of culturally defined social projects that orient viewers would be the first methodological rule in an anthropology of art. A conception of a viewer that starts with a notion of an independent artist intent on expressing emotions, on exploiting sensory effects of various formal attributes, and on making an artifact destined for placement in a museum or living room or schoolroom or store is as socially oriented as the kinds of conceptions I have described as important for Balinese viewers. Effectiveness, social effectiveness, as an overriding purpose in the making of such artifacts is not strange even in museum-dominated Western societies. The nature of advertising art, of pornography, of politically persuasive uses of visual forms is proof of that.

What is needed is more research at the molecular level of actual events of making and evaluating culturally significant artifacts, studies of the complex social worlds that each new "artwork" creates, close examination of the roles of various perspectives and their continuous active integration by all participants, and recognition of the intimate place of culturally defined projects in all of these processes.

Larger processes and changes are much easier to see than the many small ones that are their components. Anthropological fieldwork rarely can achieve the kind of microscopic level of scrutiny such an approach asks for, since chance and the immediate interests of the fieldworker often militate against close study of maker and viewer acts of interpretation in vivo. Historical work, especially in the absence of written documents, is even more inhospitable to detailed questioning. Nonetheless, I am convinced that a model of the sort presented above must stand, if not in the center of specific and actual research, at least as its imagined foundation.

"Timelessness"

To call something "timeless" is to make two different statements: first, that the object or idea is unchanging and enduring, to stress continuity over variation; and second, that it has an appeal that overrides place, time, and circumstances, that it speaks to all human beings regardless of the context of making or the context of viewing. In both cases the role of agent (maker or viewer or both) is downplayed, and history is ignored.

Agency and context in art should never be overlooked, even when little is known about the first makers and viewers of certain artifacts. I have stressed, enlarging on Howard Becker's work, that making and viewing are not only active but always collective and intentional. They may be very minor actions, and innovations may be small, but they can build incrementally and cumulatively up to major ones. The reverse process, moving from major societal transformations down to minor local ones, of course, also occurs when large societal changes bring about important transformations in small acts of making and viewing. But even these seismic shifts work through the details of local circumstances and parochial interpretive cultural guides.

Another meaning of "timeless" is "traditional." An assumption that the colonial administrators of Bali in the first part of the twentieth century preserved much of its traditional ways is an easy one to make in view of the massive transformations that occurred in the second part of the century. Thus, pausing before considering what happened in Batuan in the second half of the century to take stock, as I do in this chapter, feels natural to a Western reader largely because the pervasive Western ideological construct of traditional versus modern makes it seem so.

It is easy to assume that World War II created the circumstances for the end of Bali's "traditional" ways, that after the shocks of the Japanese occupation, the achievement of independence from colonial occupa-

tion, and the invasion by tourists, Balinese society was increasingly to lose its imagined Edenic unity, homogeneity, smallness of scale, and sacredness—in short, its traditionality. If "traditional" means stereotyped and unchanging, then the term never fitted Bali, even in precolonial times. In fact it has been asserted that in Southeast Asia in general already in the first millennium, novelty was usually valued and change welcomed.[60]

In my view, the basic characteristic of all human productions, displays, and performances, including the carvings of Pura Désa Batuan, is that they are historical, that they are constantly changing, both physically and, especially, in the ways they are conceived. This approach places the focus, as has been stressed in earlier sections, not on the objects but on the viewers, including, of course, the first viewers—the makers and their collaborators. It also places stress on the viewer as agent—as creator within a historical context.

. .

My history of Pura Désa Batuan begins in the colonial period. There are inklings of a major change that occurred along with the establishment of colonial authority. This was the reorienting of the entire temple layout from the west to the south, from a gate that opened out on to empty fields to one that faced a traveled road. This turn toward the human world suggests that the primary audience, the *niskala* visitors to the temple, was being importantly supplemented, although never displaced, by human audiences.

Perhaps this shift was in response to major societal changes brought on by colonial control, as represented by the building of an extensive system of paved roads, linking distant villages together. It may be that the people of Batuan were looking increasingly out of their village, a process that was to accelerate greatly in the postcolonial years. In the late 1950s a great performance shed (*wantilan*) that drew audiences from the entire region was erected on the road outside the temple.

Perhaps back in the 1920s when the new gates were planned this structure was already envisioned. And yet a "secular" shift toward interest in larger, nonlocal audiences may have been balanced by an even more significant "religious" shift in the reverse direction, toward local audiences who could never be seen.

My hypothesis here is frankly speculative and derives from the observation that the new gates were not only oriented toward the road, but also were much more ornate than the nineteenth-century ones they replaced. Could this new stress on elaborate style also be attributed to the nature of the new social organization? I think yes, that the new ornateness of Pura Désa Batuan could be indirectly due to the Dutch replacement of the royal rulers with a bureaucratic system of descending local officers. The warring princes gave way to increasingly rational and extensive systems of tax collection, police, and judiciary. True, most of these new civil servant positions were taken by members of the former ruling families, the *triwangsa,* but their organization and authority was no longer directly oriented toward the *sakti* ancestors of each of these noble families.

It may be that most or all *pura désa* in Bali of the nineteenth century were simpler than the state and royal temples. If this is so, perhaps it is an important clue regarding the intent of the rebuilders of Pura Désa Batuan. In the precolonial period, the effort after *wibawa* in temples may have been felt appropriate mainly for *puri,* the home of rajas and the temples of the rajas. The legitimate authority of a raja was based on the mystical potency of the king and his entourage. The elaborateness of royal buildings was seen as both claim and embodiment of that potency.

In the precolonial world, perhaps much of the most elaborate village ritual attention, at least in lowland Bali, was directed at the rulers, who were seen as powerful mediators between human beings and the numerous invisible deities that both threaten and protect human beings. With the advent of the colonial power and the evident reduction in *sakti* of the contemporary kings and princes, it may be that everyone in Bali shifted their hopes away from the kings and toward the deities of locality and ancestry. Where before the term *"gumi"* referred to the realm of a king, now the word *"gumi"* came to mean the realm of the group of deities who gather in the *pura désa* of each community. Of course, the former royal temples and other translocal temples remained important, but, according to this theory, new life and energy was instilled into the *pura désa, pura puseh,* and *pura dalem* of every village.

Put another way, I hypothesize that in the early part of the twentieth century in Bali there occurred an important change from a use of architecture and stone carving for the enhancement of royal claims to *wibawa* to one of popular or *désa* claims to *wibawa.* The earlier claim that a royal court could make that it was a powerful mediator to the divine, and therefore capable of providing security and well-being to its people (its *gumi,* its *jagat*), was now being made by village temples and other local entities such as the *barong.*

The tremendous upsurge in popular involvement in dance and drama during the 1930s that has been remarked on by many people[61] may have been part of this shift toward identification on the part of most of the population, nobles as well as commoners, with their own local village and its deities. While some of the top royal houses, such as Gianyar, Bangli, and Karangasem, continued to use architecture and stone carving, as well as the performance arts, for an enhancement of their claims to *wibawa,* many of the lesser noble houses no longer did so.

From the perspective of the commoner members of Batuan, seeking for ways to deal with the terrible fear of impending or continuing physical suffering due to cruel, angry acts of gods, demons, or ancestors or to the aggression of fellow human beings (which are the paramount concerns, even today, expressed in Balinese talk), royal courts outside the village may no longer

have offered much reassurance. While in the precolonial world the appeal of rival princes to the allegiance of commoners may have been largely their promise to control the destructive forces of the universe, under the colonial regime these claims could no longer be made.

Some nobles and kings had increasing secular power under the Dutch, but decreasing cosmic power. People of both *sakti* and political influence such as Batuan's Déwa Gedé Oka were getting rarer and rarer. The commoner villagers were forced in colonial times to turn to their own local resources—in this case, the Pura Désa Batuan—for reassurance. This shift of attention may be visible in those works of imagination and artistry made then for the Pura Désa, works that not only announce but also embody that protective potency against suffering promised by its local gods.

It may be that the noble families of Batuan had paid only the minimally needed attention to Pura Désa Batuan before the twentieth century, but after they were defeated by the Dutch, they committed themselves to redesigning it. Perhaps there was something of a shift of focus and activity on the part of the Triwangsa residents of Batuan from palace architecture to commoner village temples. The introduction of the intricately carved and impressive Padmasana altar in the 1920s may have been another sign of this shift of attention on the part of the Triwangsa, especially the Brahmana groups. Perhaps they had grown more numerous within the village at the same time that their kings and princes had shown clear loss of both *sakti* and material strength.

This thesis may be borne out by my interpretation of the meanings of the Ramayana figures within the temple. While Ramayana statues are found in temples all over the island and have a generalized meaning of invoking the Indic epic, it may be that seen through the interpretive frame of ritual scenarios, where attention is on the local gods of Batuan and their worshipers, on the *niskala* deities and their human communicants, the Ramayana figures have a special local meaning in Bat-

uan. However, this may have been, even in the 1930s, a mainly commoner point of view. The Triwangsa in Batuan, as "newcomers" to the village whose ancestors came from abroad and who also maintained their kinship and temple ties outside it, always had a precarious position within the temple. Perhaps this was more so after their alliance with the Dutch during the colonial period. One might imagine that the Triwangsa could have seen the statues of King Rama and his court as correlatives of themselves. I wouldn't be surprised if a genealogically inclined Déwa from Batuan might trace kinship (collaterally) to Rama. Perhaps, to the Triwangsa, the presence of the court of Rama is a deliberate suggestion of the importance of nobles to the cosmic well-being of the villagers. This speculative interpretation, of course, is complex, and difficult to substantiate. I have shown how, during the period of the making of these carvings, certain nobles of Batuan were much involved in planning the temple renovation. It is highly probable that their perspectives played a large part in it.

The great tale of the Ramayana and the statues representing it may have been read differently by nobles and commoners. The nobles would look at those figures mainly as characters in the story (e.g., Rama, Rawana) and stress their eternal hierarchical relations to one another, and to their human selves. In contrast, the commoners might have seen them not in terms of characters but in terms of the plots of the narrative (the combat, the rescue), as reminders of the activities the whole array of *niskala* beings that are present during any ritual. Balinese recognize that more than one interpretive frame may be applied simultaneously to one text or artifact. Freud's concept of overdetermination, the piling up of contradictory meanings within one image, the collapsing of several images into one, and the acceptance of contrary modes of interpretation and response to visual forms—all at once—would not seem strange to Balinese. Westerners would do well to learn from their example and be careful not to settle on one

exclusive way of thinking about and responding to these carvings. To do so would result in reductive readings, ones that leave out important dimensions of significance. After all, within Western traditions, the capacity to fuse many mutually enriching meanings is one criterion for giving an object the accolade "art."

Conversely, it cannot be presumed, without careful study, that there was no one overriding consensus concerning cosmological reality within which all these diverse interpretations may have found room. The precolonial and the colonial periods could not have been lacking in alternative positions on *niskala* beings and their wishes, but today it is difficult to find out about them. Such positions can, however, be guessed at from evidence of rival sources of priestly *sakti* among groups such as the Pasek, the Pandé, the Sungguhu, and the Bujangga, dissident views expressed during possession both by *balian* and members of the worship group. Bali before the last half of the twentieth century was never "simpler" nor more "traditional," but the kinds of complexity I was able to observe directly were of a quite different nature, and added variety onto rather than displacing earlier agreements.

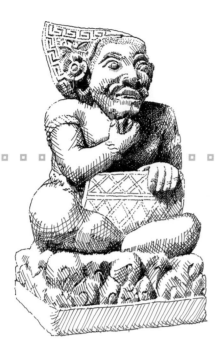

The Age of the Last of the Dutch Rajas (1948–1950)

The world upheaval of World War II had major conse-
quences felt all the way down to Batuan. It brought
about the end of the Dutch colonial dominance and
the acceleration of the entry of the rest of the world
into Bali. The changes in Batuan were slow and confus-
ing at first, but rapid and extensive by the 1990s. By the
end of the twentieth century the transformative new
practices and ideas were being accepted, taken advan-
tage of, and even expedited by members of the village.

Internal political forces for independence already in
motion before the war within the Dutch East Indies,
working even at the village level, were given a great push
by the events of the war and its aftermath, the eviction
of the Dutch colonial administration. Within the vil-
lage new notions of progress (Ind., *kemajuan*) and free-
dom (Ind., *merdeka*) took hold on everyone's imagina-
tion. At the time of the events reported in this chapter,
these were just whispers and hints, but after several de-
cades they were to become open calls to action. And
along with these demands there developed self-con-
scious ideologies of traditionalism and modernism.

New social institutions and modifications of exist-
ing ones accompanied these new ideas. As the century
wore on, schools were introduced, tourism and other
kinds of commercialization were expanded, and the

government administrative apparatus, no longer dominated by royalty and gentry, grew, providing new jobs for the newly educated and creating the core of a new middle class.

With increasing rapidity the variety of voices multiplied. It was not that the prewar Balinese world had no diversity, but with the absence of mass communications, the impact of such alternative visions of the world as those of the Pandés, the Bali Aga, the many claimants to royal authority, the priestly intellectuals, the Chinese, and the Muslims had been muted and locally confined.[1] Religious ideas too diversified after the war. The commonsense notions about the purposes of worship were not diminished in their pervasiveness and strength, but they were augmented and challenged by the gradual development of the theology of the Hindu Dharma movement. In the period reported on in this chapter, the years immediately after the Japanese surrender, these transformations were not yet apparent, partly because of a strong movement in which the colonial-supported nobility (and their associated commoners) strove to reinstate the old patterns of authority and social relationships. The effects of these social and cultural upheavals on Pura Désa Batuan and its carvings are the subject of this and the following chapters. The new forms of social relationships—of commodification, individualization, and intellectualization—left visual traces that are definite but not conspicuous.

Any periodization of the rebuilding of Pura Désa Batuan based on political eras would not fit with the timing of the actual building and carving efforts. The temple restoration that began after the Japanese retreated lasted some years after independence in 1950, until at least 1954, and its intricate links with Batuan's noble house were still like those of the prewar era. It seems as though the change to the new government of the Republic of Indonesia did not immediately cause changes at the local level.

Dating of temple carvings can be roughly guessed from endpoints marked off by the major temple festivals, the *karya agung,* and by the appointments of new *bendésa,* usually at the time of a *karya agung.* Two great *karya agung* rituals were held, the first in 1950, the second in 1954. At the close of the 1954 Karya Agung, a large memorial carving with the date on it was erected. By this time, of course, the new era of "freedom" had been well under way, and the power of Batuan's noble house had been seriously eroded. Nonetheless, it seems that the full impact of antiroyalist ideologies and the decline of the influence of Batuan's noble house did not take effect until the second half of the 1950s.

The Colonial Government Reinstated

The Japanese invaded Indonesia in 1942 and ruled in Bali until the middle of 1945. For everyone this meant harsh economic suffering, since the occupying army systematically seized all rice, cloth, and other important products to support their soldiers. No new building of any sort was put up during the occupation. On the other hand, the anticolonial political movements in Indonesia (which had been already simmering in the 1930s) were given a boost by the Japanese through their attempts to win over the population by the introduction of mass political communication. A desire for national self-determination and democracy, long discussed by the colony's tiny intellectual elite, spread throughout the Dutch East Indies.

When the Japanese retreated from Bali in disarray, in 1945, there followed a turbulent three years in which a strong nationalist political and military opposition to the return of the Dutch colonial domination went into action. A near civil war developed between those who supported the idea of a new republican state against those who desired the strengthening of the old monarchies and saw the Dutch recolonization as a means to that end.

But despite strong popular nationalism, the Dutch succeeded in 1948 in reestablishing their colony in the eastern part of the former Dutch East Indies, including Bali. They set up the State of East Indonesia (Negara Indonesia Timur) with its capital in Makassar. And in Bali they reinstated their "Dutch rajas," who had loyal retainers in nearly every village. Those opposing Dutch control were temporarily silenced. This revived colonial government was to last only two years, to be replaced by the independent Republic of Indonesia in 1950.

Everything was subtly changing throughout the period. Where awareness of the injustices of rule by the Dutch working through the hereditary royal elite had emerged in private discussions among a few intellectuals even before the war, now such talk was much more open and common. The new governing arrangements were transparently using the royalty as puppets, and everyone could see it.

In north Bali, where advanced Dutch schooling was available, a movement toward the modernization of Balinese society and the elimination of caste had started, and its ideas were carried down to south Bali by the teachers, who throughout the 1950s had all been trained in north Bali.[2]

The State of East Indonesia had as its prime minister the former raja of Gianyar, Anak Agung Gedé Agung. His brother was named the new raja of Gianyar and was appointed by the Dutch as the head, in Bali, of a governing Council of Rajas. The raja of Gianyar was thus the chief administrator in Bali for the Dutch. The Dutch, aided by their Balinese collaborators, were nearly able, within a year, to crush the republican resistance. Many were killed, others co-opted, and a fragment withdrew to mountain villages, to hold out. The effect on every local community was earthshaking. Everyone, or at least all young men, took sides, sometimes covertly. Those republicans who remained in their villages quietly continued to hold to their antimonarchist and anti-colonialist convictions and nurse their growing resentment against all who collaborated with the Dutch.

In Batuan, the royalist group, loyal to Gianyar and the Dutch Negara Indonesia Timur, was headed by the sons of the noble prince who had dominated the village in the colonial days. It was by far the strongest but not most numerous faction within the village, and its opposition, the republicans, was a silent majority. In late 1948, the leader of the republican fighters in Batuan, I Ketut Ngendon, a prominent painter, was captured and executed. The remains of his small band were captured and imprisoned in Gianyar, and village opposition to the Dutch was temporarily silenced.[3]

But the social tensions unleashed by the events of the Japanese occupation and subsequent struggle for independence continued. The opposition to the "Dutch rajas," although silent, was fostered by the continuing noisy existence of the Republic of Indonesia in Java, centered on Jogjakarta. In many places, and probably also in Batuan, the position of royalty became shakier and shakier. This was to be the last stand of colonial control of Bali.

Renewing Pura Désa Batuan

Temples all over Bali were being rebuilt and renovated in the ten years after the Japanese left. Perhaps this was in response to government encouragement; more likely it was a pious attempt to make up for neglect of the gods during the deprivations of the Japanese occupation. However, another new motivating element was also at work; as one Dutch commentator remarked, the temple rebuilding of the time was clearly buoyed up by the young people's enthusiasm for "national reconstruction" and "modernization," goals closely intertwined with the desires for democracy and self-determination.[4] The link between temple renovation and modernization was directly expressed, during this time, by the

new custom of carving dates on recently completed carvings.

The Dutch government of the State of East Indonesia took a strong interest in the arts in Bali.[5] This had an important effect in Batuan, where the painters were supplied with drawing materials and produced a number of paintings for an exhibition in the Hague, in 1949 or 1950, organized by the prime minister, Anak Agung Gedé Agung. The exhibition was part of an effort to revive tourism in Bali. At the same time, a number of music and dance contests, in which village troupes competed, were set up in every regency. This was a revival of a colonial institution. Many of the craftsmen of Batuan who worked on the temple renovations were active participants in the development of the tourist arts, and tourism thus had, indirectly, a visible influence on their works.

Batuan's *krama désa* also made plans to renew their temple, and a *karya agung* was projected for 1950. In preparation for that great festival a number of renovations were planned. The major part of the temple had been restored in the colonial period, but some untidy portions remained, especially on its east side.

A new executive committee was in place. It may have been chosen by the temple as early as 1936 or several years later. The *bendésa,* for the first time in recoverable history, was not a commoner but a noble, a son of Déwa Gedé Oka named Anak Agung Gedé Raka. Perhaps this was the only time in its history that a Triwangsa person held a formal temple office.[6] Like his father, Anak Agung Raka was an expert dancer, in both *gambuh* and *arja.* In 1932 he had gone to Paris to perform with the Pliatan gamelan group. To a certain extent he too was learned in the scriptures. Raka had a commoner assistant, an elderly man named I Wayan Pageh Lana, whose compound was also near the noble house.[7]

Perhaps the appointment of Anak Agung Raka as Bendésa was merely a formal recognition of his de facto dominance over village life, for it appears that his father, while not officially called *bendésa,* had carried out most of the functions of one, while his commoner assistant took the title. It may have been that throughout the first part of the century the head of Batuan's *puri* was the de facto *bendésa.* Certainly, all the named commoner *bendésa* until the 1960s were from families in the *banjar* Pekandelan, whose houses were interspersed among those of the nobility, men who as children had played with the noble boys and whose sisters had married into the Triwangsa group.

The team of stone carvers who worked on the new projects included Triwangsa artisans for the first and only time in Batuan's history.[8] Never again would nobles and commoners work side by side as members of the *krama désa* on Pura Désa Batuan. On the team were two Triwangsa stone carvers who were father and son, Déwa Putu Kebes and Déwa Nyoman Cita (formerly spelled Tjita). The latter, still in his teens in the 1940s, was to become in the 1980s the carver of the great giant figures that straddle the road in front of the temple, to be discussed in chapter 9. In this period, Cita made the small seated peasant woman at the side of the Eastern Gate ensemble. His father, Déwa Putu Kebes, a well-known mask and headdress maker, contributed four exquisite small statues to sit on the base of the Padmasana and on the Méru Alit, within the Jeroan.[9] All the rest of the stone carvers of this period were commoners, including I Wayan Ramia from Banjar Tengah, I Wayan Wina from Banjar Puaya, I Purna and I Krepet from Banjar Peninjoan, and I Wayan Ruta from Banjar Puaya.

In 1982 I interviewed I Ruta, who was then in his seventies. He had been an apprentice to I Wina and I Krepet when they were the major carvers in the first wave of reconstructing the temple. When that team had finished the two great gates on the south, they turned in the late 1930s to work on the temple next to Batuan's main graveyard, Pura Dalem Jungut. It was then, said I

Ruta, that he was first allowed to make his own statues. In the late 1940s he went on as a master carver to make an important set of statues on the Semanggén in Pura Désa Batuan, described below, and several statues on the new East Gate. Later he was hired to make stone carvings for noble houses and temples in Pliatan, Ubud, Mengwi, Bangli, and Karangasem.

I Ruta's training in temple carving was not restricted to the job in Batuan; further training was also arranged by his "lord" (his *gusti*), the noble to whom his family had fealty from precolonial times, a man from the *puri* in Sukawati, who was also the Dutch-appointed Perbekel of the Batuan region. In the late 1920s and early 1930s he had run a major stone-carving workshop inside his palace, where statues of Ramayana figures were made for the temple of Besakih.[10] I Ruta had been a child at that time, but in the late 1930s the prince sent him to be an apprentice in a related *puri* in Denpasar. I Ruta told me that there he was set to copy other stone carvings and also to study shadow puppets for iconographic details.

It is significant that from his early teens to the end of his life, I Ruta was active in the tourist wood-carving industry, and I believe that that experience had demonstrable effect on his temple carvings. In the Puri in Denpasar, I Ruta made many wood carvings that his master sold to tourists. He was paid for this work with room and board. Later he sold his own wood carvings in a souvenir shop in Batuan, in a larger one in Celuk in the 1950s, and in the 1970s and 1980s in a big art shop run by I Regug, the man who was to become Batuan's Bendésa in the 1980s.

It may be as a consequence of this involvement in tourist art that some of I Ruta's works in Pura Désa Batuan are strongly naturalistic. One important early genre of tourist carving had been figures of ordinary people, farmers with plows or fighting roosters and young women dancers. I Ruta's figures for the temple are a set of commoner men seated and discussing tem-ple matters. Another is of a man singing the accompaniment to the *gambuh* dance at the East Gate (see figure 7.14). It seems quite clear that, in both subject matter and style, I Ruta's work on the temple was influenced by his work for tourists.[11] Naturalism did not enter Bali with tourist art, of course, as H. L. Hinzler has shown.[12] However, it became a major trend in the 1930s. None of these works are true portraits but rather social types.

Another team was put together to make paintings for the top of the Méru Agung, where boards for them had been left blank in the 1930s. It was a similar mixture of nobles and commoners. The drawing and painting was done under the supervision of Pedanda Ketut of Gria Kawan and Déwa Nyoman Moera (a noble who had spent most of his life in the Gianyar royal court as a painter). But most of the actual painting was done by commoners who were active in the new tourist painting: I Rata from Puaya (who was a student of Déwa Putu Kebes), I Ramia from Banjar Tengah, I Saweg from Banjar Tengah, and I Madé Djata from Banjar Pekandelan.[13] These paintings on the Méru Agung were replaced in about 1993 and are illustrated in chapter 9.

A Variety of Works Made between 1943 And 1954

Since the major structures of the temple had been finished before the war, most of the postwar years were given over to lesser new works and to the refurbishing of the rest. As a consequence, a listing of works for any of these times must include a variety of smaller works as well as several larger ones.

One major job of refurbishing was of the Semanggén, the high and long pavilion within the Jeroan where the visiting gods are enthroned and the *pedanda* sits to perform his rituals. When they erected new columns supporting its roof, they decided to decorate the foot of each column with a small figure, the ones by I Ruta.

Most of the other new works were erected just outside the temple on its east side. In the late 1940s there was in Bali a general outbreak of theft of gold-covered god-figures from temples. The poverty brought on by the Japanese occupation was exacerbated by postwar inflation and several crop failures.[14] It may be that the Dutch government, in its zeal for peace and order, put pressure on local temples to take steps to prevent this theft. It was probably at this time that the Batuan congregation decided to move their god-images from their previous storage in the Méru Agung within the Jeroan to a safer place within the Pamangku's home compound.

To house the god-images outside Pura Désa Batuan a new altar, the Panyimpanan, was built within the Pamangku's family temple, together with a pavilion for the placement of offerings near it.[15] I discuss this altar, which was completely redone in 1981, in chapter 9. Interestingly, in 1981 the government provided a subsidy for this building, apparently continuing the policy of encouraging safe storage of valuable god-figures.

Now there was need for ceremonial processions of the god-figures from their safekeeping in the Pamangku's family temple into the temple for rituals. It necessitated the building of a suitable gateway out of the Pamangku's family temple and another one into the temple on the east side. Until the god-figures were moved, there had been only a small gap in the wall into the temple on that side, perhaps completely unembellished, through which the Pamangku entered the temple from his houseyard only a short distance away. Now the congregation, headed by the Bendésa Anak Agung Raka, built an impressive East Gate, a *candi bentar* surrounded by stone figures as an opening into and out of the temple. Before the building of the East Gate, the land had sloped down from the wall sharply, and it was decided to excavate it so that an impressive stairway could lead up to the new gateway.

A wide and flat pathway was then laid out leading from the gate to the Pamangku's houseyard. And a dec-

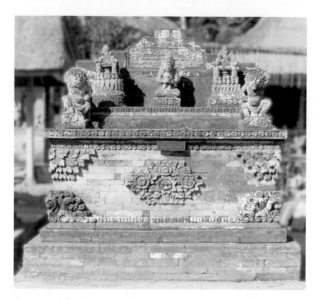

Figure 7.2. The Bagia. In the center, in position of meditation, is Ida Sanghyang Siwa as a *pedanda*. On either side of him are replicas of the complex offering called the *bagia*. On the lower level in front of Siwa are two *raksasa*. Carver: I Ruta from Puaya. Date: 1954. Photographed in 1995.

orated doorway, a *candi kurung,* was built providing a special egress for the god-figures from the Pamangku's houseyard temple (directly out, rather than through the houseyard as is customary for houseyard temples).

To mark the end of the ceremonial period and to consecrate all of the new carving, a *karya agung* is held. One was held in 1950 and another in 1954. To memorialize this last one, a special new altar called the Bagia was erected. I can't tell with certainty which works were produced before 1950 and which in the second effort.

The *Bagia,* a Commemoration of a *Karya Agung*

This blocky plinth with various figures on top of it was built after all of the major new works of the period were complete. The term *"bagia"* refers to a large ritual offering made of bamboo, flowers, and figures of rice-

flour clay. This offering, containing many different offerings, was buried beneath the stone plinth, as a step in the consecration of the new East Gate and Mrajan Désa. A date, 1954, is carved on it. Atop the plinth is the figure of the god Siwa in meditation pose in the center, with two representations of the *bagia* offering on either side. Below in front are two *raksasa* guards. The figures were carved by I Ruta, demonstrating his competence in carving in traditional style as well as naturalistic.

The Statues of Merdah and Mélem on the Méru Alit

Standing on a ledge on the Méru Alit are two statues, above the heads of the worshipers, identified by most as Merdah and Mélem (although one person thought they were Gareng and Petruk, followers of the Pandawa, of the shadow play). Here they are standing in the posture of priests, with their hands in a prayer position:

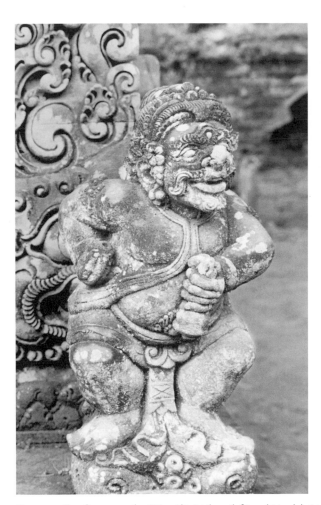 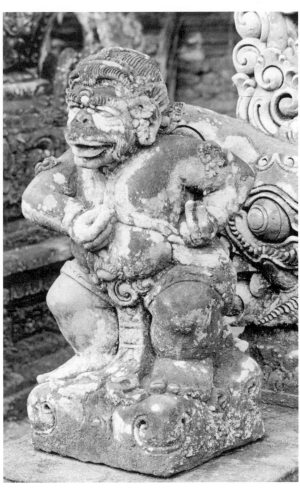

Figure 7.3. Two figures on the Méru Alit: Mélem (left) and Merdah (right). Added in the late 1940s by Déwa Putu Kebes. Carver: Déwa Putu Kebes, Banjar Gedé, Batuan. Date: late 1940s. Photographed in 1983.

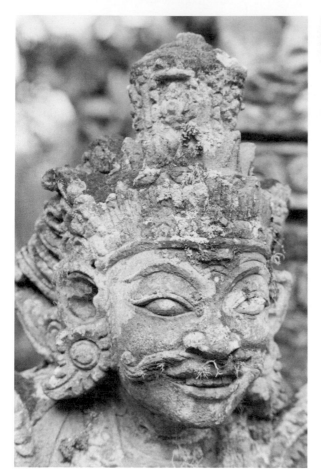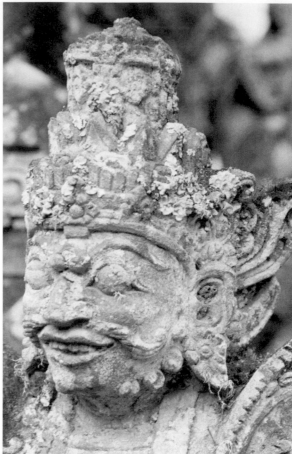

Figure 7.4. Two figures on the Padmasana: Wisnu (left) and Brahma (right). Added in the late 1940s by Déwa Putu Kebes. Carver: Déwa Putu Kebes, Banjar Gedé, Batuan. Date: late 1940s. Photographed in 1983.

one is holding a priest's bell; the other is carrying a bowl for holy water, and there is a place in his hand to put a flower, also used for rituals. These two figures were added in the late 1940s, together with the wooden door. They were made by Déwa Putu Kebes, probably in the late 1940s.

The Two Figures at the Foot of the Padmasana

The two figures at the foot of the Padmasana, like those on the Méru Alit, were made by the noble carver Déwa

Putu Kebes. Kebes was best known for the vitality and liveliness of his carvings, as seen here.

The Statues of Villagers on the Balé Semanggén

Around the floor of the Balé Semanggén, holding up each of the pillars of the roof, are the twelve small statues of seated men made by I Ruta. A figure that holds up a post is called a *sendi* (post support), and it usually takes the form of an imaginary animal such as those on

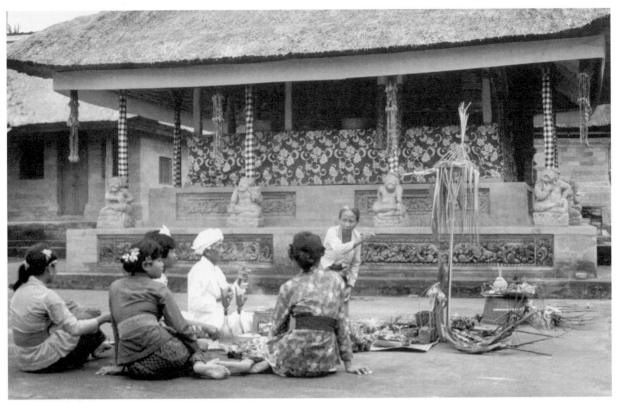

Figure 7.5. The Balé Semanggén, showing some of the small statues of the members of the *krama désa*. In foreground, the Pamangku of Batuan and his wife are carrying out a small *caru*. Carvers: I Ruta of Puaya and two assistants. Date: late 1940s. Photographed in 1986.

the Pangaruman above. But these post supporters are ordinary Balinese people, almost life size, each quite differentiated as specific individual persons, with various expressions and gestures, of a naturalistic and comic quality.

The group seems to represent the executive committee and, through it, the *krama désa*. One has a distinctive head scarf, and probably represents the *bendésa*. Another holds pen and *lontar* and is probably the scribe. Another holds the offerings necessary for any such meeting, the *canang* and *basé* betel-chewing ingredients for the gods. Yet another has a *sirih* mortar of the sort needed by a toothless older person for betel chewing. They all sit cross-legged below the level where the guest-

gods and the Pedanda are enthroned during temple festivals. Since they are all at the same level, they must be the commoner members of the egalitarian *krama désa*.

The act of attendance at a meeting of the *krama banjar* or *krama désa* is considered *ngayah*. So also dancing in a temple ritual. In depicting themselves in the act of *ngayah,* either in council meeting or in dance, the people of Batuan are invoking directly their parts in the great transaction between humans and deities that every ritual carries out. Like the dancing statues of the Ramayana story, these figures are another self-reference to the human makers and maintainers of Pura Désa Batuan.

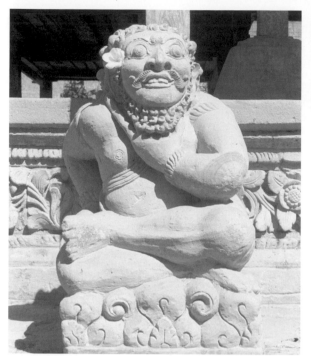

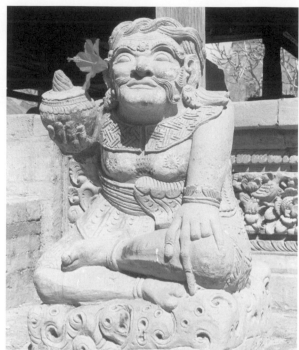

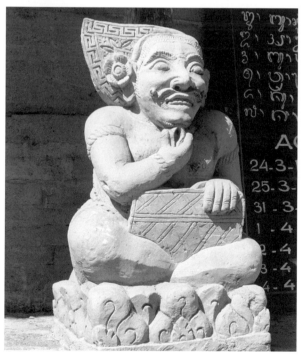

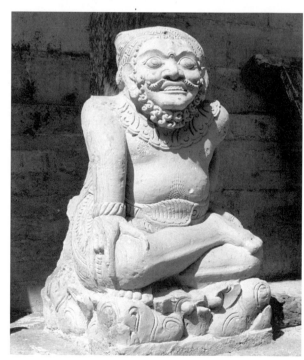

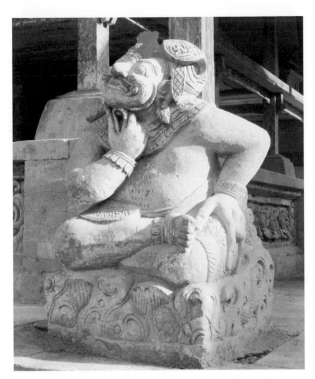

Figure 7.6. (Opposite and above) Members of the *krama désa*. Carvers: I Ruta of Puaya and two assistants. Date: 1940s. Photographed in 1985.

The Gate of the Mrajan Désa

The team of stone carvers also put up an ornate arched gateway into the *mrajan,* not from the Pamangku's living area, as usual, but one that opens from the pathway on the outside. This is a view of the inner face of the gateway, a good example of a pattern made of ivy leaves and flowers. On its outer side the doorway had lettered across the top in capital Latin letters KELAR PADA T. 13.4.49. (finished on the date of April 13, 1949).

The East Gate and Its Guardians (1950–1954)

The East Gate was planned and executed as a single entity, as were the two great southern gates, and therefore it should be viewed as an ensemble. The gate itself is a *candi bentar,* a split gate. This is odd, since its welcoming openness gives direct access into the Jeroan, whereas on the other sides the inner court is shielded by closed doors. It does not even have an *aling-aling* screen blocking view into the interior. I have no explanation of this anomaly, other than the surmise that since the area near the East Gate consists of only other temples and the home of the Pamangku, perhaps there was a feeling that these structures and spaces themselves provide a buffer between the inner *tenget* space and the rest of the world.

At the base of these broad stairs, a small distance away, are two large, square plinths with antique statues on them that are thought of by some as *pangapit lawang* (guardians of the door). The figures on top of these high platforms face the gate, and seem to close off the space between them and the gate, a space where the incoming deities of Pura Désa Batuan pause to witness the *segehan* ceremony before entering. Within this carefully framed *kuuban kori* (gateway realm) is a theaterlike

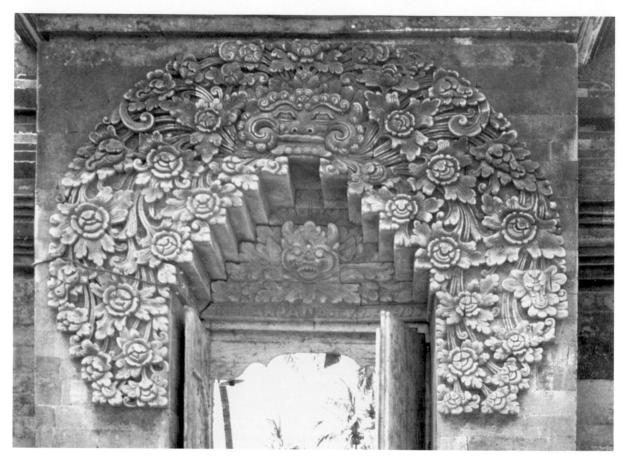

Figure 7.7. The Gate of Mrajan Désa, seen from inside. The head is a *saé*, or lionlike figure, not a *boma*. Carvers: I Ramia (Banjar Tengah), I Wina and I Ruta (Banjar Puaya), and I Purna and I Krepet (Banjar Peninjoan). Date: 1949. Photographed in 1986.

scene of six figures and, below them, two large stone fantastic beasts. They are dancing the *gambuh*.[16]

No visitor gods go through the East Gate, and no *panggung* temporary altar is placed there for them. The scale of the whole is close to human, giving the East Gate a quiet domestic feeling, at least in contrast to the other major gates.

The Lionlike Animals Guarding the East Gate

In the portion of the tableau lowest and farthest away from the doorway crouch two great carved animals

with leonine manes. Some of my consultants said they were *singa* (lions), while others that they were *bruang* (Malayan bears). They may have been inspired by the animal figures attributed to the hand of Kebo Iwa (see figure 4.12).

The Statues on the Pangapit Lawang of the East Gate

Two large plinths stand before the East Gate, with figures on their top, facing it. The two are not really *pangapit lawang,* but rather something else, but I do not

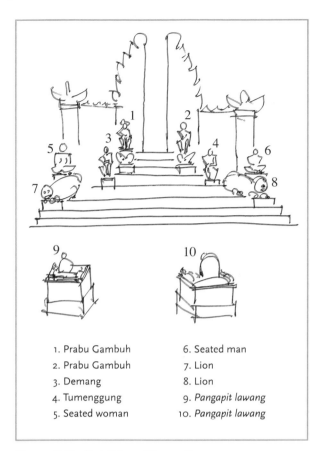

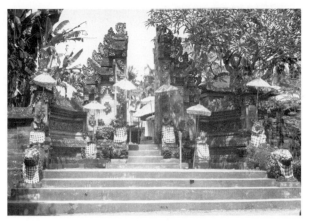

Figure 7.9. The East Gate and its statues, during the Odalan.
Date: late 1940s or early 1950s. Photographed in 1986.

1. Prabu Gambuh
2. Prabu Gambuh
3. Demang
4. Tumenggung
5. Seated woman
6. Seated man
7. Lion
8. Lion
9. *Pangapit lawang*
10. *Pangapit lawang*

Figure 7.8. The East Gate and its guardians.

have adequate information on them. They do not stand, as most *pangapit lawang* do, right next to the gateway, and their figures do not face outward from the gate; rather, altars and their figures both face toward the door, as if to watch what comes in and goes out. Further, unlike the usual *pangapit lawang,* they are not placed symmetrically with the door between them. One of the pair of figures is placed opposite the middle of the gate, while the other is off to one side. A knowledgeable consultant, who called them *pangapit lawang,* said that the centered one can also be called a *balé pelik.* Both, he said, were asking permission on behalf people or *niskala* beings to enter. One is "politely asking to see if the one you want to meet is there" while the other is "wait-

ing his turn in a queue. The two figures have human forms, and may be either *niskala* beings or *sakti* humans. The statues were made before the earthquake, but the plinths, despite their aged look, must have been placed there when the area was cleared in preparation for the stairs.

The Gambuh Performers at the East Gate

The human figures outside the East Gate stand welcoming, greeting, and announcing, like those before the southern gates. But these particular figures are unique in form and associations. Like the others, they are neither deities nor demons, but depictions of human dancers. The dance portrayed here is the *gambuh* dance, and its performers are dancing a welcome, echoing the live *gambuh* dance of the villagers that is done whenever the gods come out. The six figures seem to comprise a tableau from the dance.

At each side of the group of dancers sit a man and woman who may be singing the songs *(tandak)* that accompany the dance. At the top of the stairs next to the gate, as *pangapit lawang,* are figures of two prime ministers from the drama, named, according to one of my

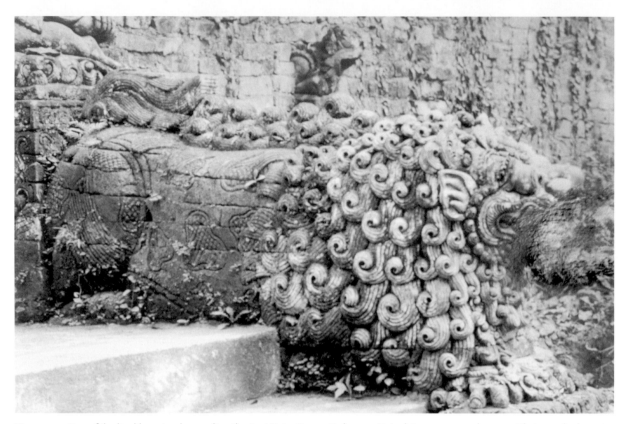

Figure 7.10. One of the lionlike animals guarding the East Gate. Carver: Unknown. Date: late 1940s or early 1950s. Photographed in 1983.

consultants, Prabu Megada and Prabu Pamootan, distinguished by their distinctive costumes. The Prabu on the right is in the *agem nyerita* dance position for telling the story. The one on the left is doing the step called *matangkis* (to parry or ward off). Below them and a little to their sides are two of their *bupati* (ministers), named Demang and Tumenggung, doing their usual comical dance that makes fun of royal and bureaucratic pomposity. The group as a whole echoes the message of the Ramayana statues that were created in the 1930s: they too are villagers performing a specific dance as part of their *ayahan* homage to the gods of Batuan.

Unlike the *topéng* dance-drama, which through its stories calls forth potent ancestral shades of particular local dynasties and always anchors its tales in named nearby locales, the *gambuh* speaks of remote times, places, and peoples (Java during the kingdoms of Daha, Gegelang, Madura, Lasem, and Singasari). The *gambuh* is also distinguished from other Balinese dance genres by its particular orchestra, its difficult and graceful dance movements, and its special repertoire of stories and songs often referred to as the Malat cycle.

The Gambuh Dance, Self-Reference, and Naturalism

No one with whom I spoke had ever heard of *gambuh* statues standing at a temple. Perhaps the new teams were inspired by the work of their predecessors, who

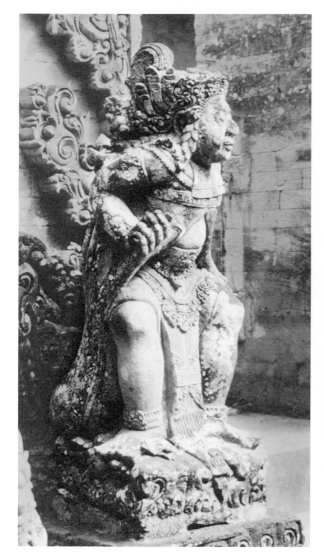

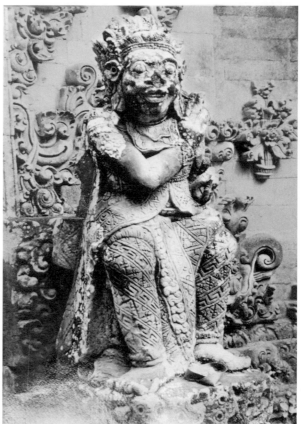

Figure 7.11. The two *prabu* (prime ministers) of the *gambuh,* as *pangapit lawang* of the East Gate. Carvers: I Ruta (left) and I Remya (right). Date: late 1940s or early 1950s. Photographed in 1983.

placed the Ramayana in dance at the front and interior of the temple. However, putting figures of *gambuh* dancers as the guardians of a temple gateway is unusual.[17] As far as I can ascertain, Batuan was original in its placing of *gambuh* dancers before a *pura désa.* If so, there must have been some social motivation driving these images.

The associated meanings of this little tableau are complex, and relate, I believe, to the role of the Tri-

wangsa group within the *krama désa* of Batuan at the time. Here again some social history of Batuan and its *gambuh* troupe needs to be recounted. While the *gambuh* in Batuan is today a sacred dance (and events in the 1960s were to prove how very sacred it is felt to be), it may not have been tied to the temple rituals for as long as the villagers think.

In general, I think it very likely that the *gambuh* dance originated (perhaps in the late seventeenth century, al-

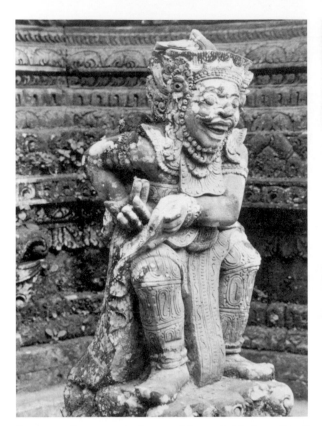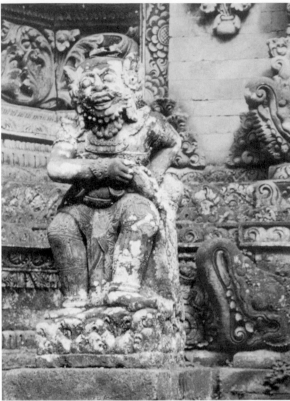

Figure 7.12. The two comic dancers of the *gambuh* in front of the East Gate: Demang (left) and Tumenggung (right). Carver: I Remya. Date: late 1940s or early 1950s. Photographed in 1983.

though some put it more than a century earlier) first as a sensuous entertainment for the courts. It devolved into an entertainment for the *jaba* audiences and then later (perhaps only in the twentieth century) was adopted as a sacred dance in Pura Désa Batuan, possibly evoking the *sakti* ancestors of the Triwangsa. Vickers has shown that, in the eighteenth and nineteenth centuries, the *gambuh* was part of the court culture of the various competing princedoms. Typically it was performed before the court, important visitors, and onlooking villagers as a royal diversion, and its content was a romantic evocation of erotic desire and heroic boldness. Even in the twentieth century, the *gambuh* continued to be thought of strongly as a presentation or validation of

the grandeur of a particular princely court, and Vickers reports the cultivation of such troupes by several Balinese regents in the colonial government.[18]

Correspondingly, in Batuan, the history of its *gambuh* troupe has been closely linked to the royal court of Gianyar. As I have recounted above, the man that the Dutch made their first Prabekel of Batuan, Déwa Gedé Oka, was a prince descended from the house of Gianyar whose father had been placed in Batuan by the Gianyar king as his representative. Déwa Gedé Oka had spent his childhood and youth in the court at Gianyar and had learned *gambuh* there. A local story says that when he danced in the rival court of a Cokorda in Sukawati, the Cokorda's wife fell in love with him and

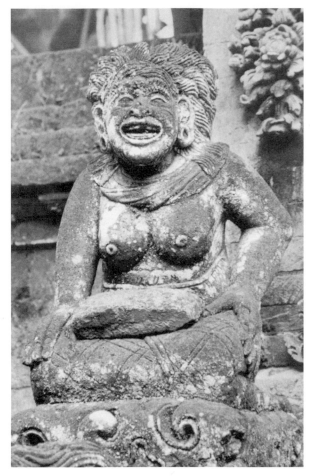

Figure 7.13. Seated woman, singing, probably a *tandak* for the *gambuh*. Carver: I Ruta. Date: late 1940s or early 1950s. Photographed in 1983.

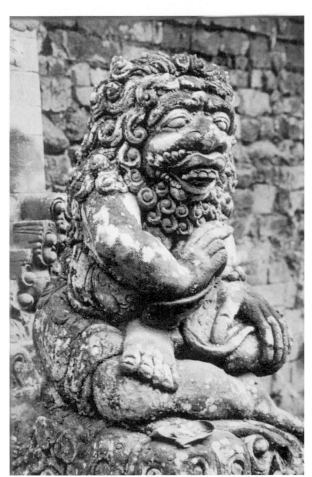

Figure 7.14. Seated man, singing, probably a *tandak* for the *gambuh*. Carver: Déwa Nyoman Cita. Date: late 1940s or early 1950s. Photographed in 1983.

collapsed in a swoon onto the stage area; the next night the couple eloped to Tabanan, to Puri Subamia. They spent six months in exile there (for the Cokorda's family was ready to go to war because they considered the Batuan Déwa to be beneath them), and during that sojourn Déwa Gedé Oka created a *gambuh* troupe for Tabanan. This story underlines both the erotic content of the *gambuh* and its performative context of courtly festivities.

It is very likely that the *gambuh* was introduced to Batuan by the young Déwa Gedé Oka, perhaps as recently as the first decade of the twentieth century.[19] But how this court dance became attached to Pura Désa Batuan as essential to its rituals is unknown. Oral history states merely that it was always danced by the Triwangsa. People also suggest that an earlier group of Triwangsa had introduced the other sacred dance, the *wayang wong,* and that when the *gambuh* was brought in, a commoner *banjar,* Dentiyis, was given the responsibility to do the *wayang wong,* together with its sacred masks.[20]

A third reason for the importance of *gambuh* in Batuan in this century was the attention given it by foreign visitors. Walter Spies and Colin McPhee were both greatly interested in *gambuh,* and the former frequently commissioned special performances for the elite tourists he frequently guided. Money for costumes may also have come from these foreigners. In Spies' photographs and in the films made by Gregory Bateson and Margaret Mead, the costumes appear to be new and unusually elaborate. In 1973, Tillman Seebass and associates filmed and recorded a performance by the Penyama Triwangsa.[21] In 1980 the dancer I Madé Jimat put together a new commercial dance troupe (of mixed *triwangsa* and *jaba*) that did, among other genres, the *gambuh.*

The presentation of *gambuh* figures before the gate of the temple therefore invokes associations of a strong tie between the Triwangsa and Pura Désa Batuan. This assertion, given Batuan's particular history of the development of the *gambuh* and its close involvement with Puri Gianyar, is not an abstract statement about *gambuh* in general, but one about the particular Triwangsa *gambuh* troupe of Batuan.

Perhaps these figures are understood to show the Triwangsa segment of the community dancing the *gambuh* and standing in for the whole of the Batuan *krama désa,* performing a respectful welcome for the royal deities. Perhaps, therefore, it is an assertion that Batuan's Triwangsa are full members of the *désa.* It could have been the presence of antiroyalist ideologies, perhaps not yet in Batuan itself yet but elsewhere in Bali, that stimulated this carved affirmation. The local noble house, itself a branch of the Gianyar royal house, may have seen the writing on the wall that they were to be the last of the Dutch-supported rajas.

I see the East Gate construction as a self-conscious artful statement of a strategic nature, an effort to respond to an increasingly problematic and ambiguous situation, one that would explode in the coming years. Perhaps the eastern gateway in its entire conception and in its details betrays a concern, if not a defensive anxiety, about the position of the Triwangsa group within Pura Désa Batuan. It seems to me that the stone carving completed during the ascendance of the last of the "Dutch rajas," the Gianyar puppet king, and of his kin in Batuan expresses the "naturalness" of the dominance of Batuan's (and Bali's) aristocracy over even the worship of Batuan's gods.

However, this view would not have been entirely accepted by the commoners, who did most of the carving work. The commoners, as will be seen, accepted tenaciously the importance of the *gambuh* dance to the temple gods, but did not recognize the exclusiveness of the "ownership" of the *gambuh* by the Triwangsa. The Triwangsa may have felt that the *gambuh* was theirs since it pertained to their ancestral spirits, but the commoners clearly thought that the *gambuh* belonged to the gods of Batuan, as will become clear in the next chapter.

The naturalistic style of the statues at the East Gate, especially that of the two singing commoners at each side, is new. It goes back, within Pura Désa Batuan, to the little statues of the *krama désa* on the Balé Semanggén, which may have been done in the late 1940s. These were by I Ruta, who made two of the *gambuh* figures as well. The other singing commoner, a man, is by Déwa Nyoman Cita, who was to carve a number of statues in what was by then called the "new style."

Ordinary people have been represented in Balinese painting for more than a century, if not longer, but not as naturalistically as these are. The earlier ones were caricatured, while these have realistic proportions and faces.[22] Recognizing that these figures of *gambuh* performers made in the late 1940s and 1950s are naturalistic makes one see that some of the earlier figures of masked dancers made in the 1930s were also naturalistic.

The Age of Freedom (1950–1967)

For nearly twenty years after 1954 little or no new carving was done in Pura Désa Batuan. Minor repairs were made and all ceremonies carried out, but it appears that no larger projects were undertaken, mainly, as far as I can tell, because of a major crisis within the temple community, one that was so serious it nearly came to violence. This conflict had its roots in the new social forces at work: increased education, growing belief in egalitarianism and against royalty, and increasing expansion of social horizons out of the local community.

In political terms the period I call the age of freedom, *jaman merdeka,* began in 1950 with Indonesian independence and ended in 1967 with the replacement of Sukarno by Suharto as head of the Indonesian state. But temple building followed a slightly different periodization. The momentum of the work started soon after the Japanese retreated and continued on until 1954. Then, for unclear reasons, temple carving did not start up again until the early 1970s, after Suharto and his Orde Baru (New Order) had transformed the social circumstances of the village.

The neglect of new temple building and carving for so long could have been due to the widespread poverty

in Bali in the 1950s and 1960s. At the beginning of the period, the economy was just beginning to recover from the strains put on it by the Japanese occupation. A sequence of severe inflations and the withdrawal of the Dutch and delays in establishing new governmental offices staffed by Indonesians weakened the market system. The tourist trade, which started up everyone's hopes between 1946 and 1950 when Dutch firms encouraged it, slumped especially during Sukarno's fierce antiforeign campaigns of the late 1950s and early 1960s. A volcanic eruption in 1963 strewed ashes over many rice fields, ruining them for several years running, and severe droughts for several years in a row got the rest.

However, an argument could be made that poverty —aside from acute shortages of the sort experienced in the Japanese period—is no real inhibition in Balinese temple work. All of the raw materials are at hand for the taking—stone from the ravines, bamboo and palm trunks from the gardens. All of the labor can be found within the village congregation. And all of the food, which is the main compensation of the laborers (who are of course the villagers themselves), can also be found in the village. In Batuan, for instance, immediately after the devastating Japanese occupation, the extensive work described above on the East Gate and associated structures was carried out. I am convinced that the reasons for building or not building Balinese temples in different historical periods have been not economic but social.

The major barrier to new carving in the 1960s was, in my understanding, the growing dispute in regard to the duties of noble members of the temple, a painful fight that did not reach its climax until 1966, when the commoners ejected the nobles and the nobles built their own *pura désa* adjacent to Pura Désa Batuan.

A study of this village-level conflict and its aftermath tells a good deal about conceptions of temples and the relationship between worshipers and gods in Bali. I will discuss the theological implications of the debate at the end of this chapter. But the first part of the story concerns how it was that political parties became entangled in the ritual work of Pura Désa Batuan.

. .

Right after the transfer of sovereignty to the Republic of Indonesia, the new leaders began work on establishing a system of parliaments at both national and local levels, and an array of political parties sprang up to promote their leaders. The important ones, in Bali, were the Nationalist Party of Sukarno (PNI), the Communist Party (PKI), and the Socialist Party (PSI).[1]

In every village there were mass meetings aimed at recruitment into each of the new parties. It was the beginning of the age of political speeches (Ind., *pidato*), of loudspeakers, posters, and parades. Regional elections were the first held, in 1950; then in 1955 there was a general election, and again in 1960. Throughout the next years, until the terrifying events of 1965, it was a heady period of hope.

Increasingly, as the era developed, this political party mobilization was accompanied by an ominous threat of physical confrontation among the opposing groups. Youth groups in the villages sometimes patrolled their areas armed with knives and machetes.

In talking with older men in the 1980s, men who were middle-aged in the 1950s, I found that they referred to the parties as *pasukan-pasukan* (Ind., "military troops"). This is understandable, for as they looked back over that period and the time of the Japanese occupation before it, force and voting were closely intertwined. The Japanese had lined their mass meetings with soldiers. The nationalist revolution against the returning Dutch was phrased in terms of partylike youth movements and was experienced in part as an undercover guerrilla war. After the departure of the Dutch, several of these terrorist groups continued to operate against the new government, considering it merely a

conservative extension of the royalist pro Dutch administration of 1948–1950. Although these groups were finally subdued and the political parties began to be developed toward the general elections of 1955, the young men of nearly every village developed a militant stance.

The word most often heard in the 1980s describing the period of the 1950s and 1960s is *kacau,* an Indonesian term meaning "confusion, disorder, agitation, mix-up." The use of this term referred, I believe, to the general social situation in which every village was split into opposing factions. One man told me that even the members of the army were divided along party lines.

The time was one of learning a new kind of political citizenship, of new ideologies, of voting, patronage, and party loyalty—but the one "lesson" everyone in Bali seemed to have learned was that political parties are divisive and lead to violence. By the time the events of 1965 were over, nearly everyone was against the free operation of the electoral system.

To understand the events of the 1950s through the 1980s it must be recognized that Balinese society was undergoing a major transformation, linked to the extraordinary growth of schools and mass media, to the great enlargement of the civil service and the new jobs it entailed, and, toward the end of the time, to the economic expansion of the tourist sector.

From the 1950s on, with each year, increasing numbers of young people entered adulthood with Westernized education, setting themselves off from their parental generation. Not only that, but with every generation, each new cohort of twenty-year-olds had more education than its predecessors.

In the generation confronting the sudden appearance of political parties in the 1950s in Batuan there were only a few people who had had any education, and that only elementary. In 1950 there were only a few elementary schools and one high school (grades 7–9) in all of Bali. The new government first built dormitories for Balinese secondary school students in Javanese cities and then gradually began to train teachers and to set up schools in villages and towns. Throughout Bali in the 1950s, villages themselves were building school buildings and hiring teachers (often from north Bali) themselves. In Batuan the government built a new elementary school in the 1950s, but it did not provide desks, so the people hammered together makeshift ones.

Thus each decade's events in Batuan were met and interpreted by a new young generation. And each one had a greater understanding of the nature of political parties and of the larger economic and political processes of the nation. From the beginning these new educated young people were granted a disproportionate deference by their elders in village issues. The nationalist revolution had been energized and, at times led, by *pemuda* (Ind.), young men and women, who had greater awareness of the stakes of the fight for independence. Subsequently, the newly educated could read and talk the new political language embodied in school Indonesian, and they claimed to understand more about the modern world than their elders. Each new younger generation emerging from the schools had a slightly different view of matters from that held by their immediate predecessors.

By the 1960s, many new village schools had been set up, and there was now a small elite group who had gone through junior high school, who could read the newspapers and interpret events. The latter had had to go abroad, typically to Surabaya, for their secondary education.

By the 1970s there were high schools in Bali and a new university, and another new generation of even better educated young people. In the 1980s in Batuan there were a number of college graduates, several of them anthropology majors.

With sovereignty came efforts to build and improve the government bureaucracy through a policy in which all foreigners were replaced by indigenous people. In Bali, at first, many of these positions went to Javanese

and other non-Balinese, but as the decades wore on, more and more young Balinese entered the government. In Batuan, increasingly, the aim of schooling was to gain a position as a civil servant, and soon after, to be employed in a tourist enterprise.

Increasingly, those who were civil servants, teachers, or tour guides had greater and greater influence in village affairs. These modernizing young intellectuals were a new social phenomenon. Some of them had already spent years outside Batuan, usually in school or in commerce. They saw politics in terms of national issues, rather than village ones, and attempted to convey that larger sense to their families and neighbors.

By the 1960s, the main basis for leadership within the local community had shifted. No longer were older people automatically given authority, and increasingly they were displaced by younger educated people. This process shows up even in the affairs of the temple, in the successive choices for the powerful position of *bendésa*.

In the colonial period, the man chosen to be *bendésa* was a man of some maturity, one who knew Balinese literature (at least the sorts of texts that are manuals for rituals and healing), who knew something about the performing arts, and who very often was also a highly skilled stone carver. At the same time, the other local leaders, for instance, the village headman or *prabekel,* were appointed by the Dutch, who chose only those who were literate in Malay, written in Latin letters.

In the late 1940s, a noble was chosen as *bendésa.* This was Déwa Gedé (later called Anak Agung) Raka, son of the old Prince of Batuan. He was young and modern, literate in Malay, but also skilled in the arts. As a dancing star Raka had traveled a great deal (even to Paris). He served as *bendésa* backed by his elderly father, who may have been, as probably in the past, the de facto *bendésa.*

However, after Raka the succeeding *bendésa* in Batuan were commoners. In keeping with the new times they all could read and write Malay, now called Indonesian. But until 1966 they were still all protégés of the old Prince of Batuan. They all came from the *banjar* of Pekandelan, where all were former servants, retainers, or affinal kin of the nobles of Batuan. One of these *bendésa,* a dancer, told me that he saw himself as Raka's representative, and he spoke of Raka as the *bapak gumi* (father of the community). Increasingly the new *bendésa* were chosen not only for their clerical skills but also for their political savvy, for their abilities in giving the new kind of speeches, for their new views of what the village should be like. In 1966 another step was taken when the new *bendésa* came from one of the peripheral, wholly commoner, *banjar* of Batuan and was even more highly educated. It was under his leadership that the final break between the gentry and commoners of Batuan occurred.

. .

The argument was about the contribution to the temple that every member must make. The commoners protested that Triwangsa should no longer be exempt from the major portions of the regular payments, that this inequality was unjust.

Present-day traditions (which of course are open to question) state that Triwangsa had always been members of the *krama désa* but that they did not pay the regular dues in goods and services that *jaba* did. While the commoners' contributions were recorded, those of the gentry were not. Commoners did all the heavy work—carrying stone for carvings, erecting the temporary and permanent constructions for ceremonies—and they made most if not all the offerings. The contributions of the Triwangsa were primarily in the sphere of the performing arts, most particularly the staging of the dance-dramas during the larger festivals (with the one important exception, at least in this century, of the *wayang wong,* which was performed by commoners). There was

also a distinction in worship: commoners presented offerings to all the altars and god-figures of the temple, while the titled people were permitted to pray only to Sanghyang Betara Puseh, Sanghyang Rambut Sedana, and Sanghyang Aji Saraswati. They were not allowed to pray to Betara Désa or to accept his *lungsuran*. The commoners wanted to do away with all these exceptions.

The dispute began slowly, during the major temple work of 1948–1954, and did not reach a climax until 1966. At the outset (and, later, at the end) it did not involve political parties at all.[2] Someone suggested that a new *wantilan* should be the next step in improving the Pura Désa. Up until the time it was built, whenever there was a major festival, two large temporary pavilions of bamboo posts and palm-leaf roofs were erected across the road from the temple. Now the idea was to build one very large pavilion, using modern materials, with a cement platform, wooden posts, and a tile roof. The villagers planned to place a raised stage made of brick and cement in the manner of a modern theater at one end. On this stage a youth group planned to build a wooden screen consisting of a painted *candi bentar* through which dancers could make their entrances and that would serve as scenery during performances. The screen, done finally in the early 1960s, was drawn by Déwa Nyoman Cita and completed by others in the Truna Jaya dance group. The high roof, held up by strong wood pillars, was made of baked tiles (see figure 8.1).

The nontraditional character of this new building was exemplified by the use, in laying it out, of metric measures rather than the system based on a particular person's hand span. Such a structure could not be built by the old methods of collective unskilled labor and materials gathered within the village, since the cement and the tiles had to be purchased, and much of the labor had to be hired.

The idea, I believe, was that a large modern structure could attract large crowds to the shows that the villagers produced. Perhaps the proposers thought that

these crowds would add to the impressiveness of the temple. Or perhaps they saw them as a source of cash, through the many food stands that could be set up around it, each to be taxed by the temple. Or perhaps there would be profits from tourists, given the new hope arising in the late 1940s for their return. In the 1980s when I was in Batuan, the temple owned a large number of folding chairs, which they rented out to the audience, generating a sizeable take each night. (But few tourists took them, since the plays were incomprehensible and boring to foreigners.)

In any case, money was needed to build the proposed new performance shed. The idea that gentry members of the *krama désa* should no longer be exempt from full dues to the temple was in the air generally in Bali at the time.[3] The leaders of the *krama désa* asked that the nobles, who made up about one-fourth of the congregation, pay out in materials and heavy work on the same scale as the rest of the villagers. One very lucrative effort was the collective harvesting of rice for local farmers, in which normally one portion goes to the owner of the land and one goes to the laborer. When the temple is involved, it receives about half of each harvester's portion. The rice going to the temple could then be sold to buy cement and skilled labor.

The gentry refused to contribute, saying that their work on dances and music (rehearsals, costumes, instruments, and the like) was more than equal to what the commoners did. The performance shed was built anyway. The issue was not settled and stayed on to fester until 1966, when it came to a crisis.

Meanwhile, much to the annoyance of the commoners, the Triwangsa were rebuilding their own *pura dalem* temple (the Pura Dalem Puri) for themselves, and there they were doing all the heavy labor, harvesting rice, carrying rocks from the ravine, and so on. The temple was an old one, going back to the eighteenth century, but it had completely fallen down, so that only a few tempo-

rary shrines and pavilions put up at each festival were left. The manual labor that the gentry put into building their own *pura dalem* temple demonstrated to the commoners that the nobles could, if they wanted to, do any heavy jobs.[4]

The conflict within the temple membership was, from beginning to end, phrased in terms of equality on one side and hierarchy on the other. Political parties played no part in the inception of the dispute over the role of the Triwangsa within the temple, but they soon became completely entangled. The climax, after the parties had been long involved in every aspect of village life, came in late 1966 when the *krama désa* put a sign out in front of Pura Désa Batuan stating that it was a "PNI temple" and notifying all that only members of the PNI party were allowed to worship there. This was the step that inflamed longstanding antagonisms and brought about the permanent eviction (or, some say, withdrawal) of most of the Triwangsa from Pura Désa Batuan.

How this could happen requires a brief examination of the history of political allegiance in Batuan in the 1950s and 1960s. The village was almost unanimously PNI throughout the period. Yet there were pockets of people adhering to other parties, and, perhaps more important, some neighboring villages, notably Sukawati, were strongly Communist. Many of the political meetings were intervillage in scope. One would have thought that given a noble house with strong ties to the king of Gianyar, who was a leader in the Socialist Party, Batuan would also have been Socialist. But probably because of personal experience in high school in Surabaya, the young new leader of the noble house, Jero Gedé Batuan, chose PNI. Similarly, in the *banjar* of Puaya, another rising young leader, a commoner who also had gone to high school in Surabaya, promoted successfully the PNI in Puaya.

Robinson has advanced an argument that much of the political struggle of the 1960s can be understood in terms of what had happened in Bali in 1945–1950, the period of Dutch reoccupation and nationalist opposition to it. At that time those Balinese who cooperated with the Dutch were sharply, often violently, opposed by those who would not cooperate, but this division did not invariably follow a fault line between nobles and commoners. Many but by no means all of the royal landed interests were represented on the "Co" (collaborators) side. On the "Non-co" (nationalists) side, there were some powerful princely individuals and families fighting against the colonial regime, and these tended to play down or even give up their titles. In subsequent years the patterns of political loyalties and interests were even more complex. In Batuan, as in the rest of Gianyar, the fact that the royal house of Gianyar was emphatically pro-Dutch affected but did not determine party membership.[5]

It may be that the Batuan members of the Communist Party were motivated by antimonarchist ideals. The two leaders who were killed in 1965 were school teachers whose fathers had been active in the antimonarchist nationalist movement in 1946–1947. However, there were never more than eight members of the Communist Party in Batuan, so it never played an important role in Batuan's temple conflict.

There were, however, a number of other active antimonarchists and their kin who joined the PNI. This created a hidden schism within the local PNI that was not recognized until the temple crisis in late 1966. All of the *banjar* that had no Triwangsa were antimonarchist and gave (passive) support to the revolution. Batuan Gedé with its strong contingent of Gianyar-tied Triwangsa was almost entirely monarchist.

Socialists were probably rare in Batuan, despite the fact that one of the national leaders came from the Gianyar royal house, and in any case the national Socialist Party was banned after 1960 because of its links to the abortive independence movement for Central Sumatra in 1957–1958. But after 1963, a small party named

SOKSI attracted some sixty members in Batuan.[6] Based mainly in Java, with ties to the former Socialist Party, SOKSI had a major leader living in nearby Sukawati. For some people of Batuan, SOKSI's main attraction was that it was against both the PNI and the PKI. Its membership was very mixed; some had the title of Déwa, some were from the Brahmana Buda group, and many were commoners. It was the resistance by these SOKSI members to the PNI leaders' attempts to convert them that was to generate the troubles in the Pura Désa.

There is a tendency in today's talk in Batuan, on the part of the older people who experienced them both, to identify the terror of 1945–1950 with that of 1965. There were continuities and similarities between the two upheavals, but there were major differences as well. It would be a mistake to give in to the temptation to see them as two battles in a single war against royalism. What they mainly had in common was a resort to covert violence.

In the 1950s and early 1960s, the political parties competed mainly on a level of theatrical display — with banners, music, dance performances (every local chapter of every party had its own dance troupe and special songs), and impassioned speeches. But these performances soon built up into militant and fierce confrontations.[7]

In 1965 came the terrible "Gestapu" massacres, in which many of those who were considered members of the Communist Party were executed by their fellow villagers. It was only after those disturbing events that the climax of the dispute about Pura Désa Batuan came. In Batuan, there had been a Communist Party rally in which two young Brahmana teachers of Batuan were installed as village heads of the party. They held the rally on a field just east of Pura Désa Batuan, land owned by the clan of Brahmana Siwa, ironically the same land on which the new Triwangsa Pura Désa was to be built about a year later. The army, according to many, pulled strings in the background to foster their killing.[8]

After the killings the conflict within the temple congregation flared. While in Batuan, unlike nearby villages, only the two teachers were killed, many there saw these events as destroying the unity of the village. Shocked at the breakup of families and old friendships, the leaders desired to bring the village back to wholeness and solidarity.

However, a new cultural notion of "social unity" as unanimity and consensus (Ind., *"persatuan"*) had emerged along with the parties. Perhaps it came from the Western notion of "solidarity." The term *"persatuan"* was on everyone's lips. The notion was that all of one's obligations — family, neighborhood, village, nation *(banjar, désa, pura, negara)* — should collapse into a single overall oneness. A single political party for the community seemed to fit. But this totalistic ideology is quite different from those underlying the older social institutions of the villages, all of which operate to protect diversity of social ties — to allow two people to oppose one another in one context and to support one another in the next. For instance, throughout all of the controversy over the temple membership, all commoners kept on good terms with those particular gentry toward whom they owed specific fealty, that is, toward the Brahmana families who were their *siwa* or ritual protectors, and toward those particular Déwa families who had for generations been their *gusti* or lords. But the new idea of *persatuan* would override these particularistic loyalties.

In Batuan someone came up with the idea that *persatuan* in the *désa* could be attained through the leverage of the temple gods. Since the Communist Party had been eliminated, there remained only the tiny SOKSI group. The plan was to squeeze the Batuan members of SOKSI out of the temple, so that they would join PNI in order to enter the temple, rather than face the wrath of Ida Betara Désa. The living would be threatened not only by the curses of *niskala* beings, but also by their uncremated dead, who might in turn punish their own descendants.

It was at this point that the PNI leaders of Batuan posted a sign outside the Pura Désa stating that it was the "Pura Désa PNI." But something went awry. Two days later a meeting was called, and at that meeting the sign was taken down; it was no longer the non-PNI that were to be excluded, but the Triwangsa. The idea of threat of exclusion from the temple had been picked up and exploited by a new faction.

The form of the meeting itself was entirely novel, and it was given a new, Indonesian, name. It was neither a meeting of the *krama désa* nor of its steering committee, the *prajuru désa;* now it was a *"déwan désa,"* an Indonesian term, and it was made up of all the important people of the village. The meeting decided that no one could worship in the temple if they did not perform the same labor in temple rituals as everyone else and present offerings in the same way everyone else did as well. It was the fall of 1966, and the great ceremonies of the sixth month, leading up to the Taur Kasanga, were about to be held.

The Triwangsa, for theological reasons I will explore in a moment, could not agree to doing physical labor or to contribute dues on a level with everyone else. They came back with a counterproposition: they would give money as the equivalent of their labor. But the commoner members of Pura Désa Batuan would accept no compromise.

Then, abruptly, a large portion of the Triwangsa group gave up the fight. They had decided to withdraw from Pura Désa Batuan and erect their own *pura désa* nearby. They were led by the family of one of the *pedanda,* who donated the land for the new temple. The group pooled all its resources to build it. There was a considerable rush to get at least the main altars up, since without them and the *tirta* that is generated during temple rituals it was impossible to have any other kinds of rituals, such as burials and cremations.[9]

But not all the Triwangsa were agreed on this solu-

tion, and the group of SOKSI Triwangsa held back and attempted to continue to negotiate with the commoner members of the temple. They consulted a number of *pedanda* in distant places and were advised to ask for a major ritual in which the altars were all reconsecrated to include the Triwangsa. But again they were turned down, with the majority of the congregation voting that such a solution was too expensive.

Then the excluded group of Triwangsa went to the government and attempted to get an administrative decree that would allow them to worship in Pura Désa Batuan. But the governor could do no more than provide police for the next upcoming ritual, during which they stood by while a line of colorfully clothed Triwangsa girls and women carried offerings into the temple on their heads. The commoners jeered them and threatened them with brooms but permitted them to enter. That was the last time any of the excluded gentry ever set foot in the temple.

The conflict was not only within the village but also within the PNI of Batuan itself. One of the PNI leaders of the time was Anak Agung Gedé Agung, a young member of the royal house of Batuan, a civil servant and schoolteacher, recently graduated from high school and with some college education as well, and Raka's nephew. Agung had a view of the village as unified and epitomized by the royal house itself. He was clearly a monarchist and loyal to the prince of Gianyar.[10] His opponent within the PNI was I Djaboed, the *bendésa* in 1966, another very young man, college educated, a businessman, who saw the PNI as the champion of the working people. In an interview in 1986, Djaboed told me that he was against all *kasta* behavior, that *triwangsa* did not deserve special respect unless they had earned it. Djaboed firmly believed that in ordinary work situations, people of high title, unless they were priests, should be addressed not by their title but by their names, just as commoners are. Further, nobles should not be

spoken to in the high registers of Balinese but in just the same egalitarian speech as commoners. Djaboed claimed that the *triwangsa* were descendants of former "colonialists" and that even then they had too large a role in the government. His view of the PNI ideology was close to that of Sukarno's *marhaénisme,* which might be translated "proletarianism." He came from a *banjar,* Peninjoan, where no gentry had ever lived, and built, for his art shop beside the road, the first two-story building in Batuan (really three stories, since he put the family temple on its roof, another first). While I am of the opinion that a simple class struggle analysis (as suggested by Robinson) is not adequate to understand what was going on in Batuan, it is clear that Djaboed, as one of the actors in the dispute, held to one.

In Bali, this view of the PNI as the Nationalist Party, as the direct descendant of those parties that had fought the revolution, as the party of all the people of Indonesia concealed many potential ideological rifts for a long time. In Batuan, the rift between those villagers who had supported the republican movement in 1945–1950 and those who supported the Gianyar monarchy was very great but invisible. In that period, Batuan's noble house had control over the *désa adat,* peopling the temple-managing team with its followers and even having the *bendésa*-ship itself.[11] Since the colonial government of 1948–1950 had been headed by people from the Gianyar royal house, Batuan's noble house was automatically pro-Dutch. But the majority of the villagers of Batuan outside the central *banjar* where the nobles lived were strongly pro-Republic, and therefore antimonarchy. Resentments of the privileges of the nobility were present but unexpressed.

It was not until 1966, when an educated leadership developed among the commoners in Batuan, that this egalitarian ideology found a voice.[12] With that voice came an increasingly popular cultural construction of *triwangsa* as an important social category, a developing

notion of them as a social group, and, perhaps, a sharpening of the sense of importance (or unimportance) of the Triwangsa for the spiritual health of the Batuan community. It is very likely that the definition of *triwangsa* and *jaba* as unitary social groups was strongly furthered by the speeches of the *marhaénist* Bendésa from one of the wholly commoner *banjar.* It had perhaps been initiated by the Dutch, with their own cultural categories of "nobility" and their discriminatory practices of education for the sons of "nobles" only. But it received a new lease on life through the attack on *feodalisme* by the Indonesian nationalists.

And with that newly constructed social category came what might be called "class consciousness" (leaving aside for the moment whether genuine "classes," in the Marxist and sociological senses, had developed in Bali in the 1960s). During the 1950s while the commoners listened to antimonarchist talk and the arguments against inherited noble privilege, the Triwangsa of Batuan themselves were experiencing an unusual degree of cooperativeness within their group as they labored to bring their own temple, the Pura Dalem Puri, back into shape. In connection with that they reorganized a dance group to perform the *gambuh* in this exclusively *triwangsa* temple, a dance group (supported materially by the royal house of Gianyar) they named Penyama Triwangsa (the noble clan). One of its noble participants told me that the work on the temple and on the dance gave them a new sense of group pride and strengthened them in their later resolve to withstand the commoner pressures to contribute on equal terms to Pura Désa Batuan.

A history of controversy, given its content, can never be tidy or certain about its generalizations and categories, since that is the nature of controversy. No neat historical narratives can be trusted. There are exceptions and alternative positions of all sorts.

Neither the *triwangsa* nor the commoner group was

unanimous and homogeneous. In 1948, a fraction of gentry in Batuan were against the puppet-government of Gianyar and the Dutch. In the late 1960s, the Triwangsa group was split between those who supported the new Triwangsa temple and those who did not want to leave the Pura Désa Batuan. The latter were not permitted to participate in the ceremonies in the Pura Désa, but they continued to send off prayers regularly to it from their own house temples as a sort of insurance.

The commoners were also split. In 1948, there were commoners on both sides, some promonarchy and most against. In the 1960s, some commoners were opposed to expelling the Triwangsa from the temple and these, in fact, stayed out of the Pura Désa together with the Triwangsa.

In the 1960s, two *banjar,* Jeleka and Peninjoan, voted to expel the Triwangsa families that lived among them. This was not so difficult to do since the Triwangsa there didn't have to move away; since they were Brahmana, they merely changed their *banjar* affiliation to Banjar Siwa. In the 1970s the Triwangsa *banjar dinas* called Batuan Gedé broke up acrimoniously into three according to their clan membership, the Déwas remaining in Batuan Gedé, the Brahmana Siwa in a new *banjar,* Brahmana Siwa, and the Brahmana Boda in a new *banjar,* Brahmana Boda.

Nevertheless, through all this turmoil, the Pedanda of Batuan and their Brahmana ritual assistants remained on good relations with all their commoner clients.[13]

. .

Something of what the loss of the Triwangsa members of Pura Désa Batuan meant to the remaining congregation can be learned from the following account of how hard the commoners worked to put together a new commoner *gambuh* dance troupe to perform at the temple.

Rejecting the gentry view that the *gambuh* belonged in all senses to the Triwangsa of Batuan, that they alone could be the link to Bali's royal past, the commoners held fast to the notion that the *gambuh* is the sacred dance of Pura Désa Batuan, that it belongs to its gods, and that it is unimportant who dances it. While the nobles had considered the *gambuh* a dance of their *triwangsa* ancestors, the commoners thought it a necessary component of their own rituals, on a par with the *topéng* and the *wayang wong* dances.

When the Triwangsa withdrew from Pura Désa Batuan, they took the paraphernalia of the *gambuh* with them—its costumes and instruments. They also took the requisite dance skills, the knowledge of plots and dialogue, and the musical memory of songs and orchestral pieces. Each specialized dancer took with him the knowledge of that dance, each singer took the songs he knew, and each musician took the knowledge of his particular part in the orchestral compositions special to the *gambuh.* It was the last component, the competence to play the special music of the *gambuh,* that gave the commoners the greatest trouble. The costumes could be remade, substitutes could be found for the instruments, and the stories could be found outside Batuan.[14] At the final moment of schism, there were several highly talented commoner dancers who had been trained by the Triwangsa, notably I Kakul, who had learned the dance from Anak Agung Raka, and he was able to train a new troupe of younger people.

But there were no commoners who could play the difficult *gambuh* music, and no Triwangsa was willing to teach them. One of the participants told me of the lengths they went to to learn the music, borrowing tape cassettes to practice with and persuading one dissident noble to sneak in after dark to teach them, until he was found out. Finally they enlisted a noble born in Batuan but living in another village to work with them—as long as they went to his village for their lessons. Each

part in the music and dance had to be taught separately, and then they could put it all together to perform in unison. Some elements could be dispensed with, but most were absolutely necessary.[15]

Reconstituting the fragmented *gambuh* illustrates the point made in chapter 2, that Balinese cultural performances always integrate a scattered distribution of small pieces of knowledge into a momentary whole.[16]

. .

The main motivation of the Triwangsa in taking the stand they did in regard to the manner in which they were to *ngayah* in Pura Désa Batuan was not social or political but profoundly theological. The position of the commoners was driven by a contrary view of the nature of the cosmos and of human beings.

When a committee of the excluded Triwangsa went to a government official for help in persuading the *krama désa* to admit them to worship in the temple, the government official refused. He said, they told me later, that they ought to give in to the requests of the members of the temple. They ought to do the same service, and they ought to give the same kinds of offerings in the same way as all the others. After all, he said, every temple is dedicated to Siwa, Wisnu, Brahma, and ultimately to Sanghyang Widi Wasa. All temples are *suci*, so what's the difference?

That was exactly the problem. In the minds of everyone in Batuan the worship was not directed mainly at those general Indic gods at all, but to Ida Betara Puseh and Ida Betara Désa, the first being the god of the surrounding territory and the second being the god standing for all the ancestors of the people of the village.[17] If all souls, on death, joined and became one with Ida Betara Désa, then Triwangsa souls and commoner souls would intermingle. And then when any Triwangsa worshipers raised their hands in the gesture to Ida Betara Désa, they would be subordinating themselves to commoner souls. Their own ancestors (including their recent not-yet-cremated dead) would be offended and would curse them and their descendants. It was a matter of immediate and eternal punishment.

If a nobleman and his wife made offerings that were "eaten" by Ida Betara Désa and then took them home for themselves to eat, they would be polluting themselves with the *lungsuran* of lower beings. This would be "like eating off someone else's plate," explained one consultant. Only fellow family members do that, and only because they and their ancestors were all of the same status. The act of eating off someone else's plate places one as equal to or lower than the first eater.

When a gentry family has an *odalan* in the family temple, holy water (in this case *banyu cokor*) is generated; this holy water may be sprinkled only on members of the family or people of lower rank, for instance their vassals or *parekan*. The *banyu cokor* of Ida Betara Désa should not be sprinkled on *triwangsa* people.

Further, during certain rituals offerings dedicated to commoner ancestors (for instance, Ida Betara Buda Manis) or to the Barong are placed together with offerings to the higher gods, and then, after the deities have partaken of them, all these offerings are divided up among the team of people who have been working on preparing the ritual. If the team included *triwangsa* they would be given these "low" offerings to eat, which would be an abomination to them and their own ancestors.

Balinese use the term *"kasta"* to refer to the categories used to distinguish among the Brahmanas, the Satria, the Wesia (together the *triwangsa*), and the Sudra or Jaba.[18] In debates in Batuan, the Triwangsa said that *kasta* are religious categories. Without the overarching hierarchy framed by this grouping, one man told me, "people would not know higher from lower, east from west, north from south, near from far." And all children would

be bastards, that is, lacking an ancestral shrine and lacking empowering ancestors.

In this argument the *triwangsa* is epitomized as the *puri* (in earlier days, the *jero*) in each locality, and for some the *puri* stands for the whole of the *gumi* and is an important guarantor of the spiritual well-being of the whole region. Repudiation of the principle of monarchy, which became a rallying cry in the Indonesian revolution in all parts of the archipelago, carried with it theological implications that were argued out in Batuan in terms of the membership responsibilities of Pura Désa Batuan.

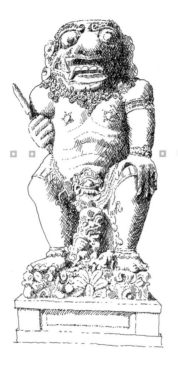

The Age of the Tourists
(1966–1995)

During the period when I was doing this research in Bali, primarily in the 1980s, political speakers were calling that time by a variety of terms. They would speak proudly of *jaman melek* (the age of awakening), *jaman pengertian* (the age of understanding), and *jaman kemajuan* (the age of progress). Or they would orate about *jaman orde baru* (the age of the New Order), following President Suharto's slogan of the Orde Baru, and, in the same spirit, about *jaman pembangunan* (the age of economic development).

But most commonly, ordinary people called it *jaman turis-turis* (the age of the tourists). All these phrases are appropriate, for they are all part of one another.[1] I chose "the age of the tourists" for my chapter title because the massive invasion of foreign (and later Indonesians from other islands) pleasure seekers has been the most eye-catching characteristic of this time, at least to outsiders.

In fact, other factors than tourism were the main drivers of the transformation of the Balinese economy and of major cultural changes, although they were not at first recognized as such by the participants. Perhaps the most influential of these were the new schools, but even more pervasive was the commercialization of life. And, slowly at first but with rapidly increasing momen-

tum, with increasing educational achievements and the development of mass media, Balinese began to have a greater awareness of the outer world and consequently of themselves.

During this period the governmental bureaucracy grew in strength, breadth, and depth of entry into village life, as did the army, which was given important functions in economic development and in local policing. This was also the time when the great religious reformation based on the theology of cosmic order began to take hold on popular imagination. The diversity of options in all fields multiplied.

No longer could Balinese be called "peasants" in the anthropological sense of the term, for many were no longer rural, nor were they parochial and local in orientation. Even though the agriculture they still practiced was largely preindustrial in form, with no tractors or harvesting machines, cash crops became increasingly important, and many industrial and service occupations became available.

A major question of this chapter is how much the temple and its carving have been affected by these changes in life and social relationships. In what ways have they been influenced by the intrusive global visual conventions that characterize the tourist paintings of today and by the new reformist ideas of religious worship?

I begin this period in 1966 with the establishment of President Suharto's New Order government and the building of a jet-plane airport. In Batuan's Pura Désa Batuan, the period also begins in 1966 with the expulsion of the Triwangsa from the temple. After the turmoil of the 1950s and early 1960s, the people turned in revulsion and fear against all political contest. The members of the former ruling family, those usually referred to as "the Puri," turned their interest away from local affairs and invested all their energies—and money—in getting modern education for their younger men, who later became leaders in the economy in the 1980s.

I divide the age of the tourists into two subperiods: the age of awakening and the age of economic development. In the first, which ended in 1981, only one major temple structure, the Balé Agung, was redone, in the front courtyard. In its bas-relief carvings and in a painting on it can be seen a new style influenced by the tourist painting in which its makers were also engaged, and with it a new understanding of "style" in the sense of alternative visual modes. The marker for the end of this first time was a great Karya Agung in 1981. Paid and prepared for and conducted without involvement of any Triwangsa other than the *pedanda,* this major ritual festival was taken by almost all in Batuan, noble as well as commoner, as a sign that the controversy was essentially over.

In the second period, beginning after 1981, a great range of new works was made, most of them peripheral to the ritual activities of the temple. Many were done in the new manner, by one carver, working with one assistant, who signed his work. Toward the end of the time, in 1993, the long neglected but ritually crucial West Gate was rebuilt—significantly, not by members of the community working together but by the Indonesian government through its scientifically and historically oriented Archeological Service, and with hired labor.

The Modern World in Désa Batuan

In the course of only two generations, from 1966 to 1995, the people of Batuan saw the social as well as physical nature of their village transformed. The commitment to modernizing, now referred to as *kemajuan* (progress), increased, and they made a number of decisions in its name. They cut down many shade trees and built numerous new schools. Electricity was brought to the village in about 1973, and the temple-managing committee installed lights and a public address system in

the temple. By the 1990s, there were electricity, running water, and telephones; paved streets and automobiles; and suffocating crowding of houseyards. Batuan was in 1995 almost a small town.

While before 1970 many Batuan people had been engaged in tourist-related activities, after that time most of them were. At the outset of the twentieth century nearly all able-bodied men in Batuan were working in the fields, but by the 1980s most were not.

Those who made and sold paintings and those who formed dancing groups were directly interacting with tourists, and many others found jobs in the secondary institutions that underpin the tourist industry, such as construction work, police work, taxi driving, and trucking. In addition, some members of the village entered the ranks of the expanding bureaucracy, the army and the police, the malaria eradication programs, and the judiciary system, and spent much of the year away from Batuan.

The changes began slowly, but by the 1990s were snowballing. In 1963 Sukarno arranged to use Japanese reparations to build an enormous new hotel, finished by 1966, on Sanur beach. In the year the hotel was finished, injection of foreign money began, mainly in the form of World Bank loans. The airport was enlarged to receive jet planes in 1966 and was further enlarged in the 1980s. After 1967, with Suharto's New Order and its energetic commitment to economic development and with investments by the World Bank in roads, luxury hotels, clean water, and electricity, and in improving the infrastructure for the supplying of Western foods and for training guides who could speak not only English but German and Japanese, the number of tourists visiting Bali increased manyfold.[2]

In Batuan, one of the visible effects has been the conversion of much dry-garden land and even rice fields into land for houses and businesses. Within every houseyard buildings have multiplied, crowding out the vegetable gardens and fruit trees of the past. At the begin-

ning of the century, I've calculated (on of course rather shaky population figures), there was about an average of two acres of rice land for every family in Bali; by 1970 there was less than one acre per family, and the projection was that by 2000 there would be only one-quarter acre per family.

In the late 1970s some people sold their rice land to pay for the building of grandiose art shops *(arsop)* along Batuan's stretch of the tourist highway, and a number of Batuan's carvers were hired to decorate them. This was a new sort of commercial architecture: red brick pavilions with intricate stone carvings, looking much like traditional *puri* or palaces and with large displays of paintings and sculptures. The first of these were not in Batuan but in Mas and Ubud to the north and in Celuk, just south of Batuan. In the store in Celuk in the 1960s, a number of Batuan people sold their wares, and one dance group performed regularly. It was not until the late 1970s that Batuan people began to spruce up their already existing small souvenir stands. By 1981 when I arrived, there were at least five of these new ornately carved art shops. By 1983, however, there was a worldwide economic slump, and the tourist river nearly dried up, not to pick up again until the late 1980s.

Batuan had had tourists wandering through it occasionally since the 1930s, but it was not until the 1980s and 1990s that their presence became numerous and daily. Some came for its art shops, some for dancing lessons, and some visited Batuan's Pura Désa. By 1995 the noble house had been transformed into a hotel. Did the continuous scrutiny of the tourists, roving over all the *sakala,* visible aspects of the life of Batuan, invade the consciousness of the temple artists? Were the foreign tourists yet one more expected audience that the artists took into account in their work on the temple? There is some evidence, to be set forth below, that the stone carvers and painters of the temple did respond in minor ways to the presence of tourists. However, the changes in life and, perhaps, values that every-

one experienced were not due to the ideas that the tourists had of Bali or to the example of the tourists' ways of life but rather to the new popular education and the new kinds of employment.

The commodification of much of daily life has had significant consequences for Pura Désa Batuan, but these have been subtle and indirect. These socioeconomic and cultural changes, while bringing about prosperity for some, also periodically created great shortages in materials, labor, and money for the temple.[3] First, one of the major sources for funding—the cockfight—was nearly eliminated. This ritual libation of blood *(tabuh rah),* for which only several fights are necessary, had long ago been expanded into hours of exuberant gambling. A temple (and formerly also a royal house) that sponsored a cockfight could tax each bout. The lengthy battle by the government to eliminate cockfights, because of the Muslim-generated antigambling movement, succeeded not in stopping the cockfights (which continue in secret), but in making it almost impossible for temples to openly tax them.[4]

An even more lucrative source of temple funds disappeared when, in 1975, the farmers adopted a new strain of rice in the Green Revolution. This new rice is harvested with large sickles rather than the small knife, so harvesting came to require a different kind of social organization, one in which a few wage laborers could do the work that formerly required a large communal turnout. Formerly, a temple in need of money could organize its congregation into work teams for harvesting, with the workers contributing their share of the harvest. However, with the new rice, almost overnight the temples lost this means for raising funds through donations in labor.[5]

With the shifts in the occupational base of the congregation of the temple, personal contributions to temple projects were no longer solely in kind and labor; increasingly, money was a major component. By the 1980s,

the names of rich donors to the temple funds were listed prominently on a poster along with the amount of their gift *(dana punya)* to the temple. A few families in the 1990s began to hire others to make their offerings or to purchase them outright from peddlers. The increasing proportion of members of the temple who worked on nine-to-five jobs and who substituted cash payments for donations in kind meant that more of the temple's income was in cash.

. .

Major innovations in religious conceptions paralleled these socioeconomic changes. I have never met a Balinese who had adopted a completely secular attitude toward life, but many have adopted the tenets of the Hindu Dharma movement. The quasi-governmental organization for religious standardization and education, the Parisada Hindu Dharma, established in 1959, held a series of conferences throughout the 1960s and 1970s on the new theological ideas and published a number of books and articles. The group then organized a teachers' education college, produced textbooks, and placed teachers, all of whom taught the new theological ideas, in all the primary and secondary schools.

A standard personal prayer was introduced in the schools: the Tri-Sandya. This is the only prayer that can be said by someone who is not a priest, with no accompanying flowers, holy water, or incense. Certain hymns, notably the "Kidung Wargasari," were taught to all schoolchildren. While the goddess Ida Betari Saraswati has special meaning in Batuan because she is embodied in the copper-engraved text enshrined there, she was given new general prominence by the schools. On Saraswati's *rahina* or holy day all the schoolchildren in every school perform extensive rituals to the Goddess of Learning. The religious authorities now speak of that day as an *odalan tedun Weda* (anniversary of the descent of the

Vedic texts), seeing in it a parallel to the Islamic celebration of the origin of the Koran. The schoolchildren were also given lessons in the reading of portions of those Indic texts and of summaries of them.

The new generation was taught a novel focus on personal responsibility for spiritual well-being. Before the 1960s most temple *odalan* were not heavily attended; each family sent a representative to be blessed with holy water and to bring home the family's offerings after they had been partaken of by the gods. But by the 1980s nearly everyone, from the oldest to the youngest, attended the major services.

This new personal piety plus the near doubling of the population of Bali has resulted in great crowding in the temples. The crowding was further intensified by the attendance of people who had moved away from Batuan, even as far as Java and Sulawesi, who now returned more often for its *odalan*. The new, wider roads and the increase in all transportation facilities now make it possible for all those who live at a distance to attend.

Many of the architectural renovations of the 1970s had to do with enlarging the spaces within the temple for the expanding congregation. There was a great need for clearing space for the population to sit for their prayers. Shrines and offering pavilions were moved to the side (for instance, the important Balé Agung and the less significant Balé Pelik; see below). Much of the ground of the temple was covered with cement, since during the rains the crowds attending festivals turned it into mud. Some changes in the organization of rituals were introduced to handle the crowds, notably a setting up of seating shifts for different *banjar* so that one group will leave the temple before another one enters. In the 1980s and 1990s there was a marked escalation in the scale of rituals in Batuan, with more temples and homeowners putting on more *utama* rituals more often, with further alterations on their temples.

The Age of Awakening: Schools, Shops, and Style (1966–1981)

After 1956 all the *bendésa* were commoners, and at first there was a string of different people, changing frequently. Most were artisan retainers of the Puri as before, but then came two politically neutral businessmen without traditional ties to Batuan's gentry group—I Wayan Sentér in the 1970s and I Wayan Regug from 1981 to 1996. They were both wealthy merchants with new art shops selling souvenirs and larger art objects to tourists, and they employed many of Batuan's painters and woodcarvers or sold their work on consignment. Their commercial connections with the artists made it easy to get them to contribute work on new carvings for Pura Désa Batuan. Neither *bendésa* was himself an artist (unlike many of their predecessors) or particularly familiar with the literary and religious bases of iconography and ritual (as most had been before). But both were very good at raising money, in their own businesses and for the temple.[6]

In precolonial times the *bendésa* had been in a position of great moral power and influence because he was the main judge in all civil and most criminal cases of the *désa,* which were considered the concern of the gods of Batuan. During the colonial period his authority gradually eroded, until he could adjudicate only minor disputes among *désa* members. However, the *bendésa* was still important in resolving quarrels about all matters concerning the temple, including renovation activities and funding. But by the 1970s his main job was the organization of ritual preparation, including the refurbishing of the temple. Both *bendésa* of this period chose artisans to work on temple carving from among the men who worked in their workshops and who brought them paintings for sale. They no longer recruited their artists from all *banjar,* but rather according to commercial ties, which were becomingly increasingly impor-

tant. The carvers and painters drew directly on the manual skills fostered by the tourist crafts.

Most of the carvers had experience in making intricately carved wood panels, which the Balinese call *pandil* (perhaps from the Dutch *paneel,* a panel), used at first for privet stands for Dutch teapots, later for wall decorations, screens, and coffee-table tops. These usually show a design of complexly interwoven vines and tendrils, sometimes with a figure in *wayang* style or a group of animals set among them.

The tourist painting school of Batuan had begun in the 1930s, when artists worked out a precise manner of using pen and black ink on paper, supplemented with brushed-in grays and colors.[7] But after World War II, everyone shifted from paper to cloth and tempera paints, finding that slipups could be more easily corrected on cloth. On cloth, the style of painting became much looser in workmanship and less detailed. However, there was a major shift in the middle 1970s, when the Dutch painter who had sponsored the beginnings of painting on paper with ink in Batuan in the 1930s, Rudolf Bonnet, returned to persuade a number of the younger ones to revive the prewar techniques of ink and pen on paper, and much more sophisticated-looking works resembling Persian miniatures resulted.[8] In particular, these painters inserted into all the empty portions of their paintings tiny birds, insects, and butterflies. It is likely that the skill with tiny details was made easier by the school education of all these painters, in which they had first learned penmanship in the precise Dutch manner.

Where in previous years the teams who worked on the temple had received their training as apprentices only in the making of earlier carvings in temples and palaces, now the new artisans came with lengthy experience in tourist painting and carving. Where in previous years the only comparisons to be made, the only sources of visual inspiration, were other temples and palaces, now there was the whole range of works displayed in tourist art shops.

The carvings on the Balé Agung, the principal work of this period, show this kinship clearly. They have the sharp, clean cuts and polished surfaces of the carvings and the precise lines, pretty images, and close attention to naturalistic details of the tourist paintings of the 1970s. One might say that the Balé Agung carvings resemble tourist carvings because of the unconscious working of habitual modes of work, carried over from the artists' daily use of techniques that do not necessarily have meaning for them. However, while habits of the hand may have been elements in the process, I believe that the shift in style was intentional, accompanied by a new concern for visible "style."

The distinction now entered people's talk (most probably during the 1970s) between *mode baru* and *mode kuna* (Ind., the new mode" and "the old mode" or, maybe, "modern" and "traditional" styles).[9] *Mode baru* was described to me as being *telek,* having deep cuts in the stone (a term that confusingly can also mean "deep" in the sense of profound), or *lampak,* or leaving wide spaces between cuts. Some ascribe it to the use of better steel tools with which one can achieve sharp lines, deep cuts, and very smooth surfaces. Some spoke of the new style as full of *korasi* or *dekorasi,* an Indonesian word derived from the English "decoration" and which has entered the language of Batuan people in the last ten years. Some people prefer the old way, and some the new, but all could now distinguish the two.

Translating this contrast as "modern" and "traditional" is tempting, but it entails dangers. In English, these terms carry inappropriate associational baggage from evolutionary notions of progress, with "traditional" standing for long-enduring, homogeneous ancient forms of life and art, "modern" for dynamic, rapidly changing ones. In Balinese discourses the terms are better understood more narrowly as contemporary local stylistic alternatives.

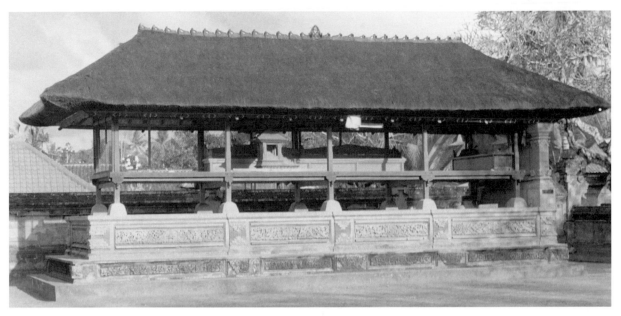

Figure 9.2. The Balé Agung. Carvers: I Madé Tubuh (Pekandelan) and a team from Puaya, Peninjoan, and Tengah. Date: 1976. Photographed in 1995.

To me the new style is more polished, more fluid, more intricate, and at the same time, somehow more facile and pretty. The old style has a distinctive rough forcefulness and solidity, even stiffness.

Along with the contrast being made between *mode baru* and *mode kuna* came an intensification of the impulse to uniqueness, individuality, and originality. The notion of distinctiveness was expressed by the word *melénan* (from *lén,* which means "other" or "different"). Admiration of the novel goes back at least to the 1930s, if not long before that. It showed up most openly in the performance arts, where the great popularity of the new musical form the *kebyar* had often been remarked.[10] But the 1970s saw an intensification of the value on originality in many areas of life. In the painting and carving worlds, high-end customers of tourist art pressured artists not to make many duplicates of successful works.

The carvings on the new Balé Agung were new not only in manner, but also in content. Like the figures at the East Gate made in the late 1950s, these bas-relief panels represent dancers from the *gambuh,* that genre that was still the center of great village controversy. The Triwangsa still claimed sole ownership (in the spiritual sense as well as in a kind of copyright) of the *gambuh* while the commoners had just, through great struggle, constituted and trained a new *gambuh* troupe and orchestra from among themselves for the temple rituals.

I see the Balé Agung carvings of the *gambuh* as one further assertion that the dance belongs not to the Triwangsa but to the gods of Batuan, necessary for any ritual that welcomes them in their visit to their local worldly realm.

The New Balé Agung

The Balé Agung had stood in the middle of the first forecourt on the south, between the two sets of great gates. It is as crucial to the important yearly ceremony

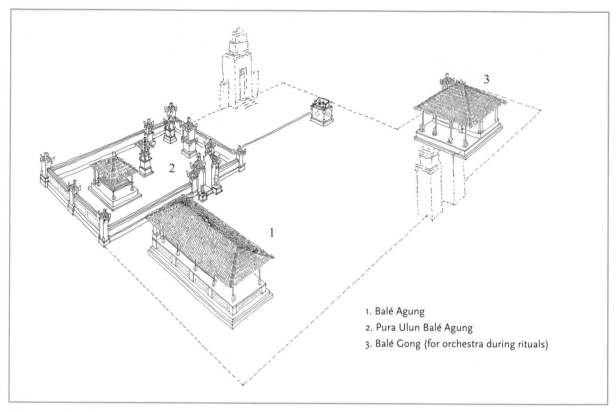

Figure 9.3. The Balé Agung, its courtyard, and its little temple, the Ulun Balé Agung.

1. Balé Agung
2. Pura Ulun Balé Agung
3. Balé Gong (for orchestra during rituals)

of the Taur Kesanga as the throne of Ida Betara Désa and most of the visiting deities of the other temples of Batuan. At the Taur Kasanga these visiting deities is said to be paying court to *(nangkil)* or respectfully escorting *(ngiring)* the deities of Pura Désa Batuan.

Ever since the gates were put in on the southern side, the Balé Agung seemed to be in the way of traffic through the courtyard. In the late 1960s, the managing team decided to move it to the side. This relocation would open up a large area for performance of the sacred dances, such as the *gambuh* and the *wayang wong,* as well as for worshipers. In keeping with the importance of this function, it was decided to ornament the Balé Agung with new carvings.

The old wooden posts and most of the other wood-

work were reinstalled in a base made out of much of the old materials. It was on that base and on the northern wall of the *balé* that the new stone decorations were put. One set of pictures, a long bas-relief, was wrapped around its base on all four sides. Two more pictures in stone were set in the northern wall of the *balé,* and an oil painting in color was placed on the inner side of that wall (not visible to most viewers).

The carvers and painters on the Balé Agung were not selected, as they had been in the past, as representatives of each *banjar* in the *désa adat* but according to their skills and connections with the *bendésa.* Thus they were not from all over the *désa* but only from *banjar* Puaya, Peninjoan, and Tengah.

Figure 9.4. Panel on Balé Agung giving its construction date (January 12, 1976). It reads "TG. 1.12.76." "TG" stands for *tanggal* (date). Carvers: I Madé Tubuh and his team. Date: 1976. Photographed in 1995.

The Bas-Relief Panel of the Date on the Balé Agung

Carved on the Balé Agung, in the form of an elaborately carved stone panel, is a date (January 12, 1976) in which the numerals are whimsically made from curling vines and tendrils. Engraving a date in Arabic numerals on buildings came into popular use after about 1950, suggesting that a new kind of historical consciousness was coming into being.[11] Although I have seen a number of dates on new temple carvings, I have not yet seen another set of numerals on a temple carving made, as this one is, from plant forms.

The Bas-Relief Panels on the Balé Agung of the *Gambuh* Dance

The bas-relief panels around the base of the Balé Agung present a light satiric parody of the *gambuh* dance, as performed by birds rather than humans, called a *gambuh peksi* (*gambuh* of the birds). I was told that since the pictures are low, below people's waists, the story had to be a humorous one. One of the Balinese I consulted commented that the length of this set of pictures, which goes all around the building, is just like the length of the performance, which goes on throughout an important section of the ritual.

These *gambuh peksi* panels were still in many aspects traditional, as befits the decorations of a temple. The background behind the bird figures is one of the curlicues and flowerettes of twisted vines so often found on walls in the older temples.

The birds depicted have been carefully observed and naturalistically done. The hero of the play, Panji, is played by a *titiran* (turtledove). The heroine, Langkasari, is a *gelatik* (rice bird). The clownish servants are *tengkék* (blue bird with a long red bill), the princess's comic servant woman, the *condong,* is a *bondol* (small, sparrowlike bird with a white head). Four *petingan* play the *kakan-kakan* (servants). The fierce and courageous minister, or *mantri,* is a *kékér* (jungle bird like a rooster).

Various instruments—flutes, drums, and gongs—are held in the claws of other birds chosen for their calls, which resemble the sounds of instruments they play: a *celepuk* is played by a kind of owl; a *sagum* plays the *kempur,* or small gongs; the *belatuk,* a woodpecker, plays the *kendang* or drum; a *kapecit* plays the *kenyir,* a small metallophone; and a *sawan ujan* (bird with red feathers) blows on a *suling* or flute.

The artisans who worked on this frieze and the other

Figure 9.5. Frieze on base of Balé Agung, showing story of Panji performed by birds. Carvers: I Madé Tubuh and his team. Date: 1975–1976. Photographed in 1988.

carvings on the Balé Agung were a new group, headed by a young painter named I Madé Tubuh from Banjar Pekandelan. He drew the outline of the bas-relief scenes on the stone, and other people did the carving, to which he later added the finishing touches. He was already a successful painter and made much of his living drawing designs on slabs of wood for other artisans to carve and polish for sale to tourists. Tubuh had been selected for the job by the Bendésa of that day, I Wayan Sentér, who was neither an artist nor a literary man but the owner of an art shop that sold paintings and carvings to tourists.

I Tubuh said that the idea of portraying the *gambuh* performed by birds was his own. It is an illustration of a classic literary text, the *Gaguritan Paksi,* or *Gaguritan Kedis,* which tells of a performance of the *gambuh* drama put on by birds.[12] But while Tubuh knew of the existence of the text of this song, he took neither his inspiration nor the iconographic details from it. Rather, he said, he drew on his experience as a tourist picture maker. At that period, birds were a common subject in the new Bonnet-inspired works on paper, and Tubuh and other painters in Batuan had made many other paintings in which birds and butterflies flew in and out of the trees of the villages depicted.

The comic aspect of these carvings lies in the shocking (to Balinese) identification of animals and humans. The notion of a strict hierarchical ranking of all living beings is so strong (and so stressful) that any play with it is deeply disturbing. Where in the West, sex is the

driving force for much humor, in Bali status is. Almost all the clowns in dance-dramas make brutal fun of pompous superiors and fawning inferiors. Here the joke is gentle, since birds are not coarse or dirty, but it is still pointed not only at the brittleness of human but also noble claims to eminence. Temple carvings are rarely humorous, while temple dance performances almost always are.[13]

The Bas-Relief Panel of the Story of Sutasoma on the Balé Agung

Another stone bas-relief panel made by the same team at the same time, on the north wall of the Balé Agung, is in the same manner, but because of its subject matter it is more traditional. It illustrates a story about Sanghyang Sutasoma (the Buddha). Sanghyang Sutasoma met a tiger who was about to eat his own child, but the Buddha persuaded the tiger to eat him instead, and the tiger did so. Then Ida Betara Indra appeared and brought Sanghyang Sutasoma back to life. Seeing this, the tiger realized what he had done and repented his greediness and brutality.

I Madé Tubuh said the story had been suggested to him by a local religious scholar, Ida Bagus Ketut Alit Budiana, and that while he himself didn't know the story, he was able to draw it easily because he was familiar with the various conventional schemata of headdress and costume.

At first glance, Sanghyang Sutasoma and Ida Betara

Figure 9.6. The story of Sanghyang Sutasoma, the tiger, and Ida Betara Indra. Carvers: I Madé Jata, I Madé Tubuh, and team. Date: 1975–1976. Photographed in 1986.

Indra seem to have been drawn in the old-fashioned *wayang* style, but a close look shows that their bodies and limbs have been shaped in rounded naturalistic forms. Their faces especially are those not of conventionalized gods, but handsome humans. The mountains in the background are directly derived from tourist paintings.[14]

The Bas-Relief Panel of a *Tantri* Story on the *Aling-aling* of the Great Door

On the *aling-aling* of the Great Door is a bas-relief panel from an unidentified *tantri* story (a story with animals in it). If a comparison is made with an earlier bas-relief panel made in the 1930s, the shift in manner is clear, especially in the deeper cuts and more rounded, naturalistic forms of the later carvings. It was made by I Krepet and his team.

The Oil Painting on the Balé Agung

The influence of tourist art on the artists themselves is even more strongly felt in a painting also made in 1976. This painting was hidden away from view by humans,

up on the platform of the Balé Agung. It was made by much the same team as the bas-reliefs, but this time headed by I Madé Jata. Tubuh was among his assistants. The story, also suggested by Ida Bagus Ketut Alit Budiana, was of Ida Betara Déwi Saraswati and Ida Betara Mahadewa. In the manner of tourist paintings, it has a scenic background and bright colors. It was done in oils, probably because a paper and tempera picture would not last in its weather-exposed position; but the painters were not used to working with oils, and they found that medium more difficult to handle than the tempera paints and pen to which they were accustomed. The painting was removed in the 1990s.

The Time of Economic Development: Space-clearing and Monumentalism (1981–1995)

The last period, up to 1995 when this research ended, I call the time of economic development *(jaman pembangunan)*. During this time tourism, globalization, and commercialization blossomed, the village prospered, and the work on the temple intensified. The period also

Figure 9.7. A bas-relief panel on the back of the *aling-aling*. Carver: I Krepet and his team. Date: 1930s. Photographed in 1983.

Figure 9.8. The painting on the Balé Agung showing the gods Ida Betara Déwi Saraswati and Ida Betara Mahadewa with human petitioners. Painters: I Madé Jata and team. Date: 1976. Photographed in 1986.

nearly coincided with the maturing of Suharto's New Order, when the long arm of the government affected the details of everyone's life.

During this entire time there was only one *bendésa,* I Wayan Regug. Wealthy and pious, I Regug introduced some important innovations in the organization of the work, changes that were responses to the major social restructuring that Bali had been undergoing since the 1970s. As I described in chapter 2, I Sentér had continued the traditional form of social organization of temple work, in which most works were made by large teams and materials and supporting labor were provided by small contributions from all. But I Regug decided to funnel much of his personal earnings into the Pura Désa as well as his own clan temple. He also succeeded in persuading other rich villagers to contribute additional large cash contributions (still called *aturan* or *dana* even though they were not in the form of labor or materials), the amounts of which were prominently posted. Individual gifts to a temple have always been permitted (including many on a small scale as people fulfill small vows made to deities — for instance, to provide them with new parasols if cured of a serious illness), but before this time very large ones were made only by wealthy gentry houses. Now with the new emerging rich merchant class, commoners could do so too.

Several of the major works of this period were almost entirely financed by I Regug, including the four monumental statues on the road before the temple, to be discussed below. I Regug paid for the materials and for the work of the stone carvers, while the congregation provided the offerings that would accompany such a project. Whenever I Regug proposed a new carving plan to the managing team, each *klian* would go back to his *banjar* and see if the congregation agreed to provide its share before they went forward. But they were not asked for their opinion on who should do the work. Selecting the craftsmen was the decision of the Bendésa himself.

Paying stone carvers for their work was new in Batuan. Other, less artistically endowed villages had long been hiring craftsmen to come to renovate their temples, but Batuan had not done that in this century. However, in the 1980s, Pura Dalem Jungut hired a team of outside carvers to redo its Pura Mrajapati. With nearly all children through high school age now in school, there was no longer a supply of young men in Batuan to serve as carvers' apprentices. I Regug's solution was to hire several of the older generation of carvers on an almost permanent basis, paying them daily wages plus a midday dinner supplied by members of the congregation. The most productive of these hired artisans was Déwa Nyoman Cita.

Déwa Cita was, technically, not a member of the congregation of Pura Désa Batuan, since he was among the Triwangsa expelled in 1966. However, Déwa Cita considered himself a member of the *krama désa* of Batuan because he had been born into it, and he thought of the extensive stone works that he made in the 1980s as *ayahan* or tribute. He told me that he accepted a much lower wage rate for his carvings for Pura Désa Batuan than for those he did for villages elsewhere.

When the quarrel between commoners and nobles erupted in the mid-1960s, Déwa Cita was one of a small group of nobles who would not join the new temple of the Triwangsa. During the years after that, he and his family presented offerings to the gods of Pura Désa Batuan within his own house temple. In 1988 nearly all of the holdouts finally joined the new Triwangsa temple, while Déwa Cita and a small group of his neighbors were accepted back into Pura Désa Batuan.[15] Déwa Cita's earliest apprenticeship in wood and stone carvings was not in a temple-carving team arrangement; instead he learned by assisting his father, an extraordinarily talented carver who made statues and masks for temples all over Bali. Déwa Cita's grandfather, Déwa Krebek, had been a well-known *balian* and shadow-puppet maker of greatly feared *sakti.* When Déwa Cita's father,

Déwa Putu Kebes, violently quarreled with his own father and struck him on the head, his kinsmen in the *banjar* voted to deprive him and all his descendants of his inheritance in house land and rice land. Landless and penniless, Déwa Cita was forced to rely on drawing and carving for his subsistence. In the late 1930s, when Batuan's tourist painting industry started, Déwa Cita was still under ten, but his older sister, Désak Putu Lambon, became an important tourist painter—and the only woman practicing the craft.[16]

Déwa Cita started painting and wood carving at about the same time. Perhaps because he never learned to speak Malay, he never sold to tourists himself, but through Batuan's merchants, first through I Ngendon, and later through the latter's kin, I Sentér and I Regug. To decorate I Regug's new art shop, Déwa Cita made a number of stone bas-relief panels and a huge stone carving of a woman in the smooth manner of the modernist wood carver of Mas, Ida Bagus Nyana.

When, about 1950, the village was working on improving Pura Désa Batuan, Déwa Cita must have been about twenty years old. His father was making some fine statues (see figure 7.4), and Déwa Cita made a spirited singing man for the tableau of the *gambuh* at the East Gate (see figure 7.14).

It was particularly during the 1970s and 1980s that some tourist artists, such as Déwa Cita, began to strive for distinctive styles in their paintings and carvings. While the making of standardized pretty views of happy peasants doing traditional farm work and dances were most popular with foreigners, there were also some buyers looking for painters and carvers with personal styles and personal reputations. Alongside the mass art of ordinary tourist wares there developed what might be called a "fine art" line, for which some artists produced paintings and carvings that were more ambitious and expensive than the run-of-the-mill tourist works. Déwa Cita was one of these, and his works for the tem-

ple in the 1980s show this striving for the new and the meaningful.

• •

Whenever I spoke with Bendésa Regug, the terms "*rapi*" and "*asri*" (Ind., "neat" and "pretty") often came up. Many of the works of *priasan* undertaken during his long term as *bendésa* were relatively small efforts to make the temple more comfortable for the growing crowds of worshipers.

Cementing the dirt floor of the temple where everyone had to sit for prayer, which seemed always to be either mud or dust, was a high priority for I Regug. He also pressed for moving several *balé* aside to allow more worshipers to sit with an unimpeded view of the inner altars. It was decided to move, first, the Balé Pelik several yards toward the edge of the central space. It had formed one side of a small and unused entrance court, and the several intervening walls were removed to eliminate the walls around this court. For the same reason the Balé Peselang was moved a yard or two south, and another large *balé* was redone in a smaller size, to be used only for a gamelan. There was even talk of moving the Méru Agung a yard or two toward the east wall, but by 1995 this had not yet been done.

I Regug also oversaw the enlargement and decoration of the storage pavilion, the Balé Lumbung, which was quite small in the 1950s, enlarged in the late 1970s (just before the last Karya Agung in 1981), and then enlarged again in the 1990s, when it was given a larger and more impressive porch, used by the managing team for meetings (see figure 2.7). Its storage area was also made bigger. Another of I Regug's tidying-up projects was rebuilding the long wall along the west side with a small back door for the kitchen area, which had been left in a tumbledown condition for decades.

One project had to do with raising money for the

temple by building a line of permanent shop stalls next to the *wantilan* dance pavilion that peddlers of food and trinkets could rent, with the proceeds going to the temple. I was told that this was financed entirely by I Regug; however, he may also have arranged for a governmental subsidy. In part, again, this project was an effort to neaten up the appearance of Pura Désa Batuan's exterior.

It was I Regug and his team who thought of putting up two glass-enclosed signs in front of the temple. One gives the name of the temple and its presumed founding date. The other gives instructions in English telling strangers how to behave within its precincts. The signs are symptoms of the new self-conscious attitude toward the temple and its rituals as oriented not only to the gods but to foreign visitors as well.

In 1993 I Regug had little labels placed on each altar, identifying it in both Balinese script and Latin letters. When I asked why these signs had been put up, I Regug's answer was that it was for the benefit of *orang riset* (Ind., "researchers"). Perhaps this innovation can be traced to the effects of my presence, but apparently other people besides me, including Indonesian college students, have been studying Pura Désa Batuan in recent years.

I Regug worked to use his considerable economic and political clout to persuade the Indonesian government's Archeological Service to get moving on rebuilding the long neglected West Gate. One of his first efforts in office was to have them survey the site, making several sample excavations, which they did in 1981. Finally, in 1991, his pressure bore fruit, and the Archeological Service, with the cooperation of the *désa,* built the West Gate anew. In the archeological survey, remains of the ancient walls of a water reservoir on the north side of the temple were found. These discoveries stimulated the village to rebuild it as the Taman, discussed below.

Perhaps the most impressive works built while Bendésa Regug was in charge are the four fifteen-foot statues along the road at the points where travelers from outside the village would first drive or walk toward the temple. These, apparently, were I Regug's own idea.

These monumental figures were inspired by the many Soviet-style monumental statues that were erected during Sukarno's rule in the 1960s at major urban crossroads in the newly developing towns. Most of these statues are heroic figures of fighters in the Indonesian revolution. In 1980, in the government-sponsored complex of tourist hotels at Nusa Dua, some giant statues of Balinese deities were erected. Batuan's four figures, put up between 1981 and 1985, are entirely new to temple architecture in their placement straddling the road and in their large scale. These large statues were innovative in another aspect. They were made not from huge river rocks hewn from the side of the ravines and onerously hauled up by twenty or more shouting young men in the old way but from great cubes of concrete reinforced by steel rods.

I Regug told me that he thought that the large size of these statues would give the temple a look of *wibawa.* Since both Bendésa Sentér and Bendésa Regug were involved in the tourist trade, and most of the craftsmen they sponsored were tourist artists who sold through them, it is reasonable to see some of the characteristics of the carvings as a response to the presence of foreigners. It may be that there was an element of national pride vis-à-vis the foreigners, at least for some of the sponsors and artisans. However, I believe that the influence of the tourists was much more indirect, via changes in the sensibilities and tastes of the members of the village themselves. For everyone, the eyes of the deities remained their primary concern.

The major new stone carving and painting projects discussed here were all sponsored by Bendésa Regug. These include the four tall statues outside the temple, which stand next to the road serving as a first marker of entry into the temple precincts; the Taman, a gardenlike pool with an island in the middle with altars on it; the small temple for Ratu Ngurah Agung; and several paintings. Made at the same time were a new door on the Méru Agung and a set of paintings high under the eaves of its three roofs that have been shown and discussed in chapter 5. Both the new style, *mode baru,* with its recognizably personal touches, and the old, more conventional style, *mode kuna,* are exemplified in these works, as if the planners wanted intentionally to display the plurality of potentialities and talents of the people of Batuan.

One pair of these giant statues out on the busy road in front of the temple is in *mode baru,* the other in *mode kuna.* The difference in style between the two sets of statues—the clarity and angularity of the cuts and the iconographic freedom of the statues by Déwa Cita, and the familiarity of those by I Jedag—was pointed out to me by several people. I don't know if I Regug deliberately chose to contrast the two styles, but I'm sure he was well aware of what he was doing, since he knew well the work of the two men: Déwa Cita was his client; I Jedag was his kinsman.

I Jedag chose to carve out two statues of the Buta Nawasari, named for his dance position, which is a familiar stone figure in many temples. The *nawasari* position, with one hand held above the head and one foot forward, indicates a readiness to act.

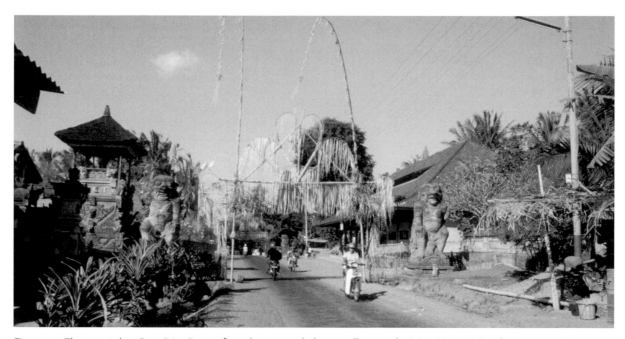

Figure 9.9. The approach to Pura Désa Batuan from the west, with the two tall statues by Déwa Nyoman Cita that announce its presence on either side of the road. The bamboo archway is the remains of decorations for an *odalan*. Carver: Déwa Nyoman Cita. Date: 1984–1985. Photographed in 1988.

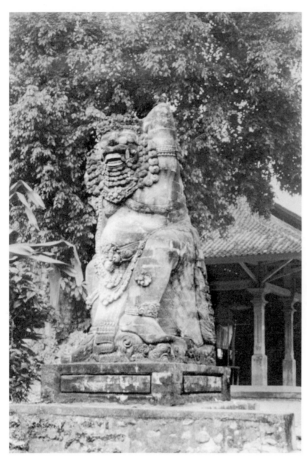

Figure 9.10. Statue by I Jedag on the south side of the road, outside the temple. The performance pavilion is in the background. Carver: I Jedag, Dentiyis. Date: 1981–1982. Photographed in 1983.

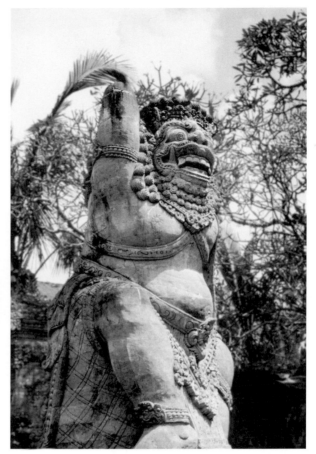

Figure 9.11. Statue on the north side of the road, outside the temple. Carver: I Jedag, Dentiyis. Date: 1981–1982. Photographed in 1984.

I Jedag's dancing *raksasa,* given what people said about the 1930s statues along the road, could easily be read as a masked human dancing, and from that a reference to the villagers themselves, performing a greeting to all who come down the road, human as well as *niskala*. The carving is precise and intricate, the proportions balanced, and the message may be that here is a conventional temple.

Déwa Cita's modern-style statues look quite different. His carving is sharp and the surfaces are smooth. They are more complex than I Jedag's in that around

their feet are smaller demons peering out. Unlike I Jedag and all his predecessors, Déwa Cita signed and dated his carvings in stone. He said to me that the base form provided him was too narrow, and he had trouble indicating movement in the figures.

Déwa Cita's iconography is original, and therefore difficult to decipher. Déwa Cita himself is a taciturn man who would tell me very little about the meanings and references of his statues other than providing me with a few clues.

The figure on the north side of the road, said Déwa

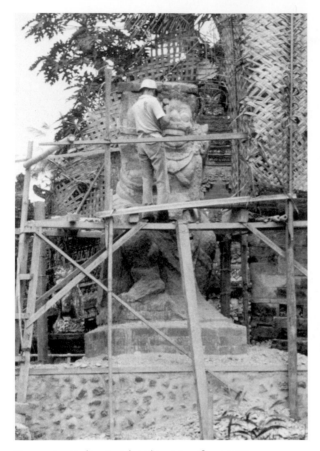

Figure 9.12. I Jedag at work on his statue (figure 9.11). Photographed in 1983.

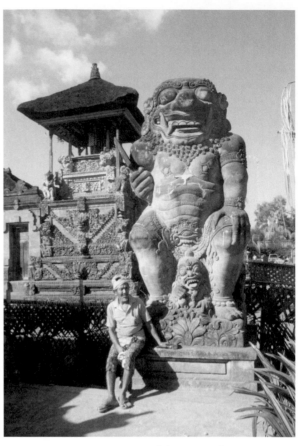

Figure 9.13. Déwa Nyoman Cita with his statue of Detia Maya (also called Raksasa Gundul). Carver: Déwa Nyoman Cita, Banjar Gedé. Date: 1984–1985. Photographed in 1988.

Cita, is of "Detia Maya, who is the son of Begawan Sutakarma." Most other people, however, called it Raksasa Gundul (the bald demon). The statue is indeed bald. He carries a stone carver's hatchet. I Regug, he said, had suggested that he make a *raksasa gundul* and pointed out, as a reference, the older statue of the same name, the bald demon who is one of the followers of Rawana in the Ramayana cycle, in the row of smaller figures made in the 1930s along the road (see figure 5.32).

At the feet of Detia Maya are demons carrying tools;

one has a modern steel saw. In the Bratayudha stories Detia Maya is an artisan *(sangging* or *undagi),* a builder and stone carver for the gods. During Kresna's battle with Arjuna the palace of the Pandawa in the forest of Sukawana was burned down, and it was Detia Maya who rebuilt it.

However, not everyone made this identification. I Madé Jata, a well-informed painter of the same generation as Déwa Cita, saw the bald figure as a warrior and his hatchet a weapon. I Jata thought that the small figure with a saw at his feet was Cikra Bala (or Cakra Bala),

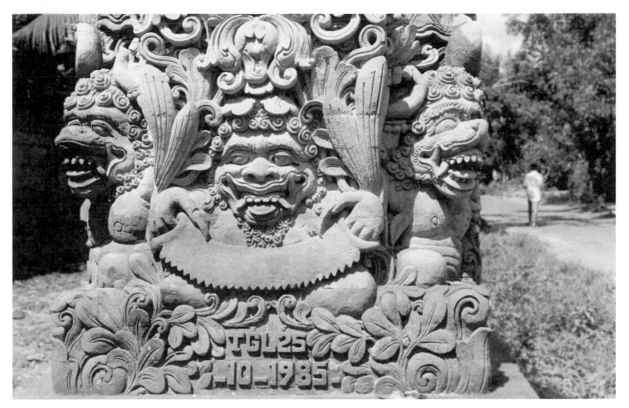

Figure 9.14. Detail of figures on the back of Detia Maya (note date, 25-10-85, carved on the statue). Carver: Déwa Nyoman Cita, Banjar Gedé. Date: 1984–1985. Photographed in 1986.

the soldier of Betara Yama in Neraka (Hell), while the small figures next to him would by *sisyan* Cikra Bala (the followers of Cikra Bala). They aren't carpenters helping to build the *puri* or the *pura*, said I Jata, basing his judgment on their faces, which have long mouths with fangs.

The statue on the south side of the road, said Déwa Cita, was of "Sanghyang Deruna *ring* Tuak who is a *pelinggihan* of Betara Surya," a figure I was unable to identify further. Déwa Cita told me that he had considered and rejected a number of other possibilities for both figures. Among these was a *Srenggi,* a devil with horns that Cita's father, Déwa Putu Kebes, had made in the late 1940s. In the end, Déwa Cita decided to do Sanghyang Deruna. He has the beak of a bird and is carrying a tool that might be either a stone carver's hatchet

or a weapon. There is no other statue like Sangyang Deruna in Pura Désa Batuan, and I do not know what he used for inspiration.

Like I Jedag's statues, these two by Déwa Cita are self-referential but in another way, in that they invoke the craftsmen who made the temple, the village stone carvers who have over the generations worked on the temple, standing as members of Pura Désa Batuan's worshiping community, welcoming all that come down the road, both human and spiritual visitors. Déwa Cita supported this interpretation when he said that they were like the two figures of Detia Maya, the legendary builder/architect/carver, that crouch high on roofed pedestals in front of the Great Door on the South (see figure 4.15).

The Taman

The Taman is a small reservoir for water for temple uses with an island in its center on which stand two altars. The island is a giant turtle. The whole is walled around, and a split gate provides an entrance. Walkways and electric lights on tall poles and ornamental shrubbery have been placed around and leading up to it. Déwa Nyoman Cita did the carvings on it, but its architectural form was set by the Archeological Service. It was built between 1983 and 1986.

When the Archeological Service did its survey of the northern portion of Pura Désa Batuan in 1981 in preparation for rebuilding the West Gate, they also found the footprint of what appeared to have been an ancient small tank for water for the temple. When told of these findings, the temple management team was eager to build a new one there, and I Regug requested permission to do so from the archeologists. In 1987 the Archeological Service responded not only with permission but also with a guide, *Bimbingan Teknis Pemugaran Kolam Pura Puseh Batuan Gianyar* (Technical guide for the restoration of the water tank of Pura Puseh Batuan, Gianyar), and a diagram. It shows the archeologists' image of what the Taman should look like. Déwa Nyoman Cita and the builders seem to have followed these plans closely.

I Regug tried to get the government to provide a subsidy for rebuilding the Taman, but his bid was not successful. However, the other members of the managing committee and their *banjar* were still very eager to do it, now that they had permission from the Archeological Service. I Regug paid for the materials and the artisans, and the *krama désa* took on the duties of digging the ground for it, with many people lending a hand. I Regug hired a few additional laborers.

Everyone was in agreement that the new Taman should look antique. Déwa Cita said they decided not to use reinforced concrete again, to his relief; I Regug instead purchased large blocks of stone that were

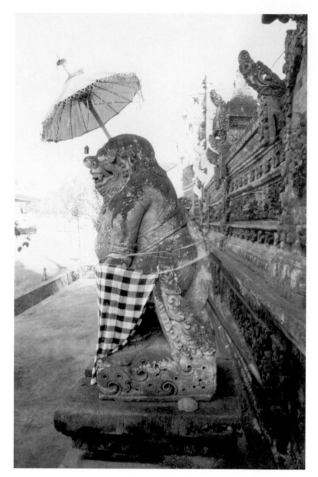

Figure 9.15. Statue of Raksasa Gundul made in the 1930s (one of the row of statues along the road). Carver: I Purna, Banjar Pekandelan. Date: 1930s. Photographed in 1988.

brought to the village by truck but unloaded with volunteer labor from the congregation.

The water for the Taman pool was a problem. There is a cluster of irrigated rice paddies (a *subak*) just to the north of the temple, and at first water was drawn off it. In the period of the archeological remains, which may have been the fourteenth century or even earlier, that *subak* may not yet have been constructed, and the Taman was filled with fresh, relatively pure water from a stream somewhat uphill from Batuan via an irrigation channel leading to the *subak* just to the south. Of course, inas-

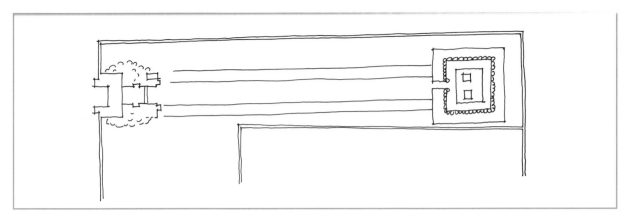

Figure 9.16. The plan for the West Gate (on the left), the Taman (on the right), and the walk connecting them, as conceived by the Archeological Service. Source: Seriarsa, Renjana, and Widja, 1987.

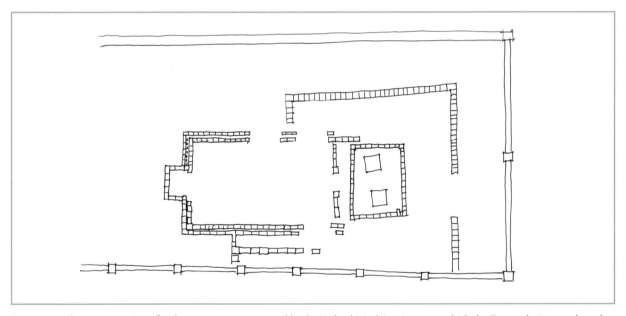

Figure 9.17. The stone remains of earlier structures, uncovered by the Archeological Service, upon which the Taman design was based.

much as Batuan is almost at the sea, any water that comes to it, except that from a spring, has come a long way and is likely to have been already used for washing and sewage. By the time in 1983 when the new Taman was begun, the only available water was runoff from the rice fields adjacent to it, no longer "pure" in any sense of the term. Nonetheless, the temple management committee still planned to use it. However, soon after the new Taman pool was opened up, the owners of land in the *subak,* who were for the most part not from Batuan, objected, saying they needed the water for themselves. So, when piped-in fresh drinking water was introduced

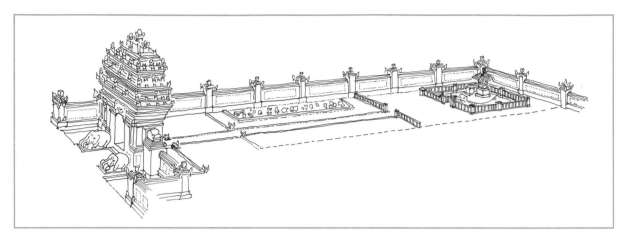

Figure 9.18. The West Gate (left) and the Taman (right), 1995.

in Batuan in about 1988, the *krama désa* laid a pipe to the Taman, set up a faucet there, and purchased the water from the government water company. Since this was fresh water it could be used for more than washing, and in fact could be used for preparing *tirta* if mixed with a little water from the holy spring, the Beji.

In 1983 when I started work on the temple, there was just a dry and weedy empty courtyard with two small altars where the Taman now stands. While offerings were and are placed before these two altars at every major ritual, they are not a necessary part of those rituals. The larger altar was called the Palinggih Taman (throne of the Taman deity) and the other the Paso Ngeleb (the basin for dipping into water). People remembered that once there had been a small pool there, fed occasionally from an irrigation canal near it, in which once a sea turtle swam briefly just before its slaughter for a festival. Turtle meat is rare, expensive, and highly desired for important feasts.

Déwa Cita's carvings here are distinctively his, yet not so strongly "new" as the statues on the road. He lavished attention on the turtle's head, which is raised up as if looking at the worshipers. I believe he had as model the well-known temple in Mas called the Pura Taman Pule, supported by the Brahmana clan of Ida

Bagus Nyana, whose works Déwa Cita admired. A mythical turtle much like the Batuan one is Bedawang Nala, who supports the whole earth. Usually depicted with one or two snakes entwined around him, encircling each leg in turn, Bedawang Nala also supports the highest gods. In Batuan he is found at the base of the Padmasana. In Besakih he supports each of the altars of the deities Sanghyang Brahma, Sanghyang Wisnu, and Sanghyang Iswara.[17] In Batuan, the turtle, without the snakes, supports the two unnamed minor deities, that of the Taman and that of the basin.

The Statue of a Woman Worshiper

Déwa Nyoman Cita made a number of other lesser statues in Pura Désa Batuan during the 1980s. Two of these are life-size statues of worshipers, seated just inside the Great Door on the South facing it as if to welcome visitors, *niskala* or human, entering it. The statues are strongly naturalistic and idealized, in the manner of *mode baru*.

The Small Temple for Ratu Ngurah Agung

Another major work of the 1980s was the small temple just east of Pura Désa Batuan for the *niskala* being called

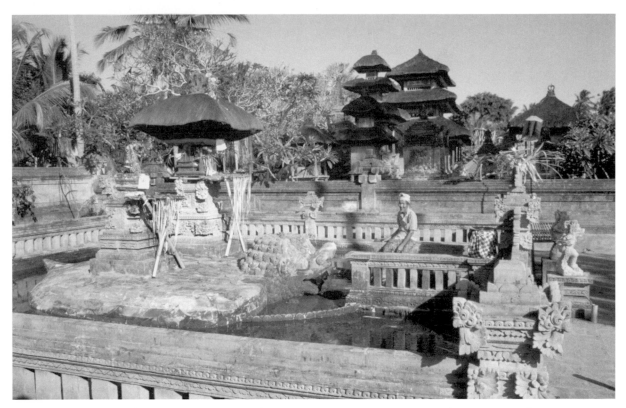

Figure 9.19. The Taman, with Déwa Nyoman Cita, its maker. Carver: Déwa Nyoman Cita, Banjar Gedé. Date: 1985–1987. Photographed in 1988.

Figure 9.20. The turtle that holds up the island in the middle of the pool in the Taman. Photographed at time of consecration ceremony. The hat is to dress him up for the ritual and the patch on his nose is a temporary amulet that is part of the consecration ritual. Carver: Déwa Nyoman Cita, Banjar Gedé. Date: 1985–1987. Photographed in 1988.

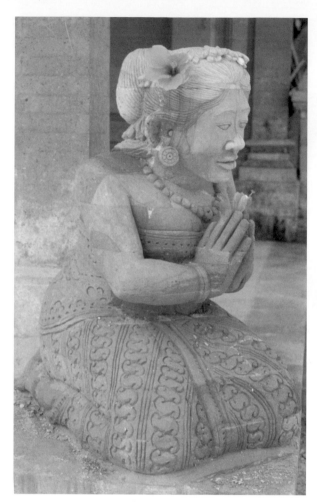

Figure 9.21. A woman worshiper. Carver: Déwa Nyoman Cita, Banjar Gedé. Date: 1985. Photographed: 1986.

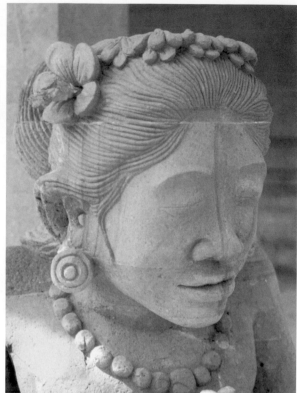

Figure 9.22. Head of figure of woman worshiper. Carver: Déwa Nyoman Cita, Banjar Gedé. Date: 1985. Photographed: 1986.

Ratu Ngurah Agung. In contrast to other works of the time, this one is completely old style. There is no god-figure enthroned here, as with many of the altars of Pura Désa Batuan, but its dweller is extremely important in all rituals. During the Odalan every household brings a food offering to this deity before going into the temple with offerings for the temple gods.

This shrine formerly stood out in the middle of a field by itself. Some (gentry) say that Pura Ngurah Agung commemorates the stay in Batuan for three years of

Dalem Sukawati, the king who later moved to Suka-wati. He stayed in Batuan for three years while his palace, Puri Grogak, was being built. The strong, noble leader of Batuan who reigned through the first half of the twentieth century was said to have meditated regu-larly here, as described in chapter 5. The temple offi-cials stressed to me that every time the Triwangsa planned to hold a ritual in their new Pura Désa Sila Murti just to the east, they had to come to ask permis-sion from this deity, Ratu Ngurah Agung. But it was

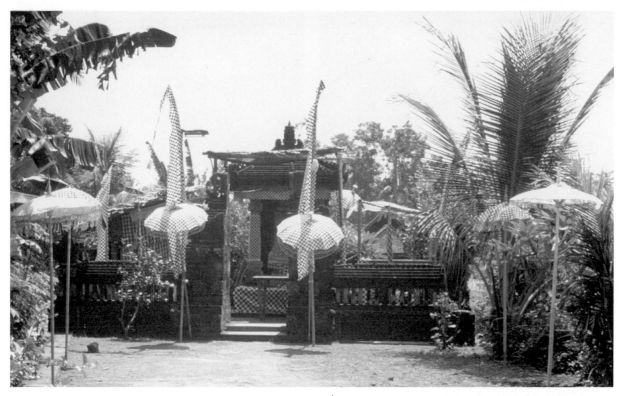

Figure 9.23. The shrine of Ratu Ngurah Agung, just east of Pura Désa Batuan. Carvers: unknown. Date: 1980s. Photographed in 1986.

only after the eviction of the Triwangsa that a formal path was made directly linking it to Pura Désa Batuan and reinforcing the tie of its deity to those of Pura Désa Batuan. It is not a great stretch to guess that its rebuilding and the path to it were yet further assertions that the deities of Pura Désa Batuan are superior to and autonomous from those of the nobles.

The Panyimpanan Altar in the Mrajan Désa

Also completely new in 1981 was the shrine for storage of the god-figures of Batuan in the Mrajan Désa. This was, I think, the only work of the century that was built by a hired carver from the adjacent village of Negari. This altar is not outstanding, although there is an interesting head of a Barong set into its base, carved entirely

in new style. The door is unusually flamboyant in its painted carving, also, I believe, a product of the man from Negari.

The Paintings on the Balé Peselang

In the 1990s several new paintings were placed on the Méru Agung, the Méru Alit, and the Balé Peselang. The painters were a large team, headed by Déwa Nyoman Cita of Banjar Gedé and I Ketut Karawan of Pekandelan. The others included I Madé Tubuh of Pekandelan; I Mustika, I Madé Gendra, and I Wayan Regug of Dentiyis; and I Wayan Jaya, I Barak, and I Naka of Tengah. All of these were tourist painters.

The Balé Peselang is the pavilion on which the two Barong of Désa Batuan stand during the Odalan ritu-

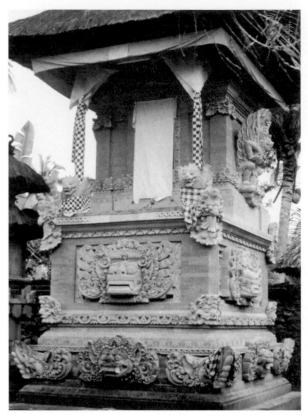

Figure 9.24. The Panyimpanan Altar in the Mrajan Désa (within the houseyard temple of the Pamangku). Carvers: from the village of Negari. Date: about 1981. Photographed in 1985.

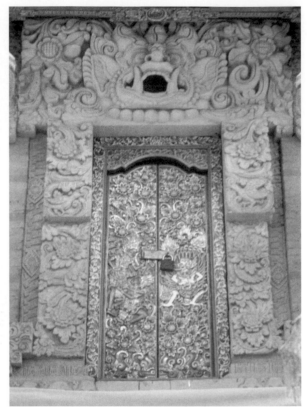

Figure 9.26. The door of the Panyimpanan Altar, within which the god-figures are stored. Carver: unknown. Date: about 1981. Photographed in 1985.

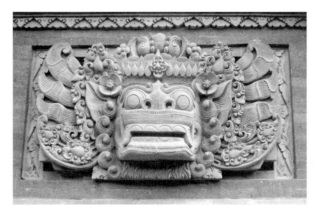

Figure 9.25. A stylized Barong on the Panyimpanan. Carver: from the village of Negari. Date: about 1981. Photographed in 1985.

als. The term *"peselang"* means "something borrowed," and this title might indicate that it is a *balé* that is put to a number of different uses. It had been left undecorated throughout most of this century. The managing team chose for its paintings to illustrate the story of Garuda's attempt to free his mother from slavery to the goddess Dewi Gadru and her family of snakes, and of his visit to the gods for *amerta* to gain her freedom. Garuda had to fight for this holy liquid against all the gods, but in his *sakti* they could not defeat him. He took their *amerta* and brought it as ransom to Dewi Gadru, who then freed his mother. Later the gods stole the *amerta* back again. The wooden statue up in the rafters, made at the same time, is of Garuda.

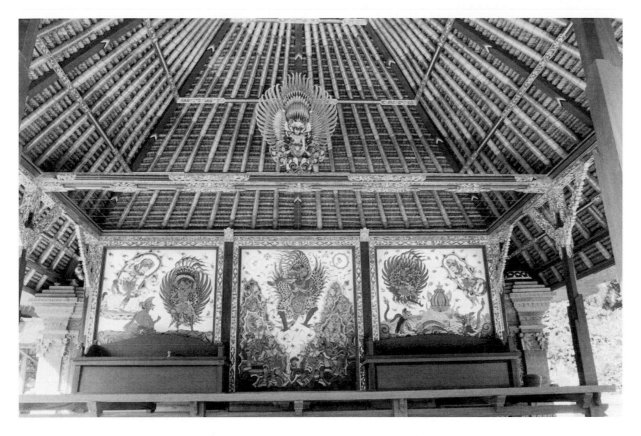

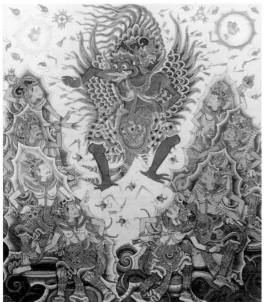

Figure 9.27. (Above) Three paintings on the Balé Peselang: The Story of Garuda and the Amerta. Painters: Déwa Nyoman Cita, I Ketut Karawan, and team. Date: 1990s. Photographed in 1995.

Figure 9.28. (Left) Painting of Garuda on the Balé Peselang. Painters: Déwa Nyoman Cita, I Ketut Karawan, and team. Date: 1990s. Photographed in 1995.

The Paintings on the Méru Alit
and the Pangaruman

The paintings on the Méru Alit and the Pangaruman were done on panels left blank by the rebuilders of the 1930s. The new paintings are self-consciously in the old style. Those on the Méru Alit are of the Déwa Nawa Sanga, the Nine Gods. The nine deities consist of the eight gods of the directions, plus Sanghyang Siwa. Since there were twelve panels and only nine gods, three spaces were left figureless with blue sky and stars.

The Government Enters the Temple
(1979 and 1991)

Throughout the centuries there have always been a tension and an interaction between social agents external to the *désa* and those internal to it. The members of the *krama désa* have the entire responsibility for their relationships with the *niskala* beings attached to the temple. Yet the temple is not strictly "local"; "foreign" deities come to every ritual, to give homage to Batuan's gods or to witness the respect paid to them by their people, and "foreign" personages also sometimes attend.

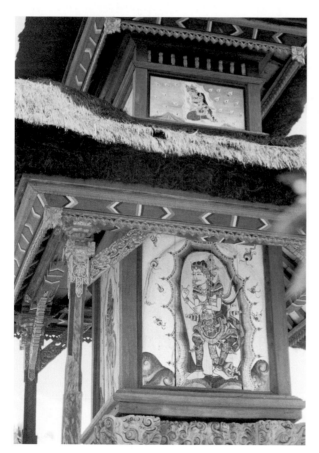

Figure 9.29. Paintings on the Méru Alit. Painters: Déwa Nyoman Cita, I Ketut Karawan, and team. Date: 1990s. Photographed in 1995.

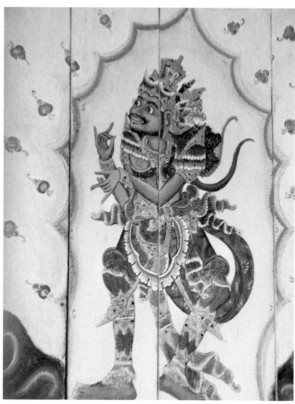

Figure 9.30. Painting on the Méru Alit, rear side. Painters: Déwa Nyoman Cita, I Ketut Karawan, and team. Date: 1990s. Photographed in 1995.

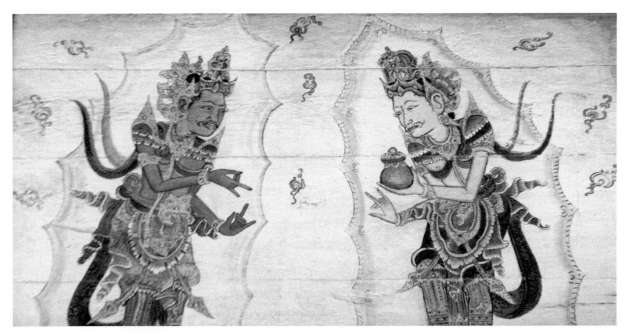

Figure 9.31. Painting on the Pangaruman. Painters: Déwa Nyoman Cita, I Ketut Karawan, and team. Date: 1990s. Photographed in 1995.

At the end of the first millennium, the time of the Prasasti edict, the most powerful king in all Bali of the moment, whose claim to authority had nothing to do with Batuan, paid homage to Batuan's god. There is no evidence that the raja of the Prasasti changed the rituals of Pura Désa Batuan, and the text of the edict lists the villagers' obligations to the king, not those they had toward their gods. Two later noble houses built their palaces right next to Pura Désa Batuan, that of the Klungkung-centered Prince Batu Lépang and that of the house that became Puri Sukawati just to the south, perhaps with the intent of absorbing by proximity some of the *sakti* quality of its deities.

The god of a temple is sovereign in his temple, and only the people of his congregation who worship him can directly influence his attitude toward humans. Any others may of course worship him, but until a formal relationship is set up, their pleas may not be attended to. Therefore, people who are not of the congregation, even if they have power and authority elsewhere, have no authority over those gods, and therefore no authority over the modes of worship of the congregation. However, they may have influence.

When the Dutch took over the governing of Bali, they believed that the well-being and smooth running of its temples were important for the governance of the colonial state. This policy was implemented by the appointment in 1918 of a Dutch architect, P. A. J. Moojen, to organize a restoration of the earthquake-destroyed temple of Besakih and the allocation of government funds toward that task.[18] Moojen surveyed the damage of many other temples, but his recommendations for their restoration were not often taken.[19] At the same time, those Balinese princes appointed by the colonial authorities to head the major principalities, called regencies by the Dutch, met together right after the earthquake to determine that the cause of the earthquake was godly anger over the extreme neglect of Pura Besakih. They then decided to moblize the labor and material supplies from the people of all Bali (the first time

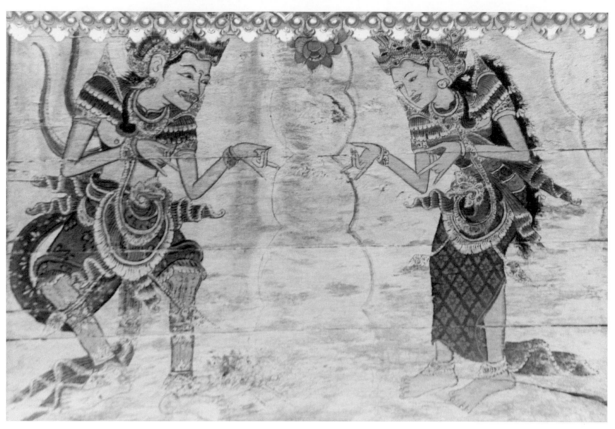

Figure 9.32. Painting on the back of the Pangaruman. Painters: Déwa Nyoman Cita, I Ketut Karawan, and team. Date: 1990s. Photographed in 1995.

such a comprehensive category had been invoked, defined by the new colonial boundaries of one territory within what was now the Dutch East Indies). The Regents of Bali and Gianyar together with the Stedehouder of Karangasem ordered their *punggawa* (the Dutch-appointed district heads) to collect donations from all the citizens of their regencies for its restoration. They made this demand in their capacities as Dutch administrators, in the name, therefore, of the state, not in their capacities as rajas. For the first time there was a bureaucratic state of Bali, and it was empowered to act for a temple.

The Dutch Archeological Service was also concerned with temple restoration. Its purposes had little to do with bolstering Balinese religious practices, but rather with scholarly research into the history of Bali. It was the Archeological Service, not the Dutch government, that first effectively intruded on the inner temple affairs of Batuan. Its strong, enforceable edict, imposed in 1918, prohibiting the villagers from repairing the ritually important West Gate of Pura Désa Batuan, endured until 1991. The Indonesian government, centered in Jakarta, then adopted something of the same sense of state responsibility for religious piety and scholarly data.

Over the decades after the Besakih restoration, the colonial state supplied funds for the rebuilding of some temples. The practice was continued in the post-

colonial period. In Batuan, the rebuilding of the Pany-impanan altar was done with a subsidy from the government, probably both in the 1950s and in 1981.

The organization of the Parisada Hindu Dharma in the 1960s and thereafter was expressly intended to regularize religious observance through setting up a licensing process for *pedanda.* Another governmental entity has been overseeing the writing down of temple regulations, the *awig-awig désa,* a process that was going on in Batuan in the 1980s. The effects of these governmental entries into matters that used to be entirely local are still to be studied.

In this section I will discuss the two major examples of governmental involvement in the carvings of Pura Désa Batuan. The first was a relatively minor contribution, made through the auspices of the Parisada Hindu Dharma. The second is the final rebuilding of the Great West Gate by the government Archeological Service.

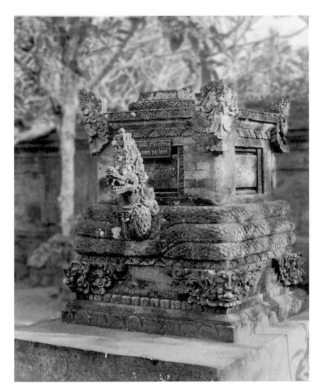

Figure 9.33. The shrine of Sang Hyang Basuki. Carvers: from a nearby village. Date: 1979. Photographed in 1995.

The Shrine of Sang Hyang Nini Basuki

The shrine of Sang Hyang Nini Basuki is a small carved altar, far in the rear of the temple, out of the ritual circle, unimportant today. It was commissioned by the temple, but the conception, design, and impetus for its building came from the Department of Religion, which distributed diagrams for it in 1979. It was funded entirely by the Indonesian central government, and it was not made by members of the village, apparently because it was felt to be "foreign."

The altar commemorates and continues a miraculous event that occurred during the government-sponsored pan-Bali ritual of Eka Dasa Rudra in March 1979,[20] when a pot containing hot cooking oil suddenly was filled with a magical snake, the avatar of Sang Hyang Nini Basuki, who lives at the top of Gunung Agung. (The name of Pura Besakih, which stands high on the slopes of Gunung Agung, is thought to be a version of "Basuki.") The oil in which he lay became a powerful heal-ing lotion. Small portions of that *(enget)* oil, periodically diluted with other oil, were distributed to all those villages who prepared an altar for it, including Batuan.[21] The oil is distributed by the temple priest to anyone who asks for it. However, the Pamangku told me in 1985 that few people avail themselves of this oil, and no offerings are made to it at the Odalan.

The altar of Sang Hyang Nini Basuki is in the form of a stone urn with a lid on the top. The serpent Sang Hyang Nini Basuki is entwined around the urn.

The Great West Gate

After the earthquake in 1917 and the prohibition by the Archeological Service of any restoration of this gate by the people of Batuan, its former site was allowed to be-

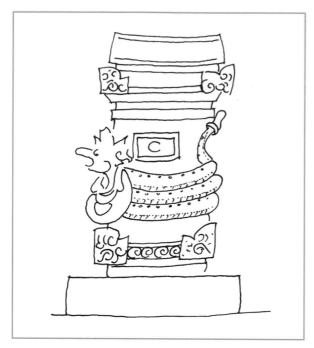

Figure 9.34. Sketch provided by the government for the altar of Sang Hyang Basuki.

come a dense thicket. Though a path through it was always kept open, it was feared as a very *tenget* place, and no one would go near it except during ceremonies. Nonetheless, it remained the most important portal of the temple, the one through which the god-figures on their brightly decorated palanquins were carried out of the temple when they went to the sea for the annual purifying ceremonies. And it was always the gate through which the visiting gods entered for the great festivals.

In 1900, Bendésa Regug, exploiting his many connections with the Indonesian government, finally persuaded the Indonesian Archeological Service (Jawatan Purbakala) to rebuild it. The team of archeologists, under the supervision of Drs. I Madé Sutaba, began work in 1991.

The reconstruction plans and skilled work were provided by the Archeological Service. They also supplied

the stone, a kind that is stronger than the local varieties. Batuan's *krama désa* contributed all the unskilled labor and necessary rituals.

The archeologists digging in Batuan had uncovered the earlier foundations of the wall and gate. Twelve of the stone "buds," which serve as the many pinnacles of the three tiers of roofs, and the larger stone crown that stands at its peak had been found on the surface and preserved. A large fragment of a lintel for the top of the doorway with a head of a demon carved in it had been lying inside one of the smaller adjacent temples. (It had been there for many decades, and I was told that once someone had tried to put it over the door of that *pura panti,* but during the work it had slipped and badly injured, some say killed, the craftsman working on it, a fierce statement that it did not belong there.) Four stone elephants were found among other remains. From these materials, and a hypothetical conception of what the gate must have looked like originally, the archeologists constructed the new gate.

The remaining ancient stone fragments of carvings that were not used by the archeologists in their reconstruction of the West Gate were placed near it on a square cement floor, and today at every ritual small offerings are placed before them. There is an odd squared-off space around the base of the gateway, down about a foot or more below ground level. My Batuan consultants said that it was supposed to represent a lake or sea out of which the mountain rises. But the archeologist later told me that the dropped-down area was there to indicate the original level of the gateway.

The wooden door of the West Gate was new in 1993. The main carvers were I Ketut Ceteg and I Ketut Karawan from Pekandelan, Déwa Nyoman Cita from Batuan Gede, I Ribag from Puaya, and I Wayan Ritug from Tengah. They decided to depict on it four great holy men of Bali: Empu Bharada and Empu Kuturan (on the side facing east) and Gaja Mada and Kebo Iwa (on the western side). One of the artists told me he

found the idea and the model for them "in a book from a hotel."

A modern-looking parked pathway leading up to the gate on both sides was installed, with small electric lamps and fancy shrubs.

On the outside of the new wall next to the West Gate is a stone inscription, painted with gilt, that states

> Suaka Peninggalan Sejarah dan Purbakala
> Bali—NTB—NTT—TIMTIM
> dan
> Desa Adat Batuan
> Peresmian Purna Pugar Gapura Kuno
> Pura Desa/Pusa
> Desa Adat Batuan
> Jumat 15 Januari 1993
> oleh
> Gubernur KDH TKI Bali
>
> [signature]
> Prof. Dr. Ida Bagus Oka

This says that the gate was made by the office of the Preservation of Historical and Prehistorical Remains of Bali together with the Désa Adat of Batuan, and that it was dedicated officially on Friday, January 15, 1993, by the Governor of the Province of Bali, Prof. Dr. Ida Bagus Oka.

While the governor and the Archeological Service took credit for the restoration and authenticity of the West Gate, some of the people of Batuan were worried about it. A number of them told me they thought that the new gateway had not been made with ritual propriety and was therefore not really safe. Despite all of the rituals performed before, during, and after its construction, they believe that the measurements made for it were based on the meter as a unit rather than span of the hand of a man who stood in for all the "owners" of the temple, as is required, a fundamental misstep that basically undermined its validity. The building of the West Gate by the archeologists had been invited by the *krama désa*. Perhaps its leaders had tourists in mind, perhaps they wanted to have a "neater" and more "complete" temple, but most probably they bowed to the larger strength of the government bureaucracy.

I asked an archeologist about the issue of measurements, and he said they didn't lay it out by meters, but followed closely the measurements of the original foundation stones. For those who worship in the temple, "restoration" does not mean recovering the original proportions, but rather renewing the ties between the *niskala* beings who come to the temple and its living human worshipers. For them this new gate, no matter how important it is ritually, is still a foreign installation, more appropriate to tourists than to the gods.

Unknown to the villagers of Batuan, there was some dispute among archeologists about the appropriateness of the design of the new gate. The evidence that they had for its original form was fragmentary and ambiguous, so they used as a model the gateway of the Pura Puseh of Canggi, in nearby Sakah, which was considered by the archeologists to be contemporary with Batuan's West Gate, perhaps in part because it is mentioned in the oral traditions of Kebo Iwa, related in chapter 4. The gateway in Canggi had been restored by the Dutch Archeological Service in 1949–1950. Although the Canggi temple is mentioned in *prasasti* edicts dating from 993 C.E. and 1098 C.E., the archeologist A. I. Bernet Kempers doubts that its restoration represents the Canggi gate as it may have been any earlier than the fourteenth century, and the same might be said for the restoration of the Batuan gate. Bernet Kempers wrote about Canggi,

> The original shape of the roof's top is unknown, the gate's upper part having long since disappeared. Since the building is part of a pura still in use, a stone slab was placed on the top to finish this main gate during the 1950 restoration. (Departing from the Archaeological Service's usual

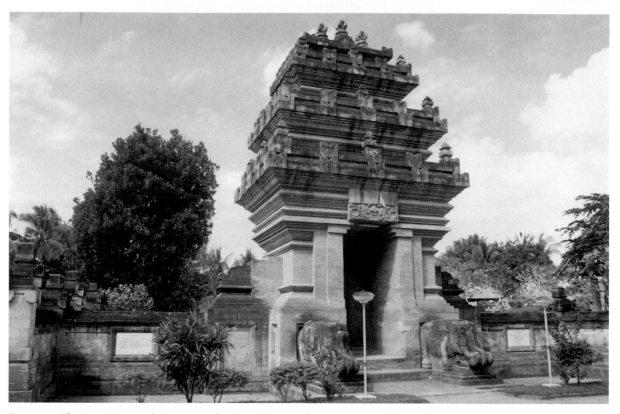

Figure 9.35. The Great Door on the West, as archeologically restored in 1993 (note parklike garden and electric lampposts). Carvers: Indonesian Archeological Service. Date: 1991–1993. Photographed in 1995.

methods [of keeping restorations carefully close to actual material evidence], this addition was made on the analogy of the Gunung Kawi rock-cut *candi*s; consequently this top cannot be used for any dating proposals.)[22]

Historical authenticity was far from the concern of most people of Batuan. I suspect that, had they been permitted to rebuild their gate themselves, they would have designed one that looked more like the two great southern gates, finding them not only more attractive, but also more meaningful, and therefore more proper.

. .

By the end of the twentieth century, the contexts within which the carvings of the temple were fabricated and

viewed had been transformed. The external sources of power over one another's actions had shifted from the regional nobility and royalty to larger new ones, first the colonial and then the postcolonial government.

Within the village, the loci of power and influence over group decisions and, perhaps, tastes had also shifted. For instance, commercial holdings and bureaucratic skills rather than ownership of agricultural land, became the main key to prominence within the village. Where formerly a *bendésa* had been a wealthy farmer who was also able to read Balinese writings and converse with royally sponsored literati, now the *bendésa* was a successful shopkeeper who was able to read newspapers and converse with government officials. At the end of the twentieth century, tourist commerce and burcau-

Figure 9.36. Parklike pathway leading to the Taman inside the Great Door on the West. Right, on concrete platform, a display of ancient fragments of statues. Photographed in 1995.

cratic perquisites entailed a new kind of local leader who had new kinds of skills for foraging materials, and perhaps inspiration, from new kinds of sources. Transformations in the larger contexts entailed the emergence of new kinds of local mediators between village and broader sources of power.

I do not mean to suggest that "traditionally," by which is usually meant precolonial or early colonial Bali, the village temple congregations had been closed communities, with their members planning and building their temples in isolation, to be opened up to strong external influences by the end of the century. On the contrary, even in the eleventh century, the *prasasti* spoke of those local scribes who mediated between the royal court and the villagers.

The profoundly rooted local nature of temple rituals meant that social organization of the congregation remained local too. The main deities, firmly tied, as they are, to their village lands and to their living descendants, require that only the people of their *gumi* may make decisions for them. Even though in recent years there has been some importing of artisans, the raising of certain local people to star status with the signing of their works, greater use of money to replace local labor, and new senses of time affecting ritual schedules, at the end of the century the life of Pura Désa Batuan remained firmly within its own local community.

Interplay between local and regional institutions must always have been important in the ways in which temple carvings were imagined, created, and evaluated.

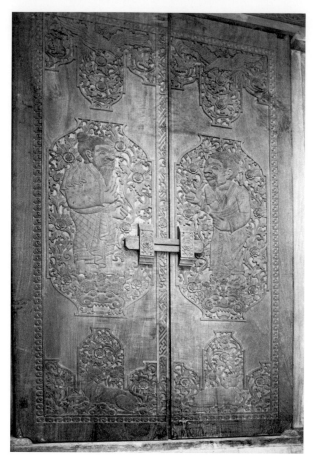

Figure 9.37. The new wooden door to the Great Door on the West. Carvers: I Ketut Ceteg, I Ketut Karawan, and team. Date: 1993. Photographed in 1995.

that was required was a great increase in labor, and that cost nothing. The consequences of prosperity or poverty must have varied at different eras through the history of the twentieth century. In the latter part of the century, when the tourist market boomed in Batuan, it was not so much the increased money supply that made a difference in the temple as the new skills of the artisans, polished through increased practice.

How much the ideational dimension of temple work has also changed and affected decisions, sources of ideas, and images, remains unclear. The Hindu Dharma movement has, since the 1970s, made efforts to change the nature of worship. It has a strong puritanical tone linked to its stress on personal piety and on monotheism. Through its school activities it has taught generations a standard theology that has the potential to change the forms of the temple and its carvings, but, up to now, has not done so. The Hindu Dharma movement has also pushed for greater simplicity in rituals, most particularly those centered on personal transitions, such as cremations, in an effort to make sure that proper rituals are performed for everyone, no matter how poor they are. To this end they have sponsored group cremations, which have become much more common, but the amount of expensive display continues to be great. These efforts are "protestant" in their implications, suggesting a future turn toward purity of worship and simplicity of visual forms. However, this temple has showed no sign of such puritan concerns. Its audiences may now be viewing its arrangements and decorations differently than they once did. Nonetheless, it seems to me that, at least in the 1990s, local conceptions and local execution were still completely in control. The major gods are still the *niskala* beings of Batuan itself, although the other deities are given their due. The local social institutions that govern, or at least constrain, the imaginations of the village builders and carvers have been modified by the increased population, by literacy, by new modes of record keeping, new

However, how this worked was never simple. For instance, when one looks for effects of changing socioeconomic contexts, shifts in local prosperity come immediately to mind. Yet the poverty and isolation of the immediate postwar years did not prevent a major push toward restoration as soon as the Japanese left. Everyone in Bali experienced great deprivation at that time, yet important renovations were accomplished, using entirely local materials and labor. The rock, quarried from the ravines nearby, the bamboo and wood, the food for the workers did not need to be purchased. All

sources of temple income, new notions of democratic participation. But they remain unmodified in their religious underpinning and their fundamental form.

The product of all these kinds of work—Pura Désa Batuan—can be seen as a record of a historical sequence of acts and events in the course of which the various parts of the temple were made, acts of making, viewing, correcting, appreciating, and so on. Any study of temple carvings must recapture and understand those events and reconstitute the circumstances within which each new set of carvings made sense and gave pleasure to their makers and viewers.

Afterword

I stopped in at Pura Désa Batuan in July 2000 to check a few last details, and I met the latest *bendésa*. A young man, he was yet another art shop owner, a relative of I Regug. He said he remembered watching me taking notes in the temple and talking with his uncle when he was a schoolboy. He readily gave me permission to take some more photos and then asked me to help him make a brochure in English to hand out to tourists. He had read an article I had published in 1986 in the *Bali Post* about the way Pura Désa Batuan had been in 1022 B.C. in a scrapbook that I Regug had made in 1986.[1] When he asked me to write the brochure, I remembered how various Batuan people had remarked to me that my publications would make good promotion material for the tourists, and the thought reminded me that tourists' eyes must have been much on the minds of the makers, at least in the 1980s, if not in the 1930s.

On that day in July 2000 the temple was sparkling with new bright colors and gilt paint and busy with people, even though no ceremony was in the offing. It seemed to me to be a triumphant vanquishing of the devastations of time—earthquakes, fungus, mold, tropical storms, and searing sun. Groups of tourists wandered through, dressed in sarongs and sashes rented to them by the temple committee, brought in by buses

on their way to the big art shops on Batuan's main road. Pura Désa Batuan had become in two decades a major tourist destination.

At the time I began this research on the temple in 1983, tourists were brought to Pura Désa Batuan only during ritual festivals to watch the preparations, worship, and dances. There were none there at other times, and the temple itself was not yet painted up, looking in its quiet dustiness like most other temples in Bali.

I stressed in the first part of this book that the carvings and architectural forms were made for the pleasuring of the *niskala* beings of Batuan, but the events recounted in its second part show clearly that other, human, eyes were also played to. From the early 1920s, when the whole spatial orientation of the temple was shifted toward the main road where traffic from other villages passed daily, to the 1980s, when monumental statues were erected straddling that road, the makers themselves were thinking also of viewers coming along it to Batuan from neighboring villages and court centers, of political leaders and even perhaps of foreign tourists.

Niskala beings remain, of course, the main audience for most of the makers. In the absence of institutions for the explicit expression of critical opinions—either theological or secular—the makers of the temple have had to rely on their own imaginations and convictions to decide what would appeal to these various human and nonhuman populations. Without such critical apparatuses, the audience responses of the tourists or neighboring villagers, no more than the deities, could not be known. The makers of the temple, as before, have to rely on their own conceptions of the desires and pleasures of the viewers.

What their imagined viewers might want is still, potentially, a subject for difference or even controversy. Indications are that grounds for argument of the sort that surfaced in the 1950s and 1960s between the commoners and the Triwangsa continue to exist. Newspaper reports in late 2001 showed that the hegemony of the Brahmana priests at the provincial level was now being challenged in the name of "democracy."[2] A layman, rather than a Brahmana priest, was chosen as head of the executive body of the Parisada Hindu Darma council, the quasi-governmental director of all theological schools. Recommendations to the new council included one that asked for provision of services to all elements of the Hindu community regardless of sect, caste, or school of thought, implying that certain elements have been in the past undemocratically excluded. Another one asked for an elimination of the "caste system," which here meant giving up various privileges of the Brahmana priests, notably their authority over local rituals, and allowing certain commoner heads of sects a measure of temple authority. The Hindu Dharma doctrines of cosmic harmony and of stone images as metaphoric of rather than direct stand-ins for *niskala* beings, which never were important directives for the work of the architects and sculptors of Pura Désa Batuan, were, for the first time perhaps, being openly called into question in the twenty-first century.

I have tried in this book not to ignore complexities of that sort. The historical approach that I have followed has constantly corrected my tendencies to oversimplify for the sake of conceptual propositions, helped me to resist looking for some timeless essence of "Balinese culture." It has aided me in questioning my impulses to ignore certain phenomena in order to achieve more elegant formulations. Taking any item or activity as an example of a generalization that I have myself dreamed up, setting up comparisons that Balinese do not make is impoverishing. At the same time, I have attempted to avoid the opposite historicist extreme of ignoring evidence of the use by the people studied of enduring and pervasive cultural frames that override the blips of contingency, power maneuvers, economic calculations, and theological differences.

Foremost among the larger cultural frames that I

have attended to is the notion of *karya* or "work" in its two aspects. The first, discussed in chapter 2, is material: the physical labor, the technical artistry, the social collaboration of gathering materials and skills, and the organization put into a project. The second, discussed in chapter 3, is spiritual: the service and homage paid to the *niskala* beings that pervade the village. Service can be a demonstration of the glory of those beings and, correspondingly, of the safety and strength of the temple community. By means of temple work the constant threat of the destructive anger on the part of the *niskala* beings—which could release not only all sorts of natural disasters but also the malevolence of local human sorcerers—may be dispelled. This threat is rarely mentioned or depicted, yet it is understood as the pervasive primary context of the temple rituals. Various indigenous understandings of the local, indigenous notions of context and purpose of temple work have been interwoven in my narrative.

Another kind of "work"—one that has both indigenous and nonindigenous recognition—is the work of interpretation and evaluation. Balinese modes of exegesis, from literary mystical exegesis of the meanings of the Padmasana to popular references to folktales and dramatic plays, were explored. To these I added my own analysis of those meanings embodied in ritual acts that have not been singled out by the figurative interpretations made by Hindu Dharma theorists.

The interplay among these notions of "work," theirs and mine, exemplify the struggle I have had with the dilemma of describing indigenous matters in my own nonindigenous terms. Not only have I tried to comprehend Balinese cultural frames and put them into English words, I have constantly questioned my own cultural frames and my own definitions of context and purpose. I've experienced an expanding awareness of the nature of my own interpretive work. As in this analysis of some concepts subsumed under the terms *"karya"* and "work," the discourses available to Balinese and to me are intermingled, as indeed they were entangled in our talk, as they spoke of *cahaya* and *idup* and *sakti* and I thought about beauty and vitality and effectiveness, as they spoke about *seni* and *mode baru* and I thought about prettiness and tourist attractiveness.

I have paid attention not only to implicit cultural definitions of ritual practices but also to evidence of the exertion of particular kinds of social power over them —for instance, the constant pressure of commercial interests to convert the temple into a tourist attraction and the control by the central government over the form of the ritually important West Gate. I looked also for evidence of the creative changes brought about by social agents, both collective and individual, in the decisions made by the various *bendésa* and by individual sculptors, such as Déwa Nyoman Cita. An agent-centered history seems natural to anyone who attempts an account of the "art" of Bali, yet it has been necessary to scrutinize not only the acts and imaginations of the people involved in the events of the temple's building and rebuilding but also the complex cultural conceptions of agency.

In sum, my approach has been fieldwork generated (its limitations of chance circumstance somewhat corrected by its duration), discourse guided (listening not only to "them" but also to my colleagues; examining not only intentions but also evaluations), agent centered (looking not only at expressive but also performative acts), context sensitive (both immediate and removed), and above all historical (in sources, methods, and evidence).

As I have shown in chapter 6, my own commonsense notion of "art," culturally enmeshed though it was, provided me usefully with a heuristic ready-made scholarly purpose—to seek out extraordinary material objects (that is, visible objects) that had been made with artistry and imagination—but it did not carry me very far. I have concluded that there need be no special anthropological theory of art and no particular meth-

ods for its study. "Art" for me is no longer an appropriate ethnographic category under which to subsume the temple and its carvings. A vague and polysemic term, "art" usually refers to some specific kind of pan-human activity together with its products and the norms invoked to evaluate them. The term is a complex product of Western history and of the development of art-connected institutions, such as museums, markets, and art criticism, and is too specific for cross-cultural comparisons.

John Dewey provided the epigraph at the beginning of this book, and his general support for discovering the pragmatic nature of most human action has helped me. But for all his resolution to see "art" as a human activity, as a form of human experience in the midst of action, nonetheless he assumed that the making of "art" is, in the end, a unitary and universal mode of action uniquely marked by the intensity of its expressiveness. For Balinese, the making of the temple, while it required extraordinary levels of work, was never unusual. For them, *niskala* beings are everywhere, not just in the temple, and all acts, even the most mundane, are made in full awareness of their presence and co-sociality. Therefore the work that they did in building the temple was profoundly ordinary.

Dewey's dictum that "we must arrive at the theory of art by means of a detour" tells us to go off the main highway temporarily, but my own work suggests that there is no golden city of a theory of "art" to arrive at, whether by detour or by royal road. Instead, I found myself wandering through a tangle of intersecting streets and paths, exploring busy crossroads and quiet culs-de-sac of everyday existence to find some of the meanings of the temple and its variegated life.

Notes

■ ■

Preface

1. 1980:4.

2. Clifford 1988b:198. The word "religion" is another good example.

3. For introductions to Balinese culture and arts see Lansing 1995 and 1983; Ramseyer 1977; Eiseman 1989 and 1990; and Hobart, Ramseyer, and Leeman 1996. Every attempt to summarize and epitomize Balinese discourses and practices has been criticized by subsequent scholars for oversimplifying or misconstruing, and the above are not exempt. For introduction to aspects of Bali's social organization, see C. Geertz 1964 and H. and C. Geertz 1975. For writings on "the" Balinese temple (a frustrating mirage), see Lansing 1983, 1991; Ramseyer 1977; Covarrubias 1956: chap. 9; Goris 1960, 1960; Ramseyer 1977; Lansing 1983. Studies of particular temples include Stuart-Fox 1987 and Schulte Nordholt 1991b.

Chapter 1: A Temple and an Anthropologist

1. For some results of my study of Batuan's paintings, see H. Geertz 1994.

2. I had thought of Batuan's temple as containing significant artifacts that could not be commodified or collected. But this proved not to be entirely so. With the advent of Westerners, architectural drawings (by Nieuwenkamp after 1904) and photographs (by Moojen after 1917) began the process of circulating images of temple carvings. In the 1930s Walter Spies designed and helped build an architectural museum, consisting of examples of temple forms from all over the island. As for commercialization, by the 1950s concrete mold-cast altars and gates were commonly on sale, but not in Batuan.

3. Gell 1992:42.

4. Bakhtin 1981.

Chapter 2: Those Who Carry the Temple on Their Heads

1. On the term *"kaiket,"* or "tied to something or someone," see Lansing 1974.

2. The base form of *"nyungsung"* is *"sungsung,"* "to be carried on the head." Most Balinese terms for actions have a base form of this sort, which is almost always in what might be called a "passive" tense or a "nounal" form, to which a prefix may be added that makes it "active" and "transitive." A base that starts in "s" will be made active with "ny-," one that starts in "t" or "d" will be made active with "n-," and ones that start with "k" or "g" or no consonant will be made active with "ng-." The terms in the next paragraphs, for instance, have both "active" and "passive" forms: *"ngéling"* comes from *"éling,"* "to be remembered."

3. Balinese words and expressions are commonly tagged as "high" versus "ordinary" or by other terms for the many

"levels" of speech. Since words of various levels usually appear side by side in a single utterance, the term "register" is perhaps preferable. Barber (1979), whose dictionary is the most careful in this regard, makes the following distinctions: High, Low, Middle, Court, Refined, and Kawi. But even more subtle distinctions can be made in practice. What is important to a translator into English of any phrase in a text is the fact that choice of register indicates the person spoken to, the person speaking, and the person spoken about. This is semantic burden that should not be lost. Thus, when deities are addressed or spoken about, the high Balinese register of every term must be used. In my translations of such terms I use the locution "to or about a respected person" to indicate that they are high in register. For instance, a word indicating the relation between deity and worshiper is *"druwé,"* meaning "that which is owned"; but since it is a very high register, deriving from the highest register of all, the Kawi term *"duwé,"* it also means "that which is owned by a person of high status." When *"druwé"* is used in a sentence about the temple and its gods, it is not about the human beings who "own" the temple but the deities who "own" the human beings (Degung Santikarma, personal communication). Likewise, the term *"ngayah"* comes from *"ayah,"* "service to a higher person," indicating that the work is done for a king or a deity.

4. The population of the *désa dinas* (or administrative village) of Batuan in 1983 was about 8,400, but that included ten *banjar* whose members do not worship at Pura Désa Batuan. I estimated the population of the *désa adat* (the community that supports the Pura Désa) in 1983 at 4,700, including the gentry (who number about 1,000.) In considering the work on Pura Désa Batuan, a better statistic is the number of heads of families *(pangarep,* or in Indonesian, *kepala keluarga,* or *K.K.)* who were members, with their wives or other partners, of the temple. In 1980s, this was about 625, whereas in 1916 it was only 400. These numbers should be doubled, since each represents a couple, to get at the temple's workforce, thus 1,250 in the 1980s and 800 in 1916. During much of the rebuilding of the temple in the 1920s and 1930s the workforce was somewhere in between those figures, that is, about 1,000 men and women (Karang 1983; Ballot 1916).

5. Whether or not Batuan should be called a "peasant village," as I call it in the subtitle to this book, is certainly debat-

able. While the term, however defined, probably fits at the beginning of the twentieth century, by its end, as described in chapter 9, it is questionable.

6. For the political economy of precolonial Bali, see Schulte Nordholt 1988 and van der Kraan 1980, 1995. For colonial Bali, Schulte Nordholt 1991a, 1991b. For postcolonial Bali, Robinson 1995, Warren 1993, Picard 1996.

7. On kinds of temples and their relation to social organization, see H. Geertz and C. Geertz 1975; Goris 1960a, 1960b, 1960c, 1960d; Grader 1960a, 1960b; Lansing 1983, 1991; and Stuart-Fox (1987). The terms for temples and for their supporting groups vary in Bali. I translate by "clan," very loosely, such terms as *dadia, soroh,* and *panugeran.*

8. The term *"banjar"* can also be differentiated into *banjar adat* and *banjar dinas* when the situation requires precision.

9. There are always two kinds of supporters of a temple, core members and peripheral ones, a distinction made everywhere in Bali but called by various different terms. The term derived from *sungsung, panyungsung,* is in many places confined to those supporters who give only partial contributions and visit the temple mainly for prayer, while the core supporters are usually called *pangempon, pangemong, pamaksan,* or *pangarep.* The *pangempon* are required to contribute in full, while the *panyungsung* need contribute only as they themselves choose. See Pitana 1997:236.

10. See Warren 1993 for detailed analysis of the functioning of the *banjar* councils in a nearby and similar village, also in Gianyar, together with illuminating case studies.

11. The Pura Désa Batuan congregation was 625 in 1985. Its *banjar* were grouped into four *témpek* (Puaya, Jeleka-Tengah-Pekandelan, Dentiyis-Dlodtunon, and Jungut-Peninjoan). At some earlier period there were only two *témpek,* but they were multiplied when the population grew. Banjar Gedé, which consisted, after Pekandelan split off from it some time in the 1960s, entirely of Triwangsa, was not a member of the temple but rather a government *banjar dinas.* In the 1970s Gedé again split into three: Gedé, Geriya, and Buda, consisting respectively of Satria, Brahmana Siwa, and Brahmana Buda, all *banjar dinas.*

12. Since *banjar* constitute work groups for periodic ritual-related activities for the Pura Désa, it has been suggested (even by me, in 1975) that the *banjar* are the secular arm of

the sacred entity, the *désa,* but this is incorrect, for the work done is "religious" as well. The *banjar* organizations are also important in carrying out death rituals, which are not the concern of the *pura désa,* and each one has its own small temple (or at least an altar) for the gods of its territory. There has been some scholarly discussion about whether the *banjar* are divisions of the *désa* or the *désa* a collection of *banjar.* See H. Geertz and C. Geertz 1975:16–17, Guermonprez 1980, Ottino 2000, Warren 1993. The earliest account of Pura Désa Batuan (of 1022 C.E.) does not mention *banjar.* The population was much smaller then.

13. On Bali's complex ritual calendars see Goris 1960c, Eiseman 1989.

14. The kinds of priests in Bali are much more numerous than this account suggests, and the ritual roles that they carry out much less standardized. What I say here is sufficient for a description of the situation in Batuan. The Parisada Hindu Dharma organization has, ever since its formation, attempted to systematize the process of priestly appointments, and in so doing has introduced new distinguishing terminology. A *pedanda* falls in the category of *sulinggih,* who officiates at high ceremonies, while a *pamangku* falls in the category of a *pinandita,* who officiates at lesser ceremonies. These broader categories have been devised to take into account other kinds of priests *(jero kubayan, jero gedé, mangku dalang, jero balian, prasutri, sri mpu, rsi bujangga, rsi,* and *dukuh).* The *tirta* formed during a ritual of a *pinandita* is lower than that of a *sulinggih.* The preparation and training of a *pedanda* is much longer and more arduous than that of a *pamangku,* and after a *pedanda* is consecrated, he or she may no longer carry out worldly activities, while a *pamangku* may continue any economic activity he or she wants. A *pedanda* may come only from the Brahmana group. For a partial account of these differences, and the current controversies concerning them, see Pitana 1997:28.

15. The *pamangku* of the temple that Belo (1953) studied, although very elderly, always did all tasks that involved direct contact with the gods.

16. H. Geertz and C. Geertz 1975:30–31.

17. See M. Hobart 1975, 1979; Warren 1993. Hobart's field research, on which he based these statements, was in 1970–1972, while Warren's was from 1981 to 1991. Both worked in Gianyar, in villages similar to Batuan.

18. See Warren 1993 for an analysis of some of these intravillage conflicts.

19. For other studies of the building of Balinese houses and temples, see Howe 1983, Kagami 1988, and MacRae and Parker (2002).

20. This measuring process is called *nyikut karang* (from *sikut,* "to be measured," and *karang,* "enclosed land"). It is also referred to as *ngukur* and *nyikat,* the last in the high register, indicating that it is done by or for a person of highest rank.

21. This is according to Hinzler (1995) who studied some of these *asta kosali* texts. Howe (1983) reports that the carpenters he studied did not refer to written sources. Hooykaas has published a number of texts that *pedanda* may have read or written (1964, 1966, 1974). However, no one has yet done a detailed study of the practice of *pedanda,* how they read their texts, and what they do, say, and know.

22. The secrecy of the contents of the *lontar* that give mantra and ritual actions has been preserved through a formula warning at the end or beginning of such texts. It says *aywa wera!* (Do not reveal [these secrets]!). The implied threat is of sickness and death to anyone who is insufficiently prepared for intimate contact with deities and demons and with the knowledge of how to reach them. This restriction on dissemination of mystical or ritual writings has been challenged in recent years by intellectuals who advocate open publication. Perhaps these people don't accept the "commonsense" view of the danger of traffic with invisible beings.

23. Today, the *bendésa* and *prajuru* have homemade notebooks, which contain lists of all the *banten* needed, to guide them in preparing for ceremonies. These lists of *banten* and their ingredients are a sort of shorthand to describe the ceremonies. Most of what the laymen running the ceremonies know about the ceremonies may be incorporated in these lists. This language of offerings contrasts with the literati language of published books about Balinese rituals. For instance Pudja 1985 hardly mentions offerings. See Brinkgreve 1992 for a study of offerings and offering makers together with some great photographs of masterpieces in the art by Stuart-Fox. For an interpretation of the meanings of offerings by an educated Balinese woman see Putra 1983 and 1987.

24. On Balinese theater see Bandem and deBoer 1981, Boon 1990, deZoete and Spies 1973, Emigh 1979, A. Hobart 1987, Jenkins 1994, Vickers 1986, Zurbuchen (1987).

25. See McPhee's account of the organization of the music for the *gamelan gong,* which is layered or segmented according to instrument groups. The metallophones carry the melody, and very young people can do them. Other instrumental groups perform other musical functions, which are increasingly difficult to play. Each group memorizes only its own part. The drummer knows almost all parts, and teaches each group its part (McPhee 1966:63).

26. Becker 1982:35.

27. Ibid.

28. Alsop 1982.

Chapter 3: The Purposes of Pura Désa Batuan

1. Studies of "Balinese religion" include Belo 1953; Brinkgreve 1992; Connor 1986a; Eiseman 1989; Goris 1960a, 1960b, 1960c, 1960d; Howe 2001; Lansing 1983; Mershon 1971; Neuhaus 1937; Pitana 1997; Stephen 2001, 2002; Stuart-Fox 1982; Swellengrebel 1960; Vickers 1984, 1991.

2. For a history of the Hindu Dharma movement see Bakker 1993. For accounts of Balinese thought in the 1950s, see Swellengrebel 1960:68–76, C. Geertz 1973:170–189. Leo Howe's perceptive study (2001) of Hinduism in Bali appeared after I finished writing this book. He chose the term *"agama Hindu"* for the movement I call "Hindu Dharma."

3. Bakker 1993:39–44. John MacDougall has written an unpublished history of the relations of Western Theosophy to Balinese theological thought. Some of those who turned to Indic theology in the 1950s were Ida Bagus Mantra (who later was an important part of the Hindu Dharma movement and the governor of Bali) and Nyoman Suwandi Pendit, who both studied at Tagore's school. Also studying in India were Gedé Pudja, Ida Bagus Oka Punyatmadja, and Cokorda Rai Sudharta (all of whom later taught and published in the Hindu Dharma vein) (Bakker 1993:102).

4. Wiana et al. 1985:1 (my translation).

5. Ibid., 1–3 (my translation).

6. Ibid. The *lingga,* as a form, is rarely found in modern Bali, and the *candi* form is employed mainly as a model for gates. Both are more common in Java.

7. Jensen and Suryani 1992:27. Suryani writes with the authority of a native Balinese and as well that of an anthropologist and psychiatrist who has both studied and treated many mentally disturbed Balinese. The phrase *tri hita karana* ("the three sources of well-being" is only one translation of a phrase used by Balinese writers with a variety of meanings) was first used in 1966, in a statement by the Parisada Hindu Dharma (Stuart-Fox 1987:28).

8. Jensen and Suryani 1992:27.

9. Puniatmaja n.d., vol. 20, p. 1.

10. The writer is Swellengrebel, who was a Christian missionary in Bali in the late 1930s and again in the 1940s and 1950s and a Durkheimian in his anthropological training. The Christian teachers in the Singaraja high school may have discussed these matters with their young students who later became an important part of the emerging Balinese intellectual community. There may be an intricate history of mutual influence between the latter and some of the influential Western scholars. See also the writings of the time by Goris (1960a; 1960d). Other Western writings whose conceptions of Balinese religion are similar to those of the Hindu Dharma movement are Ramseyer 1977; Hobart, Ramseyer, and Leeman 1996; Stuart-Fox 1987; Lansing 1974.

11. Swellengrebel 1960:53.

12. Ibid., 36.

13. See Bakker 1993:232.

14. See Tan's analysis of the layout of the Balinese houseyard, based apparently on Swellengrebel's model (Tan 1967) and Boon's criticism of Tan's "substantivist, even 'territorial' assumptions about cosmology and space" (Boon 1990:81–82). See also Covarrubias 1956:88 and Gelebet 1981–1982.

15. *"Kaja"* and *"kelod"* are often translated as "north" and "south," but this is incorrect. *"Kaja"* probably means more precisely "up the ridge." Stuart-Fox found a group of temples on the west slope of Gunung Agung that were not oriented toward the peak of the mountain, but rather merely uphill. The slope of the mountains right there was disturbed and irregular so that "uphill" was not the same as "toward the peak" and in a situation of choice the temple builders

had oriented their worship upward instead of mountainward (Stuart-Fox 1987:118). In Batuan, *kaja* happens to be north, actually only a few degrees away from the compass direction.

16. It was probably Goris who introduced the notion that *kaja* and *kelod* represent a heaven and a nether world to the Balinese. In his essay "The Religious Character of the Village Community," he first translates *kaja* and *kelod* quite correctly as "higher than the village" and "lower than the village," but then on the next page, with no explanation or justification, he transforms them into "the upper world" and "the nether world" (Goris 1960c:85–86). See also Swellengrebel 1960; Tan 1967; Lansing 1974; Stuart-Fox 1987; and Hobart, Ramseyer, and Leeman 1996 for examples of a stress on the cosmic-ethical implications of the *kaja-kelod* axis. For critiques of the Swellengrebel and Goris interpretations see Lovric 1987:48–51, M. Hobart 1990, and Wiener 1995. James Boon in 1977 early voiced suspicion that images of an orderly cosmos are, for Balinese, neither to be understood as ideals nor as the actual condition of life (Boon 1977:191–192, 204–205).

17. My sources on the activities of *balian* are primarily Connor 1986a and 1986b but also McCauley 1984, Lovric 1987, Wikan 1990, Ruddick 1986, and my own experience.

18. Connor 1986b:79–80, 112–119, 150–164.

19. Ibid.

20. Connor 1986b:59.

21. Connor 1986b:70–71; see also 72.

22. See H. Geertz 1994, especially chapters 3–5, where I give an analysis of the capacity to communicate and negotiate with *niskala* beings, the ability that is sometimes called *sakti*. In one tale, *sakti* is said to be "the power of the gods themselves" (83).

23. Despite the pervasive concern with sorcery or witchcraft in everyday life in Bali, many scholars have assumed that these ideas and practices are peripheral to the "real" Balinese religion and have dismissed them as not directly related to the higher matters addressed by priests in temples. Acts of "black magic" are, in Balinese common sense, manifestations of the powers of the deities, and as such their meanings are integral to temple worship. I would even argue that, to most Balinese, the gods themselves are very like great sorcerers, different from human beings only in the much greater extent

and effectiveness of their abilities. These ideas were presented in my *Images of Power* and an unpublished paper titled "Sorcery and Social Change in Bali: The *Sakti* Conjecture" (H. Geertz 1995) distributed at the 1995 international conference of the Society for Balinese Studies "Bali in the Late Twentieth Century."

24. Connor 1982:6.

25. My analysis of the temple rituals of Pura Désa Batuan holds for the 1980s. It is based primarily on studies of particular ceremonies in which I not only participated, but also took careful notes on and conducted interviews about, especially during the years 1985–1986 and 1988.

26. I capitalize terms such as Odalan when I refer to particular ceremonies such as those performed in Pura Désa Batuan, and write them in lower case, italicized, when I refer to fairly general practices in Bali. The same convention holds for the word for "temple priest": "the Pamangku" of Batuan is a particular person, as against *pamangku*, meaning priests in general.

27. In addition there is an annual special one-day ceremony, also called an *odalan*, dedicated to the deity Sanghyang Aji Saraswati, the goddess of learning and the arts, who enters the set of sacred texts on copper tablets that are a sort of charter of Pura Désa Batuan (discussed in chapter 4). Also significant are the many smaller rituals performed in the temple in which the gods are addressed but are not expected to materialize themselves. These include the prayers of the islandwide festival of Galungan and those of the many *rahina* (the "holy and dangerous days," especially Kajeng Kliwon, Buda Cemeng, Purnama, and Tilem).

28. For descriptions and interpretations of *odalan* see Belo 1953; Hooykaas 1977; Covarrubias 1956:271–275; Stuart-Fox 1987; Eiseman 1989; Grader 1960a; Goris 1960c, 1960d. None of these descriptions is complete, and further research is needed.

29. In the Western scholarly literature, the *odalan* has been taken as "the" definitive temple ritual, the one that sets out the primary frame within which temple forms should be understood. This is a serious error in that it overlooks the complementary ritual, the *taur kasanga* series, which also requires the emergence of the gods of Batuan and also takes place

largely within the temple. Every scholar-visitor to Bali has participated repeatedly in *odalan,* but, since the *taur kasanga* occurs only once a year, in the spring when few foreigners are about, it is not as well known. I base this description on my own observations in 1986, on interviews conducted then and subsequently, and most of all on the insightful report (unpublished) on his fieldwork on Batuan's Taur Kasanga, prepared at my request in April 1997, by the Balinese anthropologist Degung Santikarma. The two published studies that I know of are by Goris and Grader (Goris 1960b, Grader 1960a). Writings on the Eka Dasa Rudra, an islandwide ritual centered at Besakih in 1979, have been helpful, for it was an enlarged *taur kasanga.* These include Bagus 1974, Lansing 1983, and Stuart-Fox 1982.

30. The *taur kasanga* has not been studied as well as the *odalan* in part because it is classed as a ritual addressed only to demons and also, I suspect, because early Western scholars considered its central ritual act as merely a step in a sequence of ceremonies leading up to Nyepi, the day on which all Balinese are supposed to stay off the roads, light no fires, do no cooking, and make no noise. Foreign scholars—and some Balinese writers—have taken to referring to the whole three- or four-day ritual as Nyepi, thus playing down its central ritual acts, the presenting of offerings to the gods and demons, first at the sea and then within the temple, in the *taur kasanga* itself. The abstinence on Nyepi is merely a minor final ritual step. If one term must be chosen to stand for the whole series of rituals of the ninth month, I think it preferable to call it, as the temple officials do, Taur Kasanga rather than Nyepi. Why Western scholars chose to center attention on Nyepi is unclear. Perhaps it is because a day of quiet and staying at home is, to foreigners, extremely odd, since Balinese are so busy on all the other days of the year. See Bateson and Mead 1942:1–2, Covarrubias 1956:277ff.

31. Every ritual festival that I have attended in Batuan has been slightly different from previous ones, depending on which elements in the ritual were considered by the current organizers to be dispensable, which Brahmana priest was consulted, which dancers were available, how much energy and materials were available, and so on. Thus besides the famous regional diversity in rituals in Bali, there are also, within any locality, short-run historical variations because each ritual event is a particular communication with particular gods in particular circumstances.

32. To perceive the more general patterns in any of Bali's rituals, one must be sure to stretch one's account of the scope of each ritual to include its first beginnings and its last endings. The Odalan, for instance, begins a month earlier than the actual day of the offering and goes on from one to seven days after it. The Taur Kasanga begins at least a day before the actual presentation of the *taur* with the making of offerings at the sea in the presence of all the gods of Batuan, and, in Batuan, at any rate, can be considered to have begun three months earlier with a similar worship at the sea in the sixth month. It is more precise, therefore, to refer not simply to an *odalan* but to the *odalan* series, not to a *taur kasanga* but to the *taur kasanga* series, each a complex sequence of rituals named by their central act. Similarly, the researcher in search of more general patterns must include linked rituals from a larger geographic spread than the interior of the temple itself. This is important in both an *odalan* and a *taur kasanga.*

33. I give the full title before the proper name of each deity, following Balinese customs of respectful speech. "Ida" not only means "he" in the high register, but is also a title, as is "Ratu," which means "king." "Betara" means "lord god" (and in Sanskrit can mean "great man"). "Sanghyang" means "the holy one."

34. This distinction between Betara Puseh and Betara Désa, with the former considered as the god of the place and the latter as ancestors of commoner first settlers, is the reverse of that reported elsewhere, for instance in Jane Belo's account of the situation in Sayan (Belo 1953), where Betara Désa is the god of the place. However, I've checked this again and again in Batuan. The same terminology was reported by Mead and Bateson in their field notes of the late 1930s. See also Warren 1993:20.

35. Goris (1960c:84–85) gives the "three temples" translation.

36. Exactly which three gods count as "the" Kahyangan Tiga seems to vary in Bali from place to place. Some say that they are the gods Désa, Puseh, and Balé Agung, while in most places they are the gods Désa, Puseh, and Dalem. For those, especially those in the Hindu Dharma movement, who see the Hindu Trinity as the godhead, the Kahyangan Tiga are Siwa, Brahma, and Wisnu. It may be that the Balinese stress

on these trinities (as an interpretive frame for their ritual practices) is relatively recent, probably starting as late as the eighteenth century and certainly given a strong push in the middle twentieth century by the Hindu Dharma movement.

37. There is also another *pura dalem* in Batuan, called Pura Dalem Puri, which serves the noble population of Batuan and also of two neighboring *désa* of Sukawati and Sakah. The god of this noble *pura dalem* must have attended ceremonies in Pura Désa Batuan before 1966, but no mention is made of him today.

38. These are the kinds of temples I called *pura dadia* in *Kinship in Bali*. They are also called *pura pamaksan*.

39. I call them "the Barong" following Western usage, but the Balinese do not, usually referring to these *niskala* beings by their proper names or titles. Many, of course, in speaking with Westerners, use the term *"barong,"* which, however, means only "mask" and does not necessarily refer to the spirit being itself. There are many other kinds of *barong* masks in the shape of tigers, boars, and the like which may be entered by many different spiritual beings. The Western usage refers only to *barong két* (the dragon), which may have been first introduced in Bali as recently as the end of the nineteenth century (see Bandem and deBoer 1981). It is instructive to realize the historicity of a ceremony that Balinese take to be timeless. On the *barong két* in general see deZoete and Spies 1973, especially chapter 3; Belo 1960; Eiseman 1989:293–321. The Batuan *barong két* are each accompanied by one or more *rangda*. The term *"rangda"* likewise is a word not for the name of a *niskala* being but for a type of mask, the fanged "witch" with long, hanging breasts and ropelike hair. When a *rangda* mask is the possession of a *pura dalem,* it is entered by Durga, a transformation of Siwa. But in the cases of the two Barong from Puaya and Peninjoan, the beings that enter the *rangda* masks are considered followers *(pangiring)* of the Barong.

40. The members of the *krama désa* of Pura Désa Batuan take most responsibility for the rituals and economic upkeep of Pura Lumbungan. However, the Pura Lumbungan also has a congregation of its own, the people who own land in Subak Batuan Dauh, just to the south, and Subak Sakah, immediately north of Pura Désa Batuan. For them it is their *ulun swi* or *ulun carik* (temple on the upper edge of the rice field). It is unusual to have an *ulun swi* linked so closely to a *pura désa.*

See Lansing 1991 for a study of *ulun swi* and other "water temples." The members of the two rice-field groups bring offerings *(mapinunas)* to the Pura Lumbung at various stages in the growth of their rice. Although most of the nobility have been excluded from Pura Désa Batuan, when they are members of these groups, they are not prevented from bringing offerings to the Pura Lumbung. The confusion and conflation of the two represented by Batuan's Pura Lumbung may be the residue of an ancient situation where there was only one *subak* (irrigated area drawing from a single source of water) near Désa Batuan.

41. These networks of holy water supplies for temple rituals are evidence of involvement of even more gods in each local temple's ceremonies, as Lansing first pointed out (1991). Scholars who have worked on regional relations among temple gods are Reuter (2002), Hauser-Schaublin (1997), Ottino (2000), and MacRae (1997). They should be studied further.

42. In *Kinship in Bali* (1975) I termed the *pasimpangan* and *penyawangan* altars "way stations."

43. In many other parts of Bali, especially in older villages (Bali Aga) the term *"balé agung"* refers to a larger structure where human beings sit during important village rituals. See Goris 1960c for a discussion of the nature and functions of the Balé Agung and other Balinese temples. Goris, following Korn, believed that the original (pre-Hindu) form of the Balé Agung was that of the mountain villages, where the Balé Agung is large enough to let the human worshipers sit. There is good evidence, however, that there have long been two different structural types in Bali, both called the Balé Agung, one prevalent in old-time villages, the other in the villages of the lowlands, one for humans, the other for the gods (Korn 1932:188).

44. The term *"maturan"* is the active form from the root *atur,* "a respected person is given or said something"; thus *"maturan"* means "to say or give something to a respected person." *"Aturan"* means "that which is said or given." What is "said" is implied in the common phrases *nunas rahayu* (to ask a respected person for well-being) and *nunas ica* or *nunas paicén* (to ask a respected person for a blessing), which are used to state the purpose of a *maturan* or of an *odalan.* Thus the acts of *maturan* are more than exchanges; they are communicative dialogues, much like conversations.

The term *"macaru"* is the active form of the root *caru*, "an offering to demons." The term *"caru"* comes ultimately from the Sanskrit, "oblation boiled with milk or butter for presentation to gods or *manes* [spirits of the dead]" and in old Javanese means merely "an offering." Other related words are *segeh* (a small *caru*) and *taur* (a large *caru*). *"Segeh"* meant in old Javanese "hospitable reception of a guest" and is related to a present-day Balinese word, *suguh,* "food and drink offered to a high-status guest." The term *"taur"* is Old Javanese, where it means "offering or sacrifice," but is not derived from Sanskrit. In contemporary Balinese, *"taur"* means "to pay or to repay, or to redeem a debt to a person of higher rank." Thus the main meaning of *"macaru"* is "to present an offering," and the object of that act, the demons, is a lesser aspect of that meaning.

45. On *caru* see Eiseman 1989:226–234.

46. Most bamboo altars stand on four legs. In contrast, an altar on a single stake is the kind said to be used by sorcerers when requesting *sakti* powers to harm as well as heal. See my *Images of Power,* chapters 4 and 5.

47. Individuals' levels of participation in the temple ritual are called by different terms in different parts of Bali. The first is full participation *(ngayah* or *nyungsung)* and full prayer with a food offering *(maturan);* the second is partial participation, with just a brief prayer and a small offering (usually called *mabakti).* I believe that before 1966, when Triwangsa were permitted to pray in the temple, the Brahmana people only did a *mabakti* in front of the Padmasana, although some of them would also *ngayah* with a dance and music performance as their offering.

48. A description of an even more elaborate *taur kasanga,* which involved several priests including a specialist called a *sengguhu,* is given by Goris. He says there were

two very distinct groups [of offerings], those for the gods of the upper world and those for the nether-worldly deities. The celestial offerings are in this case all sorts of items placed on a very high platform in the east, with a somewhat lower platform for the officiating *pedanda* facing it, thus in the west. These offerings are for the sun god Surya. . . . The *Sengguhu* is seated in the south with his face to the

north, while the nether-worldly offerings intended for Wisnu as the god of the nether world, or if one prefers for the *buta* and *kala* are spread out on the axis of this system. In this case, then Wisnu, as god of the north and the nether world, is identified with Kala and Durga. (1960c:119)

Note that both high and low beings are addressed, and that the high god Wisnu is identified with what Goris calls the "nether world." See also Grader 1960a:229–230 where he points out that in a *segehan* offerings are always made simultaneously both on the higher altar and on the ground.

49. See Grader 1960a:230 for a description of a *taur agung* in Buleleng, in front of the prince's palace, at the crossroad. Here both a *pedanda* and a *sengguhu* priest officiate. They get holy water from the village temple and distribute it to every *banjar* and to every individual worshiper to take home. They then scatter holy water everywhere, present offerings of cooked rice, burn torches, and make a great deal of noise.

50. The kind of disaster that is god-provoked *(kapongor)* is not contrasted with an illness caused by a *buta* (demon) but rather with one caused by a human being, a sorcerer *(désti),* and then the ill person is said to be *kadésti.* I do not know whether an illness said to be caused by a *buta* or by *buta kala* is also characterized as *kapongor.* If that is so it would support my thesis that *betara* and *buta* are nearly, but not quite, interchangeable.

51. For descriptions and analysis of the Eka Dasa Rudra ceremony, see Stuart-Fox 1982, 1987 and Lansing 1983. Stuart-Fox pointed out that it is easier to see the logic of a ritual in its elaborated and expanded form because its parts are more differentiated, in contrast to the everyday forms, which are highly compressed, with many elements conflated with one another.

52. Bagus 1974:65 (my translation).

53. However, it may also be that the fusion and differentiation of demon and deity are understood to occur only at the uppermost levels, not on the level of everyday life. There is considerable need for more research in this area.

54. Stuart-Fox reports that the deities of lesser temples around the high temple of Panataran Agung in the Besakih

complex are spoken of as servants or assistants of the major deities. He labels these "functionary deities." So one is a *pasek* (organizer or headman), another is a *penyarikan* (scribe), another a *pandé* (official in charge of ornaments [i.e., arms and talismans]) for the higher god (Stuart-Fox 1987:151–152).

55. Margaret Mead and Gregory Bateson state that "gods and souls *(atma)* are in some sense 'children.' When a man in trance, possessed by a god or soul, addresses an ordinary mortal, he says *'bapa'* ('father') or *'mémé'* ('mother')" (Bateson and Mead 1942:251). I believe this was a linguistic error, since a speaker uses the term with which the hearer would address him as a substitute for "I," as when a mother speaking with her child uses *mémé* (mother) as her first-person pronoun. The deity was using these words as first-person pronouns.

56. A picture of a temple procession in *Images of Power,* on page 24, shows the gods transported in royal sedan chairs, accompanied by people carrying parasols, banners, and spears. See also the picture in the same book of Durga coming from over the sea, on page 96, for a similar pictorial statement of the equivalence between kings and deities.

57. See Guermonprez 1987 and Pitana 1997.

58. Some commoners are members of the literati and have studied *kawi* and ritual with a *pedanda*. The difference is that literate *triwangsa* are taken to stand for all *triwangsa* while literate commoners are understood to be exceptions. Commoners with the titles of *pasek* and *pandé* are considered by some to have descended from the high gods but to have been lowered to commoner status.

59. The contrast in ritual treatment of the high Indic gods and the local deities might be construed, but misleadingly, as evidence of a perennial opposition between indigenous and Hindu religious ideas. It would be misleading because, over the years of Bali's history, neither the "indigenous" nor the "Hindu" have stayed the same. Nor did "Hinduism" come to Bali once only, nor were the various historical waves similar to one another. Archeologically, the evidence for "nonindigenous" imports begins long before Indic traces start, with the spread of Bronze Age culture from South China for eight centuries before the Common Era. The material evidence for the coming of Hinduism shows that there have been new influxes of quite different Indic ritual practices with related theologies and iconographies—Theravada Buddhist, Mahayana Buddhist, and various kinds of Hinduism—at different times over the centuries, including, importantly, the latter half of the twentieth century. Reading contemporary religious practices as evidence for cultural history is, of course, common. But it should always be carefully supplemented with philological and archeological evidence. For introductions to the literature on Indic sources of present-day Bali, see Stutterheim 1929, 1935; Bernet Kempers 1991; Lansing 1983; Goris n.d., 1954, 1960c; Boon 1977. Jane Belo (1953) had a Sanskritist look for traces of Sanskrit *sloka* in the prayers of the Pamangku of Sayan. Hooykaas has since transliterated and translated a large number of written texts and identified Sanskrit phrases (1964, 1966, 1974, 1977: esp. 27–28). See also Goudriaan and Hooykaas 1971.

60. That the term *"gumi"* refers not to a geographical territory but rather to the personal realm of a deity is suggested by the following linguistic usage: When speaking of a small anomalous group that lives just over the border in the adjacent village of Sukawati who go to the *pura désa* in Sukawati but worship in the Pura Dalem Jungut in Batuan, one of my consultants said that "they *magumi* in Sukawati but *madalem* in Jungut." The *"ma-"* prefix indicates action taken; thus a translation is "They go to the *pura* of the *gumi* in Sukawati [i.e., its *pura désa*], but go to the *pura dalem* in Jungut, Batuan."

61. Many major temples have *panangkilan* temples—for instance, the Pura Hyang Tiba in Sakah and the Pura Panataran Sukawati (where its *triwangsa panangkilan* are referred to as *padarman*)—but *pura dalem* do not.

62. Competitive social pride is an important culturally constructed motivation in everyday life in Bali. A sign that it can invade ritual activity was the decision of the *banjar* of Peninjoan in Batuan not to parade their Barong because his tattered costume would reflect poorly on the dignity of his whole community. Another example is the sending of a god-image on a decorated litter to participate in the Taur Kasanga festival by a clan-temple if the group is prosperous, but holding back if the group is poor.

63. In *Kinship in Bali* I noted that a prosperous and growing kinship group or *dadia* is likely to build or renovate its clan temple, on the grounds that a large and grand temple in-

dicates the status of its gods and therefore of its congregation; in contrast, when such groups shrink or weaken, they may neglect their temple.

64. It was Barbara Lovric who first raised the question of the "dark side" of Balinese religious practices and conceptions, in her thesis in 1987. Another early unpublished thesis also suggested the necessary complementary relationship between the rituals addressed to "demons" and those addressed to the "gods" (O'Neill 1978). See also H. Geertz 1994.

Chapter 4: The Age of the Balinese Rajas (before 1908)

1. These names for these "ages" are in Indonesian. The language is appropriate, since the idea of historical periods came to Bali through contemporary Indonesian journalism and scholarship.

2. Some of the main sources on Balinese precolonial history are Bernet Kempers 1991; Hauser-Schaublin 1997; Hinzler 1976, 1986; Lansing 1983; *Sejarah Daerah Bali* 1978; Schulte Nordholt 1988, 1991a, 1997; Stuart-Fox 1987, 1991; Stutterheim 1929, 1935; Vickers 1986, 1989; Wiener 1995.

3. The transliterated text of the Batuan Prasasti can be found, together with a Dutch translation, in Goris 1954:96–101. The term *"prasasti"* derives from the Sanskrit and Old Balinese and means "charter, inscription, edict." The people of Batuan have not used this term until recently. They usually refer to the bundle of copper leaves as "Ida Sanghyang Aji Saraswati." I imagine that it was Goris and the other philologists who introduced the term *"prasasti."*

4. For details of almost all that is known archeologically about the period from the tenth through the fourteenth centuries in the area around Pejeng in central Bali, see Stutterheim 1929 and 1935. A more recent summary with excellent photographs can be found in Bernet Kempers 1991.

5. The inscription is long, and gives more details of life at that time. It apparently marked the settlement of several long-standing disputes between Baturan and the neighboring village of Sukawati (which bears the same name today), for it outlines the boundary between them and the division between the two villages of the required work on the raja's land.

The villages were probably surrounded by forests, for there is mention of forest products such as lumber and materials for making rope, and the sea may have come closer to Baturan than it does today, for there is mention of shipbuilding. The edict lists the rice fields owned by a general on the raja's staff, Senopati Kuturan, and the names of his ten local sharecroppers. It goes into details of donations required at meetings of the royal court of justice, disposal of land and other goods of people in the village who died without heirs, punishment for theft, and how to get permission to hold cockfights in the temple. A variety of crafts are mentioned, including ikat weaving, yarn dying, carpentry, stonemasonry, tunnel building, painting and carving, jewelry making, door making, mat weaving, goldsmithing, and blacksmithing, but it is likely that these craftsmen were occasional visitors from outside the village. An analysis of the many names and titles mentioned in the inscription shows that Bali at the time had a highly differentiated social organization, with many grades from high royalty through lesser nobles, and—even within the village—a distinction between literate and illiterate local people. Much of the theological language of the inscription is Indic in origin.

6. Included in this invocation are the gods of the Nine Directions, the Sun and Moon, Indra, Yama, Kuwera, Basawa, and Durga.

7. Stutterheim 1929: figure 43 and 1935: plates XIII and XIV.

8. Stutterheim 1935:32.

9. Ibid., 37.

10. Bernet Kempers 1991:58–59.

11. It was Roelof Goris who first and most strongly put forth the hypothesis that these slightly carved stones and the stone seats to be found in certain mountain temples date from an ancient "megalithic culture" in Bali that had links all over Indonesia and Polynesia and even to Scandinavia and northwestern Europe and Central America. See Goris n.d. [1953?]:23–32; Sutaba 1980; Lansing 1983:24–25. Bernet Kempers (1991) discusses the sarcophagi but does not mention the theory about the large stones.

12. On Kebo Iwa in the *topeng* repertory see deZoete and Spies 1973:296. See also Wiener 1995:301–302.

13. Bernet Kempers 1991:114–115. There is a photograph of Pura Hyang Tiba's elephant on p. 115.

14. For an example of a Ming dynasty elephant that closely resembles the Batuan ones, see Wang 1998: illus. 27.

15. From a sociological perspective, temples in Bali are place markers for social groupings, and a study of a community's temples is a study of their main social categories and to a certain extent their histories. I was able to trace some of Batuan's family histories through their temples. See Hauser-Schaublin 1997.

16. H. Schulte Nordholt, personal communication.

17. When a large stone statue was found buried in the ground nearby early in this century, the *pamangku* of the temple of Gusti Ngurah Batu Lépang was possessed by a *niskala* being who declared that the statue had formerly been part of his temple. It was then moved to a shrine within that temple. The being who possesses the statue, named Jero Gedé, is said to emerge at times and walk around Batuan. You can hear his footsteps, and people say that *"Jero Gedé sané ngukuhin jagat Batuan"* (Jero Gedé defends Batuan). Many schoolchildren (from all strata of the village) come to give offerings to Jero Gedé before examinations. Jero Gedé is said to be very efficacious and the statue to be very *tenget*.

18. There is a spot said to be the former clan temple, the Mrajan Sangging, of a clan of artisans. Today it is just a small pile of rubble in among the houseyards of the Brahmana Siwa. It is venerated by its immediate neighbors, but only with daily small *canang* offerings. It has no *odalan*.

19. H. Schulte Nordholt, personal communication.

20. On nineteenth-century kingdoms, see C. Geertz 1980 and Schulte Nordholt 1997. Dates in the history of Bali have been difficult to establish. The founding of the kingdom of Gianyar must have taken place toward the end of the eighteenth century. This would place the Gianyar Déwa families moving into Batuan at about the beginning of the nineteenth century. For recent historical studies that mention the kingdom of Gianyar, see Wiener 1995 and Vickers 1989.

21. In 1848–1850, R. Friedrich traveled in south Bali. He reported that Brahmana Buda were very few, living only in Budakling and Batuan (1959:34). By 1985 there were branches of Brahmana Buda in Sukawati just south of Bat-

uan, in Gunungsari in Pliatan, in Wanasari in Klungkung, in Kaliungu in Badung, and in Culik in Lombok, among other places.

22. Before the 1930s, Pura Dalem Puri's rituals and renovations were largely financed by the Klungkung-oriented noble clan today referred to as Puri Sukawati. For more than a century, until the middle of the twentieth century, the Triwangsa of Batuan had only to provide householder's offerings; all the rest of the costs of ceremonies and temple upkeep were borne by the palace in Sukawati. After the palace failed to carry out this obligation for several decades, the temple was formally given over, in the 1950s, to the care of the local Triwangsa group as a whole. By that time the temple had been so neglected that it had no walls or gates, and some of the altars were mere bamboo structures. It was entirely rebuilt in the 1950s, and the main architect and stone carver was Déwa Putu Kebes, who did a few carvings in Pura Désa Batuan at the same time.

23. I don't know where "Mitra" is, but it might be Bitra, on the road to Gianyar from Batuan.

24. C. Geertz 1980.

25. Wiener 1995.

26. Vickers states this well in his article on the meanings of a poem written around 1842 or 1843:

The *Geguritan* may be read as a poem in praise of the Déwa Agung's [the high king of Klungkung] strength. It tells how he creates *ramé* and turns its destructive side into a kind of *amerta* for his kingdom. In this sense it is about power, power in the form of *sakti,* which is both spiritual and material, manifest *(sakala)* and unmanifest *(niskala).* At the end of the poem this power is manifest in the glow of the *prabawa,* the collection of natural signs which show that the ruler had *sakti* and charisma *(wibawa).* The *prabawa* takes the form of signs of the apotheosis of the deceased ruler who has been the object of the *ligya* ritual, but since he is not mentioned by name, it should also be assumed that this *prabawa* belongs to his descendant and successor, the Déwa Agung. The *prabawa* manifests the status and position *(linggih)* of the Déwa Agung as ultimate ruler. This position places him above the other kings and lords, above

the ambiguous Brahmana priesthood, and above his subjects, who appear as escorts *(pangiring)*, palace officials *(kanggon)*, followers *(roang)*, subjects *(panjak)*, villagers and peasants *(anak tani)*. There is always a risk that the Déwa Agung will not be able to manifest his *linggih* as power, which would allow him to be defeated by other kings, his status to be usurped by the priesthood, or even his subjects to go their own way, to desert or even rebel. Vickers (1991:108–109)

27. See Goris 1960a:88 for an account of the nature of royal *pura panataran* and Schulte Nordholt 1991b for a detailed history of such a temple (re)building.

28. For examples of the *karang bintulu,* see Hinzler 1987, part 1, photographs 28 and 30, which were made I believe by Hinzler in the 1970s and 1980s; and the drawings (made between 1870 and 1894) part 1, Cod. Or. 3390-23 and Cod. Or. 3390-24.

Chapter 5: The Age of the Dutch Rajas (1908–1942)

1. C. Geertz 1980; Schulte Nordholt 1991a, 199b.

2. The term *"triwangsa"* itself has very likely been adopted only in this century, under the colonial administration, to refer to what might have been a new social concept of "nobility." Before the coming of the Dutch, there was probably no need for such an all-encompassing category, since the social distinctions of titles were multiple, fluid, and highly particulate. See H. and C. Geertz 1975, especially pages 20–23.

3. In 1916, the Dutch controleur reported that for the Gianyar District, he had appointed 10 *punggawa* who were all *triwangsa,* 140 *prabekel* of whom 85 were *triwangsa,* and 381 *klian banjar,* of whom 58 were *triwangsa* (Ballot 1916, 1917). For further development of this argument, see Robinson 1995:33.

4. See Schulte Nordholt 1991a: chap. 2.

5. Schulte Nordholt 1988.

6. In 1916, there were 396 families in Batuan. These were divided into 296 *pangayah* and 100 *pamijian*. The breakdown into the *banjar* of the time was as follows:

Banjar	*Pangayah* (commoners)	*Pamijian* (nobles)
Batuan-Grya [Batuan Gedé]	21	68
Jeleka	32	6
Tengah	12	13
Tegenungan	6	13
Den Tiyis	33	
Kabetan	6	
Delod Tunon	13	
Peninjoan	50	
Jungut	12	
Puaya	111	

The *klian dinas* were commoners in all the *banjar* except Batuan Gedé. The nobles were all living in the first four *banjar* on the list, as they still are today. Tegenungan, which lies across the ravine to the east of Batuan, was shifted to a different *désa dinas* by 1938, and by the 1980s was no longer part of the *désa adat,* although it took still took part in Batuan's *melasti* just before the Taur Kasanga. Kabetan was combined with Den Tiyis at some time later (but in 1916 its members were still struggling, in vain, to attain *pamijian* status, hence the separation) (Ballot 1916, 1917).

7. A photograph showing the *balé kulkul* was published in 1938 (deZoete and Spies 1973: plates 98, 63, and 64). There was a Karya Agung Ngebekan Jenuken in February 1936, a major ceremony probably consecrating the new architectural work, and the photographs would have been taken at that time or soon after. Subsequent *karya agung* were probably held in 1950 (a Karya Agung Mesaba Nini), in 1954 (a Karya Agung Mesaba Désa), and in 1981 (a Karya Agung Ngenteg Linggih). Although these dates are based on oral accounts and therefore not necessarily accurate, it appears that temple renovation was undertaken in 1917–1936, 1936–1950, 1950–1954, 1954–1981, and 1981–present.

8. David Stuart-Fox estimates that the *padmasana* was introduced into Bali during the seventeenth or eighteenth centuries by Brahmana (Stuart-Fox 1987:97–100) For other materials on the *padmasana* see Hooykaas 1964:93–140; see also Covarrubias 1956:7, showing and discussing the picture, made

in 1934–1935 by Ida Bagus Made Togog of Batuan, of "The Balinese Cosmos: The World Turtle, Bedawang, and the Supreme Being, Tintiya" (Tintiya is otherwise called Cintia, and Sanghyang, Widi Wasa).

9. Ida Betara Sanghyang Siwa is often also referred to as Ida Sanghyang Surya, the holy sun. But there is always built, right next to the Padmasana, a temporary bamboo altar to Surya, the sun. One well-informed consultant said that the temporary altar is addressed to the physical material sun, while the Padmasana was to Ida Sanghyang Surya.

10. On the Dutch Archeological Service and P. A. J. Moojen and their activities in relation to Bali's temples, see Bernet Kempers 1991:87–89 and Lansing 1991:96–97, 99.

11. It is possible that Déwa Gedé Oka actually introduced the *rejang* to Batuan, and even possibly the *gambuh,* although no one told me so. Most people apparently assume that both of these performance genres are very old in Batuan. However, this would not be the first time that a local noble introduced court-inspired rituals. See Schulte Nordholt 1991b.

12. The word *"agung"* is also applied to some of Batuan's gates (as in *kori agung,* where it means "large"), but since it is in the high register it pertains to high beings, thus means "grand." The low-register equivalent, not used for these temple structures, is *ageng.*

13. See Stuart-Fox 1987:322–3, 95; and 1982:19–20.

14. The term *"arum"* (aromatic) is also used to refer to the inner courtyard of some royal palaces and temples. For instance, the inner part or *jeroan* of Pura Dalem Jungut is called the *arum.*

15. See Hinzler 1987 for some good examples of *karang.*

16. Hinzler 1987, part 2, p. 68.

17. In the 1950s the leader of the painting team was Ida Pedanda Ketut from Geria Kawan, Batuan, who put the first marks on. The team consisted of I Made Jata (Banjar Pekandelan), I Rata (Banjar Puaya) I Ramia and I Saweg (Banjar Peninjoan), and Déwa Nyoman Moera (Banjar Batuan Gedé).

18. For an outline of the Ramayana as told in the *wayang wong,* see deZoete and Spies 1973:153.

19. My consultants were not always in agreement about the identities of the monkey characters. One older man said that what I have called Anoman and Subali were Sugriwa and

Subali, identical twin monkeys. I chose to follow another man whose knowledge of the iconography, based as it is on dance costumes in the dramatic dance, the *wayang wong,* was based on his own participation in that sacred dance.

20. See Wiana et al. 1985:16–20.

21. See Hooykaas 1964:95–140. Hooykaas gives an extensive philological study of the texts relating to the *padmasana.* Hooykaas starts out by saying that a *padmasana* will "invariably" be found in all of Bali's thousands of temples. This is, or was in the past, untrue. See also Covarrubias 1956:6 for an illustration, by Ida Bagus Madé Togog of Batuan, of Bedawang Nala, the serpents, and Sanghyang Cintia.

22. This closely resembles a *wéda* given by Hooykaas (1964:104), as a Brahmana Buddha prayer for a priest's daily ritual. For discussion of its possible translations, see the same article by Hooykaas. That it is a Brahmana Buddha version is not surprising, since my consultant was a client *(sisia)* of a Buddha (or Buda) priestly family. See also the government-issued high school textbook by Wiana et al. (1985:20–23).

23. Puniatmaja n.d.: "Lesson 17. Padmasana and Other Roofless Shrines." Original in English, prepared for teaching hotel employees about Balinese culture.

24. For an interesting analysis of another door, see Wiener 1996.

25. See Bateson and Mead 1942:178–179 for an analysis of the similar figure of Rangda as an expression of primordial infantile terrors.

26. One person thought that Balang Tamak is appropriate to a *pura désa,* in the same way that Pan and Men Brayut (who are also featured in many folktales) are appropriate to a *pura dalem.* (There are statues to them in front of Pura Dalem Jungut, where childless people go regularly to pray for fertility.)

27. Stuart-Fox (1987:20).

28. See Wiener 1995 and Schulte Nordholt 1997 for many examples of magical rifles.

Chapter 6: Forms, Meanings, and Pleasures

1. My thinking in these areas has been aided and reassured by reading the article by George Marcus and Fred Myers that

formed their introduction to *The Traffic in Culture: Refiguring Art and Anthropology* (1995).

2. Bakhtin 1981. It was James Clifford (1988a) who first pointed out the pertinence of Bakhtin's insights to ethnographic writing.

3. I have tried in this book not to use the confusing terms "we," "our," and "us" to refer to holders of Western ideas; these pronouns are ambiguous when there is no other indication as to the referent group intended. What is meant by "we" "we human beings," "we cognoscenti," "we Westerners," or, perhaps, "we anthropologists"? Perhaps what "we" means in books of this sort is "those of us readers who share this particular—unspecified—discourse," a presumption of some reach.

4. Schapiro 1994a:51. Schapiro does not always adhere to the approach suggested by this definition in his own art-historical practice.

5. Gombrich 1968:352. The two articles by art historians Schapiro and Gombrich, both written for social scientists, are an instructive pair. Schapiro provides an evenhanded survey of the many uses of the term "style" by art historians, while Gombrich provides a strong critique of the "historicist" or Hegelian conception of society and artistic styles in it and develops an interesting alternative to it.

6. Gregory Bateson (1978) described this aspect of style well in its use in 1930s paintings.

7. Bonnet n.d.:158; 1936.

8. Schapiro 1994b:51.

9. Holt 1967:168.

10. Gombrich 1968:352.

11. Ibid., 353.

12. Ibid., 357.

13. Gombrich 1972.

14. Goris 1960:87–89.

15. Ibid., 87; Stutterheim 1929.

16. Bernet Kempers 1991.

17. Goris 1960c:88.

18. Ibid., 87–88.

19. Nieuwenkamp 1922.

20. Vickers 1991.

21. Margaret Wiener (personal communication) told me that when she moved to Klungkung with her two Gianyar collaborators, they were struck by the simplicity (they called it *polos*) of the Klungkung temples. Her consultants felt that this was a deliberate choice on the part of the temple builders, a choice that indicated that the owners had *wayah di tengah* ("inner maturity" or "understanding").

22. In the open-ended questions that I usually set, indigenous conceptions of style rarely arose. While I visited many different temples in other villages, the subjects I pursued were always similar to those that engaged me in Batuan: the native interpretations of the carvings, based on their larger ritual intentions. For my consultants, formal features such as style seemed to have had little importance compared to issues of iconography and meaning. Different styles did not seem to carry meanings of any weight, at least explicitly. Further research is needed on present-day and past carving styles. Making comparisons entails not photographing and juxtaposing images, but rather exploring the local history of each set of carvings, establishing each one's context as I have done, and only then eliciting local distinctions and categories of styles, before beginning to construct comparative generalizations.

23. A number of anthropologists have been developing approaches to discovery of indigenous aesthetic systems. Robert Farris Thompson (1973) was the pioneer. Others include Myers (1989), Morphy (1991, 1992), Coote (1992), and Shelton (1992).

24. For a history of *kebyar* see Seebass and van der Weijden 1996 and Tenzer 2000.

25. The term *"lemuh"* can be used positively as "supple," as one consultant used it to praise a statue made in the 1950s of the Prabu in the Gambuh at the East Gate (discussed in chapter 7), saying that it has a lot of *seh* (movement) and is *lemuh* (supple).

26. *Cahaya* and *sakti* are given visual iconographic form in paintings through the showing of flames coming from a figure's head, genitals, elbows, and knees. See H. Geertz 1994 for examples.

27. See Wikan 1990 for a discussion of this term.

28. Panofsky 1955:10.

29. A vocabulary-centered approach to aesthetics (and other cultural domains) was pioneered by Ruth Benedict in regard to ethics in her influential study of the Japanese, *The Chrysanthemum and the Sword,* in which she compiled and analyzed a linked cluster of words pertaining to human relationships.

Anthropologists who have followed up on this idea include Witherspoon 1977, C. Geertz 1983, and Morphy 1991, 1992.

30. Schapiro 1994:33.

31. Ibid., 47.

32. Ibid., 33.

33. Ibid., 37.

34. One totalizing discourse that certainly was present in the 1930s is that of symbolic numerology. Stuart-Fox (1987) discusses this largely Brahmanic intellectual tradition in regard to temple organization (chapter 3). Most important to the notion of order and harmony are what he calls the center-focused classifications (5, 9, 11, in which there are four or eight or ten points around an additional one in the center). These interpretive frames seem to me to have been imposed on the temple structure, rather than guiding its formation.

35. Cole 1983:275–285. Other Balinese terms of similar meanings are *tegep, tileh,* and *utuh.*

36. Such an assembling of disparate elements into a "whole" of sorts has been pointed out by James Boon as a more than peculiarly Balinese affair, which he compares to the literary genre of Menippean satire. (Boon 1990: chap. 4).

37. In small-scale rituals, such as the offerings for Galungan presented within a home temple, I found that several of the constructed *banten* or offerings performed this same dual purpose: they were considered to serve not only as offerings but also as temporary *palinggih* for the visiting gods. The same is true for altars such as the Padmasana and for major gateways.

38. The picture is signed "I Saweg." I had trouble identifying who this was, and it was common practice for artists to sign their works with other people's names. There is a man named I Saweg who is the 1930s generation and also a good draftsman, but when I showed him these pictures, he denied that he had made them. I Madé Jata, also from that generation, said that the pictures might have been made by I Rata of Puaya, one of the stone carvers. These pictures are in the Bateson Collection of Balinese Paintings in a large notebook on which, in Bateson's handwriting, it is said that they all depict Pura Désa Batuan, and each drawing is identified with particular figures within the temple.

39. On *wayang wong,* see Bandem 1980, Bandem and deBoer 1981, deZoete and Spies 1973.

40. Casual contact with the *wayang wong* masks is dangerous since these particular ones are *tenget,* and I was forbidden to photograph them except when they were being performed during the temple ceremonies.

41. Is it off the point here to recognize that some Balinese conceptions of "self" and "person" are quite different from those assumed in Western discourses? See, for instance, Connor's discussion of Balinese conceptions of the "person" or "self" as divisible and multiple, Strathern's (1988) concept of the New Guinea conventions of the self as "dividual," and McKim Marriot's (1976) early introduction of the subject.

42. Panofsky's "spheres of meaning" (Panofsky 1955:40) should not be understood, as he understood them, as "aspects of the work of art as a whole" but rather as strategies of interpretation a viewer uses. Panofsky meant these to be useful for professional art historians, but in my opinion they can be generalized to acts made by any and every viewer. His first type, what he calls "pre-iconographic description," which he takes to be natural and based on "practical experience" rather than prior (cultural) knowledge, has been shown by Bourdieu (1968) to be itself culturally guided. Only the most vague and general interpretations of forms, such as faces or figures, could be possibly said to be "natural" and "universal."

43. I owe the general viewer-centered conception of "art practices" not only to Gombrich (1960), but also to Nelson Goodman (1968, 1978), especially as the two are read by W. J. T. Mitchell (1986). Gombrich's concept of "making and matching" should be understood as another imaginative, interpretive strategy.

44. Suleiman 1980.

45. Belting 1994:3.

46. Ibid., 15.

47. Ibid., 16 (italics in original).

48. See Hinzler 1976 and Hauser-Schaublin 1997.

49. However, Rama is also said to be a human who is reincarnation of Wisnu. See deZoete and Spies 1973:chap. 5. It may be that these ordinarily careful researchers assumed that the Indic version of the Ramayana that they knew from published versions was the same as Balinese versions, and therefore they did not elicit from the performers themselves their understanding of the nature of Rama. Unfortunately, I too neglected to ask people to relate the story to me in their own terms.

50. See Emigh 1979. Emigh's consultants (Batuan dancers)

stressed the notion that the *topéng* play enacted a visitation by ancestral beings.

51. Kumbakarna in his fight with his brother is presented as a just king. He stands on the right of Rawana, from their point of view. Therefore Kumbakarna encompasses Rawana.

52. Gell 1992, 1993, 1998.

53. Gell 1998:96.

54. The conception of magic as an impersonal force is not that held by the Balinese and I suspect not by those peoples in New Guinea where Gell worked.

55. Gell 1998:81–82.

56. For me, Gell takes a too narrow view of "meaning and communication" (basically the narrow structuralist and semiotic models), but what he says does not contradict the basic communicational stance that I take.

57. In ignoring culturally specific notions of agency, that is to say, of nonhuman agents, Gell misses an important aspect. For the Balinese, the constant social involvement in *niskala* beings in human lives means that "agency" is much more complex than Gell allows. Gell appears to accept the usual notion of "magic" as a force that can compel various sorts of action in a nonagentive way (Gell 1998:108–109).

58. David Freedberg, in his *Power of Images* (1989), sets out an argument—buttressed with wide-ranging evidence—similar to that taken here: that there is no important difference in viewers' responses between "secular" and "sacred" art and that "effectiveness" ("the power") is attributed to images by any human viewer. He rejects the

> long-standing distinction between objects that elicit particular responses because of imputed "religious" or "magical" powers and those that are supposed to have purely "aesthetic" functions. . . . We must consider not only beholders' symptoms and behavior, but also the effectiveness, efficacy and vitality of images themselves; not only what beholders do, but also what images appear to do; not only what people do as a result of their relationship with imaged form, but also what they expect imaged form to achieve, and why they have such expectations at all. (1989:xxii)

59. See Baxandall 1985 and Rosen 1995.

60. See Wolters 1982 for a theory that the societies of Southeast Asia in the first millennium valued and welcomed novelty.

61. See Bandem and deBoer 1981 and Seebass 1996.

Chapter 7: The Age of the Last of the Dutch Rajas (1948–1950)

1. In fact, in research on colonial and precolonial Bali, diversity has been treated as a geographic, local phenomenon, tending to ignore the social intricacy and historical spread of alternative ideas. For suggestions about that diversity see Goris 1960a and Guermonprez 1987 on Pandé, Korn 1960 and Dananjaja 1980 on the so-called Bali Aga, Gerdin 1982 on Balinese in Lombok, and Barth 1993 on Balinese Muslims.

2. For aspects of Bali in the 1950s see Bagus 1991, Vickers 1989, Picard 1999, Robinson 1995.

3. See H. Geertz 1994, 1991. The story of Ida Bagus Wayan Truwi is instructive in showing that perhaps even as early as the 1930s there were whispers of anti-Dutch and antimonarchist ideas in south Bali and in showing that diverse positions were held within the Triwangsa group. He was the young Dutch-appointed *perbekel* in Batuan during the period of the research in Batuan of Margaret Mead and Gregory Bateson. Their research assistant was I Madé Kalér, a young man from Singaraja who had been educated in Singaraja and Surabaya and had worked in Batavia and who held many of the new nationalistic ideas. Kalér became good friends with Truwi and told me in an interview in 1985 that he became anti-Dutch during his employment with Mead, in part because Mead and Bateson treated him in a noncolonial respectful way. Perhaps he and Truwi discussed this. Later, in 1945, Truwi joined the antimonarchist nationalist fighters under Batuan's I Ngendon. After Ngendon was executed, Truwi and a group of other Batuan nationalists were arrested, and imprisoned in Gianyar. They were brought out to Batuan one day by the police and publicly humiliated and beaten (see H. Geertz 1991). On release from prison, Truwi changed his name to Tapa and moved to Denpasar, where he became a merchant. He did not return to Batuan to live for more than twenty years. Kalér swore that he would never work for the Dutch, and when the Japanese left, he was one of the founders of the independent nationalist school, Sa-

raswati, which has since grown into a whole system of non-government private schools.

4. This was C. J. Grader, who was in the cabinet of Anak Agung Gedé Agung from 1947 to 1948 and doing fieldwork on temples in Bali in 1949. See Grader 1960b:177–178, esp. page 178 on rebuilding the Pura in Kapal.

5. See Robinson 1995: chap. 6, where he argues that a Dutch ideological view of Bali as "apolitical, socially conservative and nonviolent" and stabilized by its traditional arts and religious festivals led the Dutch to a policy of stimulation of the arts through subsidies, competitions, exhibitions, and cultural displays in the period right after the war.

6. The substitution of the honorific title Anak Agung for Déwa Gedé in certain cases began in the 1930s when *triwangsa* who held office above the village level in the Dutch administration began to be addressed in that fashion, and soon thereafter it was extended to their immediate families.

7. Wayan Pageh Lana's second name (Lana) was added in ordinary speech, as is village custom, to distinguish him from the other man named Pageh, who had been the former Bendésa. Lana was the name of the second Pageh's oldest child.

8. During the 1930s work on the temple, there were a number of Triwangsa stone and wood carvers in Batuan, but they did mostly commercial work and did not contribute to the temple carvings. One of these was Ida Bagus Buda, whose work showed up in Bonnet's collection; another was Déwa Gedé (later Anak Agung) Kompiang, who in the 1950s worked on the Pura Panataran Agung of the Déwa clans in Batuan. Another was Déwa Putu Kebes, who while he did not work on the temple carvings in the 1930s, did so in the 1950s. During the 1980s, his son, Déwa Nyoman Cita, did a great deal of carving for Pura Désa Batuan.

9. Déwa Putu Kebes contributed little to Pura Désa Batuan in the 1930s. He was in disgrace with the temple community because he had hit his own father on the head (the head is the main location of *niskala* beings so this is a serious offense). The *banjar* voted to take away the right to house-land and rice fields, and he spent much of the 1930s in self-imposed exile from the village. In the 1950s he made several statues for Pura Désa Batuan, but he was preoccupied with the rebuilding of the Triwangsa Pura Dalem, on which very little carving was done.

10. Stuart-Fox 1987:20.

11. A group of similarly naturalistic small statues (but of musicians) were made in Sukawati for the Pura Panataran there; in the 1930s or early 1940s a Cokorda from Sukawati donated several of them to the Bali Museum.

12. See Hinzler 1987 for a set of drawings, including some of the first "realistic" drawings in Bali, made in the last three decades of the nineteenth century.

13. On Déwa Nyoman Moera, see Hohn 1997. I Djata and I Saweg, who were very young at the time, later became important tourist painters. See H. Geertz 1994.

14. Robinson 1995:236–237.

15. Because the Pamangku is a commoner, his houseyard temple is normally referred to as a *sanggah* (commoner houseyard temple), but now it was often referred to as the *mrajan désa* (noble temple of the village).

16. Vickers 1986, deZoete and Spies 1973, Bandem and deBoer 1981, Bandem 1983. Vickers lists the temples in Pedungan, Tumpak Bayuh, Padang Aji, and Anturan as the only other ones where the *gambuh* was performed as part of a temple ritual.

17. In the Bali Museum is a set of stone statues of *gambuh* flute players that were donated or sold to it by the then head of Puri Gedé Sukawati. These came either from the *puri* itself or from the clan temple (Pura Panataran) associated with it. It is not clear when they were made, but it is very possible they were made at or about the same time as the Batuan figures.

18. On *gambuh* see Vickers 1986, 1989; Seebass and van der Weijden 1983; Bandem and deBoer 1981; Bandem 1983.

19. Adrian Vickers, who has done extensive research in Batuan on the *gambuh*, was told by several people that Déwa Gedé Oka brought the dance for the first time into Batuan (personal communication 1996).

20. DeZoete and Spies (1973:chap. 4) emphasize the lack of popular interest in *gambuh* in the 1930s, compared to other more lively dance genres. It may be that outside of Batuan the dance was not valued, but within the village it was always of great importance. In Batuan, several institutions prevented the *gambuh* from being totally neglected. First was the requirement that the *gambuh* be presented at every important temple ceremony. Second was the continuous strong support

given the troupe by the Puri of Gianyar. The Gianyar royal court not only periodically summoned them to perform at ceremonies and before eminent visitors (usually foreigners) but also supplied them with materials for new costumes when needed. In 1930 there was a Dutch-government-sponsored islandwide competition for the best *gambuh*. In 1948 when the Gianyar raja was installed as the local colonial administrator for the new colonial nation of Eastern Indonesia, he held a massive cremation, with a nine-level cremation tower. The Batuan *gambuh* troupe was given a great boost when the raja commissioned them to perform throughout the festival of the cremation. The king bought them new costumes, for theirs were in tatters. They gave their troupe a new name, the Penyama Triwangsa (Triwangsa kin), in the manner of other traveling performance teams. One of my consultants, in speaking of the emotion-filled events of the 1950s and 1960s, discussed below, said he thought that this experience gave the younger members a new sense of identity and solidarity as nobles. A further push for the recognition of *gambuh* came in the 1970s, when the new Indonesian Academy of the Dance hired several *gambuh* dancers and musicians to teach.

21. Seebass and van der Weijden 1983.

22. See Hinzler 1987, Vickers 1984.

Chapter 8: The Age of Freedom (1950–1967)

1. For an excellent general history of this period see Robinson 1995. Any history centered on only one village, as this is, is inevitably distorting and must be complemented with materials from elsewhere.

2. I know both too little and too much about political events in the 1950s and 1960s, enough to have a general idea (and also to be aware of grave possibilities of error), but not enough to be certain of details. Interviewing in the 1980s about political events of twenty and thirty years before leaves one with many feelings of uncertainty. In addition, the continuing discrimination against former members of the Communist Party and their descendants on the part of the Indonesian government made most people cautious. The family of one of the two PKI leaders who were executed during the killings of 1965 have omitted him from their written genealogy. The account that I give here is definitely biased by my

partial reliance on those who were willing to tell me anything, that is, those of my own neighborhood in the *banjar* of Batuan Gedé, Pekandelan, and Gria.

3. A movement against the privileges given to people of the *triwangsa* category had been strong in the 1920s and 1930s in northern Bali (Robinson 1995; Bagus 1969). Beginning in the 1930s, most of the teachers in southern Bali were from the north. It is very likely that those from Batuan who held these ideas originally (I Ngendon, for instance, who was killed in 1948; see chap. 7) heard them from teachers from the north.

4. The Batuan Pura Dalem Puri, a death temple for all *triwangsa* in the area around Batuan (including Sakah and Sukawati), had been the sole responsibility of the noble house of Sukawati, but this family had long neglected repairs. The Pura Dalem Puri had once owned land, which had served as a source of income for temple repairs and offerings, and most nobles were obliged only to present family offerings. But by the 1940s this rice land had been absorbed into the private property of the Sukawati noble family. In 1938 the head of Puri Sukawati died. After that his descendants did nothing for the temple, and by the 1950s, all had collapsed. The Triwangsa were ashamed of their temple, especially since the two commoner *pura dalem* had been newly refurbished in the late 1930s. They finally got the noble house of Sukawati to relinquish its rights in the temple, and organized themselves to rebuild it. They worked (putting out hard labor and heavy contributions in materials) on it between 1949 and 1956. Most of the stone carving was by Déwa Putu Kebes with the assistance of his son, Déwa Nyoman Cita (see chapter 9).

5. See Robinson 1995:178. In the period starting at the end of 1949, Balinese society was close to civil war between former "Co" and "Non-co" sides. Tempering this conflict were other oppositions that cut across those lines.

6. SOKSI was so small in numbers that Robinson never even mentions this party.

7. Robinson (1995:215) describes a buildup of party competition in 1964 and 1965 between PNI and PKI as mass organizations using mass media.

8. Robinson 1995.

9. The new temple for the Triwangsa was usually referred to as Pura Désa Sila Murti, and it was considered by them to

be a *pura désa,* as shown in the following list of their altars: a Padmasana, a Gedung Méru Tiga (the equivalent of the Méru Agung), a Ratu Ngurah, and a Pangaruman. They also put up a Balé Agung and a Pura Ulun Balé Agung, indicating that they considered that the Taur Kasanga would be held there, as is necessary in a *pura désa.* In my 1980s interviews, several commoners asserted that it could not be a *pura désa,* that there could not be two *pura désa* in one community. Perhaps the Triwangsa saw themselves as moving to become a separate *désa adat.* The temple was started in 1966 and completed in 1967, but there was a long period, until 1986, during which a group of about thirty Triwangsa remained outside both temples. In 1986 most of these finally joined the Pura Sila Murti, while about twelve decided to accept an offer to rejoin Pura Désa Batuan. These latter gave the same material dues but were excused from heavy labor and allowed to substitute for it the making of special offerings and performing sacred dances. The stone carver Déwa Nyoman Cita (on whom see chapter 9) was one of these.

10. This man is quoted in H. Geertz 1991:186 on a 1947 eruption of this village conflict.

11. See H. Geertz 1991.

12. How much this egalitarian ideology was linked to material interests of, for instance, land tenure and agricultural labor, is unclear. Robinson makes a strong and credible case that the key cultural difference that dovetailed with class interests in Bali in the 1950s and 1960s was that between those who wished strongly to preserve existing social relations (including "caste" prerogatives) and religious institutions and those who wished to see significant changes in both, in the direction of greater democracy, meritocracy, and egalitarianism. He shows that most members of the Communist Party and its agricultural labor union, the BTI, in Bali were poor farmers and tenants (Robinson 1995). However, in Batuan, the strength of the royalist backers of the PNI managed to keep out the PKI. But it did not keep out egalitarians from the PNI itself. In Batuan, however, the link between material "class" interests, such as access to agricultural land, does not seem to have been a salient part of the controversy. As far as I could tell (based, however, on shaky oral accounts), by the late 1950s, the noble house of Batuan and most Triwangsa in Batuan had neither large landholdings nor large numbers of

sharecroppers. Those who had had fairly good-sized holdings had sold or pawned much of their land to finance education for their sons and to set up expensive art shops along the main road. By the 1980s agriculture was not a major income generator, compared with tourist-sector enterprises and the civil service. More research would be needed to support my impression that the conflict over the temple membership did not have an economic base or, despite the involvement of the political parties, a political one in the narrow sense.

13. The Batuan Pura Désa was not alone in pressing the Triwangsa to contribute equally. In Pura Désa Sukawati just south of Batuan, in 1952, the commoners tried to get the local gentry to participate on equal terms, but most of the Triwangsa refused, opening up a still-continuing dispute. See Warren 1993 and Pitana 1997 for other cases.

14. During the conflict between Batuan's Triwangsa and the Jaba, the *gambuh* troupe was not the only thing broken up. A set of fine instruments, a *gamelan semar pegulingan,* was stored away, fell into disrepair, and was not used again until the 1980s. A set of *topéng pajegan* masks, which had been made by Déwa Putu Kebes in the 1920s, was also stored away, never to be used until 1988, when they were finally brought out and danced by I Ketut Kantor.

15. They were aided by extra-village forces. In the 1970s, there was a strong government-supported movement to revive "traditional" Balinese dances in the newly formed Indonesian Academy of the Dance. I Ketut Kantor, who formerly danced with the Triwangsa troupe, was employed by ASTI to teach *gambuh* among other dances. His troupe was invited to Jakarta to perform in 1970 or 1972, and new costumes were bought in connection with that trip. On return from the performance, they named their new troupe after the place in Jakarta where they danced, the Taman Mayasari.

16. A dispute that occurred in 1966 several months before the final expulsion of the Triwangsa from Pura Désa Batuan, in which the antagonisms between the gentry and commoners were fanned nearly into flames, illustrates the complexity of these events. One of the commoner temples, a *pura dalem* in Dentiyis, was having a Karya Agung, a major ritual festival. The managing committee of Pura Dalem Dentiyis wanted to have a *gambuh* performance within the temple as one of their

sacred, *aci,* offerings. When the leader of the Triwangsa *gambuh* troupe was approached, he said they would do it only if all 150 members of the troupe were invited. He did this because there had been rumblings of discontent within the dance group, and he was afraid that if he selected only a few to perform, the others might be angry. The Dentiyis temple had limited funds, just enough to give a proper full rice meal to only 30 people (which is the usual number needed for a *gambuh* performance), so the managing team asked for only 30 performers. The Triwangsa group said they would not come unless all 150 people were fed, but the leader of the Triwangsa dance group wanted to settle the dispute in a friendly way, so he suggested that the Dentiyis temple not give them all a full meal, but just coffee and cake, a generous offer. But the managing team of Dentiyis refused, saying that if they did not give the performers a full dinner, the dance would not be a real *aci* offering because the blessing of the gods, the *pica,* is imbued in the rice and meat dinner that is prepared within the temple. Without a complete ritual transaction—dance performance in return for *pica* blessing in the dinner—the dancing would be merely commercial. The temple was planning a set of non-*aci,* commercial performances in the evenings after the temple rituals were completed, and for these they would pay money and cake and coffee. But they were requesting the *gambuh* as an *aci* performance and so did not want to have it on the commercial basis. Both sides refused to budge, and each one thought that the motivation of the other was contempt for the opposing group.

17. *Triwangsa* praying to Betara Puseh but not to Betara Désa seems to contradict the usual statement that a *pura puseh* is for a "collectivity of deified village founders" while a *pura désa* is for the "living community" (see Stuart-Fox 1987). Batuan usage is, however, confirmed in Margaret Mead and Gregory Bateson's field notes of July 23, 1937; Mead and Bateson also report both the distinction in kinds of contribution to temple needs and the distinction in regard to government corvée labor. These two distinctions were clearly linked in the thought of their informant, who was most likely Ida Bagus Wayan Truwi (Tapa), the *prabekel* of the time, who was a Brahmana Buda. For more on Truwi, see chap. 7, n. 3.

18. A history of the term *"kasta"* in Indonesian and Balinese usages would be highly informative. I would guess that it entered Indonesian discourses only in the 1960s, and that therefore it entered by way of English, not Dutch. The only piece of (negative) evidence that I have immediately at hand is that it is not in the 1961 Indonesian-English dictionary compiled by Echols and Shadily.

Chapter 9: The Age of the Tourists (1967–1995)

1. That these terms for the present period are all in Indonesian indicates that the discourse of historical periods is one on the national level. Most speeches, indeed most intellectual talk, are conducted in the Indonesian language. For this period see Picard 1996; Robinson 1995; Warren 1993; Vickers 1989, 1996. I end "the period of tourists" in 1995 not because it ended historically, but because that was the end of my field research.

2. On tourism in Bali, see Picard 1996 and Vickers 1996. What records there are show that in 1923 there were only about a hundred tourists a year visiting Bali, through the 1930s the numbers averaged about twelve hundred a year, and by 1940, it was three thousand a year (Hanna, 1976:104). In the postwar years, tourism began gradually, but by the 1970s there were more than a hundred thousand a year, and in 1980s a continual rapid rise to at least half a million a year in 1990. Picard states that these numbers are too low, and exclude Indonesian visitors. He guesses that by 1994, there were probably four million tourists a year visiting Bali, and that against a population of only about three million (Picard 1996:52).

3. There is a small amount of rice land owned by the temple *(laba pura),* but it is enough only to support its *pamangku* and to provide for routine offerings.

4. The Parisada Hindu Darma and the government allow three sets of cockfights as part of the ritual, but often these permissible bouts lead to continuous covert gaming for half a day.

5. New kinds of money-raising activities were tried. For instance, in Batuan, when the Triwangsa were finishing their new *pura désa* in 1975, they built a movie theater and bought a secondhand projector. But by the early 1980s this enterprise had failed, in part because the pictures were of very poor quality, but mainly because many villagers now had television sets and videotape players. In the 1980s Pura Désa Batuan

charged admission to the dance performances held each night during its Odalan. The young people of some of the smaller temples in Batuan set up, as money-making enterprises, one-night cafés where beer and food were served, called *bazar, bar,* or *warung amal.*

6. I Sentér and I Regug are cousins, both members of a wealthy clan in Dentiyis, the same one of the painter I Ngendon who led Batuan's small group of republican fighters against the Dutch in 1946–1950. In fact, I Sentér as a child had accompanied his mother, I Ngendon's sister, herself an active freedom fighter, in hiding during that period. (See H. Geertz 1991 and 1994 for more details on I Ngendon, his life and execution.) This group had an even longer history of opposition to the Jero Gedé Batuan and its royal kin in Puri Gianyar, since their ancestor had been a *perbekel* of the royal house of Negara (immediately east of Batuan) during a war between Negara and Gianyar (see MacRae 1997, Schulte Nordholt 1997).

7. See H. Geertz 1994.

8. For examples of both pre-1970 and post-1970 painting, see Hohn 1997.

9. *"Mode"* comes from the Dutch. That these terms are in Indonesian may suggest that the notions (at least in their contemporary meanings) came in through Indonesian discourses. An alternative phrasing, also Indonesian, is *cara baru* and *cara kuna.*

10. Seebass 1996.

11. Carving dates on temple altars is a postcolonial development. In Pura Désa Batuan, the other date is the one on the Bagia, 1954. Elsewhere people were putting dates on altars. For instance, in the temples of Kemenuh, I found the following dates: 1942, 1949, 1953, 1972.

12. See Vickers 1986.

13. Comic carvings are occasionally found in temples. An article by Schulte Nordholt (1986/7) illustrates some of these that depict and make fun of foreigners.

14. About mountains see H. Geertz 1994:10–12, Rhodius and Darling 1980.

15. The temple duties of this group of Triwangsa who rejoined the temple in 1988 were, basically, those that they had requested at the beginning of the conflict in 1966. They were not expected to do heavy labor, and they did not have to take turns watching over the temple at night during the Odalan. Instead they were given a special task of making a large offering called a *gebogan* (an ornate structure about six feet high that stands in front of the Méru Agung during the ceremony), and each day that they worked on offerings they were given the noon meal *(pica)* that contains the blessings of the gods. But they did not eat the leftover offerings *(lungsuran)* that had been given to Betara Désa, a matter of considerable tension in the conflict. On the Odalan of Sanghyang Aji Saraswati, they did eat the *lungsuran,* since this is the leftover not of ancestral beings, but of the goddess of arts and writing. They also gave the same contributions in cash and materials as everyone else.

16. See H. Geertz 1994:107.

17. Hinzler 1987: Part 1, 50.

18. Stuart-Fox 1987:347–349.

19. Wiener 1995:361 and Moojen 1926.

20. On the history and implications of the Eka Dasa Rudra ceremony of 1979 see Stuart-Fox 1982, 1987; and Lansing 1983. Similar, government-sponsored ceremonies have since been held, yearly at the time of the local Taur Kasanga, at Besakih.

21. Stuart-Fox 1982:129–130.

22. Bernet Kempers 1991:114. See Moojen 1926:plate LXXXVII for an early photograph of the gate at Canggi before 1926. Bernet Kempers (1991:112–114) has a picture of the gate at Pura Canggi in about 1990. For photographs of the *candi* at Gunung Kawi, see Bernet Kempers 1991:154–155 or Ramseyer 1977:42, illus. 38.

Afterword

1. H. Geertz 1986. These materials have been incorporated in chapter 4.

2. *Jakarta Post,* December 27, 2001.

Glossary

Indonesian words are indicated by the abbreviation "Ind." within parentheses.

abstrak (Ind.). Abstract.

aci. Offering.

adat. Custom.

adegan. Support, column; from *adeg,* to stand.

adegan surya. Temporary altar to the sun.

aéng. Fierce.

agem. Dance posture or movement.

ageng. "Large," in medium register.

agung. "Great," in high register.

aling-aling. Screen. (See pp. 121–122.)

alus. Smooth, refined.

amerta. Holy water.

amerta kamandalu. Holy water made from seawater.

anak. Person.

Anak Agung. Title for upper level of Satria or Wesia category.

anak sakti. Sorcerer, master of *sakti.*

arca. Figure that serves as vehicle for a deity; see *pratima* and *prarai.*

arja. Popular musical drama.

asri (Ind.). Pretty.

aturan. Offering.

awig-awig. Organization rules of a temple group.

ayah. To be served. (See pp. 14, 181.)

aywa wera (Old Javanese). "Do not reveal" (to anyone), prohibition against reading sacred writings without proper rituals.

babataran. Floor or pedestal.

bagia. Large ritual offering.

balé. Domestic structure like a pavilion.

balé agung. Major altar in a temple.

balé bengong. Palace pavilion that is raised above the wall.

balian. Healer. (See p. 41.)

balian tapakan. A healer and medium. (See p. 28.)

balian wisada. A healer or diviner who works from sacred texts. (See p. 28.)

banjar. Ward, hamlet, neighborhood, subgroup of *désa*. (See p. 18.)

banten. Offering.

banyu cokor. A kind of holy water.

bapak (Ind.). Father, uncle.

bares. Good-natured and kindly.

barong. Mask; the mask of the Chinese-dragon-like costume; Chinese-dragon-like *niskala* being. (See p. 251.)

basé. *Sirih* leaves for betel-chewing.

batu. Rock.

bendésa. Traditional leader of the temple organization.

betara. Deity; *betara-betara,* deities.

boma. Carved head of a demon with round, popping eyes.

Brahmana. Category in title system.

Brahmana Buda. Subgroup of Brahmana category.

Brahmana Siwa. Subgroup of Brahmana category.

bruang. Malayan bears.

buana. World, realm.

buana agung. The great world, macrocosmos. (See pp. 38–39.)

buana alit. The little world, microcosmos, the individual person or local community. (See pp. 38–39.)

buta. Demon; *buta-buta,* demons (See p. 64.)

buta yadnya. Category of rituals addressed to demons. (See p. 44.)

byar. Sudden blaze of light.

cacad. Crippled, disfigured.

cahaya. Brightness, shining, radiance. (See p. 148.)

cahaya idup. Radiance of life.

calonan. Unworked (stone carving), sketch (for a drawing).

canang. Offering consisting of betel-chewing supplies.

candi. Gateway to a temple; altar or monument. (See p. 125.)

candi bentar. Open gateway to a temple in the form of a split *candi* form.

candi kurung. Closed gateway to a temple.

cané. Offering consisting of betel-nut chewing ingredients.

cara bekerja (Ind.). Manner of work.

caru. Medium-sized ritual of offering to demons on the ground; see *macaru.*

caru agung. Major ritual of offering to the demons.

cawang. To present offerings from one place to a more distant altar.

celepuk. Instrument in Gambuh orchestra.

ceritra (Ind.). Story.

Cokorda. Title for noble from Satria category.

condong. Female character in Gambuh play.

dadia. Temple group based largely on kinship.

dana punya. Gift (to a temple).

dekorasi (Ind.). Decoration, ornament.

désa. Village, village temple. (See pp. 13–14.)

désa adat. Village organization for a village temple.

désa dinas. Village organization under the government.

désti. Sorcerer, witch.

detail (Ind.). Detailed.

Déwa. Title for noble from Satria category.

déwa. Deity; *déwa-déwa,* deities. (See p. 64.)

déwa yadnya. Category of rituals addressed to gods. (See p. 44.)

déwan (Ind.). Council.

dienst (Dutch). Service.

don panggang. Package of cooked rice wrapped in leaves.

drama gong. Popular musical drama.

druwé. See *duwé.*

duwé. Owned (by someone), alternate form of *druwé.* (See p. 13.)

éling. To be remembered. (See pp. 14, 45.)

feodailisme (Ind.). Feudalism.

gado-gado. Mixed salad.

gaguritan. Popular verse genre in colloquial Balinese.

galak. Fierce.

Galungan. Major calendrical holy day.

gambuh. Traditional musical drama.

gamelan gong. Orchestra.

Garuda. Mythical bird similar to an eagle.

gedong. Building with a walled enclosure and a door.

gelungan. Headdress.

genep. Full or complete. (See p. 153.)

gerak (Ind.). Movement.

gumi. Earth, world, realm. (See p. 70.)

gundul. Bald.

Gusi. Title for noble from Wesia category.

Gusti. Title for noble from Wesia category.

gusti. Lord.

ias. Ornamented, beautiful, decorated. (See p. 71.)

ica. Blessing.

Ida Bagus. Title for noble man from Brahmana category.

idup. Vitality. (See pp. 148–149.)

ijuk. Black palm fiber used for thatching roofs.

jaba. Commoners, alternative term for *sudrawangsa;* outside, person from outside. (See p. 18.)

jaman (Ind.). Era, age.

jaman Jepang (Ind.). Era of the Japanese.

jaman kemajuan (Ind.). Age of progress.

jaman melek (Ind.). Age of awakening.

jaman merdeka (Ind.). Era of freedom.

jaman orde baru (Ind.). Age of the New Order.

jaman pembangunan (Ind.). Age of economic development.

jaman pengertian (Ind.). Age of understanding.

jaman raja-raja Bali (Ind.). Era of the Balinese kings.

jaman raja-raja Belanda (Ind.). Era of the Dutch kings.

jaman turis-turis (Ind.). Age of the tourists.

jelék. Bad.

jempana. Sedan chair.

jero balian. Priest.

jero gedé. Priest.

jero kebayan. Priest.

jeroan. Interior; the central courtyard of a temple.

jeroan tengah. Courtyard in a temple next to the *jeroan.*

jiwa. Life.

jotan. Meal sent around to a neighbor or kin announcing a major family ceremony.

kadésti. To be the victim of sorcery.

kahyangan. Place where *hyang* or holy beings are; holy being. (See p. 126.)

kaiket. Tied (to someone).

kaja. Toward the mountain peak. (See pp. 40, 248–249.)

kangin. Toward the east.

kaponger. To be the victim of god-provoked disaster. (See p. 63.)

karang. Architectural design or pattern; houseyard.

karang bintulu. Carving pattern of a demon's face with one eye and a grimacing mouth with two fangs, four square teeth, and a protruding tongue.

karat. Radiance, high value.

karya. Ritual, work for the gods. (See p. 14.)

karya agung. Major ritual.

kasta (Ind.). Caste. (See p. 264.)

kauh. Toward the west.

kawi (Old Javanese and Old Balinese). To be created or composed; written language that is sacred, literary, and ancient.

kayu. Plant, wood.

kayun. Desire, intention, thought, heart.

kebyar. Genre of gamelan music new in the 1930s; a dance.

kehen. Rectangular-shaped altar with a door on the longer side and with multiple roofs.

kelod. Toward the sea. (See pp. 40, 248–249.)

kemajuan (Ind.). Progress.

kempur. Small gong.

kendang. Drum.

kenyir. Small metallophone.

kepala keluarga (Ind.). Governmentally considered head of the family.

kesan (Ind.). Feeling.

kewisésan. Sorcery; from *wisésa,* mystical power.

kikir. Stingy.

klian banjar. Head of a *banjar.*

komiti. Committee.

kongkrit (Ind.). Concrete.

korasi. From *dekorasi* (Ind.), decoration.

kori. Door.

krama banjar. Sub-organization of *krama désa.*

krama désa. Organization of congregation of village temple.

kuat (Ind.). Strength.

kulkul. Signal drum made of a hollow log.

kuren. Couple (usually husband and wife) who as a household are members of a temple group. (See p. 23.)

kuuban. Area, especially around a gate or door. (See p. 123.)

lawang. Door, in high register.

lawar. Feast dish made from various chopped-up meats, vegetables, spices, and raw uncooked blood.

leluhur. Ancestral spirit; from *luhur* or *luur,* high.

lemuh. Flaccid, flabby.

lén. Other, different.

letuh or **leteh.** Impure, polluted, dangerous.

léyak. Form a sorcerer can take.

lingga (Sanskrit). Tall, columnar form symbolizing Shiva.

lontar. Book whose pages are made of palm leaves.

lugra. To consent, give permission.

lungsuran. Leftover food on someone's plate.

luur. See *leluhur.*

mabakti. Act of worship.

macaru. To present offerings to the demons; from *caru,* ritual of offering to demons on the ground. (See p. 55.)

madya. Middle level between *nista* and *utama.*

maiasan. To be ornamented or made beautiful, decorated; from *ias,* ornamented or beauty.

makiis. Procession to the sea and making of offerings there to gods and demons.

manca. Minister or representative of a king.

mandala. Circular form of ritual offerings, with star-like positions of various deities around its edges. (See p. 39.)

mangku dalang. Priest whose ritual consists of putting on a shadow play.

manis. Sweet, refined.

mantra. Spell or prayer; ritual offerings in a circular form, with various star-shaped deities positioned around it.

marhaénisme (Ind.). Populism.

masupatin. To free an object of mystical flaws; from *supat,* to dissolve flaws, to free from sin.

maturan. To present offerings to the deities; from *atur,* to speak or to present something to a higher being. (See pp. 54–55.)

maturan ajuman. A kind of offering.

maturan piodalan. Ritual of offering to gods at the time of the *odalan.*

maturan ring segara. Presentation of offerings to the gods at the sea.

mawinten. To have been purified or consecrated.

melasti. Ritual march of the gods to the sea.

melénan. Different.

merdeka (Ind.). Freedom.

merta. See *amerta.*

méru. Type of roof on an altar; type of altar with multiple roofs.

méru agung. Major shrine in a temple.

mlaspasin. To purify an object so that it can serve as the vehicle of a deity; from *plaspas,* to be purified.

mode. Manner or mode.

mode baru (Ind.). New style.

mode kuna (Ind.). Old-fashioned or traditional style.

mrajan. Houseyard temple in upper register, contrasting with *sangga* in the lower register.

mrajan désa. Set of shrines where god-figures of the *pura désa* are stored between rituals (in the houseyard temple of the priest).

muput. To complete; from *puput,* completed.

nangkil. To come before or pay respects to a higher personage; from *tangkil,* to be paid respect.

nawasari. Dance pose with one hand above the head and one foot forward.

nebus or **nebas.** To redeem a debt.

némpél. To lean against; from *témpél,* to be stuck to, adhere to.

ngayah. See *ayah.*

ngelarang. To oppose or forbid; from *larang,* to forbid, prohibit.

ngéling. See *éling.*

ngiring betara. To escort the gods; from *iring,* to be accompanied, in the high register.

nguntap. To invite; from *untap,* to be invited; closing ritual.

nguub. To mark off an area around a gate; see *kuuban.*

niskala. Invisible, intangible.

niskala beings. Invisible, intangible beings, gods, demons, spirits. (See p. 36.)

nista. Humble, low, despised.

nunas. To request something.

nunas ica. To ask a respected person for a blessing.

nunas rahayu. To ask a respected person for a blessing of well-being.

nyaga-nyaga. To guard continuously; from *jaga,* to guard or watch over.

Nyepi. Day of silence at the end of Taur Kesanga.

nyidiang. To be able (to do something); from *sidi,* efficacious.

nyikut. To measure out; from *sikut,* measure.

nyikut karang. To lay out a new houseyard.

nyungsung. See *sungsung.*

odalan. Calendar-scheduled temple festival.

Padmasana. Shrine for Betara Siwa.

pajati. Ritual offering indicating the reliability and truth of the worshiper; from *jati,* truthfulness and sincerity.

pajenengan or *pajeneng.* Inner area of a temple where the deities are enthroned; from *jeneng,* to live or reign, in highest register.

pakéling. Ritual remembrance or call to attention; see *éling,* to remember.

palih. Architectural form of horizontal strata.

palinggih or *palinggihan.* Altar for the highest deities; object that may be a vehicle for a deity; from *linggih,* to be seated, in the highest register.

pamaksan. One who supports a temple; from *paksa,* group.

pamangku or *mangku.* Temple priest. (See pp. 24–25.)

pamedalan. Gate or door.

pamijian. One who is excused from colonial road building; formerly a servant of the king. (See p. 102.)

panangkilan. Altar that deities from other temples can visit; from *tangkil,* to visit.

pandil. Wood carving to be used as privet stand for a teapot.

pangamel. One who holds (something); from *gamel,* to hold or grasp, in high register.

pangamong. One who supports a temple; from *among,* to give care, to tend.

pangapit. To pinch or grip from two sides.

pangarep. Head of family, one who supports a temple; from *arep,* foremost full member of a temple.

pangastawa. Prayer stating purpose of offerings.

pangayah. One who is required to work for the colonial government building roads; formerly, a person who does *ayah* work for the gods. (See p. 102.)

pangebek. Filler; from *bek,* complete, full.

pangémpélan. From *témpél,* to stick to, to border.

pangempon. One who supports a temple; from *empu,* to take care of.

panggung. Temporary altar placed outside the gates of a temple. (See pp. 51–52.)

pangiring. One who accompanies another of higher status; from *iring,* to accompany, in high register.

pangléyakné. Ability of a *léyak* or sorcerer.

panglukatan. Ritual cleansing.

pangrombo désa. Group of women who make small offerings for daily temple rituals.

pangurus. Organizer.

panjak. Retainer, soldier.

panti. A kind of temple group.

panyarikan. Scribe or secretary.

panyawangan. Altar from which to send offerings to distant altars; from *cawang,* to concentrate one's thought so as to make contact with a distant god.

panyimpenan. Altar in which to store god-figures; from *simpen,* to be stored.

panyungsung. One who supports a temple; from *sungsung,* to be supported on one's head.

paras. Stone, volcanic tuff, or sometimes limestone.

parekan. Servant.

Pasek. Category for upper-level commoners of higher status.

pasimpangan. Altar where deities visit temporarily; from *simpang,* to visit.

pasukan (Ind.). Soldier; *pasukan-pasukan,* troops. (See p. 197.)

patih. Minister of the king in dance-drama.

patra. Pattern for carving; see *karang.*

patut. Appropriate, fitting.

pawisik. To be given a message from a deity; from *wisik,* spiritual inspiration.

pecatu. Rice fields, the tillage of which also requires service to a king or lord.

pedanda. Brahmana priest. (See pp. 24–25.)

pegawai (Ind.). Civil servant.

pekayuné. Thoughts, feelings, intentions.

pemuda (Ind.). Youth.

penasar. Clown-servant in shadow play and other dramas. (See p. 32.)

penyarikan. Scribe or secretary.

persatuan (Ind.). Unity, solidarity.

pesuan. Dues in an organization.

petingan. Kind of bird.

pidato (Ind.). Political speech.

pinandita. Priest.

pinget. Magically powerful, needing concealment.

polos. Simple. (See p. 146.)

prabawa. See *wibawa.*

prabekel. Government head of a village; formerly a vassal of a raja.

prajuru désa. Leader or organizer within *krama désa.* (See p. 21.)

prani. Offerings to the gods given at the time of a *taur.*

prarai. Figure that serves as a vehicle for a deity; see *pratima* and *arca.*

prasasti. Charter, inscription, edict. (See p. 78.)

prasutri. Priest.

pratima. Figure that serves as a vehicle for a deity.

punggawa. Governmental head of a region; formerly a vassal of a raja.

pura. Temple.

pura dalem. Temple next to village cemetery and burning ground.

pura désa. Temple of the village territory.

pura lumbung. Temple for harvest.

pura panti. Temple for a small group, usually kinsmen. (See pp. 47–48.)

puri. Palace.

pusaka. Heirloom.

rahayu. Well-being and safety. (See p. 164.)

rahina. Holy day.

raksasa. Demon, ogre.

ramé. Lively, crowded, busy, copious. (See p. 146.)

rangda. Widow in archaic speech; the mask of the widowed queen in the play *Calon Arang.*

rapi (Ind.). Neat.

regen. Governmental head of a large region, often a former king; from Dutch "regent."

rejang. Sacred dance.

renyep. Depth of cut.

residen. Dutch colonial regional officer; from Dutch "resident."

riset (Ind.). Research.

roang. Friend or helper.

roban jero. Retainers of king or noble.

rsi. Priest.

rsi bujangga. Priest.

rum. Fragrant.

rumit. Entangled, complex. (See p. 149.)

saé. Stylized facelike pattern of a demon with one eye and large teeth; a demon face with squinting eyes.

saksi. To witness.

sakti. Mystical power or mastery. (See pp. 73, 163.)

sané nyungsung pura. Those who support the temple.

sanggah. Household or houseyard temple of commoner.

sangging. Artisan.

sastra. Literature.

Satria. Category in title system.

saung. Gamecock.

sawan ujan. Bird with red feathers.

segehan. Small-sized ritual of offering to demons on the ground.

seh. Movement. (See p. 154.)

seka. Organization.

sembah. Gesture of worship of joined hands above the forehead.

sendi. Post, support.

seni (Ind.). Art, artfulness. (See p. 149.)

sikut. Measurement; see *nyikut.*

simpang. To stop in, to visit.

singa. Lion.

sirih. Kind of leaf chewed with betel nuts.

sisia. Ritual clients, usually of a Brahmana priest.

soda. Offering consisting of a decorated plateful of food.

soroh. Kind, group, category.

sri empu. Priest.

Suarga. The other, invisible, world.

subak. Group of rice fields irrigated from a single source of water; the organization of farmers who own and work the land within a *subak.*

suci. Pure, purity, sacred, safe. (See pp. 68–69.)

sudrawangsa. The "lowest kind" of people, the commoners. (See pp. 17–18.)

sulinggih. Priest.

sungsung. To be carried on one's head. (See pp. 13–14.)

surya. Sun.

tabuh rah. Libation of blood.

tandak. Singer.

tandang. Dance posture or movement.

tangkep. Boldness, strength, energy, elegance.

tantri. Genre of folktale with animal characters, usually derived ultimately from Indic stories.

taur. Large-sized ritual of offering to demons on the ground.

taur kasanga. Ritual at the end of the ninth Balinese month. (See p. 44.)

tegal. Dry garden land.

tegep. Complete.

témpék. Small group of people in a specific territory or area. (See p. 23.)

tenget. Haunted, sacred, dangerous. (See p. 7.)

tetuek pekayuné. To concentrate or focus one's thoughts.

tileh. Complete.

tipat. Package of cooked rice.

tirta. Holy water.

tirta kamandalu. Holy water made from seawater.

titiran. Turtle dove.

topéng pajegan. Masked dance ritual.

toya panglukatan. Holy water for ritual cleansing; also *tirta panglukatan.*

tri hita karana. Sanskrit-derived phrase meaning roughly "the three fundamental principles" or "the three sources of well-being."

triwangsa. The "three upper kinds" of titled people, the nobles or gentry. (See pp. 17–18.)

tukang. Artisan.

tukang banten. Specialist in making offerings.

tukang pahat. Stone-carver.

tukang ukir. Wood-carver.

ulaka. Brahmana man who is a ritual expert but not a *pedanda.*

ulun swi. Temple on the upper edge of a rice field.

umat (Ind.). People.

undagi. Builder, carpenter, stone-carver.

urip. Vitality.

utama. Highest, excellent, majestic.

utang. Debts.

utuh. Complete.

wangsa. Kind of person, category.

wantilan. Large pavilion for dances and cockfights.

waringen. Sacred banyan tree; also *wringen.*

wayang. Shadow play.

wayang wong. Dance in which dancers imitate shadow puppets.

wéda. Prayer.

wenara. Monkey.

Wesia. Category in title system.

wibawa. Greatness, glory, exaltation. (See p. 72.)

widiadara-widiadari. Spirits, angels.

wuku. Week in Balinese sacred calendar.

yoni (Sanskrit). Concave form symbolizing Shakti.

Bibliography

Alsop, Joseph. 1982. *The Rare Art Traditions: The History of Art Collecting and Its Linked Phenomena Wherever These Have Appeared.* Princeton, N.J.: Princeton University Press; and New York: Harper and Row.

Anderson, Benedict. 1972. "The Idea of Power in Javanese Culture." In *Culture and Politics in Indonesia,* ed. Claire Holt, 1–69. Ithaca, N.Y.: Cornell University Press.

Anderson, Richard L. 1989. *Art in Small-Scale Societies.* 2d ed. Englewood Cliffs, N.J.: Prentice-Hall.

Bagus, I Gusti Ngurah. 1969. "Pertentangan Kasta dalam Bentuk Baru pada Masyarakat Bali" [Caste conflict in a new form in Balinese society]. Denpasar: Universitas Udayana.

———. 1974. "'Karya Taur Agung Ekadasa Rudra': Rite Centenaire de Purification au Temple de Besakih (Bali)" [Centenary ritual of purification at the Temple of Besakih (Bali)]. *Archipel* 8.

———. 1991. "Bali in the 1950s: The Role of the Pemuda Pejuang in Balinese Political Processes." In *State and Society in Bali,* ed. Hildred Geertz. Leiden: KITLV Press.

Bakhtin, M. M. 1981. "Discourse in the Novel." In *The Dialogic Imagination,* ed. Michael Holquist. Austin: University of Texas Press.

Bakker, F. L. 1993. *The Struggle of the Hindu Balinese Intellectuals: Developments in Modern Hindu Thinking in Independent Indonesia.* Amsterdam: VU University Press.

Ballot, A. M., "Report Controleur" [Controller's report]. ARA, Min v. Kol. V 4-9-1917, no. 32., 18-2-1916.

Bandem, I Madé. 1980. "Wayang Wong in Contemporary Bali." Ph.D. diss., Wesleyan University.

———. 1983. *Ensiklopedi Tari Bali* [Encyclopedia of Balinese dance]. Denpasar: Akademi Seni Tari Indonesia.

Bandem, I Madé, and Frederik Eugene deBoer. 1981. *Kaja and Kelod: Balinese Dance in Transition.* Kuala Lumpur: Oxford University Press.

Barber, C. C. 1979. *Dictionary of Balinese-English.* Aberdeen: University of Aberdeen.

Barth, Fredrik. 1993. *Balinese Worlds.* Chicago: University of Chicago Press.

Bateson, Gregory. 1978 [1967]. "Style, Grace, and Information in Primitive Art." In *Steps to an Ecology of Mind.* London: Granada.

Bateson, Gregory, and Margaret Mead. 1942. *Balinese Character.* New York: N.Y. Academy of Sciences.

Baxandall, Michael. 1985. *Patterns of Intention: On the Historical Explanation of Pictures.* New Haven, Conn.: Yale University Press.

Becker, Howard S. 1982. *Art Worlds.* Berkeley: University of California Press.

Belo, Jane. 1953. *Bali: Temple Festival.* New York: J. J. Augustin.

———. 1960. *Trance in Bali.* New York: Columbia University Press.

Belting, Hans. 1994. *Likeness and Presence: A History of the*

Image Before the Era of Art. Chicago: University of Chicago Press.

Bernet Kempers, A. J. 1991. *Monumental Bali: Introduction to Balinese Archeology and Guide to the Monuments.* Berkeley, Calif.: Periplus Editions.

Bonnet, R. 1936. "Beeldende Kunst in Gianjar." *Djawa* 16:60–73.

———. N.d. [1953?] "A New Era, a New Art." In *Bali: Atlas Kebudajaan (Bali: Cults and Customs),* ed. R. Goris.

Boon, James A. 1977. *The Anthropological Romance of Bali, 1597–1972: Dynamic Perspectives in Marriage and Caste, Politics and Religion.* Cambridge: Cambridge University Press.

———. 1990. *Affinities and Extremes.* Chicago: University of Chicago Press.

Bourdieu, Pierre. 1968. "Outline of a Sociological Theory of Art Perception." *International Social Science Journal* 20 (4): 589–612.

Brinkgreve, Francine. 1992. *Offerings: The Ritual Art of Bali.* Sanur, Bali: Image Network Indonesia.

Clifford, James. 1988a [1983]. "On Ethnographic Authority." In *The Predicament of Culture.* Cambridge: Harvard University Press.

———. 1988b [1985]. "Histories of the Tribal and the Modern." In *The Predicament of Culture.* Cambridge: Harvard University Press.

Cole, William Stadden. 1983. "Balinese Food-Related Behavior: A Study of the Effects of Ecological, Economic, Social, and Cultural Processes on Rates of Change." Ph.D. thesis submitted to Department of Anthropology, Washington University, St. Louis.

Connor, Linda. 1982. "In Darkness and Light: A Study of Peasant Intellectuals in Bali." Ph.D. thesis, Department of Anthropology, University of Sydney.

———. 1986a. "Balinese Healing." In Linda Connor, Patsy Asch, and Timothy Asch, *Jero Tapakan: Balinese Healer—An Ethnographic Film Monograph.* Cambridge: Cambridge University Press.

———. 1986b. "A Balinese Trance Séance and Jero on Jero: 'A Balinese Trance Séance Observed.'" In Linda Connor, Patsy Asch, and Timothy Asch, *Jero Tapakan: Balinese Healer—An Ethnographic Film Monograph.* Cambridge: Cambridge University Press.

Coote, Jeremy. 1992. "'Marvels of Everyday Vison': The Anthropology of Aesthetics and the Cattle-Keeping Nilotes." In *Anthropology, Art, and Aesthetics,* ed. Jeremy Coote and Anthony Shelton. Oxford: Clarendon.

Coote, Jeremy, and Anthony Shelton, eds. 1992. *Anthropology, Art, and Aesthetics.* Oxford: Clarendon Press.

Covarrubias, Miguel. 1956 [1936]. *Island of Bali.* New York: Alfred A. Knopf.

Danandjaja, James. 1980. *Kebudayaan Petani Desa Trunyan di Bali* [The culture of the farmers of Trunyan village in Bali]. Jakarta: Pustaka Jaya.

Dewey, John. 1980 [1934]. *Art as Experience.* New York: G. P. Putnam's Sons.

deZoete, Beryl, and Walter Spies. 1973 [1938]. *Dance and Drama in Bali.* Kuala Lumpur: Oxford University Press.

Echols, John M., and Hassan Shadily. 1961. *An Indonesian-English Dictionary.* Ithaca, N.Y.: Cornell University Press.

Eiseman, Fred B., Jr. 1989. *Bali: Sekala and Niskala.* Vol. 1: *Essays on Religion, Ritual, and Art.* Berkeley, Calif.: Periplus Editions.

———. 1990. *Bali: Sekala and Niskala.* Vol. 2: *Essays on Society, Tradition, and Craft.* Berkeley, Calif.: Periplus Editions.

Emigh, John. 1979. "Playing with the Past: Visitation and Illusion in the Mask Theatre of Bali." *Drama Review* 23 (June).

Freedberg, David. 1989. *The Power of Images: Studies in the History and Theory of Response.* Chicago: University of Chicago Press.

Friederich, R. 1959. *The Civilization and Culture of Bali.* Calcutta: Susil Gupta (India).

Geertz, Clifford. 1964. "Form and Variation in Balinese Village Structure." *American Anthropologist* 61:1–33.

———. 1973 [1964]. "'Internal Conversion' in Contemporary Bali." In *The Interpretation of Cultures.* New York: Basic Books.

———. 1980. *Negara: The Theatre State in Nineteenth-Century Bali.* Princeton, N.J.: Princeton University Press.

———. 1983 [1976]. "Art as a Cultural System." In *Local Knowledge: Further Essays in Interpretive Anthropology.* New York: Basic Books.

Geertz, Hildred. 1986. "Seribu Tahun yang Lalu di Bali: Suatu Pandangan Dari Sudut Ilmu Antropologi" [A

thousand years ago in Bali: An anthropological view]. *Bali Post,* July 20 and 22.

———. 1991. "A Theatre of Cruelty: The Contexts of a Topéng Performance." In *State and Society in Bali,* ed. Hildred Geertz. Leiden: KITLV Press.

———. 1994. *Images of Power: Balinese Paintings Made for Margaret Mead and Gregory Bateson.* Honolulu: University of Hawai'i Press.

———. 1995. "Sorcery and Social Change in Bali: The *Sakti* Conjecture." Paper presented at the Conference "Bali in the Late Twentieth Century," Sydney, July.

Geertz, Hildred, and Clifford Geertz. 1975. *Kinship in Bali.* Chicago: University of Chicago Press.

Gelebet, Ir. I Nyoman. 1981–1982. *Arsitektur Tradisional Daerah Bali* [Traditional architecture in Bali]. Bali: Departemen Pendidikan dan Kebudayaan, Proyek Inventarisasi dan Dokumentasi Kebudayaan Daerah.

Gell, Alfred. 1992. "The Technology of Enchantment and the Enchantment of Technology." In *Anthropology, Art, and Aesthetics,* ed. Jeremy Coote and Anthony Shelton. Oxford: Clarendon Press.

———. 1993. *Wrapping in Images: Tatooing in Polynesia.* Oxford: Clarendon Press.

———. 1998. *Art and Agency: An Anthropological Theory.* Oxford: Clarendon Press.

Gerdin, Ingela. 1982. *The Unknown Balinese: Land, Labour, and Inequality in Lombok.* Goteberg, Sweden: Acta Universitatis Gothoburgensis.

Goffman, Erving. 1974. *Frame Analysis.* New York: Harper and Row.

Gombrich, E. H. 1960. *Art and Illusion: A Study in the Psychology of Pictorial Representation.* Washington, D.C.: National Gallery of Art.

———. 1968. "Style." In *The Encyclopedia of the Social Sciences,* ed. David L. Sills. New York: Macmillan and the Free Press.

———. 1972. "Introduction: Aims and Limits of Iconology." In *Symbolic Images: Studies in the Art of the Renaissance.* Oxford: Phaidon Press.

Goodman, Nelson. 1968. *Languages of Art.* New York: Bobbs-Merrill.

———. 1978. *Ways of Worldmaking.* Indianapolis: Hackett.

Goris, R. N.d. [1953?]. *Bali: Atlas Kebudayaan* [Cults and customs]. Djakarta: Republic of Indonesia.

———. 1954. *Prasasti Bali* [Balinese inscriptions]. 2 vols. Bandung, Indonesia: Lembaga Bahasa dan Budaja, Universitet Indonesia.

———. 1960a [1929]. "The Position of the Blacksmiths." In *Bali: Studies in Life, Thought, and Ritual,* ed. W. F. Wertheim et al. The Hague: W. van Hoeve.

———. 1960b [1933]. "Holidays and Holy Days." In *Bali: Studies in Life, Thought, and Ritual,* ed. W. F. Wertheim et al. The Hague: W. van Hoeve.

———. 1960c [1935]. "The Religious Character of the Village Community." In *Bali: Studies in Life, Thought, and Ritual,* ed. W. F. Wertheim et al. The Hague: W. van Hoeve.

———. 1960d [1938]. "The Temple System." In *Bali: Studies in Life, Thought, and Ritual,* ed. W. F. Wertheim et al. The Hague: W. van Hoeve.

Goudriaan, T., and C. Hooykaas. 1971. *Stuti and Stava (Bauddha, Saiva, and Vaisnava) of Balinese Brahman Priests.* Amsterdam: North Holland Publishing.

Grader, C. J. 1960a [1939]. "Pemayun Temple of the Banjar of Tegal." In *Bali: Studies in Life, Thought, and Ritual,* ed. W. F. Wertheim et al. The Hague: W. van Hoeve.

———. 1960b [1949]. "The State Temples of Mengwi." In *Bali: Studies in Life, Thought, and Ritual,* ed. W. F. Wertheim et al. The Hague: W. van Hoeve.

Guermonprez, Jean-Francois. 1980. "On the Elusive Balinese Village: Hierarchy and Values versus Political Models." *Review of Indonesian and Malaysian Affairs* 24:55–89.

———. 1987. *Les Pandé de Bali* [The Pandé of Bali]. Paris: École Francaise d'Extreme-Orient.

Haering, Wolfram. 1981. *Touristische Kommerzialisierung der Balinesischen Malerei.* Bielefeld: Diplomarbeit, Fakultat fur Soziology, Univeristat Bielefeld.

Hanna, Willard A. 1972. "Too Many Balinese." In American Universities Field Staff, *Fieldstaff Reports,* Southeast Asia series, 20 (1).

Hauser-Schaublin, Brigitta. 1993. "Keraton and Temples in Bali: The Transcendent Organization of Rulership between Center and Periphery." In *Urban Symbolism,* ed. Peter Nas. Leiden: E. J. Brill.

———. 1997. *Traces of Gods and Men: Temples and Rituals as*

Landmarks of Social Events and Processes in a South Bali Village. Berlin: Dietrich Reimer Verlag.

Hinzler, H. I. R. 1976. "The Balinese Babad." In *Profiles of Malay Culture: Historiography, Religion, and Politics,* ed. Sartono Kartodirdjo. Jakarta: Ministry of Education and Culture.

———. 1986. "The Usana Bali as a Source of History." In *Papers of the Fourth Indonesian-Dutch History Conference,* ed. Taufik Abdullah. Yogyakarta: Gadjah Mada University.

———. 1987. *Catalogue of Balinese Manuscripts.* Leiden, E. J. Brill.

———. 1995. "Building in Bali Past and Present: A Question of Re-Orientation." Paper presented at the Third International Bali Studies Workshop, Sydney, July.

Hobart, Angela. 1987. *Dancing Shadows of Bali.* London: KPI.

Hobart, Angela, Urs Ramseyer, and Albert Leeman. 1996. *The Peoples of Bali.* Oxford: Blackwell.

Hobart, Mark. 1975. "Orators and Patrons: Two Types of Political Leader in Balinese Village Society." In *Political Language and Oratory in Traditional Society,* ed. Maurice Bloch, 65–92. London: Academic Press.

———. 1979. "A Balinese Village and Its Field of Social Relations." Ph.D. thesis submitted to School of Oriental and African Studies, University of London.

———. 1990. "The Patience of Plants: A Note on Agency in Bali." *Review of Indonesian and Malaysian Affairs* 24:90–135.

Hohn, Klaus D. 1997. *Reflections of Faith: The History of Painting in Batuan (1834–1994).* Netherlands: Pictures Publishers Art Books.

Holt, Claire. 1967. *Art in Indonesia: Continuities and Change.* Ithaca, N.Y.: Cornell University Press.

Hooykaas, C. 1964. *Agama Tirta: Five Studies in Hindu-Balinese Religion.* Amsterdam: Noord-Hallandsch Uitgevers Maatschappij.

———. 1966. *Surya-Sevana: The Way to God of a Balinese Siva Priest.* Amsterdam: Noord-Hollandsch Uitgevers Maatschappij.

———. 1974. *Cosmogony and Creation in Balinese Tradition.* The Hague: Martinus Nijhoff.

———. 1977. *A Balinese Temple Festival.* The Hague: Martinus Nijhoff.

Hooykaas-Van Leeuwen Boomkamp, Jacoba. 1961. *Ritual Purification of a Balinese Temple.* Amsterdam: Noord-Hollandsche Uitgevers Maatschappij.

Howe, L. E. A. 1983. "An Introduction to the Study of Traditional Balinese Architecture." *Archipel* 25:137–158.

———. 1984. "Gods, People, Spirits, and Witches: The Balinese System of Person Definition." *Bijdragen tot de Taal-, Land-, and Volkenkunde* 140:193–222.

———. 2001. *Hinduism and Hierarchy in Bali.* Oxford: James Currey, Santa Fe, School of American Research Press.

Indonesia Source Book. 1996. Jakarta: Indonesia National Development Information Office.

Jenkins, Ron. 1994. *Subversive Laughter: The Liberating Power of Comedy.* New York: Free Press.

Jensen, Gordon D., and Luh Ketut Suryani. 1992. *The Balinese People: A Reinvestigation of Character.* Singapore: Oxford University Press.

Kagami, Haruya. 1988. *Balinese Traditional Architecture in Process.* Inuyama, Japan: Little World Museum of Man.

Kamus Bali-Indonesia [Dictionary, Balinese to Indonesian]. 1990. Denpasar: Dinas Pendidikan Dasar, Propinsi DATI I Bali.

Karang, Tjokorda Gedé Oko. 1983. *Monographie Désa Batuan, Kecamatan Sukawati, Gianyar* [A monograph on the village of Batuan, Sukawati, Gianyar]. Batuan: Kantor Kepala Désa Batuan.

Keesing, Roger. 1984. "Rethinking *Mana.*" *Journal of Anthropological Research* 40 (1): 137–156.

Kersten. 1984. *Bahasa Bali* [The Balinese language]. Ende, Flores: Penerbit Nusa Indah.

Korn, V. E. 1932. *Het Adatrecht van Bali* [The adat law of Bali]. The Hague: G. Naeff.

———. 1960 [1926]. "The Village Republic of Tenganan Pegeringsingan." In *Bali: Studies in Life, Thought, and Ritual,* ed. W. F. Wertheim et al. The Hague: W. van Hoeve.

Lansing, J. Stephen. 1974. *Evil in the Morning of the World: Phenomenological Approaches to a Balinese Community.* Ann Arbor: Center for South and Southeast Asian Studies, University of Michigan.

———. 1983. *The Three Worlds of Bali.* New York: Praeger.

———. 1991. *Priests and Programmers: Technologies of Power in*

the Engineered Landscape of Bali. Princeton, N.J.: Princeton University Press.

———. 1995. *The Balinese.* Fort Worth, Tex.: Harcourt Brace College Publishers.

Lovric, Barbara. 1987. "Rhetoric and Reality: The Hidden Nightmare." Ph.D. thesis, Department of Indonesian and Malayan Studies, University of Sydney.

MacRae, Graeme. 1996. "Ubud: Cultural Networks and History." Paper presented at the Third International Bali Studies Workshop, University of Sydney, July 3–7.

———. 1997. "Economy, Ritual, and History in a Balinese Tourist Town." Ph.D. thesis, Department of Anthropology, University of Auckland, New Zealand.

MacRae, Graeme, and Sam Parker. 2002. "Would the Real *Undagi* Please Stand Up? On the Social Location of Balinese Architectural Knowledge." *Bijdragen tot de Taal-, Land- en Volkenkunde* 158 (2): 253–281.

Maquet, Jacques. 1979. *Introduction to Aesthetic Anthropology.* Malibu, Calif.: Undena Publications.

Malraux, André. 1967 [1947]. *Museum Without Walls.* New York: Doubleday.

Marcus, George E., and Fred R. Myers. 1995. *The Traffic in Culture.* Berkeley: University of California Press.

Marriot, McKim. 1976. "Hindu Transactions: Diversity without Dualism." In *Transaction and Meaning,* ed. B. Kapferer. ASA Essays in Anthropology 1. Philadelphia: ISHI Publications.

McCauley, Ann P. 1984. "The Cultural Construction of Illness in Bali." Ph.D. thesis, diss., Department of Anthropology, University of California, Berkeley.

McPhee, Colin. 1966. *Music in Bali.* New Haven, Conn.: Yale University Press.

Mershon, Katharane Edson. 1971. *Seven Plus Seven: Mysterious Life Rituals in Bali.* New York: Vantage Press.

Meyerhoff, Barbara. 1978. *Number Our Days.* New York: Simon and Schuster.

Mitchell, W. J. T. 1986. *Iconology: Image, Text, Ideology.* Chicago: University of Chicago Press.

Mitter, Partha. 1977. *Much Maligned Monsters: History of European Reactions to Indian Art.* Oxford: Clarendon Press.

Moojen, P. A. J. 1926. *Kunst Op Bali: Inleidende Studie tot de Bouwkunst* [Art in Bali: Introductory studies in architecture]. Den Haag: Adi Poestaka.

Morphy, Howard. 1991. *Ancestral Connections: Art and an Aboriginal System of Knowledge.* Chicago: University of Chicago Press.

———. 1992. "From Dull to Brilliant: The Aesthetics of Spiritual Power among the Yolngu." In *Anthropology, Art, and Aesthetics,* ed. Jeremy Coote and Anthony Shelton. Oxford: Clarendon Press.

Myers, Fred R. 1989. "Truth, Beauty, and Pintupi Painting." *Visual Anthropology* 2:163–195.

Neuhaus, Hans. 1937. "Barong," *Djawa* 17 (5) and (6):230–239.

Nieuwenkamp, W. O. J. 1922. *Zwerftochten op Bali* [Travels in Bali]. Amsterdam: Elsevier.

O'Neill, Roma M. G. Sisley. 1978. "Spirit Possession and Healing Rites in a Balinese Village." M.A. thesis, Department of Indonesian and Malayan Studies, University of Melbourne.

Ottino, Arlette. 2000. *The Universe Within: A Balinese Village through Its Ritual Practices.* Paris: Editions Karthala.

Panofsky, Erwin. 1955 [1939]. *Meaning in the Visual Arts.* Garden City, N.Y.: Doubleday.

Picard, Michel. 1996. *Bali: Cultural Tourism and Touristic Culture.* Singapore: Archipelago Press.

———. 1999. "The Discourse of Kebalian: Transcultural Constructions of Balinese Identity." In *Staying Local in the Global Village,* ed. R. Rubenstein and L. Connor. Honolulu: University of Hawai'i Press.

Pitana, I Gde. 1997. "In Search of Difference: Origin Groups, Status, and Identity in Contemporary Bali." Ph.D. thesis, Australian National University.

Proyek Pelita Pemugaran dan Pemiliharaan Peninggalan Sejarah dan Purbakala Bali [Project to guide the restoration and maintenance of historic and prehistoric relics in Bali]. Departemen P & K, Bali. 1981–1982. "Pura Désa Batuan."

Pudja (Puja), Gede. 1985. *Pengantar Agama Hindu Untuk Perguruan Tinggi* [Guide to the Hindu religion for university level]. Jakarta: Mayasari.

Puniatmaja, I. B. Oka. N.d. [before 1985]. *Hinduism.* Nusa Dua, Bali: Pusat Pendidikan Perhotelan dan Pariwisata—Bali.

Putra, I Gusti Agung Mas. 1983. *Mejejaitan: Merangkai Janur di Bali* [Making offerings: Weaving palm leaves in Bali]. Denpasar: Proyek Penyuluhan Agama Propinsi Bali, Perwakilan Dep. Agama Propinsi Bali.

———. 1987. *Upakara Manusa Yadnya* [Rituals for human beings]. Denpasar: Proyek Penyuluhan Agama Propinsi Bali, Perwakilan Dep. Agama Propinsi Bali.

Ramseyer, Urs. 1977. *The Art and Culture of Bali*. Oxford: Oxford University Press.

Rein, Anette. 1994. *Tempeltanz auf Bali: Rejang—der Tanz der Reisseelen* [Temple dance in Bali: Rejang—the Dance of the Souls of the Rice]. Munster, Hamburg: LIT Verlag.

Reuter, Thomas Anton. 2002. *Custodians of the Sacred Mountains: Culture and Society in the Highlands of Bali*. Honolulu: University of Hawai'i Press.

Rhodius, Hans, and John Darling. 1980. *Walter Spies and Balinese Art*. Amsterdam: Tropical Museum.

Robinson, Geoffrey. 1995. *The Dark Side of Paradise: Political Violence in Bali*. Ithaca, N.Y.: Cornell University Press.

Robson, Stuart O. 1972. "The Kawi Classics in Bali." *Bijdragen tot de Taal-, Land- en Volkenkunde* 128:308–329.

De Roever-Bonnet, H. 1991. *Rudolf Bonnet, Een Zondagskind, Zijn Leven en Zijn Werk* [Rudolf Bonnet: A Sunday child, his life and his work]. Wijk en Alburg, Netherlands: Pictures Publishers.

Rosen, Lawrence, ed. 1995. *Other Intentions: Cultural Contexts and the Attribution of Inner States*. Santa Fe, N.M.: School of American Research.

Rubin, William. 1984. "Modernist Primitivism: An Introduction." In *"Primitivism" in Twentieth Century Art,* ed. William Rubin. New York: Museum of Modern Art.

Rubinstein, Raechelle, and Linda Connor, eds. 1999. *Staying Local in the Global Village*. Honolulu: University of Hawai'i Press.

Ruddick, Abby. 1986. "Charmed Lives: Illness, Healing, Power, and Gender in a Balinese Village." Ph.D. thesis, Brown University.

Samuel, Geoffrey. 1993. *Civilized Shamans: Buddhism in Tibetan Societies*. Washington, D.C.: Smithsonian Institution Press.

Santikarma, Degung. 1997. "Upacara Tawur Kesanga di Desa Adat Batuan" [The ritual of Taur Kasanga in the Désa Adat Batuan], ms.

Schapiro, Meyer. 1994a [1953]. "Style." In *Theory and Philosophy of Art: Style, Artist, and Society: Selected Papers*. Vol. 4. New York: George Braziller.

———. 1994b [1966]. "On Perfection, Coherence, and Unity of Form and Content." In *Theory and Philosophy of Art: Style, Artist, and Society: Selected Papers*. Vol. 4. New York, George Braziller.

Schulte Nordholt, Henk. 1986–1987. "Stenen vreemdelingen op Bali" [Stone foreigners in Bali]." *Orion*, December–January, 8–12.

———. 1988. "Een Balische Dynastie: Hierarchie en Conflict in de Negara Mengwi, 1700–1940" [A Balinese dynasty: Hierarchy and conflict in the kingdom of Mengwi, 1700–1940]. Ph. D. dissertation, Vrije Universiteit te Amsterdam.

———. 1991a. *State, Village, and Ritual in Bali*. Amsterdam: Centre for Asian Studies, VU University Press.

———. 1991b. "Temple and Authority in South Bali, 1900–1980." In *State and Society in Bali,* ed. H. Geertz. Leiden: KITLV Press.

———. 1997. *The Spell of Power: A History of Balinese Politics, 1650–1940*. Leiden: KITLV Press.

Seebass, Tilman. 1996. "Change in Balinese Musical Life: Kebiar in the 1920s and 1930s." In *Being Modern in Bali: Image and Change,* ed. Adrian Vickers. New Haven, Conn.: Yale University Southeast Asia Studies.

Seebass, Tilman, and Gera van der Weijden. 1983. "Komprimierte Form eines 'gambuh' (Tanzdrama) in Batuan (Distrikt Gianyar, Bali)" [Compressed version of *gambuh* (dance drama) in Batuan (Gianyar District, Bali)]. A film with published notes. Gottingen: Institut fur den Wissenschaftlichen Film.

Seriarsa, I Wayan Sepur, with I Putu Renjana and I Wayan Widja. 1987. *Bimbingan Teknis Pemugaran Kolam Pura Puseh Batuan Gianyar* [Technical guide to the excavation of the water tank of Pura Puseh Batuan Gianyar]. Gianyar: Suaka Peninggalan Sejarah dan Purbakala Bali.

Shelton, Anthony. 1992. "Predicates of Aesthetic Judgement: Ontology and Value in Huichol Material Representations." In *Anthropology, Art, and Aesthetics,* ed. Jeremy Coote and Anthony Shelton. Oxford: Clarendon Press.

Stephen, Michele. 2001. "Barong and Rangda in the Con-

text of Balinese Religion." *Review of Indonesian and Malaysian Affairs* 35 (1): 35–193.

———. 2002. "Returning to Original Form: A Central Dynamic in Balinese Ritual." *Bijdragen tot de Taal-, Land- en Volkenkunde* 158 (1).

Strathern, Marilyn. 1988. *The Gender of the Gift.* Berkeley: University of California Press.

Stuart-Fox, David J. 1974. *The Art of the Balinese Offering.* Jakarta: Penerbitan Yayasan Kanisius.

———. 1982. *Once a Century: Pura Besakih and the Eka Dasa Rudra Festival.* Jakarta: Penerbit Sinar Harapan and Citra Indonesia.

———. 1987. *Pura Besakih: Temple, Religion, and Society.* Leiden: KITLV Press.

———. 1991. "Pura Besakih: Temple-State Relations from Precolonial to Modern Times." In *State and Society in Bali,* ed. Hildred Geertz. Leiden: KITLV Press.

Stutterheim, W. F. 1929. *Oudheden van Bali* [Antiquities of Bali]. 2 vols. Singaradja: Kirtya Liefrinck-van der Tuuk.

———. 1935. *Indian Influences in Old-Balinese Art.* London: India Society.

Suleiman, Susan R., ed. 1980. *The Reader in the Text: Essays on Audience and Interpretation.* Princeton, N.J.: Princeton University Press.

Suryani, Luh Ketut, and Gordon D. Jensen. 1993. *Trance and Possession in Bali: A Window on Western Multiple Personality, Possession Disorder, and Suicide.* Kuala Lumpur: Oxford University Press.

Sutaba, I Madé. *Prasejarah Bali* [Prehistory in Bali]. 1980. Denpasar: B. U. Yayasan Purbakala Bali.

Swellengrebel, J. L. 1948. *Kerk en Tempel op Bali* [Church and Temple in Bali]. The Hague: Van Hoeve.

———. 1960. "Introduction." In *Bali: Studies in Life, Thought, and Ritual,* ed. W. F. Wertheim et al. The Hague: W. van Hoeve.

Tan, Roger, Y. D. 1967. "The Domestic Architecture of South Bali." *Bijdragen tot de Land-, Taal- en Volkenkunde* 123 (4): 442–475.

Tenzer, Michael. 2000. *Gamelan Gong Kebyar: The Art of Twentieth-Century Balinese Music.* Chicago: University of Chicago Press.

Thompson, Robert Farris. 1973. "Yoruba Artistic Criticism." In *The Traditional Artist in African Societies,* ed. Warren L. d'Azevedo. Bloomington: Indiana University Press.

van der Kraan, Alfons. 1980. *Lombok: Conquest, Colonialization, and Underdevelopment, 1870–1940.* Singapore: Heineman.

———. 1995. *Bali at War: A History of the Dutch-Balinese Conflict of 1846–1849.* Clayton, Australia: Center of Southeast Asian Studies, Monash University.

Vickers, Adrian. 1984. "Ritual and Representation in Nineteenth-Century Bali." *Review of Indonesian and Malaysian Affairs* 18 (1).

———. 1986. "The Desiring Prince: A Study of the Kidung Malat as Text." Ph.D. dissertation, University of Sydney.

———. 1989. *Bali: A Paradise Created.* Victoria, Australia: Penguin.

———. 1991. "Ritual Written: The Song of the Ligya, or the Killing of the Rhinoceros." In *State and Society in Bali,* ed. Hildred Geertz. Leiden: KITLV Press.

———, ed. 1996. *Being Modern in Bali: Image and Change.* New Haven, Conn.: Yale Southeast Asia Studies.

Wang, Boyang. 1998. *Imperial Mausoleums and Tombs,* trans. Liu He. Vienna: Springer.

Warren, Carol. 1993. *Adat and Dinas: Balinese Communities in the Indonesian State.* Kuala Lumpur: Oxford University Press.

Weck, Prof. Dr. med. Wolfgang. 1976 [1937]. *Heilkunde und Volkstum auf Bali* [Medicine and national characteristics in Bali]. Jakarta: P. T. Intermasa.

Wertheim, W. F., et al., eds. 1960. *Bali: Studies in Life, Thought, and Ritual.* The Hague: W. van Hoeve.

Wiana, Drs. K., with Drs. Tjok. Raka Krisnu and I. B. Kade Sindhu, B.A. 1985. *Acara III.* Jakarta: Mayasari.

Wiener, Margaret J. 1995. *Visible and Invisible Realms: Power, Magic, and Colonial Conquest in Bali.* Chicago: University of Chicago Press.

———. 1996. "Doors of Perception: Power and Representation in Bali." *Cultural Anthropology* 10 (4).

Wikan, Unni. 1990. *Managing Turbulent Hearts: A Balinese Formula for Living.* Chicago: University of Chicago Press.

Williams, Raymond. 1977. *Marxism and Literature.* Oxford: Oxford University Press.

Witherspoon, Gary. 1977. *Language and Art in the Navajo Universe*. Ann Arbor: University of Michigan Press.

Wolters, O. W. 1982. *History, Culture, and Region in Southeast Asian Perspectives*. Singapore: Institute of Southeast Asian Studies.

Zoetmulder, P. J. (with S. O. Robson). 1982. *Old Javanese-English Dictionary*. The Hague: Martinus Nijhoff.

Zurbuchen, Mary Sabina. 1987. *The Language of Balinese Shadow Theater*. Princeton, N.J.: Princeton University Press.

Illustration Credits

All drawings are by Sandra Vitzthum unless otherwise indicated. Photograph credits are as follows:

Hildred Geertz: figures 1.1 (p. 3), 2.1 (p. 13), 2.3, 2.4, 2.5, 2.6, 2.7, 2.8, 2.9, 3.1 (p. 35), 3.4, 3.10, 3.11, 3.15, 3.16, 4.9, 4.12, 5.5 (right), 5.20, 5.21, 5.28, 7.5, 7.7, 7.9, 9.5, 9.6, 9.8, 9.9, 9.10, 9.11, 9.12, 9.13, 9.14, 9.15, 9.19, 9.20, 9.21, 9.22, 9.23, 9.24, 9.25, 9.26.

Sandra Vitzthum: figures 2.7, 3.5, 4.6, 4.8, 4.11, 4.13, 4.14, 4.15, 5.3, 5.4 (right), 5.5 (left), 5.6, 5.7, 5.8, 5.9, 5.10, 5.12, 5.22, 5.23, 5.25, 5.26, 5.30, 5.31, 5.32, 7.2, 9.2, 9.4, 9.27, 9.28, 9.29, 9.30, 9.31, 9.32, 9.33, 9.35, 9.36, 9.37.

Benjamin Geertz: figures 5.4 (left), 5.11, 5.13, 5.15, 5.16, 5.17, 5.24, 5.27, 6.3, 7.3, 7.10, 7.11, 7.12, 7.13, 7.14, 9.7.

Deborah Hill: figure 7.6.

Index

Djaboed, I, 198–199

Djata, I Madé, 177

door/gate area: *kuub,* 129; *kuuban,* 130, 132; *kuuban kori,* 123, 129, 183–186

doors: to altars, 114; guardians of, 129–138, **130, 132, 135–138,** 183–186; iconography of, 234–235; to temple, **46,** 114. *See also* door/gate area; gates, temple; Kori Agung

"double voicing," Bakhtinian, 10, 140–141, 148, 258n2

drama. *See* dance-drama; *gambuh;* shadow play

Dumont, Louis, 65

Dutch-appointed local officials, 102

earthquake of 1917, 104

edict. *See* Prasasti edict

education after 1950, 193

Eka Dasa Rudra, 64, 233, 252n51

Emigh, John, 259n50

emotion in art, 166

Empu Bharada, 234

Empu Kuturan, 234

evaluation, aesthetic, 71–72, 151. *See also* aesthetic categories, Balinese; interpretive frames

Freedberg, David, 260n58

Freud, Sigmund, 170

Friedrich, R., 255n21

gambuh (dance), 56, 185–190, 209, 261nn16–18, 20, 263n16; commoners and, 200–201, 209; *gambuh peksi* (of the birds), 211–212; introduction of, to Batuan, 187–190, 257n11, 261n19; link to *triwangsa,* 187–190, 209, 261n20, 263n16; in statues and carvings, 184, 185, 209, 211–212; teaching of, 95, 200–201, 263n15; vs. *topéng,* 186

Garuda, 118, 228, **229**

gates, temple, **46, 51,** 107–108, 120–123, **122,** 162; East Gate, 122, 183–186, 190; and god-passage, 70; kinds of

(closed vs. split), 19, **121;** South Gate, 51–52; South Split Gate, 121, 132–138, **135;** West Gate, 51–52, 122, 217, **223, 224,** 233–236. *See also* door/gate area; doors; Kori Agung; screens

Gell, Alfred, 8, 140, 165–167, 260nn54–57; his theory of art, 164–167; on meaning and communication, 166, 260n56

Gianyar noble house, 93

god-figures: bathing, 50; carrying, 50; order in procession, 50; returned to altars, 62; vs. ornaments, 115

gods and demons *(dewa* and *buta). See* deities/demons/spirits; *niskala* beings

Gombrich, E. H., 141, 144–145, 159, 258n5, 259n43; his "beholder's share," 159

good vs. evil, 39, 64

Goodman, Nelson, 259n43

Goris, Roelof, 78, 145–146, 249n16, 251n43, 252n48, 254nn3, 11

government: *désa adat/désa dinas,* 21, 102, 246n4, 256n6; *kepala keluarga,* 246n4; *klian dinas,* 256n6; *prabekel* (or *perbekel*), 102; *punggawa,* 102; *regen,* 102; *residen,* 102. *See also* civil servant class

Grader, C. J., 252nn48, 49, 261n4

harmony. *See* order

healers: *balian,* 37, 41–43, 249n17; *balian tapakan,* 28; *balian wisada,* 28

Hindu Dharma movement, xiii–xiv, 9–10, 36–41, 65, 66, 119–120, 126, 174, 206, 238, 248nn2, 3, 250n36. *See also* Arya Samaj; Parisada Hindu Dharma

Hinduism, 253n59; Balinese, 9–10; modernist, 37

Hinzler, H. I., 114, 247n21

Hobart, Mark, 26

Holt, Claire, 143, 144

holy water, 24, 57; from the sea, 59–61; networks, 49, 251n44

Hooykaas, C., 247n21, 253n59, 257nn21, 22

Howe, Leo, 247n21, 248n2

iconography. of demon heads, 123, **124;** of door, 234–235; *gambuh peksi,* 211–213; *lingga,* 87; of Padmasana, 119; of paintings on Balé Peselang, 228, **229;** of statues, 154–160, 219–221; of temple, 28–31. *See also* pattern; Ramayana

imaginative integration, 159

innovation, 6, 32, 78, 168, 217; after earthquake, 105–106. *See also* originality, Balinese value on

inside-outside. See *jaba-jero*

interpretive frames, xiii–xiv, 9, 36, 67–68, 134, 159–160, 242–243; and over-determination, 170–171. *See also* viewers, interpretive strategies of

Islam, 37

jaba-jero (inside-outside), 17, 67, 68, 199

Japanese occupation, 174

Jata, I Madé, from Pekandelan, 114, 213, 220, 221, 257n17, 259n38

Jedag, I, 218–219, 221

Jero Tapakan, 42

Jimat, I Madé, 190

Kahyangan Tiga, 47, 250n36; conception of, 94, 126

kaja-kelod ("north-south"), 39, 40, 248n15, 249n16

Kakul, I, 200

Kalér, I Madé, from Singaraja, 260n3

Kantor, I Ketut, 263n15

karang. See pattern

Karawan, I Ketut, 227, **228,** 234, **238**

Kebes, Déwa Putu, 149, 150, 176, 177, **179, 180,** 216, 221, 255n22, 261n9, 262n4

Kebo Iwa, 89–92, 99, 234, 235, 254n12

kemajuan (progress), 173, 204

Ketut, Pedanda, of Gria Kawan, 177

kingdoms, 92–95, 104; nineteenth century, 94–95, 255n20. *See also* Pejeng kingdom

Klungkung, Déwa Agung, 92, 255n26

About the Author

Hildred Geertz has spent much of her career seeking an in-depth and nuanced understanding of other cultures. Her first field research was in Java in 1952–1954 and resulted in the book *The Javanese Family*. She worked in Morocco in the 1960s and coauthored *Meaning and Order in Moroccan Society* with Clifford Geertz and Lawrence Rosen. Her fieldwork in Bali, which began in 1957–1958 and continued at intervals until 1995, has resulted in four books: *Kinship in Bali* (with Clifford Geertz); *Images of Power: Balinese Paintings Made for Gregory Bateson and Margaret Mead;* the present book, *The Life of a Balinese Temple;* and *Tales of a Charmed Life: A Balinese Painter Reminisces* (forthcoming from the University of Hawai'i Press). Her research combines participant observation, the elicitation of oral histories, the study of documents, and an exhaustive knowledge of the scholarly literature on Bali.

In her thirty years of teaching at Princeton University's Anthropology Department, Geertz taught courses in art and anthropology, social theory, and fieldwork methods. She was department chair for five years and is now professor emeritus. These days, she spends most of her time telling stories about Bali to her granddaughters, Andrea and Elena.

 Production Notes for Geertz / THE LIFE OF A BALINESE TEMPLE

Cover and interior design by April Leidig-Higgins
Text in Monotype Garamond with display type in Scala Sans and Gill Sans

Composition by Copperline Book Services, Inc.

Printing and binding by Thomson-Shore, Inc.

Printed on 70 lb. Fortune Matte, 500 ppi

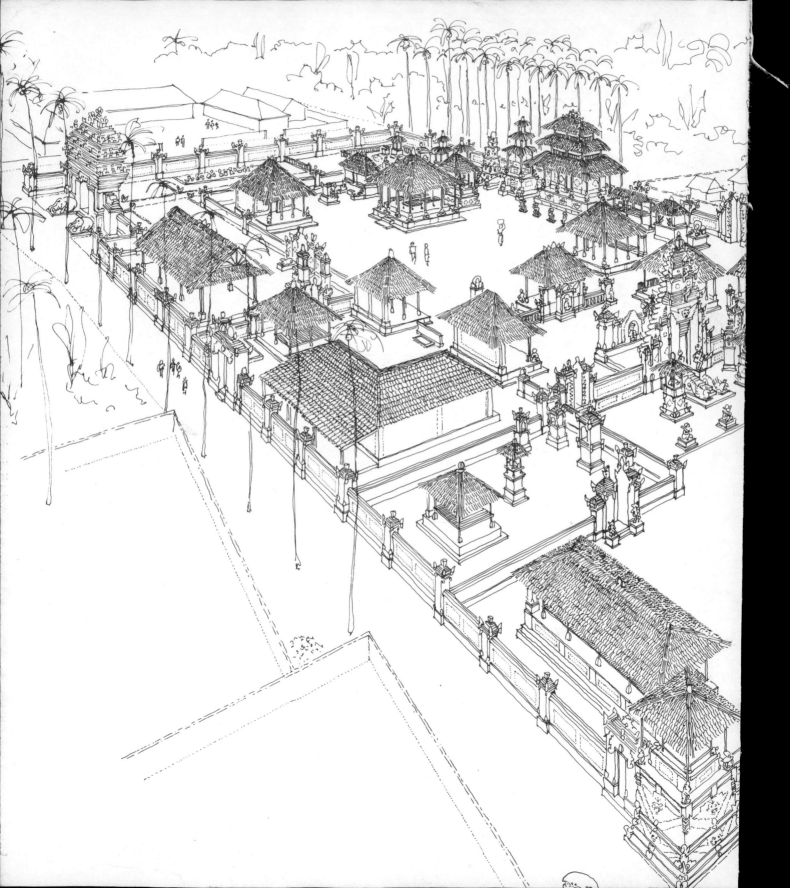